GARLAND STUDIES IN

AMERICAN POPULAR HISTORY AND CULTURE

edited by

JEROME NADELHAFT
UNIVERSITY OF MAINE

A GARLAND SERIES

Garland Studies in American Popular History and Culture

Jerome Nadelhaft, series editor

MAKING VILLAINS, MAKING HEROES

JOSEPH R. MCCARTHY,
MARTIN LUTHER KING, JR.
AND THE POLITICS OF
AMERICAN MEMORY

GARY DAYNES

GARLAND PUBLISHING, INC.
A MEMBER OF THE TAYLOR & FRANCIS GROUP
NEW YORK & LONDON / 1997

Copyright © 1997 Gary Daynes

Library of Congress Cataloging-in-Publication Data

Daynes, Gary.
 Making villains, making heroes : Joseph R. McCarthy,
Martin Luther King, Jr. and the politics of American memory.
 p. cm. — (Garland studies in American popular history
and culture)
 Includes bibliographical references and index.
 ISBN 0-8153-2992-X (alk. paper)
 1. Popular culture—United States—History—20th century.
2. McCarthy, Joseph, 1908–1957. 3. King, Martin Luther, Jr.,
1929–1968. 4. United States—Historiography. 5. Mass media—
Social aspects—United States. I. Title. II. Series.
E169.04.D39 1997
973.9—dc21 97-38427

Printed on acid-free, 250-year-life paper
Manufactured in the United States of America

For Amelia, Lucy, and Magdalen

And for Kristine
whose love and work made them and this possible

Contents

Acknowledgments

Thanks to Professor Raymond Wolters, who has helped with this project from the beginning. Thanks also to Peter Kolchin, Donald Meyer, and Jan Blits of the University of Delaware, Jessica Elfenbein of the University of Baltimore, Neva Specht of Appalachian State University, and Neil York and Frank Fox of Brigham Young University, all of whom read and critiqued earlier versions of this work. Kristi Long, my editor at Garland, has provided outstanding help in strengthening the final draft of this book.

Portions of two chapters have appeared in print elsewhere. Thanks to the editors of *Locus* who have granted permission to reprint portions of Chapter 1, which appeared as "History, Amnesia, and the Commemoration of Joseph McCarthy in Appleton, Wisconsin," *Locus: Regional and Local History of the Americas*, 8 (Fall 1995), 41-64, and to the editors of *Atlanta History*, who have granted permission to reprint portions of Chapter 2, which appeared as "Fighting for an Authentic Past: The Commemoration of Martin Luther King, Jr. in Atlanta, Georgia," *Atlanta History: A Journal of Georgia and the South*, 41 (Spring 1997), 5-26.

Making Villains,
Making Heroes

1
History and the Incivility of Public Life

This book is about the place of history in American life. More specifically, it is about how people produce and use knowledge about the past. It is a subject that draws my attention both because it is so common and so contentious. Surely we are the most historically minded Americans to ever live. We flock to historical sites, flood museums, re-enact battles, read histories and historical novels, tune in to the History Channel, attend historical movies, and commemorate an astounding number of anniversaries.

Though we use history for entertainment, we use it also for enrichment and education. Indeed, Americans are turning to the past in great numbers to explain and to soothe, to build self-esteem and cultural pride. What is more, we seem to do it in a distinctively American way. Michael Kammen, in his massive survey of the role of tradition in the United States, *Mystic Chords of Memory: The Transformation of Tradition in American Culture*, argues that American commemorations have been decentralized affairs with the federal government playing a minor role in commemorating the past. Further, public manifestations of the past, with a few exceptions, have held consensus and stability in high regard. In the period since World War II, these trends have remained steady, while interest in the vernacular past—the stories of everyday life and everyday people—has grown. Together, the urge to consensus, Washington's laissez-faire approach to the past, and the increasing interest in events of local importance have produced entrepreneurial, depoliticized commemorations, Kammen argues. He also points out that without stable funding for long-term historical education, history and commemoration have become more closely related, with the passage of major anniversaries often being the main catalyst for consideration of the past.[1]

Kammen's contention that American commemorations tend toward consensus has come under attack since the publication of his book in 1991. The attack is two-fold, one line of criticism advancing

from scholars, the other through current events. Historians have been quick to point out that what looks depoliticized on the national level is actually the result of a highly politicized historical process, one that sheds complexity and conflict and gains official sanction as information passes from those who experience the past to those with the power and money to commemorate it.[2] Harvey Kaye, a historian of American radicalism, in a review of Kammen's book, chided him on exactly this point. Kaye referred to *Mystic Chords of Memory* as "yet another version of 'consensus history'," and then, addressing Kammen's statement that "there is a powerful tendency in the United States to depoliticize traditions for the sake of 'reconciliation'," wrote, "Where Kammen sees a 'powerful tendency' I would ask us to look more closely for 'powerful' human agencies. And where he sees the 'depoliticization of traditions for the sake of reconciliation,' I would ask us to remember that we actually may be witnessing 'the pursuit of hegemony' in which the governing class attempts to (re)secure the political and social order through 'consensus-building'."[3] Kaye's comments were not confined to criticism; he placed Kammen's book in the context of the New Right's tendency to use a conflict-free interpretation of the American past as part of its attack on political radicalism. Kaye, in turn, accompanied his review of *Mystic Chords of Memory* with a call for radical historians to continue to push into public view the idea that the creation of history is tied to the hegemony of the powerful.[4]

The debate between Harvey Kaye and Michael Kammen's way of seeing the American past is an old one. Historians have long struggled with the "bias" questions—Can history be objective? Can historians divorce their own experience from their interpretations of the past? Should they?[5] But the willingness to impute political[6] motives and outcomes to scholarly history is an innovation of the fairly recent past, a trend born since 1960 and matured in the "culture wars" of the last decade.

The growing academic interest in pointing out links between scholarly work and partisan politics is matched only by the public's willingness to do the same thing. More than the scholarly critique of consensus, it is this urge, among journalists, politicians, and organized interest groups, that makes Kammen's argument about "consensus" commemorations look false in the 1990s. Since the publication of *Mystic Chords of Memory*, we have witnessed feuds over multicultural

education and the core culture, the National Endowment for the Humanities and the National Archives, the bombing of Japan and the conquest of the American West. We have become inured to the claims of bias in history, for they come, almost *pro forma* from the right and the left, Christians and atheists, politicians and bureaucrats, scholars and laymen. The problem that this book addresses, then, is not just one of making good history, but also of history's role in American civil society.

This book sets out to evaluate the extent to which political bias has actually influenced the creation of history in the United States since the 1950s. It is founded on the belief that events can best be understood through an examination of their histories. It is therefore suspicious of the link assumed between present politics and history, because that assumption overlooks the history of history—the general processes by which bits of knowledge about the past escape obscurity and the specific ways in which different groups of people create history.[7]

I have used as tools to carry out this evaluation a series of investigations into the ways that journalists, scholars, and people in their home towns have commemorated the lives of Joseph McCarthy and Martin Luther King, Jr.[8] This is an unusual comparison, I know. Historians have traditionally thought of themselves as history producers, while seeing journalists, politicians, and citizens as history users, myth makers, or memory keepers. Academics have assumed a rigid categorical division between "history"—the stuff made by scholars—and "memory"—the product of the people. They assume that history is an objective production, while memory is independent, non-scholarly, popular. Take, for example, this description from the introduction to an outstanding collection of essays edited by Genevieve Fabre and Robert O'Meally, *History and Memory in African-American Culture*. Fabre and O'Meally write that while history is a scholarly discipline, memory is "a personal activity, subject to the biases, quirks, and rhythms of the individual's mind. . . . Compared with the helter-skelter and dreamy impressionism of human memory, history is closer to human knowledge, which can fall back on the stability of fact and reasoned truth."[9] But if post-modernism has taught us anything, it is that scholars are subject to the same "biases, quirks, and rhythms" as regular people.[10] At the same time recent studies in cognition have pointed out that memory is far from a haphazard construction—it has its own structures, rules, and procedures.[11] Also, the line between

scholarship and public memory is increasingly blurred. Academics curate popular exhibits and write personal essays. Citizens pen scholarly books and speak with authority about the past.[12] The distance between "history" and "memory" has narrowed. Rather than automatically separate them, then, I have found it more fruitful to think about them together, limn their structures, and describe their outcomes. This is not to say that there are no differences between how scholars and non-scholars think about the past, but instead that those differences only take on meaning through comparison.

Even stranger than a comparison across the lines of history and memory is the comparison of King and McCarthy. They have, on the surface, little in common. McCarthy was a rural, midwestern conservative; King an urban liberal from Georgia. McCarthy was an uncouth man surrounded by the staid civility of the Senate; King was unfailingly polite in a milieu that urged him to violence. McCarthy lent English his name as invective—McCarthyism; King offered a signal phrase for society—I Have a Dream. A vast celebratory apparatus—songs, monuments, tributes, the holiday—has grown up around Martin Luther King's life. Joseph McCarthy has garnered only a gravestone and a bust hidden away in a county courthouse. King is a hero, McCarthy is a villain.

But there are several reasons why McCarthy and King are appropriate subjects for a book about the creation and meaning of history in the modern United States. More than any other post-World War II Americans, their lives are common public knowledge, subject to frequent historical allusion, the objects of scholarship, the sources from which spring many pronouncements on the lessons of the past. Because of their celebrity, King celebrations and McCarthy denunciations reflect both their own merits and changes in American society. Telling their commemoration stories is thus a way to shed light on much of contemporary American cultural history.

Of course, these are simply reasons for studying King and McCarthy, not justification for comparing them. The stories of their legacies could make up two long, separate books. And, indeed, each of the six chapters that make up the body of this book can be read as a separate, self-contained essay. But several concerns, raised both within and without the walls of academe have led me to put King and McCarthy together. First, scholarly works on the legacies of famous people tend to focus most often on the stories of heroes (or people who,

in an author's estimation, deserve to be heroes).[13] This is not to say that all such studies of "good" people are celebratory. Often scholarship is an effort to debunk, to make the great seem human. Nor is it to say that "bad" people are always left out. Hitler, Stalin, and closer to home, Benedict Arnold have all drawn scholarly attention. But by not comparing the treatment of Benedict Arnold with that of, say, George Washington, scholars have missed the chance to talk in broader terms about the role of the past, good and bad, in the present. Second, scholars of historical memory have tended to focus on academics or the national media or local memories. In looking at all three I again seek a broad perspective on the role of the past in American life. Third, Leo Ribuffo has argued that historians too often consider the right and left in the United States as if they resided on different planets, and that this segregation leads to a myopic view of American life.[14] Thinking about McCarthy and King together overcomes such separation.

Beyond these scholarly concerns, McCarthy and King go together because by comparing them we can evaluate much of the rhetoric about what role history should play in the present. Take for example the tone of uneasy celebration that surrounds anniversaries in the United States. Behind the platitudes about how good it is to know the history of the invasion of Normandy, the liberation of Nazi death camps, or the march across Selma bridge (to name three recent examples), is the clear but unstated concern that Americans are forgetting or trivializing these events. But the moral assertion that remembering is better than forgetting ignores the fact that some people want to forget the past, or be forgiven for their role in it. Further, it overlooks the unemotional pressures that lead to the disappearance of the past—irrelevance, death, inadequate funding, and the natural shift from broad public acclaim to essentially scholarly interest among them. Of the two people considered here, McCarthy leads King down the path to obscurity. Chapter 2, a look at commemorations of McCarthy in Appleton, Wisconsin, is an examination of the process of forgetting, a process that in Appleton led both friends and foes of McCarthy to agree that McCarthy was irrelevant, even while they continued to praise and damn him. It also explores the links between the urge to forget and the production of history.[15]

If someone like Martin Luther King, Jr. survives the process of forgetting that has led McCarthy's memory to oblivion in Appleton, there is sure to be debate about how to define the survivor's "true"

legacy. Conflict over the definition of a legacy often grows out of conflicting ways of organizing the past. This has been the case in the recent battle over the interpretation of the Enola Gay at the Smithsonian. Originally a disagreement between curators and veterans groups over the moral and historical context in which atom bombs fell on Japan, the debate eventually became a political issue and degenerated into partisan squabbling. It was ultimately resolved by Congressional Republicans threatening to withhold the museum's funding. The museum director agreed to change the exhibit, and the debate ended.[16]

The battle over the Enola Gay is certainly an example of the powerful exercising "hegemony" over the less powerful, to use Harvey Kaye's formulation. But before and beneath the application of political pressure, the debate was about appropriate styles of remembrance. Veterans asserted that the atom bomb saved their lives, and therefore, on an emotional level, deserved praise. Historians countered with their scholarly *bona fides*—evidence that the Truman administration had more than the lives of GIs on its mind when it destroyed Hiroshima.[17] Smaller, similar squabbles have broken out over the interpretation of Martin Luther King's legacy in Atlanta. And as in the case of the Enola Gay, differences over the style of commemoration preceded claims of political bias. Chapter 3, a study of King commemorations in Atlanta, defines three ways of organizing the past into history—memorial, tributary, and scholarly[18]—that have been active in recalling both King and McCarthy and explains how these conflicting styles of commemoration led to public disagreement about the interpretation of King's life.

The chapters following those on Appleton and Atlanta examine the adoption of the styles of commemoration in the media and the university, while addressing the validity of other claims of political bias. Conservatives often state that the mass media are overwhelmingly liberal. This being the case, one would surmise that the mass media would ignore or abuse McCarthy while heaping attention and praise on King. And it is true—King has received more positive press than McCarthy—but it is only part of the story. Both McCarthy and King have been poorly treated by scholarly standards; McCarthy by attributing to him all sorts of nasty things that he never did, King by focusing narrowly on only one part of his message. This badly written history (and the alternately unimaginative and overimaginative public figures who were the sources of it) is a result of the commemorative

styles that journalists and politicians have used to recall McCarthy and King.

Chapter 4 outlines McCarthy appearances in the press since his death. It finds that while McCarthy has always appeared as a bad guy of the 1950s, people from across the political spectrum have, at different times, claimed to have been victims of him and his spawn, "McCarthyism." Because emotion and personal experience—the bases of the tributary style—have been the primary link between journalists, politicians, and McCarthy, there has been a widespread disregard for the past—for understanding exactly what McCarthy did and to whom. Thus, McCarthy's history in the press takes its form from the way he is remembered, not the political affiliations of the journalists and politicians evoking his memory.

Chapter 5 examines how Martin Luther King has fared in the national press. While coverage of McCarthy focused on personal experience, reporters and politicians invoking King's name used the memorial style to draw to his memory those who had not personally experienced parts of his life. The ultimate memorial act, creating a holiday in King's honor, brought the nation to King while at the same time making him palatable to the nation. The result has been the achievement of an "official" memory of King, that, because based on an agreeable reading of King's life, has opened King to criticism from adherents to other historical styles.

In recent years, universities have been accused of being even more biased than the press. Historians have come under fire for ignoring and featuring the founding fathers, paying too much and too little attention to minorities, and promoting or obstructing a radical agenda in their classrooms. As with the media, the accusations of bias miss the larger factors influencing the interpretation of the lives of McCarthy and King. While the ideologies of scholars writing on King and McCarthy are clear, liberals and conservatives among them seem more concerned with making their work relevant than promoting a particular political agenda. Chapter 6 outlines scholarly treatments of McCarthy. In his case the urge to relevance has, since the mid-1950s, attracted a series of scholars—first sociologists and psychologists, then political scientists, and then historians and biographers. The shift in disciplines, typical of the scholarly style of commemoration, has accompanied a diminished sense of McCarthy's relevance. The first generation of writers sought to influence political policy, the next disciplinary practice, the third only

historical understanding. The dominance of the scholarly style in writing about McCarthy has created an accurate picture of him. But it has also raised questions about the public relevance of such a scholarly McCarthy, and, in turn, about the utility of the scholarly style.

Scholarship on King, discussed in Chapter 7, did not travel from sociologists to political scientists to historians. Instead at the stage where social scientists alone had analyzed McCarthy, historians were writing about King. This change in the scholarly style, this willingness to give up distance for relevance, to cross disciplinary boundaries, has had an important effect on how historians have commemorated King. Having abandoned their traditional claim to being relevant simply by providing correct historical information, and without the natural ties to politicians that political scientists have, historians were forced to make their work relevant by attuning it to the winds of public opinion. The result has been a long series of King biographies, each claiming to provide a new view of King, each struggling to correct public opinion. The urge to rectify public opinion, often taken as a sign of intellectual arrogance and scholarly radicalism, is, in this case, a result of the way scholars do their business. The claims to having new interpretations of King, often criticized as a sign of presentism and relativism in the academy, turn out to be mostly marketing ploys. The claims of innovation mask a long-standing consensus among King historians about the outlines and meanings of King's life.

This book concludes with an evaluation of the legacies of McCarthy and King and the ways in which they have been remembered. This appraisal is concerned both with the ability of the memorial, tributary, and scholarly styles to create good history and their ability to make that history publicly useful. Drawing on recent work in the fields of public theology, sociology, legal philosophy, and political science, I argue that knowledge of the past is essential for civic well-being, and that the scholarly style creates the best knowledge about the past. However, the scholarly style cannot survive without its memorial and tributary counterparts, both of which are more accessible, command more money, and draw greater public fealty. The challenge, then, is to improve the quality of the history produced by non-scholars, a step that can only be taken when the partisans of the memorial and tributary styles are willing to recognize the value of distance, evidence, and limits in public discourse. This step can only be taken if scholars hew to these standards in their own public pronouncements on the past, and

lead non-scholars to adopt them as their own. As with the other people working to improve the quality of public discourse, I can offer no fail-safe process that will create a harmonious public square. I can suggest, though, that the path to a decent and open public life does not lead through the swamps of easy accusations of political bias.

Notes

1. Kammen is clearly not thrilled with the culture of tradition in American since 1945, especially in its willingness to serve profit-making entities and the amnesia that accompanies often nostalgic looks at the past. Michael Kammen, *Mystic Chords of Memory: The Transformation of Tradition in American Culture* (N.Y.: Knopf, 1991), 13-4; 532-5; 572-88, 660-73. Kammen's contention that memories of the past in the U. S. tend to be improvised more often than elsewhere in the world is corroborated by William Johnston in his study of anniversary celebrations in America and Europe in the 1980s. William Johnston, *Celebrations: The Cult of Anniversaries in Europe and the United States Today* (New Brunswick: Transaction Publishers, 1991), 18-22.

2. The best statement of this view is John Bodnar, *Remaking America: Public Memory, Commemoration, and Patriotism in the Twentieth Century* (Princeton: Princeton University Press, 1992). See also George Lipsitz, *Time Passages: Collective Memory and American Popular Culture* (Minneapolis: University of Minnesota Press, 1990), especially the book's final essay, "Buscando America (Looking for America)," 257-271. Lipsitz's tone is more optimistic than Bodnar's; in the realm of popular culture the "powerful" have been less able to neuter memory than they have in the realm of patriotism.

3. Harvey Kaye, review of *Mystic Chords of Memory*, by Michael Kammen, in *American Quarterly,* June 1994, 257.

4. Ibid., 252-3.

5. The best history of historians struggling with their own role in creating history is Peter Novick, *That Noble Dream: The 'Objectivity Question' and the American Historical Profession* (N.Y.: Cambridge University Press, 1988).

6. The word political is a hopelessly vague one, I know. And its vagueness has grown among scholars, who, in their works use "politics' to refer to any sort of struggle for power. Using this definition, history has been political as long as it has been a profession, with different interpretations, schools, and scholars vying for money, publication, and prestige. I use the word in a much narrower sense here, though, for the new aspect of scholarly battles is not that they reflect struggles for power but that they reflect struggles for public power, for

influence, ultimately, in governing the United States. Harvey Kaye did not accuse Michael Kammen of shilling for the GOP, but he did imply that Kammen's work supported, in spirit, the philosophy of the New Right, thus granting *Mystic Chords of Memory* political influence.

7. The focus on process, though a part of some of the best books on collective memory (see for example Gladys Engel Lang and Kurt Lang, *Etched in Memory: The Building and Survival of Artistic Reputation* (Chapel Hill: University of North Carolina Press, 1990), 1-15, 318-351), is absent from the books by Kammen and John Bodnar, note 2 above. On this dearth, see Michael Frisch, review of *Mystic Chords of Memory*, by Michael Kammen, and *Remaking America*, by John Bodnar, in *Journal of American History*, Sept 1993, 619-21.

8. There are other sources that I could have included as well— memoirs and popular culture (buttons, films, songs) come to mind. I have left them out for practical and theoretical reasons. To consider all memoirs and pop culture representations of King and McCarthy would take far too long. And, memoirs and pop culture lack the community, the awareness of other arguments, the willingness to engage in debate, and the public results of that debate that the media, academics, and towns have.

9. Genevieve Fabre and Robert O'Meally, eds., *History and Memory in African-American Culture* (N.Y.: Oxford University Press, 1994), 5-6.

10. The classic statements of this position come from Hayden White, in *Metahistory: The Historical Imagination in Nineteenth-Century Europe* (Baltimore: Johns Hopkins University Press, 1973) and *The Content of the Form: Narrative Discourse and Historical Representation* (Baltimore: Johns Hopkins University Press, 1987). For a more anecdotal approach, see Peter Novick, *That Noble Dream: The 'Objectivity Question' and the American Historical Profession* (N.Y.: Cambridge University Press, 1988).

11. James Fentress and Chris Wickham, *Social Memory* (Cambridge, Eng.: Blackwell, 1992), 20-35, 42-85.

12. For two examples of the blurring, see Dolores Hayden, *The Power of Place: Urban Landscapes as Public History* (Cambridge, MIT Press, 1995); and Suzanne Lacy, ed., *Mapping the Terrain: New Genre Public Art* (Seattle: Bay Press, 1995).

13. This is most true of studies of American Presidents. See, for example, John William Ward, *Andrew Jackson: Symbol for an Age* (N.Y.: Oxford University Press, 1953); Merrill Peterson, *The Jefferson*

Image in the American Mind (N.Y.: Oxford University Press, 1960); Peterson, *Lincoln in American Memory* (N.Y.: Oxford University Press, 1994); Wilbur Zelinsky, *Nation into State: The Shifting Symbolic Foundations of American Nationalism* (Chapel Hill, University of North Carolina Press, 1988), 20-68. But see also Gladys Engel Lang and Kurt Lang, *Etched in Memory*, note 8 above; Richard Posner, *Cardozo: A Study in Reputation* (Chicago: University of Chicago Press, 1990) and John Rodden, *The Politics of Literary Reputation* (N.Y.: Oxford University Press, 1989).

14. Leo Ribuffo, "Why Is There So Much Conservatism in the United States?" *Journal of American History*, Apr 1994, 441-7.

15. More definitions. In this work I use the phrase "the past" to refer to any event that has already occurred. "History" on the other hand refers to organized knowledge about the past. because "history" does not include everything that happened in the past, an integral part of making history is choosing which parts of the past to remember. See Chapter 2 below for a more complete explanation.

16. The fight over the Enola Gay has occasioned a great amount of media coverage. For a starting point to the debate, see David C. Morrison, "Airpower *Uber Alles*," *National Journal*, 2 Apr 1994, 805. On the Smithsonian's decision to scale back the exhibit see Karen De Witt, "Smithsonian Scales Back Exhibit of Plane in Atom Bomb Attack," *New York Times*, 31 Jan 1995, A1. For the responses of historians to the Enola Gay incident see the forum on "History and the Public" in the *Journal of American History*, December 1995.

17. On the different styles of remembrance involved in the Enola Gay dispute, see Edward T. Linethal, "Can Museums Achieve a Balance Between Memory and History?" *Chronicle of Higher Education*, 10 Feb 1995, B1.

18. The memorial style is characterized by an effort on the part of commemorators to draw others to the person being commemorated. It relies for its authority on claims of being "official," rather than the truth of its portrayal of the past, in part because the urge to entice others to accept requires that it present a portrayal of the past that does not offend. The "tributary" style is less concerned with converting others than it is with demonstrating the correctness of its position. Claims for correctness are based on personal experience and emotional ties to the person being commemorated. The "scholarly" style bases its

arguments on being correct as well. But while the tributary style relies on personal experience and emotion to prove its correctness, the scholarly style relies on distance—the passage of time, the existence of confirmable evidence—and limits—temporal, spatial, evidentiary—to prove its points.

2
McCarthy Does Not Matter: The Commemoration of Joseph McCarthy in Appleton, Wisconsin

His [McCarthy's] role in history is greatly exaggerated. When I hear of another biography of him planned, I say, why? Why bother? We know all we could ever want to know about Joe McCarthy.
—Stanley Kutler[1]

Joseph R. McCarthy has secured a place in history, for good or ill. Whether he has secured a place in the Outagamie County Courthouse is more problematic.
—James Meyer[2]

Between 1986 and 1991, the Outagamie County Council debated whether a bust of Joseph R. McCarthy that stood near the main entrance to the county courthouse should be removed to the Outagamie County History Museum. Council members who held McCarthy in low esteem pushed for the bust's transfer to the museum. McCarthy supporters demanded that the bust remain in the Outagamie County Courthouse, at one point suggesting that the building be named after the deceased senator. After a long, angry debate, the council finally gave up in exasperation. The bust stayed where it was. Shortly thereafter a new addition to the courthouse moved the entrance, consigning the bust to a rarely visited corner of the building. It stands there today.[3]

The fate of McCarthy's bust raises several questions about Joseph McCarthy's place in American history and in the history of his home town, Appleton, Outagamie County, Wisconsin. Most Americans know little about Joe McCarthy. Most of those who do know much about McCarthy think of him in negative terms. He is, in academic and popular writing, a bully, a loudmouth, a liar, a trampler

on civil liberties, an emblem of intolerance, a man unworthy of support. Yet, in Outagamie County, McCarthy opponents could not muster enough strength to move McCarthy's bust. But this inability stemmed more from ignorance than support for McCarthy. The bust stayed where it was not because Appletonians cared so much about McCarthy, but because they ultimately cared so little.

Appleton's citizens are not alone in knowing little about their past. American public space is filled with scholars and activists decrying historical amnesia. It is central to the on-going debates about American educational reform and the squabbles over historical theme parks. And it rises every time Americans are called to commemorate a historical event. In most cases, historical knowledge is a hero. History appears at war with amnesia, each new bit of research smiting a soldier of ignorance, each fact learned preserving one more parcel of the past. But in Appleton's consideration of McCarthy, history and forgetting are as often friends as foes. The members of the County Council who sought to move McCarthy's bust chose the museum because it was a safe place to put a relic of a past better forgotten. That history and forgetting work together in this manner should not be surprising. Forgetting, the dissipation of knowledge about the past, makes history, the gathering and ordering of knowledge about the past, possible. Instead of wondering, then, who wins the battle between history and amnesia, we might ask instead, what is the result of their collaboration? The outcome may be edifying, as in Russia, where years of official lies are disappearing and in their wake remain the stories of the millions killed in Stalin's purges. But it may be enervating as well. In 1989, during the debate over the placement of McCarthy's bust, area papers ran several articles on McCarthy's disappearing legacy. In these articles, the loudest voices in favor of continuing the process of forgetting came from academics. The epigraphs from Stanley Kutler that opens this chapter appeared in one such article. Whatever one's opinion of McCarthy, the collaboration between history and forgetting in Appleton must call into doubt history's heroic status and ask more basically, what does history do?

The RoadStar Inn is an inexpensive motel on the outskirts of Appleton, Wisconsin. Past the registration desk, across from the ice machine, against the wall of the inn's main hall, stands a rack of pamphlets—schedules of community events, advertisements for

restaurants, museum brochures, maps. The Outagamie County Historical Museum boasts an exhibit on Wisconsin pioneers. The Harry Houdini Museum celebrates Appleton's most famous escape artist, and the 1839 Grignon Mansion commemorates "a rare example of high Eastern taste on the Wisconsin frontier."[4] But a tourist in Appleton would have to search hard for a sign of Joseph McCarthy. McCarthy presents the city's boosters with a dilemma, for on the one hand he is famous, far more famous than Houdini and the other semi-marketable Appletonians, the novelist Edna Ferber and the one-time Pittsburgh Steeler Rocky Bleier. But on the other hand, he is infamous; he is the McCarthy in "McCarthyism," the man with the list of 205 or 81 or 57 "known" Communists employed by the State Department, the pugilist who punched journalist Drew Pearson, the senator condemned by the U.S. Senate for unsenatorial behavior.

Yet if McCarthy were only infamous, he would be some sort of a tourist attraction, if only in the wax museum hall-of-serial-killers tradition. The problem with McCarthy as a tourist attraction is that there is a small, vocal group of people who consider McCarthy a hero. Civic leaders have responded by making the traces of his life local, in that they are not advertised to outsiders. It is as if the town has publicly forgotten McCarthy. So, Joseph McCarthy is not on the rack at the RoadStar. The home of his youth in nearby Grand Chute is not fronted by a marker noting its historical significance. There is no plaza named in his honor. (The downtown park created in a recent urban facelift bears Houdini's surname.) The Visitor's Bureau circuit of interesting local sites stays far from the only public reminder of McCarthy, the bust still standing in the courthouse. But there is history about McCarthy to be found. The Appleton Public Library has an extensive collection of books for and against McCarthy, and a file of newspaper stories about McCarthy that stretches from the 1950s to the present. The *Appleton Post-Crescent* routinely reports McCarthy stories. And at least some people from Appleton and its environs still care enough about McCarthy to contest his legacy when anniversaries or political disputes raise his memory.

Appleton's leaders did not sit down and, all at once, declare McCarthy *persona non grata*. Forgetting is a process, one that has over the last forty years slowly separated McCarthy from Appleton and Appletonians from McCarthy's legacy. It has been borne along by death

and birth, by those wishing to forget McCarthy and those anxious to remember.

In the summer of 1954 Leroy Gore, the organizer of "Joe Must Go," Wisconsin's effort to recall McCarthy from the Senate, visited Appleton. He had expected violent opposition from residents of McCarthy's hometown. His expectation was only half right, for while a reporter from the *Appleton Post-Crescent* was openly hostile to the recall, and a few burly McCarthyites shot spiteful glares at Gore, a meeting to support the recall attracted a large number of people dissatisfied with McCarthy's public behavior. Gore ranked his time in Appleton somewhere between his triumphant visit to Madison and a notable failure in Green Bay.[5]

The more than 350,000 signatures gathered by Gore's recall effort during the summer of 1954 were but one sign of Joseph McCarthy's fading support in his home state. Historian Michael O'Brien's careful study, *McCarthy and McCarthyism in Wisconsin*, places the apex of McCarthy's attractiveness in 1951, and notes that by 1952, voters in Wisconsin were beginning to tire of their senator.[6] Public weariness grew through 1953 and into 1954 as McCarthy kept up his attack on the federal government and ignored Wisconsin's dairy crisis. When Gore, a long-time Republican, launched the recall in 1954, he did it not because he felt that McCarthy still played a powerful, dangerous public role, but because Wisconsin-ites would be poorly served by a senator clearly on the way out. For Gore, McCarthyism was dead, but the "corpse," McCarthy, would serve until his term expired in 1958 unless "embalmed" by the people of Wisconsin.[7] Though Gore's undertaking fell a few thousand votes short, by the end of 1954 the Army-McCarthy hearings, Edward R. Murrow's influential dressing down of McCarthy on *See It Now*, and the U. S. Senate's censure of McCarthy had started the formaldehyde flowing.

It is important to note what the events of 1954 did and did not accomplish. They did not end American anti-communism, or the efforts to remove subversives from government employ. Instead, they put McCarthy in his place by condemning his behavior and tactics. He fell from his position as one of America's most known political figures and an outspoken critic of the executive branch of government and his own party. He landed in the more appropriate spot of junior senator from a farm state. McCarthy's treatment by the Senate and the press between

1954 and his death in 1957 served to neutralize him. The press releases and criticisms of President Eisenhower, which had won McCarthy media attention in 1953, met with media indifference in 1956. McCarthy did not stop acting after 1954, he simply acted on a smaller, darker stage.[8]

In Wisconsin, too, the press paid him less attention, especially on controversial issues. But McCarthy still commanded some support. A McCarthy Day in Boscobel, WI, in 1955 drew 5,000 people to a parade in his honor and 1,500 to a McCarthy speech.[9] At the 1955 State Republican Convention, McCarthy garnered more support than Eisenhower. But at that meeting, again, the tendency away from controversy is apparent. O'Brien writes that "the fanatical devotion to McCarthy had died. His appearance generated little enthusiasm and no standing ovation, and a substantial minority of delegates opposed the pro-McCarthy resolution."[10]

Ironically, McCarthy's condemnation by the Senate, and the subsequent press silence during the final three years of his life improved his image at death. Had McCarthy died in December 1954, his passing would no doubt have raised a major debate about the man, some calling him a martyr, more a devil.[11] But the space between his censure and death quieted the shouts of support from the sort who had glared at Leroy Gore, and allowed McCarthy's opponents time to cultivate apathy. At the memorial services held by the U.S. Senate, McCarthy's staunchest foes chose not to speak, perhaps hoping that continued quiet would help McCarthy's memory slip into forgetting. McCarthy's friends rose on his behalf, but only rarely did they try to refight the battles of the early 1950's. Rather, they admired McCarthy's courage, praised his opposition to communism, acknowledged that his bullying and penchant for half-truths were flaws, and attributed those flaws to his Irish character and the urgency of his crusade.[12] The same division— opponents in silence, friends in character definition—appeared in Appleton, Wisconsin, where 25,000 people viewed McCarthy's body before it was buried at St. Mary's Cemetery.

The memorial outpourings in Appleton rose on local variations of the theme heard in the Senate services. In defense of McCarthy's character, the Reverend Adam Grill, McCarthy's parish priest, explained that McCarthy was, above all else, a dedicated man. The ultimate objects of Joe's devotion were God and country, but the sources of his piety and patriotism were found in Appleton. Grill recalled how as a

youngster McCarthy learned Christianity at St. Mary's. That youthful training supported McCarthy in his national service. "Mrs. McCarthy informs me that . . . frequently he [McCarthy] would ask her to take a little walk, and as they walked along the streets of Washington they would pass a Catholic church. Senator McCarthy would go into the church and spend 10 minutes or so in silent prayer," Grill told the congregation at McCarthy's memorial. Further, McCarthy learned that "Christianity without charity was void." As an adult, Joe always acted charitably. "Senator McCarthy loved his neighbors, he loved his country, he loved his state, he loved his native city of Appleton, he loved St. Mary's. One of his greatest loves was for the young, and for them he fought."[13]

Grill continued, arguing that Christianity also impelled McCarthy to oppose communism. "Senator McCarthy was like a man of old who saw this danger to his country, and, clothed in the shining armor of zeal and love, and holding within his hands the sword of truth, he went forward into the battle with the cry on his lips, 'For God and for my country'." The prophetic McCarthy directed truth against the greatest danger facing America, not Russian nuclear weapons, but communist subversion, "the common enemy of democracy and God-fearing people . . . boring from within," undermining government and the nation. Grill closed by adjuring his listeners to remember McCarthy: "We have loved him in life, let us not forget him in death."[14]

The themes of Grill's panegyric—McCarthy's Appleton origins, his good character, his Christianity, his correct opposition to internal subversion, and his memorability—dominated other local tributes to McCarthy at the time of his death. The *Post-Crescent* noted that just before McCarthy's death, the U. S. Senate had named its five greatest members. Among the five was Wisconsin's Robert La Follette, Sr. The paper pointed out that during his life, LaFollette had been very controversial, but the passage of time had vindicated him. The paper trusted it would do the same for McCarthy.[15] While the newspaper hoped McCarthy would enter the Senate's hall of fame, Cletus Wickens was more concerned with his heavenly reward. "We who believe in a just God will find some consolation in knowing that our Joe will be invited to enter the Kingdom of Heaven." Wickens also took up internal subversion, comparing McCarthy with Christ and his opponents with "a thousand Pontius Pilates who crucified him [McCarthy] with a

distortion of truths and venomous lies because of his efforts to expose the communist conspiracy designed to destroy the United States." The Seyller family of Menasha, WI expressed its expectations of McCarthy's importance in verse:

> We shall always think of Joseph,
> As we look into the sky
> He may rest beneath the earth
> But his words shall never die.

Robert Buechle agreed in prose: "I am sure that when his work is objectively evaluated, he will rank with the great men of the midwest like Bryan, LaFollette, and Taft."[16] There was some local effort to ensure McCarthy's posthumous presence in the Appleton area. Two years after McCarthy's death, a sculptor, Suzanne Silvercruys Stevenson, presented civic leaders a bust of McCarthy, bronze mounted on black marble, to highlight McCarthy's heroic courage.[17]

Though the themes appear separately here, in the aftermath of McCarthy's death, McCarthy's local origins, his character, Christianity, anti-communism, and memorability more often came jumbled together. Over time, though, as McCarthy was either vilified or forgotten by most Americans (and most Appletonians), his local defenders picked from the mixture the strand that most closely suited their feelings for McCarthy and the needs of the moment. As a result, the unified (though by no means unbiased) picture of McCarthy began to unravel, and certain threads disappeared almost entirely.

The gravestone phrase "Rest in Peace" is honored more often than not with American deaths. For the vast majority of the deceased, the last public memorial comes on the obituary page. And even for the famous, the years immediately following burial tend to be unceremonious ones, as friends seek private solace and the media the next headline. In the early years of the Republic, decades often passed before monuments were raised to the Founders.[18] Since the Civil War, the space between death and commemoration has shrunk, but there is space still.

Beyond the need for time to grieve, the silence shortly after death is a function of the way we celebrate anniversaries. The first high school reunion comes at five years, but often there is little reason to

reunite because the lives of the graduates are still unsettled. Ten years marks the first meaningful reunion and twenty years the next. So it is with the renowned dead. It takes time for people and institutions to settle on the meaning of the expired life. In Thomas Jefferson's case, forty years of wrangling and a civil war were necessary for politicians to come to enough of an agreement on the meaning of Jefferson's life to begin to raise monuments in his memory. And while Northerners and blacks immediately acclaimed Lincoln upon his death, for almost a generation Southerners were less willing to praise the man who had defeated their cause.[19] There are two processes, then, that together fill the space between death and commemoration. The first is forgetting, the second, argument leading towards an image of the deceased strong enough to found a memorial. If the consensus behind the image is sufficiently broad, or the amnesia adequately profound, the first memorial becomes the last, as in the thousands of forgotten local heroes sculpted in now-tarnished bronze, standing in town squares. For the more famous, the first commemoration sparks another, sometimes in agreement, sometimes in rejoinder. In this way history battles forgetting, even while it is remade in the image of the present-day.

It is not surprising, then, that quiet enveloped McCarthy's memory in Appleton in the years following his death. But the silence was deeper for McCarthy than for others equally well-known because the natural tendency to forget worked in concert with a growing consensus in the national press that McCarthy was not worth remembering. In 1959, Richard Rovere, a journalist who had known McCarthy, published *Senator Joe McCarthy*, an even-handed but generally unfavorable assessment of McCarthy. During the same time, "McCarthyism" became a synonym for bullying behavior used to silence political opposition.[20]

The union between natural forgetting and a negative national image accounts for the tone and content of the remarks of the small group of McCarthy supporters who sought, in the early 1960's, to bring McCarthy back to Appleton's public eye. Beginning on the fifth anniversary of his death, the "Friends of McCarthy" (FOM) met annually at his grave, seeking to resurrect McCarthy's memory. For the first four years they drew no press coverage, and then, for the next decade, but a trickle. Only when the anniversary count reached into the twenties, national politics took a conservative turn, and the rhetoric of the McCarthy forces began to attract the presence of the John Birch

Society and the odd member of the American Nazi Party did the message of the FOM get consistent media coverage in Appleton. The *Appleton Post-Crescent* wrote about only four of the first ten FOM memorial services. Most of the coverage was brief, and in 1972 only a captioned photo of mourners appeared. But in the few lines of text on McCarthy in 1966, 1967, 1969, and 1972, the concerns of McCarthy-ites, McCarthy's family, and the Appleton press are clear.

Because it is through the eyes of the local newspaper that one now sees the McCarthy memorials, the *Post-Crescent*'s perspective is particularly important in understanding changes in McCarthy's Appleton image. In many ways the newspaper stood in the late 1960's in the position that civic leaders would occupy in the debate over the bust. As a source of information, it had a responsibility to report on what happened in town. As an economic entity, it had to publish what would sell. But as a public exemplar, it had to stand in defense of the town's interests. These three roles often came into conflict when reporting about McCarthy. They certainly contributed to the confused coverage that the McCarthy memorials received. In many years, the services recalling McCarthy drew no reporter. When the commemorations drew notice from the *Post-Crescent*, the resulting article ran on page B1, the first sheet of the paper's local section. The *Post-Crescent* used this position of privilege, always given over to the most important bit of local news, to publicize and minimize, laud and criticize the McCarthy remembrances.

The scene set by the *Post-Crescent*'s reporters rarely varied—a lonely, small group of staunch local supporters (almost always around 50 according to the paper, though photographs of the scene never featured more than 10 or 15) gathered around McCarthy's gravestone, hoping to keep McCarthy's crusade alive. While this description is true, it is also partial, incomplete. Each year the small group did gather, but they gathered not just to plot, but to offer respects, to memorialize. The graveside services always featured a religious memorial offered by a priest, and a speech, usually delivered by one of the leaders of the FOM, the Milwaukee-based sponsor of the gathering. The newspaper cited the speeches, but never the services, as if the content of a prayer offered no aid in understanding McCarthy or his followers.[21]

In the speeches, some of the images of McCarthy raised at his death appear again—his courage and his staunch opposition to communism prominent among them. In 1966, Peter Wheeler Reiss,

president of FOM, told listeners that McCarthy was great not because he was a saint, but because he was brave. In fact, Reiss argued, McCarthy "almost single-handedly put the communists and their allies, the liberals, on the defensive." But this message received less coverage than Reiss' assertion that though the whole truth would never be known, "there is some justified evidence that Joe was murdered," and his accompanying apocalyptic argument that "if anti-communism can't win today, then America can't win today." The Reverend L. S. Brey concurred: "America is in the 11th hour."[22] In this way, Reiss set up a master tale that would be repeated again and again in McCarthy memorials. McCarthy's character made him a hero and his crusade a success. To stop the crusade, communists had McCarthy killed. Since that time, the forces of evil had been on the advance, threatening the nation that McCarthy so loved. Reiss' narrative had the important effect of making McCarthy appear to be a success, thus justifying a continuation of his work, and a failure, thus making a continuation of his work necessary. It also made members of FOM appear to be the chosen followers of McCarthy while building among them the sort of unity that could only grow under intense persecution.

Stories of a hidden conspiracy persecuting the true defenders of liberty have a long history in America, of course, stretching from the Founders to the Populists to Huey Long, Father Coughlin, and Joe McCarthy himself.[23] But the rhetoric of the FOM is also part of the less-remarked tradition of the language of memory. One of the most common ways of drawing attention to a particular view of the past is to claim that that view is under attack or already forgotten. Such an argument has the advantage of being partially true (after all, what bit of the past is not being constantly forgotten?), and of giving its adherents the special status of persecuted defender of the truth. Supporters of a national Martin Luther King, Jr. holiday used this strategy. More recently, so did President Clinton, speaking to commemorate the fiftieth anniversary of D-Day. This line of argument has a special appeal to the media, because it provides a discovery (the forgotten past) that is not hard to find, and a crime (forgetting) with both a victim (the friends of the forgotten) and a resolution (the article announcing the discovery).

All of which is a long way of saying that though the *Appleton Post-Crescent* can be blamed for not giving McCarthy memorials a full treatment, the FOM, by claiming that a conspiracy stood behind

McCarthy's death and diminished importance, asked for the treatment they got in 1966. In 1967, the focus on political statements about McCarthy continued. The *Post-Crescent* led its coverage by quoting Wisconsin Representative Kenneth J. Merkel. Merkel raised again the conspiracy against McCarthy, explaining that "McCarthyism" ought to be a respected word, but that the press had made it a term of derision. Because the press was obviously against McCarthy, "You and I are going to have to carry on the work of the great Senator McCarthy," Merkel concluded. And in 1969, the "murder" of McCarthy again appeared. Samuel Murray, then president of FOM, wondered aloud why no autopsy had been performed upon McCarthy's death, and then responded to his own question by implying that communists in government had stood in the way. To clinch his argument he claimed that John F. Kennedy and his brother Robert had been assassinated because, like McCarthy, "they knew who was in the conspiracy to destroy and betray us."[24]

Reporting this sort of rhetoric filled two of the paper's roles—it gave information and it was of enough interest to sell papers. But it failed the *Post-Crescent*'s responsibility to the town's reputation. And so, without directly confronting FOM, whose membership counted at least one local political leader,[25] the paper opened the organization to respectable criticism. In both 1967 and 1969 the paper noted that McCarthy's widow opposed some of the Friends' program. In 1967 she forbade them from giving a graveside speech (they removed to the Outagamie County Courthouse for the discourse). And in 1969, she told a reporter that claims of McCarthy being murdered were "ridiculous." By publicizing Jean McCarthy Minetti's desire that Joe rest in peace, the *Post-Crescent* placed McCarthy's wife in opposition to his Friends, and anticipated an image of McCarthy that would flourish in the coming years—the view that McCarthy was best remembered as a genial, loyal friend and relative, not a senator in opposition to communism.

Some time between 1969 and 1972, the Friends of McCarthy became the Senator Joseph R. McCarthy Foundation.[26] The change was in part a response to poverty—the organization needed money to support its efforts, and non-profit status made fundraising possible—but even more a response to malaise. Leaders of the foundation saw an opportunity in the Vietnam War to place McCarthy's name before the public again. Their new hopes of being nationally influential carried

over into commemorations at McCarthy's grave. Once local gatherings, memorials became a time for McCarthy-ites from across the U. S. to come together. Speeches were more directly pointed at current federal policy, and, as conservatism's appeal grew in the late 1970s and early 1980s, the foundation sought the country's attention for its Appleton activities.

These changes are noticeable in the 1975 commemoration. The foundation's new president, the Reverend Hugh Wish, delivered a pointed address blaming South Vietnam's destruction on America's failure to heed McCarthy's advice. Then he expanded his criticism. "If the warnings he [McCarthy] gave . . . had been heeded we would have been spared many of the things happening today. We would have a greater regard for patriotism, a willingness to defend our way of life and our freedom, and a better appreciation and love for our country, which we do not have now and will probably never have again." Wish played this theme again two years later, at the 20th anniversary of McCarthy's death, calling McCarthy a "truly great American, a patriot." That same year, Thomas Bergen, a law school classmate of McCarthy, echoed Wish's remarks. In Bergen's eyes, McCarthy was a hero throughout his whole life because he was a patriot throughout his whole life. He cited McCarthy's war record and his entire service as a Senator (not just his opposition to communism) as evidence.[27]

Bergen's praise of McCarthy's service in the Marines and the Senate is interesting, because by most assessments, McCarthy was a publicity hound as a soldier and an indifferent legislator.[28] The praise is even more interesting because it is not accompanied by references to McCarthy's character, once a staple of McCarthy defenses. Instead, patriotism had replaced character. Bergen criticized "Tailgunner Joe," an uncomplimentary 1977 NBC miniseries about McCarthy's WWII service, not because it attacked McCarthy's character, but because it defamed a war hero. Bergen's references to "Tailgunner Joe" and McCarthy's patriotism, not character, mark an important shift in McCarthy defenses, for they define McCarthy's legacy by his place in contemporary national culture, not his roots in Appleton, so important twenty years earlier.[29]

If Mike and Betty Bates are any indication, change had come not only to McCarthy's defense, but to the origins of his defenders. Mike Bates was only 10 when McCarthy died, and learned about him from television, not personal experience. The Bates lived in Chicago, and

traveled to Appleton for the memorial. When asked why they had made the journey, Bates responded, "My wife and I are both admirers of the late senator. Sure he was guilty of exaggeration on occasion. But history has borne out the facts. He was right."[30]

The shift in emphasis is apparent in the *Post-Crescent*'s coverage of the 1977 commemoration as well. As McCarthy's supporters placed McCarthy in a national context, the paper distanced Appleton from those supporters, emphasized local opposition to McCarthy, and reported the Foundation's philosophical links with fringe politics.

Mike Hinant's article on 1977's memorial carried the headline, "They Remember Joe 20 Years Later." The choice of the word "They" to describe people at the commemoration is an interesting one, because it separates those in attendance from the paper's readers in a way that other possible choices, like "supporters" or "the McCarthy Foundation" do not. And for the first time, a *Post-Crescent* reporter managed a little editorializing about McCarthy. Hinant called him "enigmatic"—not the same as "demagogue" or "bully" but a departure still from the paper's outright support in 1957 and its very careful objectivity in 1967.[31] The split between Appleton and McCarthy supporters was apparent as well in Hinant's coverage of McCarthy's family. In 1967 the paper reported that Mrs. McCarthy had asked that no speeches be given at the gravesite. In 1977, Hinant wrote that none of McCarthy's personal friends or family from Appleton were in attendance and noted that Rev. Wish, the Foundation's president, never knew McCarthy personally. The only Appletonian quoted in the article was Robert Takahashi, a student at Lawrence University. He said simply, "I think he [McCarthy] should be remembered for what he did, because he was wrong."[32] Hinant concluded his article by pointing out that a member of the American Nazi Party attended the memorial because, "his [McCarthy's] enemies are our [the American Nazi Party] enemies." When asked about the presence of a Nazi, Wish and Bergen said that the McCarthy Foundation had no ties to the Nazi Party, but that McCarthy would not have minded Nazis attending his memorial service.[33]

The next time a McCarthy memorial drew any coverage, in 1982, the John Birch Society had replaced Nazis as exemplars of McCarthy's support on the right margin of American politics. At a dinner following the commemoration, a rack of pamphlets enticed diners to learn more about "the illegal activities of the IRS, the courts, the banks, and metropolitan government," all pet causes of the Society.

The *Post-Crescent*'s take on the gathering paralleled that of 1977. The man who officiated at the service, the Reverend Anthony Beyer, did not know McCarthy. Supporters had traveled from Illinois, Michigan, and Minnesota to attend. They wondered who killed McCarthy, and attacked the press for tearing him down. With the exception of Mrs. Valeria Sitter, a long-time local member of the Foundation, Appletonians either ignored the service (only 40 to 50 people attended, a crowd "slightly larger than it ha[d] been in several years"), or attended out of curiosity.[34] The following year, M. Stanton Evans, a journalist with the *National Review*, spoke at the gathering. He blamed the liberal press for making McCarthy the "most slandered man in U. S. history" and demanded that the government revive the House UnAmerican Activities Committee, strengthen the FBI, and renew its battle against internal communist subversion. There was no mention of Appleton in Evans' remarks. The image of McCarthy that had begun with the Friends of McCarthy as a mix of character defense and conservative politics in the mid-1960's had grown though a phase combining McCarthy's patriotism with national politics to a stage in the early 1980's where McCarthy was nothing more than a banner around which people concerned about national politics could rally. It is a measure of how far Appleton had moved from remembering McCarthy, that in 1984, the thirtieth anniversary of the Army-McCarthy hearings, the sum of the *Post-Crescent*'s coverage of McCarthy was a column by the nationally-syndicated George Will. Will, under the headline, "Joe McCarthy as Seen Some 30 Years Later," reviewed William Bragg Ewald, Jr.'s *Who Killed Joe McCarthy?*, a book praising Eisenhower for quietly quieting the noisy McCarthy. There was no locally produced equivalent, pro or con.[35]

The word "present," generally means the here and now. But each person has his own "present," a combination of things that happened in the past, (yesterday's baseball game, for example), the present (the day's chores), and the future (tomorrow's work). It is not just the passage of time, then, that makes events part of history. Some events, because of their uniqueness or relevance, remain a part of the present long after they occur. Others never make it into history because they are kept secret or forgotten completely. Still others fade from the present into nostalgia or kitsch. Clearly, certain conditions must be met before something becomes "history." The institutions that are concerned with

the role of the past in American life are in fairly close agreement on what those conditions are. Before listing the requisites that must be met before something becomes history, a brief expansion of the definition of history—the gathering and ordering of knowledge about the past—offered above is necessary. Not everyone has the time or the inclination to "gather" and "order" information about the past. Those who do seek such information often have personal or professional reasons for doing the gathering. So, history is those past events (or people) that certain people (scholars, journalists, and politicians foremost among them) believe others, not intimately involved with the events, should know about. For the Appleton legacy of Joe McCarthy, as for most things past, the passage from the present into history has been an uncertain process, with some portions of the legacy lost, others distorted, and still others shorn of meaning. At the same time that FOM was commemorating McCarthy, the remembered portions of McCarthy's life were becoming history. By 1987, the surviving parts of McCarthy's legacy had become a part of history in the following way.

Though relevant to the present, the event is not on-going, it is over. History implies that something is past, but that knowledge of that thing is useful in navigating the present. With the exception of M. Stanton Evans in 1983, no McCarthy supporters called for a renewal of congressional investigation into communists in government. Instead, they tried to draw general lessons from McCarthy's experience and apply them to the present, as when Hugh Wish blamed the loss of the Vietnam War on a decline in "McCarthy values." The fall of Communism has pushed McCarthy's crusade even further into the past. It has also made his supporters search harder to keep his memory vital. Witness the remarks of John McManus, a publisher with the John Birch Society and a speaker at the 1990 commemoration. McManus said that McCarthy was hunting not just Communists, but a "one-world socialist conspiracy" that included organizations like the Council on Foreign Relations and the Trilateral Commission. "This is the message of the John Birch Society. It *was* the message of Joe McCarthy," he concluded.[36]

The event is commonly referred to as "history." Until the late 1970s, most McCarthy supporters had been alive when McCarthy was in the Senate. But after that time, more and more of those attending commemorations had no personal recollection of McCarthy. Here, for the first time, people began to refer to McCarthy as part of history, or

as a phenomenon of historical interest. In 1982, Mr. and Mrs. Ludwig Horn drove from Grayslake, Illinois to Appleton to attend the McCarthy memorial. The Horns went because they "had learned about him [McCarthy] from history." The same year, Jim Hunt, from Appleton, attended the services because he was "a history graduate" and therefore curious about the McCarthy memorials.[37]

Those involved in the event are dead, or do not directly provide information about the event. From the beginning, close friends and relatives of McCarthy rarely took part in the graveside commemorations. By 1982, even those officiating at the services did not know McCarthy. At about the same time, people attending the services begin to refer to television and books as the sources of their knowledge. In 1977, Mike and Betty Bates, who had traveled from Chicago to attend the McCarthy services told the *Post-Crescent* that they had first heard of McCarthy on television. Valeria Sitter, the long-time McCarthy supporter, directed her anger in 1982 against a book that argued that McCarthy had used the press. "If he used the press," she said, "It's their own fault. The press built him up and then tore him down."[38] And, of course, the sum total of George Will's remembrance of McCarthy in 1984 was a book review.

Information is instead provided by experts, who have gained that status through study, allegiance, or professional affiliation. About the same time that people began to refer to McCarthy as history, historians began to pay close attention to Appletonians who knew McCarthy. Thomas Reeves, Michael O'Brien, and David Oshinsky all conducted interviews in Appleton in the mid-1970s and published their work between 1980 and 1983.[39] In 1987, the *Post-Crescent* published a four-part retrospective on McCarthy. Most of the quotes in the articles came from academics (including O'Brien), journalists, or politicians. The few non-experts cited were members of the McCarthy Foundation or McCarthy's surviving friends. But the testimony of the "amateurs" bore the imprint of experts. Thomas Bergen, by 1987 the president of the McCarthy Foundation, devoted most of his comments to a proposed merger between the Foundation and the John Birch Society in order lay the groundwork for an organization "of all of the conservative groups in the country." And the description of McCarthy offered by Urban Van Susteren (McCarthy's closest friend) and Olive Korneley (McCarthy's sister) is quite similar to that solicited by the historians a few years earlier. Until the mid-1970s, scholars and journalists writing about

McCarthy had bent sketchy information from dubious sources to make McCarthy's upbringing appear ugly, and thus the source of his later behavior.[40] Reeves, O'Brien, and Oshinsky all sought a better understanding of the young McCarthy, and found it among McCarthy's friends. For scholarship, their work has provided a more nuanced, and (slightly) more sympathetic take on McCarthy. For many Appletonians who knew McCarthy, the historians' emphasis on his early life (a happy one by most new reports), strengthened their own tendency to think of McCarthy in those terms alone. Korneley described her brother as "extremely ambitious" but added, "He was very kind to people he knew or he didn't know. He was always nice to be around, that's for certain. He enjoyed people, especially little children and older people." Van Susteren added, "You couldn't have a better friend than Joe. . . . Joe was essentially a very simple, real, genuine man."[41]

History implies that there is an audience, usually composed of those who did not experience the event, for the information provided. It is the existence of an audience that makes differences about the past into subjects of debate, and thus of public interest. By 1987, the various interpretations of McCarthy's legacy had gained audiences and become the grounds for discussion on McCarthy. The McCarthy Foundation saw Joe as a hero, and the inspiration for further opposition to communism. Local friends of McCarthy pictured him as a decent, fun-loving, almost non-political man. And liberals (among them most academics and many local politicians) conceived of McCarthy as a villain, both because of his behavior and his attacks on civil liberties. These positions would, in turn, be the foundations for battle among politicians over the proper place for McCarthy in 1990's Appleton.

Audiences gain information through some sort of an educational process, be it through reading, commemorations, museums, or schools. Though the Friends of McCarthy started memorial services as an opportunity for those who knew McCarthy to remember him, by the 1980s the commemorations were designed to educate and convert. The Foundation advertised in college newspapers and sponsored a writing contest for high schoolers on the topic "Joe Was Right." In 1989, Thomas Bergen invited talk-show host Morton Downey, Jr. to speak at the McCarthy commemoration because, in Bergen's words, "the big crowd following Downey consists of mostly young people, and I think this is an attempt to expand and reach out and tell them what McCarthy was."[42] Those more critical of McCarthy also turned to education. In

1986, Thomas Reeves taught a radio course on McCarthy and McCarthyism that was broadcast on Wisconsin public radio and could be taken for credit at state universities.[43]

Much has been written of late about the politics of education and the battles between multiculturalists and those favoring a "core culture" curriculum. Most of it seems to be preaching to the converted, an attempt to maintain audiences for a particular view. When this is the case, political debate about an issue strays from any attempt to persuade or find middle ground. It becomes instead a battle to win the power of government to one's side, thereby defeating the enemy.[44] In the same way, after a historical image is created, its survival is determined as much by the longevity and power of its audience as the "truth" of that image. In this case, history may become nothing but a symbol to employ against one's opposition. For this reason, it is the success or failure of the educational process that, after something becomes "history," determines what remains of historical interest and what does not. In Appleton, attempts at education failed, and McCarthy remained a symbol. The result was contemporaneous ignorance of McCarthy's life *and* extreme emotions about his image. From this odd coupling came both the debate about what to do with McCarthy's bust and the ultimate decision to do nothing.

In 1986, Ron Vander Velden, a Supervisor on the Outagamie County Board, proposed that the county remove the bronze bust of McCarthy that stood in its courthouse. His proposal, though supported by twenty other supervisors, died. In 1989, the John Birch Society announced that it would move its national headquarters to Appleton, calling it a "happy coincidence" that McCarthy was an Appleton native.[45] Until McCarthy became "history," local government could afford to ignore his legacy, perhaps hoping that it would die completely. But with the passing of the thirtieth anniversary of McCarthy's death, the state-wide radio class on McCarthy, the arrival of the John Birch Society, and the publicity surrounding Morton Downey, Jr.'s possible appearance at a McCarthy memorial, McCarthy's legacy had become a public issue, that is, an issue that could affect Appleton's public image. In 1989, Vander Velden proposed removing the bust again. Having overcome the recession of the late 1970's only recently, and only with the help of history-oriented tourism, government officials struggled to decide what to do with this unpleasant bit of the past.[46]

The battle over McCarthy's bust was more than a discussion of where to place art. It was a debate over which image of McCarthy the city would endorse, and, ultimately, whether McCarthy would be publicly remembered or officially forgotten.

Vander Velden began the discussion arguing that McCarthy's historical role demanded that he be forgotten. For him, the presence of McCarthy's bust in the courthouse would signal to outsiders that the county had not changed since 1957. Said Vander Velden, "I think the fact that the bust is there is somehow a connection that we as a county board are endorsing everything that McCarthy stood for, and I don't think that's the case." He was especially critical of McCarthy's behavior. "Unfortunately, he impacted a lot of people's lives in negative ways, and its been documented that he destroyed a few people and reputations on the way." Vander Velden hoped McCarthy's statue would be removed to the Outagamie County Museum, where, in the words of William Zaferos, the *Post-Crescent*'s reporter, "McCarthy's role in history could be recognized without the county government appearing to endorse him and his actions."[47] For Vander Velden, then, the solution was to make the county safe from McCarthy by placing his bust in a museum. Had he won out in 1986, the town would have been safer than even Vander Velden hoped, for the museum had no space for the bust, and though museum officials were in the midst of planning a new exhibit layout and were "very seriously looking at a section on people who came from Outagamie County and the lower Fox River Valley: Edna Ferber and Harry Houdini, probably Rocky Bleier," according to Donald Hoke, the museum's director, "We hadn't thought of Joe McCarthy."[48]

County Executive John Schreiter spared Hoke the task by rejecting Vander Velden's petition. In so doing, Schreiter adopted the position of McCarthy's friends and family. McCarthy's bust should remain in the courthouse because it provided a positive message by "recogniz[ing] a hometown lad who was successful at what he set out in life to do." Olive Korneley, McCarthy's sister agreed, calling McCarthy a "wonderful guy to have around." But neither Schreiter not Korneley believed McCarthy's image should play a role in Appleton's public life. Indeed, Schreiter thought the bust should stay precisely because McCarthy had slipped from political relevance. "The problems that he [McCarthy] had, those things are behind us." He concluded, "This is much ado about nothing."[49]

That sentiment echoed through the following years. One of the main themes of the articles commemorating the thirtieth anniversary of McCarthy's death was that McCarthy was largely forgotten in Appleton.[50] In 1989, the arrival of the John Birch Society's national headquarters in Appleton raised the issue of the bust again, and again appeared the articles arguing that McCarthy was already well-forgotten. Here, once more, is the curious association of history and forgetting— in 1987 a five-part story commemorating McCarthy with McCarthy's irrelevance as a central theme, and, in 1989, debate over the placement of the bust coupled with assertions that the man represented thereby is unimportant.

At the close of his 1989 essay, "Can You Find Joe McCarthy Around Here?" Richard L. Kenyon noted the small size of the McCarthy Foundation (a mailing list of 550 names) and the John Birch Society (500 to 1000 Wisconsin members, "tens of thousands" nationwide). Kenyon then asked Stanley Kutler to describe McCarthy's followers. Kutler responded, "These are the true disciples who think McCarthy was a messiah come to save the country from devils. Let those people alone. They're entitled to think that." The implication of Kutler's statement is that McCarthy's supporters are in some way dangerous, that they should be left alone like chewed gum on the bottom of a table. Or as Appleton *Post-Crescent* reporter Cliff Miller put it,

> We should keep an eye on the Birchers and
> McCarthyites and a number of other movements,
> cults and con artists, who, given the opportunity,
> would be just as quick [as McCarthy] to take
> advantage of the news media to get fame and power.
> Like McCarthy, if given it, they could do a lot of
> damage in short order and they might soon be
> forgotten. But their victims and the heirs of their
> victims would long remember their pain.[51]

Kutler and Miller's messages are the same, and they explain the companionship of forgetting and history. Unpleasant historical issues are raised in order to remind people that they should be part of the past, and that those who keep them present imperil society.[52]

Given the agreement between friends and foes that McCarthy had passed into irrelevance, it is not surprising, then, that the Outagamie

County Council decided to do nothing with McCarthy's bust. An attempt to move the bust to the Outagamie County Museum in 1991 failed, largely because the John Birch Society wanted a say in how McCarthy's bust would be interpreted. Afraid of having to describe McCarthy in the durable terms required by a museum display and of the controversy Birch Society involvement would bring, the Council eventually tabled the motion to move the bust.[53]

That foes and friends of McCarthy should agree about his ultimate irrelevance but fight for five years about where his bust should stand raises one last question—Why? Why go on for so long? Why not just agree to leave the bust in one place and carry on with the county's other business? The answer lies, I think, in what comes when knowledge about the past is linked to a powerful urge to forget the past. Having some historical knowledge but lacking viable interpretive traditions in which that knowledge made sense, county supervisors failed to consider McCarthy as a historical figure. Instead they battled with historical symbols—McCarthy the hero, McCarthy the villain. The difference between battling over facts and battling with symbols is an important one, for it reflects a fundamental mistake in the way we think about the utility of history. In public life, history is considered valuable when it can be used to support a particular position. Such use inevitably pulls history into political debate. And debate, in turn, rarely has time for historical elucidation. The result is that the past takes on a symbolic role, as when George Bush compared Saddam Hussein to Hitler in order to rally support for the Gulf War. In Appleton, McCarthy had become by the mid-1980's a symbol of good or evil. And so even though both sides agreed he was irrelevant, they fought on, in harsh, unreasoned language, because McCarthy symbolized the justice of their causes—making Appleton look good to outsiders or protecting America from one-world conspiracies, for example. County Supervisor Michael Taylor cried that removing McCarthy's bust would be like "scraping the likeness of Abraham Lincoln from the face of Mount Rushmore." Kenneth Boman, who moved to table the bill that would have removed McCarthy's bust hollered that McCarthy's opponents, "wanted to have the final word. They want to defecate on McCarthy one more time." John Kellogg told the other county supervisors that if they voted to name the courthouse after McCarthy, he would be so embarrassed that he would have to "sneak in the back

door" of the building when he went to work. And at the apex of exaggeration, Mark Sanders overlooked the fact that most Americans have never heard of Appleton (and that those who have heard of Appleton rarely know McCarthy was born there) and voted to move McCarthy's bust because "Appleton, Wisconsin and Outagamie County have been the laughingstock of the nation long enough."[54] In the end, the debate over McCarthy's bust may have done Appleton's public life more damage than the bust itself ever did.

Notes

1. Stanley Kutler is a Professor of History at the University of Wisconsin, Madison. He is quoted in Richard L. Kenyon, "Can You Find Joe McCarthy Around Here?" *Milwaukee Journal Magazine*, 1 Oct 1989.

2. James Meyer is a staff writer at the *Appleton Post-Crescent*. James R. Meyer, "Bust Issue Pits History vs. Infamy," *Appleton Post-Crescent*, 13 Mar 1989, A10.

3. The debate drew a great deal of press coverage in the local paper. See, as a survey, William D. Zaferos, "McCarthy Statue Inappropriate?" *Appleton Post-Crescent*, 9 July 1986, A1, 5; James Meyer's article cited in note 1; James Meyer, "Taylor Turns Issue of McCarthy Bust Into a Campaign," *Appleton Post-Crescent*, 15 Aug 1991, B-1; James Meyer, "McCarthy Bust-Out Push Fails," *Appleton Post-Crescent*, 11 Sept 1991, A-1; "McCarthy Name Won't Be on New Justice Center," *Appleton Post-Crescent*, 11 Dec 1991, B-2.

4. Pamphlets in the author's possession.

5. Leroy Gore, *Joe Must Go* (N.Y.: Julian Messner, Inc., 1954), 120-135.

6. Michael O'Brien, *McCarthy and McCarthyism in Wisconsin* (Columbia, Mo.: University of Missouri Press, 1980), 121-6.

7. Gore, *Joe*, 19.

8. O'Brien, *McCarthy*, 204-211, David Oshinsky, *A Conspiracy So Immense: The World of Joseph McCarthy* (N.Y.: Free Press, 1983), 495-506.

9. Both O'Brien and Oshinsky see the turnout of 1,500 people for a speech by McCarthy as a sign of declining support for him, and perhaps it is, especially since some town leaders expected 50,000 people to attend. But Boscobel is a small town (the 1990 population was 2,706), over 70 miles from Madison, a city long known for its opposition to McCarthy, and over 150 from Milwaukee, the closest center of substantial McCarthy support. It seems to me, then, that the attendance of 5,000 for a parade and 1,500 is a fairly substantial turnout from rural Wisconsin in 1955. See Oshinsky, *A Conspiracy*, 502, and O'Brien, *McCarthy*, 204.

10. O'Brien, *McCarthy*, 207.

11. David Lawrence, in a column printed in the *Post-Crescent* suggested that a move to censure McCarthy would indeed make him a martyr. See David Lawrence, "Foes May Make Martyr, Hero of McCarthy," *Appleton Post-Crescent*, 23 Mar 1954, 4.

12. Comments on the floors of congress about McCarthy are collected in *Memorial Services Held in the Senate and the House of Representatives of the United States, Together with Remarks Presented in Eulogy of Joseph Raymond McCarthy, Late a Senator From Wisconsin* (Washington, D. C.: Government Printing Office, 1957). See especially Nevada Senator George Malone's call for expunging McCarthy's censure from the Congressional Record and Oregon Senator Wayne Morse's response, pp. 29-38, and the comments of New Jersey Senator H. Alexander Smith, who opposed McCarthy in the 1954 censure battle, and South Dakota Senator Karl E. Mundt, who supported McCarthy in 1954, pp. 50-56. See also the article covering the Senate service, printed in the *Appleton Post-Crescent*, "Joe Called 'Fallen Warrior' in Service of His Country," *Appleton Post-Crescent*, 6 May 1957, 1, 10.

13. "Pastor of St. Mary's Calls for McCarthy's Torch to be Raised," *Appleton Post-Crescent*, 7 May 1957, 17.

14. Ibid.

15. "Controversial Senators," *Appleton Post-Crescent*, 8 May 1957, 8. J. T. Dean of Rochester, New York expressed the same sentiments in rhyme:

Joseph McCarthy was judged by his peers,
Ridiculed, censured, and subject to jeers.
His case has received a final review
The verdict, "Not Guilty," as decent men knew.
Oh foolish Senators, weak-willed men
You have smirched the name of the best of them!
Rescind your error, admit your wrong
Fill the niche to six men strong.
Your hall of fame of varied party,
Complete it now with Joseph McCarthy.

"Sen. McCarthy's Friends Pay Their Last Respects," *Appleton Post-Crescent*, 8 May 1957, 8.

16. The remarks of Wickens, the Seyller family, and Buechle are all found in, "Sen. McCarthy's Friends Pay Their Last Respects," *Appleton Post-Crescent*, 8 May 1957, 8.

17. Jack Glasner, "Bust of Joe McCarthy Mixture of Age, Youth," *Appleton Post-Crescent*, 2 May 1959, 1.

18. Michael Kammen, *Mystic Chords of Memory* (N.Y.: Knopf, 1991), 11.

19. Merrill Peterson, *The Jefferson Image in the American Mind* (N.Y.: Oxford University Press, 1960), 3-110; Merrill Peterson, *Lincoln in American Memory* (N.Y.: Oxford University Press, 1994), 1-178.

20. McCarthy supporters have tried, without much success, to argue that "McCarthyism" means the honorable opposition to communism. See, for example, Representative Kenneth J. Merkel's comment, cited in note 24 below.

21. The articles referred to are "Friends Observe McCarthy's Death," *Appleton Post-Crescent*, 2 May 1966, B1; "Appleton Service Honors McCarthy," *Appleton Post-Crescent*, 8 May 1967, B1; "'Poison' Claim Refuted," *Appleton Post-Crescent*, 5 May 1969, B1; and a photo of the 1972 service, *Appleton Post-Crescent*, 8 May 1972, B1.

22."Friends," 2 May 66, B1.

23. Bernard Bailyn's *The Ideological Origins of the American Revolution* (Cambridge: Harvard University Press, 1967) is the classic statement on views of conspiracy in the American revolution. Richard Hofstadter noted a similar view of conspiracy among the Populists in *The Age of Reform* (N.Y.: Vintage Books, 1955), esp. 70-82; and broadened his interpretation to include much of American history in *The Paranoid Style in American Politics* (N.Y., Vintage Books, 1964). Indeed it was the tendency to view history as conspiracy that led Hofstadter, Peter Viereck, Daniel Bell, and others to draw links between the Populists and McCarthy. See Daniel Bell, ed., *The New American Right* (N.Y.: Criterion Books, 1955). The rhetoric that Populism and McCarthyism shared has continued to take an important place in the political rhetoric of populists and conservatives. See, for example, Alan Brinkley, *Voices of Protest* (N.Y.: Oxford University Press, 1982) on Huey Long and Father Coughlin. Such rhetoric continues on the far right, especially among members of the John Birch Society. For an

excellent overview of scholarship on McCarthy and the Birch Society, see William B. Hixson, *Search for the American Right* (Princeton: Princeton University Press, 1992).

24. "Appleton Service," 8 May 1967, B1; "Poison," 5 May 1969, B1

25. The photo which ran in 1972 featured Miss Valeria Sitter, described in the caption as "a member of the Oshkosh City Council and the Winnebago County Board" laying a wreath on McCarthy's grave. *Appleton Post-Crescent*, 8 May 1972, B1.

26. In 1981 the Foundation created a companion organization, the Senator Joseph R. McCarthy Educational Foundation, to place pro-McCarthy materials in libraries. Don Castonia, "The Followers and the Curious," *Appleton Post-Crescent*, 3 May 1982, B3.

27. "About 50 Attend McCarthy Service," *Appleton Post-Crescent*, 5 May 1975, B1; Mike Hinant, "They Remember Joe 20 Years Later," *Appleton Post-Crescent*, 2 May 1977, B1, 3.

28. McCarthy's claims to wartime heroism rested on a citation he received from Admiral Nimitz, noting that McCarthy had been injured while on active duty, and a record he set for firing the most rounds of ammunition on a single flight. McCarthy's injury came during a decktop celebration, not during battle. His record likewise came while his unit was far from combat. The thousands of rounds McCarthy fired destroyed a grove of palm trees. McCarthy's best-known piece of legislation was a 1949 housing bill. Oshinsky, *Conspiracy*, Chapters 2 and 4.

29. Richard John Neuhaus argues that a move away from emphasis on behavior to one on patriotism is part of a broader change on the American Right, as genteel conservatives give way to activist conservatives. See Neuhaus, *The Naked Public Square* (Grand Rapids, MI.: Eerdmans, 1984), 55, and chapters 3 and 4 generally.

30. "They Remember," B3.

31. "The McCarthy Heritage," *Appleton Post-Crescent*, 6 May 1957, 8.

32. "They Remember," B1.

33. Ibid., B3.

34. Castonia, "The Followers," B1, 3.

35. Don Castonia, "U. S. Must Renew McCarthy's Fight," *Appleton Post-Crescent*, 2 May 1983, B1; George F. Will, "Joe

McCarthy as Seen Some 30 Years Later," *Appleton Post-Crescent*, 14 June 1984, A1.

36. James Meyer, "Believers: Joe's People Come to Remember," *Appleton Post-Crescent*, 7 May 1990, B1.

37. Castonia, "The Followers," B1.

38. Ibid., B3. The book she despised, though not named, was probably Edwin Bayley, *Joe McCarthy and the Press* (Madison: University of Wisconsin Press, 1981).

39. The results of O'Brien, Reeves, and Oshinsky's research are found in Michael O'Brien, "Young Joe McCarthy, 1908-1944," *Wisconsin Magazine of History* , Spring 1980, 179-232; and *McCarthy and McCarthyism in Wisconsin*; Thomas Reeves, *The Life and Times of Joe McCarthy* (N.Y.: Stein and Day, 1982); and Oshinsky, *A Conspiracy so Immense.*

40. The main source on McCarthy's early life was Jack Anderson and Ronald May, *McCarthy: The Man, the Senator, the "Ism"* (Boston: Beacon Press, 1952). On the problems with the pre-1970's interpretations of McCarthy's upbringing see Thomas Reeves, "The Search for Joe McCarthy," *Wisconsin Magazine of History*, Spring 1977, 185-196.

41. The quote from Van Susteren comes from William D. Zaferos, "Urban and Joe: Pals Through it All," *Appleton Post-Crescent*, 3 May 1987, A1. Korneley's remarks, and many others from McCarthy acquaintances are in Zaferos, "Larger Than Life, Even in Death," *Appleton Post-Crescent*, 3 May 1987, A1. Bergen's attempts to link the Foundation with the Birch Society are outlined in Zaferos, "Joe Was Right," *Appleton Post-Crescent*, 5 May 1987, A1, 12. Experts receive top billing in Zaferos, "The Legacy," *Appleton Post-Crescent*, 4 May 1987, A1, 2; and Zaferos, "Could a McCarthy Happen Again," *Appleton Post-Crescent*, 6 May 1987, A1, 5.

42. On advertisements in college newspapers see, Tim Cuprisin, "In Defense of Joe McCarthy," *Milwaukee Journal*, 3 May 1987. On Downey, see James Meyer, "Downey to Honor McCarthy," *Appleton Post-Crescent*, 12 April 1989, A1. Downey later refused to speak, and was replaced by James J. Drummey, the senior editor of the John Birch Society's magazine, *The New American.* Around 100 people turned out to hear Drummey, more than had attended a service in a long time, but

presumably fewer than would have shown for Downey. Don Castonia, "Recalling Joe," *Appleton Post-Crescent*, 8 May 1989, A1.

43. A brochure on the course is in the Joseph R. McCarthy Folder, Wisconsin Collection, Appleton Public Library.

44. For an excellent assessment of the dangers to democracy of such battles, see James Davison Hunter, *Before the Shooting Begins: Searching for Democracy in America's Culture War* (N.Y.: Free Press, 1994).

45. William D. Zaferos, "McCarthy Statue Inappropriate?" *Appleton Post-Crescent*, 9 July 1986, A1; Zaferos, "McCarthy Bust to Stay Put for Now," *Appleton Post-Crescent*, 11 July 1986; Meyer, "Downey," A1.

46. On the troubles of Wisconsin's economy in the late 1970s and 1980s, see Robert C. Nesbit, *Wisconsin: A History*, 2d ed., revised and updated by William F. Thompson (Madison: University of Wisconsin Press, 1989), 500, 514.

47. Zaferos, "Inappropriate?" A1, 5.

48. William D. Zaferos, "McCarthy Bust to Stay Put for Now," *Appleton Post-Crescent*, 11 July 1986, A1, 3.

49. Ibid.

50. See the articles cited in note 40 above.

51. Cliff Miller, "McCarthy's Bust Needn't Just Be a Dust-Catcher," *Appleton Post-Crescent*, 4 October 1989, A-4.

52. In many ways, the debate surrounding McCarthy's bust reminds me of D-Day commemorations. Though speakers used a historical anniversary to argue that D-Day should not be forgotten, they also argued that D-Day should be "history," not the present. Indeed, the reason we are to remember a particular historical version of D-Day is because there are people for whom the issues of D-Day are still alive, like Neo-Nazis in Germany and Neo-Fascists in Italy. The rhetoric around McCarthy's bust differs only in the use of the words "remember" and "forget". We are to remember D-Day because it was a victory for freedom, we are to forget McCarthy because he endangered freedom. The message, though, is the same—if an event is made historical, then it is a tool to be used against those for whom that event lives, especially if they are dangerous.

53. See James Meyer's articles, "Joe's Fans May Get Last Word," *Appleton Post-Crescent*, 21 Aug 1991, A-1; "Bust Plan Made

More Palatable," *Appleton Post-Crescent*, 6 Sept 1991, B-1; and "McCarthy Bust-Out," A-1.

54. Taylor is quoted in "Taylor Turns Issue," B-2; Boman's remark appears in "McCarthy Bust-Out," A-1; and Kellogg and Sanders' comments come in "McCarthy Name Won't Be," B1-2.

3
Pursuing an Authentic Past: Atlanta Remembers Martin Luther King, Jr.

I was just as close to Dr. King as anybody. If there was just a certain amount of money to use, I think he [Martin Luther King, Jr.] would have spent it feeding the hungry, clothing the naked, and redeeming the soul of the nation. Secondary would have been the preservation of history. We kind of have our priorities mixed up.

—Hosea Williams[1]

Federal legislation established the Martin Luther King, Jr. National Historic Site and Preservation District . . . to 'protect and interpret for the benefit, inspiration, and education of present and future generations the places where Martin Luther King, Junior, was born, where he lived, worked and worshipped, and where he is buried.'

—*Martin Luther King, Jr. National Historic Site Historic Resource Study* [2]

If the Park Service gets its way, the majority of tourists who come here will leave with a superficial understanding of my father's teachings. . . . They will learn about the Martin Luther King, Jr. of 'I have a dream,' but they won't learn much about his leadership of labor struggles or protests against the Vietnam War. They won't learn much about what he said about racism, economic oppression and the power of nonviolence.

—Dexter King[3]

Years of cultivated apathy and the lack of interpretive traditions have combined to make Joseph McCarthy a controversial but irrelevant figure in Appleton, Wisconsin. On the surface, Martin Luther King, Jr.'s legacy in Atlanta could not be more different. King's family still resides in the city, as do many of his closest advisors. Unlike McCarthy's relatives and friends, King's coterie has played a prominent role in the city's life. Andrew Young, one of King's lieutenants in the last years of his life, has served twice as Atlanta's mayor. John Lewis, another King staffer, is currently a U. S. Representative. One of King's sons, Martin III, sat for a time on the Fulton County Commission, his daughter Bernice pastors a local church, and his wife, Coretta, has devoted her life to remembering and fulfilling King's vision.

Nor is the impulse to remember King confined to his confidants. Rather, King's legacy has become a local institution. The Southern Christian Leadership Council (SCLC), the civil rights organization led by King during his life, maintains its headquarters in Atlanta. Hosea Williams, a former leader of the SCLC, and a one-man whirlwind of civil rights advocacy, runs an annual meal program on King's birthday. The King Center for Non-Violent Social Change, founded by Mrs. King and currently led by her son Dexter, fills a city block and draws 500,000 visitors a year. The National Park Service administers the Martin Luther King, Jr. National Historic District and Preservation District which, with the King Center, has made a large section of "Sweet Auburn," the city's traditional center for black business, into a shrine. Together with the King Center, the city of Atlanta has sponsored an annual commemoration of King's birth since 1970, which, in its most recent incarnations, has grown to eleven days and become Atlanta's foremost tourist draw. And growing out of the King Center's lobbying and success at commemorating King, national legislators adopted the third Monday in January as Martin Luther King, Jr. Day, a national holiday.

That King is easily remembered in Atlanta while McCarthy is uneasily forgotten in Appleton certainly sets the two men's legacies in opposition. The urge to forget McCarthy led to unanimity among Appleton's leaders—good or bad, McCarthy was irrelevant to Appleton by the 1980s, except as a duct for political bile. But without the will to forget, Atlantans have been riven by King's legacy. The recent unpleasantries between the King Center and the National Park Service

over the content of a proposed visitor's center on Auburn Avenue (and an earlier clash between Williams and the King Center) are only the most visible of a series of disputes about King's legacy.

In its coverage of the Park Service/King Center altercation, *Time* argued that the battle raised the question of whether Coretta and Dexter King "still have the political standing and moral authority to represent Martin Luther King, Jr.'s vision." This formula is correct as far as it goes, but the confrontations accompanying King remembrances have dealt not only with who can speak for King, but how and when. Seen in the context of the last twenty-five years, the King Center's rivalry with the National Park Service appears to be less about "political standing and moral authority" than about competing philosophies of history. Specifically, the King Center, the National Park Service, and the SCLC have been divided over the images of the remembered King, the styles of commemorations in his memory, and the strategies used to ensure that a particular vision of the past appears authentic.

One might assume that given King's popularity and the undeniable historical and governmental authority of the King Center, the SCLC, and the National Park Service, these organizations would have no need to prove the authenticity of their visions of King. The truth is exactly the opposite. Unlike Appleton, Wisconsin, where the competing views of McCarthy as a hero or a villain gave authenticity (and unity) to both sides, there has been little question in Atlanta that King was a good man, worth remembering. His supporters acknowledge this, all pledging themselves to remember King and to fulfill his mission. But the absence of King opponents in Atlanta has left his supporters scrambling for ways to distinguish themselves.[4] King's goodness and the success of his legacy in Atlanta has also made the commemoration of Martin Luther King into a business and his supporters into competitors for tourist dollars, philanthropic checks, and press coverage. In this market, King supporters must differentiate their products. And as the King Center, SCLC, and National Park Service are selling history instead of bon-bons, authenticity counts.

But it is not just the dearth of opposition and the abundance of tourists that have led King supporters to divide in the search for the aura of authentic history. It is the relative absence of such history in Atlanta that allows the King Center, the SCLC, and the Park Service to hold divergent visions of who King was and how he ought to be

commemorated. Martin Luther King, Jr. was born and raised in Atlanta, leaving for his graduate education in the North and his first preaching job, in Montgomery, Alabama. He returned to Atlanta to run the SCLC and pastor Ebenezer Baptist Church with his father, but his fame was won elsewhere—in the Montgomery bus boycott and the March on Washington, on Selma's Edmund Pettis Bridge and a balcony of the Lorraine Motel in Memphis. Montgomery, Washington, Selma, and Memphis all have ready-made reminders of King's presence, historical hints for commemorating him.

Few such guideposts exist for Atlanta. King's first foray into Atlanta's struggle for civil rights—his support of student-led sit-ins at downtown lunch counters in 1960—had ambiguous results. He earned the suspicion of both radical students and the conservative black leadership by taking a moderate position on the sit-ins. Though invited to participate by the students, he demurred first, and then half-heartedly joined later. But that step was enough to annoy the city's black leadership which saw the sit-ins as a threat to the slow gains they had won by working with their white counterparts. Negotiations between Atlanta's black leaders, the city, and store owners produced a settlement calling for a halt to sit-ins and then, six months later, desegregation. Students generally opposed the agreement, seeking instead an immediate end to segregation. At a contentious mass meeting, King persuaded students to accept the agreement but won the adoration of neither students nor their adult adversaries.[5] In the years following the sit-ins, King's only participation in local civil rights activities took place in 1964 when he and the SCLC joined Local 754 of the International Chemical Workers Union in a strike against Scripto, Inc. at a plant near SCLC headquarters. King's involvement was minimal—he spent 30 minutes on a picket line and addressed strikers once. The strike lasted only a month before Scripto offered a Christmas bonus and a wage increase to its workers. The union accepted.[6] King commemorators in Atlanta have given scant attention to both events.

At King's death, then, the natural guardians of his legacy—his family and his organization—found themselves standing in King's hometown holding his mantle, with only a weak historical hook to hang it on. Coretta King and the SCLC, always rivals for King's attention, informally, naturally, perhaps without thinking about it, divided among themselves the historical resources he left behind. King's

birth, his home, and his church went to his family. His death and his activism went to the SCLC. And between them, uneasily, they shared what they could not easily divide or give away—his crypt and his philosophy.

This division of the Atlanta remnants of King's life followed logical lines, each piece going to the camp most intimately associated with it. But the intimacy of families and that of colleagues is different, and, in the case of Martin Luther King, Jr. led his family and his organization to different ways to remember him. His family, few in number, only vaguely associated with his civil rights work, and lacking an institutional mandate to continue doing exactly what Martin did (though committed to continue his work in some way), adopted a *memorial* style. That is, they sought to remember King by establishing something that would remind others about him. The first act of the memorial style was Coretta King's announcement that she would organize and lead the King Center. The SCLC, a large organization, a group pledged to non-violent direct action in pursuit of civil rights, a band always under the tutelage and in the debt of Martin Luther King, Jr. chose a *tributary* style. That is, their remembrances sought to honor King by giving something to him. The SCLC's first act after King's death was to carry out the Poor People's Campaign, the mass occupation of Washington, D.C. by an army of the poor that King had been planning at the time of his death. These two styles (and the later *scholarly* style of the National Park Service—bounded by the legal charge "to protect and interpret. . .the places where Martin Luther King, Junior, was born, where he lived, worked, and worshipped, and where he is buried") dictated to their followers the proper relationship between themselves and the public, between celebrating King, commemorating his life, and acting in his honor.[7]

At services held on King's birthday the year after his assassination, King's friends gathered to commemorate his life. Harry Belafonte presided at the ceremonies. SCLC President Ralph Abernathy, Representative John Conyers, and Rosa Parks spoke to the gathered crowd. After the service, the throng marched to the future site of Martin Luther King, Jr. Village, a low-cost housing complex to be built by the City of Atlanta. It would house the headquarters of the SCLC. Later, others gathered at South View Cemetery to cover King's grave with flowers.

Three announcements caught the press' attention on that day. The first was a call for an official commemoration. State Senator Leroy Johnson introduced legislation seeking a state holiday in King's memory. Cleveland Robinson, President of the Negro American Labor Council, told listeners that if governments did not recognize January 15 as a holiday, blacks would simply make it one by not reporting to work. Second, Abernathy pled for the life of James Earl Ray, King's accused assassin. He reasoned that clemency for Ray would be a true example of nonviolence and an honorable birthday gift for King. Abernathy said, "it is needless for us to kill one man for the sins of millions. For us to kill those that are truly guilty of taking Dr. King's life we would but be guilty of mass murder, perpetuating an atrocity no less than that of Adolph Hitler." Third, Coretta Scott King announced her plans for a center in her husband's honor. Her vision included the Martin Luther King Documentation Project, the Institute of the Black World, the Institute of Non-Violent Social Change, and the Museum of Black Life and Culture, all to be housed at the Atlanta University Center. On Auburn Avenue, she proposed to build Freedom Hall, which would feature exhibits on King's life and role in the Civil Rights Movement, and restore King's birth home. The center (estimated to cost between twenty-five and forty million dollars) would be a "practical attempt" to carry out Kings ideas and plans, to make all people "free at last."[8]

Even at this early date, nine months after King's death, differences in the style of remembrance appeared. Abernathy's "gifts" to King—the comparison with Christ, the appeal for mercy for Ray, the move of SCLC's offices to the Martin Luther King, Jr. Village—all were acts of discipleship, tributes to a fallen leader. Made public, these gifts identified the giver with the receiver, Abernathy with King. They also separated believers from agnostics, as when Abernathy argued that anyone favoring capital punishment for Ray was in some little way a Hitler. In contrast, Coretta King's announcement of the birth of the King Center (and its multimillion dollar price tag) was an invitation for others to join her in remembering King. Her goals were didactic and inclusive. In order for the King Center to be successful, people would have to make donations, do research, visit museums. Abernathy could pay tribute to King alone if needed. Coretta King required the aid of others if her remembrance of King was to succeed.

The April 4, 1969 commemoration of King's death added one other facet to the varieties of King commemorations. On that day, the SCLC sponsored a voter registration drive and ran protest marches in Memphis, Selma, and New York. In the evening, Ralph Abernathy joined Dave Dellinger of the National Mobilization to End the War in Vietnam, Luis Melendez of the United Farm Workers, the pacifist Jeanette Rankin, and Peter, Paul, and Mary in a rally against the Vietnam War. That same day, Coretta King visited her husband's grave and then returned home, saying that she planned to spend the day "in this quiet manner, not participating in any public memorials or functions."[9] That the SCLC would spend the day of King's death in protest while Coretta King passed it in contemplation is not surprising. The SCLC had been in the midst of a protest when King was shot, and opposition to the war in Vietnam was an important part of King's mature thinking, so a day of marches was not inappropriate. For her part, Mrs. King had lost her husband exactly one year before. The date was certainly one for contemplation.

And yet the difference between the SCLC's protests and Mrs. King's mourning is important, for it points up the place of action in the tributary and memorial styles. To pay tribute is first to act; to remember is before all else to think. And so the two styles differed, one dedicated to discipleship, to public avowals of fealty, to bearing gifts, to separating the good from the evil; the other to thought, to education, to unity, to the building of memorials.

Of course, as the previous list makes clear, the tributary and memorial styles are not polar opposites. Some action is required either to get people to march or to build a building in King's honor. Further, the SCLC was not solely about honoring King through activism (it always had representatives at the memorial services), nor was Coretta King only interested in building the King Center (she sometimes offered public support for the SCLC's activities). Further, King's philosophy did not allow an easy separation between activism by disciples on the one hand, and mass education toward racial unity on the other. Even at its most unifying, King's rhetoric had been sharply critical of segregationists and slow-moving legislators. And at its most radical, King's philosophy had always made room for recruits. But the contrast between the two is clear enough to suggest that the SCLC and Mrs. King had, in a very brief period of time, hitched their efforts at

remembering King to two very different times in his life. With its emphasis on protest, activism, and against-popular-opinion-standard-bearing, the SCLC was clearly wedded to the 1966-1968 King, while Mrs. King stood closer to the King of 1963-64, the speaker at the March on Washington, the recipient of the Nobel Peace Prize. These differences allowed some common cause, as in the crusade for a King holiday, but as the 1970s wore on and Mrs. King worked to build the King Center, they also permitted a fair amount of back-biting, name-calling, and general unpleasantness.

In the King commemorations of 1969 and 1970, race took center stage. Both Coretta King and the SCLC drew attention to King's blackness, and to the problems facing black Americans. In 1969, the SCLC's Rev. T. Y. Rogers told students at Spellman College that "the murder of Martin Luther King told every black person in this country that no matter who you are you are still just another nigger." In 1970, Mrs. King opened the Black World Institute at the Atlanta University Center. Its purpose was to teach all Americans that "blacks have made worthwhile contributions to the U.S." After the ribbon-cutting, students at Morris Brown College kept up the theme, offering a "celebration of blackness"—an overview of black history from its origins in Africa to contemporary black nationalism. Ralph Abernathy, in a speech at Ebenezer Baptist, repeated his conceit of the previous year, placing an imaginary phone call to King. Abernathy told King that there were still forty million poor people in America, and that although Atlantans had elected a black vice mayor, there were still "Uncle Toms and Nervous Nellies" in Atlanta's black community. At the same ceremony, Coretta King received a painting, titled "Black is Beautiful."[10]

Unity on the importance of King's race did not guarantee agreement on how to commemorate King. The SCLC continued its activism. In 1970, it sided with Atlanta sanitation workers in their strike against the city. The SCLC-led march began at King's crypt on 4 April 1970 and deteriorated into a riot a few blocks later, when strikers met replacement workers riding a trash truck. Bricks and bottles flew; one striker was shot. The following year, the SCLC turned its attention to national problems, organizing a week-long protest, based in New York City, against "those who daily amass capital while millions are starving all around them." Hosea Williams led the first contingent of

marchers to Saint Patrick's Cathedral, interrupting a service to ask Bishop Joseph Flannery how the Catholic Church could continue to invest in South Africa. Williams was arrested.[11]

In contrast, the King family avoided confrontation and activism, favoring calls for a King holiday and efforts to gain funding for the King Center. Coretta King and ex-Mayor Ivan Allen started the fundraising drive in 1969, appealing to a multiracial crowd for support. The 1970 birthday commemoration featured calls from Vincent Harding (the President of the King Center) and Mayor Sam Massell for a national holiday in King's behalf, and from Benjamin Mays (King's mentor at Morehouse College and a member of the King Center board) for rededication to nonviolence. Martin Luther King, Sr. rose, and, speaking to whites in the congregation said, "Jews and gentiles alike—I love you. I am your brother."[12]

By 1973, the differences between the SCLC and the King family had become an open breach. They were divided by the SCLC's activism, but this alone was not sufficient to drive them apart.[13] Rather, it was the way in which the two sides sought authority for their interpretation of King's life that brought open hostility. The immediate cause of the hostility was money. In 1969, when Coretta King kicked-off fundraising for the King Center, the SCLC participated in the ceremony. There was nothing in press coverage of the event that suggested that financial support for the King Center was a vote against the SCLC.[14] The next year, though, U.S. Senator Hugh Scott introduced a bill authorizing the coining of a Martin Luther King, Jr. medallion. Coretta King suggested that the front of the coin bear King's profile, and "Justice, Peace, Brotherhood" and "I Have a Dream" appear on the reverse. The Senate would present the gold original to Mrs. King; bronze replicas would be sold. The proceeds were to benefit Morehouse College's King Memorial Fund and the King Center. The SCLC would receive nothing.[15] In 1972, the King Center declared its birthday commemorations "the official family-sanctioned memorial."[16] By 1973, the King Center was the King charity of choice in Atlanta. That year the Center planned a massive fund-raiser on King's birthday. Flip Wilson, Wilson Pickett, and Jose Feliciano performed at the Omni, Atlanta's largest indoor arena. RCA sponsored the event. The proceeds, about seventy-five thousand dollars gross, went to the King Center. That same evening, the Department of Housing and Urban

Development awarded a 1.7 million dollar grant to the King Center for the construction of a neighborhood facility near Ebenezer Baptist.[17]

Hosea Williams, the director of the Atlanta Branch of the SCLC responded hotly to the Omni event. He argued that the money donated on 15 January should go to the SCLC, not the King Center, because the SCLC's program of protests was more in keeping with King's philosophy than the King Center. To show the SCLC's dedication to King's radical message, Williams led 200 people in a "Hunger and Death March" from Ebenezer to City Hall, where they demanded that the city spend 4.1 million dollars in federal funds to feed the hungry, that Governor Jimmy Carter abolish the death penalty, and that the state make 15 January a King holiday and 4 April a "people's holiday." In response, the King Center Board of Directors placed an ad in the *Atlanta Daily World*, the city's oldest black newspaper, supporting the disbursement of funds to the Center and chiding Williams for his attack on Mrs. King.[18] The split, then, came not just over money, but also over legitimacy. The SCLC based its claim to King's mantle on the *correctness* of its position—it could criticize Mrs. King because she was wrong. In contrast, the King Center founded its appeal to King's memory on its *official* position as King's successor.

In the aftermath of the money dispute the SCLC and the King Center drew further apart. The SCLC, to this point a participant in commemorations of King's death and birth, focused its energies on the date of King's demise. Coretta King, never fond of public events on 4 April, withdrew to ceremonies on 15 January and worked more diligently to strengthen the King Center. The press followed Mrs. King. Coverage of the birthday celebrations expanded; the ceremonies on 4 April garnered little attention.

The migration of celebration and attention to King's birthday deserves some explanation. Mrs. King drew notice whenever she chose to commemorate her husband—when she and the SCLC held separate commemorations on 4 April, the press gave as much coverage to her offering of a single wreath on King's grave as it did to the SCLC's elaborate protests. And after the breach with the SCLC, the King Center cultivated press coverage. It held another fund-raiser at the Omni in 1974, this time with Sly and the Family Stone, and the O'Jays in concert. With the Omni celebrations came awards to national figures in Dr. King's name. Andrew Young won the first Martin Luther King, Jr.

Nonviolent Peace Prize in 1973; Cesar Chavez took the second in 1974. For its part, the SCLC carried out no fundraising on the anniversary of King's death. It focused instead on protests and criticism of national leaders.[19]

But these explanations simply raise more questions about the relationship between the date of the commemoration, the commemorators, and the style of their ceremonies. Historian William M. Johnston has argued that commemorations in Europe and the United States almost never fall on the date of a disaster because tragedies brings the legitimacy of the state and one's own moral self-image into question. Further, Johnson points out that in the United States, individual lives are rarely commemorated. Instead, ceremonies recall events. Both of these factors worked against the SCLC's 4 April services. The SCLC sought to bring a tragedy to mind and to honor an individual—not a good combination in America.[20]

Even more important than the date of the SCLC's commemorations, though, was their style. Tributes do not require publicity or converts to be meaningful, and clearly the SCLC prized fidelity to its view of King over press coverage or public support. Indeed, for an appeal based on correctness, like that of the SCLC, to survive, it must be confronted with an opposition that can be branded as incorrect. (How else does one explain Williams' attack on Mrs. King?) Nor did the SCLC engage in the type of institution-building that the King Center championed. Pledged to a rigidly "correct" view of King, lacking a visible symbol of its cause, absent a need for publicity, the SCLC invited its own invisibility. For its part, the King Center's memorial style demanded that it reach out to others, that it be a tangible manifestation of King's life. Fundraising served not only to gather money but to make connections between Mrs. King, the King Center, and Martin Luther King, Jr.

The cost of the memorial style is that, because it depends on outside approval for legitimacy, it requires relevance to remain alive. And so the content of the King Center's ceremonies had to shift to remain important.[21] The focus on King's blackness, prevalent in 1969 and 1970, was, by 1974, gone. That same year Mrs. King announced that the King Center itself, once based at both Atlanta University Center and Ebenezer Baptist would be moved entirely to the area around Ebenezer on Auburn Avenue. The city supported the move by acquiring

seven acres of land next to the King Center, funding coming from HUD and an anonymous donor. The city's land would hold a community center named after Dr. King. The Institute of the Black World and the Museum of Black Life and Culture, part of Mrs. King's original plans, did not survive the transfer.[22]

The change of venue accompanied a change in emphasis in the Center's celebrations. Nonviolence became the topic of choice on King's birthday. Mrs. King signaled the change both in choosing a theme for 1974's celebration—Keep the Dream Alive: Do Something New—Make Nonviolence a Part of You—and in her comments. She told reporters that she had designed 1974's events to draw attention specifically to Martin Luther King, Jr.'s devotion to "the power and morality of nonviolence."[23]

Accompanying nonviolence was new attention to King's dream. The "I Have a Dream" speech had been part of memorial services from the beginning, but appeals to "the dream" as a motivator were largely absent until the mid-1970s. Then, Mrs. King linked it to the pursuit of a non-violent nation, Atlanta Mayor Maynard Jackson to helping the poor, and the *Atlanta Constitution* to "love and understanding" and to the belief that "black and white American could overcome the fears of racial division."[24]

Adopting the "Dream" as a rallying cry was not simply a rhetorical move for the King Center. It was also a way to define what sort of public action it would find acceptable. Though it had disavowed the SCLC's confrontational tactics it was clearly stung by the SCLC's criticism that the King Center was spending money for bricks and mortar when it should be buying bread for the poor.[25] In response to SCLC jibes, the King Center began to develop a philosophy of political action. SCLC-type protests were untenable, so the King Center turned its attention to voter registration drives, rallies, and lobbying on civil rights legislation. Each of these types of political action could be evoked by the dream—the right to vote as one of the Civil Rights Movement's signal accomplishments, and the mass rally and legislative lobbying as the setting and goal of King's "I Have a Dream" speech. And so ceremonies that evoked King's dream also supported black voting, the renewal of the 1964 Civil Rights Act, and the passage of the Humphrey-Hawkins Full Employment Bill.[26]

The Center's focus on legislative action had two results for its Atlanta-based ceremonies. First, the ceremonies were devoted to a policy topic as well as remembering King's life. Lobbying became an official memorial to King, a way of drawing people to him through the democratic process. Second, as attention turned to national issues, national figures played a larger role in commemorative services.[27] In 1975 U.S. Senators Birch Bayh and Charles Mathias attended the King Center's birthday commemoration to push for renewal of the Voting Rights Act. In 1976, the White House released a letter from President Gerald Ford to Coretta King. In it he proclaimed his support for "the struggle for equality and well-being for all citizens, to which Dr. King so courageously devoted his life."[28] These trends—towards lobbying and national politics—set the stage for the King Center's largest memorial to Martin Luther King—a national holiday in his honor.

On January 10, 1976 Coretta King proclaimed that the King Center would work toward two goals—passing a full employment bill and making King's birthday a national holiday. To that end she called for a massive rally on January 15, one that would bring black and white workers together in support of her goals.[29] The following year, the Center established a day-long conference on employment. The event united labor, government, and business leaders to seek solutions to unemployment. The business-labor-government meet has become a fixture of King holiday celebrations. During the late 1970s it competed with calls for a national holiday in the contest for media coverage. In 1978, for example, Minnesota Senator Hubert Humphrey's death on 13 January focused the press on the full employment bill he had sponsored. The same year marked the tenth anniversary of King's death and provoked assessments of black progress in the decade since King's demise. There was general agreement that blacks had made great gains in politics, but were falling behind economically. Frederick Allen and Alexis Scott Reeves, writing for the *Atlanta Constitution* concluded that the search for jobs was *the* civil rights issue facing blacks in the late 1970s.[30] But by the early 1980s, the passage of a full employment bill and the frustration of the national holiday effort led the King Center to focus its lobbying efforts on winning the battle for King's birthday.

In the struggle for the holiday, the King Center counted the SCLC as an ally. It could do so only because in 1979 the leadership of the organization decided that the King Center's memorial style made it

more influential than the SCLC's tributary turn.The SCLC's change was a quick one. In 1976, the SCLC had sponsored an alternative birthday commemoration to recall, in Hosea Williams' words, "the true legacy of Dr. King." Two years later the SCLC and Mrs. King had openly squabbled over the portrayal of Dr. King in the television miniseries "King." The SCLC complained that King appeared to lack courage in the film. Mrs. King took this comment personally since she had approved the script and the actors. In 1979, only months before making up with the King Center, the SCLC had marched outside Ebenezer Baptist on King's birthday to protest the award of the King Peace Prize to Jimmy Carter.[31] That year, the Reverend Joseph Lowrey, President of the SCLC, led the ouster of the SCLC's resident radicals, including Atlanta Chapter President Hosea Williams and National Field Director Tyrone Brooks.[32] By 4 April 1980, Lowrey's new-look SCLC had adopted the commemorative touch perfected at the King Center. Lowrey told reporters that the SCLC's ceremonies that year would not be "gloomy." "This is a day of commemoration and celebration. We are celebrating his life and ministry and pledging ourselves to fulfill a dream," Lowrey said. In that spirit, the SCLC inaugurated its own annual awards, to be given out on 4 April. The first recipients of the Drum Major for Justice Awards included Bill Cosby, Attorneys U. W. Clemons and Fred Gray (of Memphis Bus Boycott fame), comedian Dick Gregory, baseball star Hank Aaron, and Tommie Smith, John Carlos, and Lee Evans, the sprinters who had raised gloved fists in protest on the winners' stand at the 1968 Olympics. Also on 4 April, Mrs. King appeared briefly with Lowrey at a memorial service near King's tomb.[33]

With the King Center and SCLC in agreement, the major commemorative days covered with ceremonies (and a Republican president in the White House giving his opponents cause for unity) the push for a King holiday began in earnest. Mrs. King never called only for a day off. In 1980, for instance, she urged supporters to work "through the political process" for jobs, better housing, an improved welfare system, a society without violence or crime, and a King holiday. And in 1981 she exhorted a crowd at Ebenezer Baptist to fight the "triple evils" of poverty, racism, and violence. But that same year the Congressional Black Caucus proclaimed a national King Day its top

priority. Mrs. King endorsed their plan. By 1982, calls for the holiday were dominant.[34]

Most of the wrangling over the holiday took place in Washington, D.C., and merits only a brief mention here. Partisans of the holiday originally sought to hold it on 15 January every year, but were forced to shift the date to the third Monday in January to gain enough votes for passage. As the debate dragged through the summer of 1983, hundreds of thousands of people marched through the streets of the nation's capital to support a variety of liberal causes and passage of the King Holiday Bill. President Reagan originally opposed the bill, switching sides shortly before the congressional vote. Senator Jesse Helms called for the opening of FBI files on King to determine, he said, if King had been a Communist. The bill finally passed in October 1983. The first national holiday was to be held in 1986 and a national commission, based in Atlanta, was established to organize the festivities. The federal government provided no funds for the celebration.[35]

While the public focused its attention on the debates in Washington, D.C., several changes took place in Atlanta that deserve more comment. The commemoration of King's birth grew from one or two days to an entire week (and, after the holiday became law, to as many as eleven days). The representatives of the federal government attending the ceremonies were no longer liberals, as they had been in the 1970s. Instead, with the election of Ronald Reagan in 1980, conservatives represented Washington, D. C. in Atlanta. During the 1970s the King Center and the SCLC had generally agreed with the politics of their guests. In the 1980s, that was rarely so. And the ideological differences were complicated by the Reagan administration's willingness to send conservative blacks to Atlanta. The King Center, under construction throughout the 1970s, was finally dedicated in 1982. Immediately, the press began to evaluate the Center's fiscal and social practices. Finally, the federal government declared the area around the King Center a national historic site, began restoring the buildings and interpreting the stories that made up "Sweet Auburn." By so doing, it introduced a style of remembrance and source of legitimacy that competed with those favored by the King Center.

The lengthening of King commemorations in the expectation of a national holiday allowed the King Center to expand its offerings.

Originally just a memorial service at Ebenezer Baptist, the holiday added the nonviolent peace prize and labor meetings in the 1970s, and then, early in the 1980s, the "Salute to Greatness" awards, a parade, a conference built around the annual theme, various motivational speakers, youth programs, teach-ins, plays, music, and the occasional television tribute. The King Center had initiated many of these events, but others had started elsewhere and were brought under the Center's umbrella. But while the number of events grew, the style of remembrance did not change. Almost all of the new events served either to celebrate or teach about King's life.[36]

With the expanded schedule, King's birthday became a tourist attraction, an event that warranted a several-day stay in the city. Matching tourist possibilities were expanded opportunities for businesses to link their products with Martin Luther King. Anheuser-Busch was the first company to take advantage of this opportunity, running an ad featuring King's dream speech in the *Atlanta Daily World* in 1984.[37]

But while King's birthday was commemorated over a longer period, the actual date of King's birth became less important, both because most of the events in his memory fell on other days by 1983 and because those events that did fall on January 15 were not always the most "sacred" on the calendar. For example, in 1984, the Ecumenical Service held at Ebenezer Baptist, long the centerpiece of King celebrations, fell on January 14th while the 15th was home to a musical, "Martin," and a televised commemoration of King's life, "A Celebration of Life: A Tribute to Martin Luther King, Jr."[38] In all, the effect of the expanded calendar of celebration was to broaden interest in King by thinning out the holiday's message.

The message of King Day was thinned not just by the expanded slate of events, but by the guests asked to fill them. Until 1980, guests of national renown attending the King commemorations were liberals and Democrats. In addition to Birch Bayh and Charles Mathias who attended in 1975, and Jimmy Carter's appearance in 1979, Ted Kennedy, Hubert Humphrey and Walter Mondale visited King ceremonies between 1976 and 1982. They came both as allies of the King Center's programs and as governmental leaders. But beginning in 1981 with Ronald Reagan's election, guests appeared who held policy positions antithetical to those supported by Mrs. King. That year, Matt

Mattingly, Georgia's first Republican Senator in a century, spoke at the Ecumenical Service. He tried to convince listeners that the Republican party sought "true social and economic justice for all Americans." In 1983, Samuel Pierce, the lone African American in Reagan's cabinet, and Vice-President George Bush spoke at King commemorations. And starting in 1986, William Bennett, Reagan's Secretary of Education attended annually, often leading a teach-in on King at local schools.[39]

Mrs. King's response to the presence of ideological opponents was gracious, but half-hearted. She introduced Mattingly, listened to his comments, and then refuted them kindly with a comparison between the racial climate in the 1950s and that of the 1980s. She presented Pierce with the new King Special Award, and invited Bush to introduce Martin Luther King, Sr. at a "Salute to Greatness" dinner in his honor. For their part, visitors from the Reagan administration restrained themselves in Atlanta, generally limiting their comments to safe topics, often focused on King's dream. A sort of compromise emerged from the celebrations of the mid-1980s—conservatives would not openly contradict Mrs. King. In turn, she would leave criticism of the Reagan Administration to others, most notably Joseph Lowrey and Jesse Jackson. A similar entente existed between the King Center and American businesses. Though ideologically committed to ending materialism, Mrs. King recognized that the King Center badly needed corporate sponsorship to survive. The "Salute to Greatness" became the place for honoring corporate donors, while the Ecumenical Service still featured the occasional attack on capitalist excesses.[40]

The careful treatment of corporate donors was especially important for the King Center, because its completion in 1982 and the succeeding push for a national King holiday thrust it into the public eye. The Center's new visibility opened it to renewed attacks from partisans of the tributary style like Hosea Williams. (Williams made the remarks quoted at the opening of this chapter in an article assessing the King Center in early 1983.) But added to Williams' voice were others that questioned the King Center's ability to manage its money and provide meaningful service while upholding King's legacy. Journalist Michael Szymanski noted in 1984 that the King Center had no punch bowl of its own for receptions, no matching china for meals, and not enough money to run regular tours through King's birth home.[41]

Doubts about Coretta King and her ability to manage the King Center while staying faithful to her husband's legacy were particularly threatening because Mrs. King's standing as an interpreter of King's life depended on her ability to uphold her official status. The need to appear official meant that she not only had to act as her husband would have acted, but make the center appear to be stable and professional as well. The Center's financial troubles were thus both a threat to its programs and to its legitimacy.

In response to this challenge, the Center launched a campaign bent on reinforcing its position as the official interpreter of King's life. In January 1984, only three months after the creation of a national King holiday, the Center produced a kit containing instructions on proper remembrances of King. Lloyd Davis, the Executive Vice-President of the King Center, called the package the way that "people will learn the official way we celebrate the holiday." It included postcards of King, photos of the King family, a cassette recording of King's "dream" speech, and suggestions for appropriate Christian, Muslim, Hindu, and Jewish services. Coretta King added a list of appropriate activities for King Day—flying the flag, driving with auto headlights on, participating in a peaceful march, planting a tree, attending motivational rallies, and singing "We Shall Overcome" among them. She defined the Center's place in recalling King: "The Center is the primary source for information about him." Christine King Farris, Martin's sister, vouched for the authenticity of the Center's facts. "This is the only officially sanctioned way to celebrate Dr. King's birthday. I've seen information that has been gathered that is not authentic. We can certainly give authentic information, that is not distorted or misconstrued." Almost two years later, on the eve of the first national holiday, the Federal Holiday Commission, headed by Coretta King and composed of several leaders of the King Center, issued further instructions on proper King commemorations. Among the list of "don'ts" were advocating a single issue, participating in civil disobedience, and leveling personal attacks against individuals, organizations, or nations. On the other hand, naming buildings after Dr. King, ringing bells, studying King's life at church, using commercial advertising to teach about King, and signing the "living the dream" card were all appropriate.[42]

No number of orthodox celebrations would shore up the King Center's weak financial flank. And so Coretta King, only ten months after paying off the construction debt on the King Center, took to the fundraising trail again, this time seeking 13.5 million dollars for an endowment fund. Atlanta-based Coca-Cola kicked off the drive with a donation of up to five hundred thousand dollars. Stroh's brewery followed suit, underwriting the 1985 "Salute to Greatness" dinner so all of the proceeds could go to the King Center.[43]

Mrs. King's fundraising efforts for the Center were quickly derailed by more pressing financial problems. The legislation authorizing King Day had expressly provided no federal funds for the celebration, and just eleven weeks before the first national King holiday, the commission had raised only two hundred fifty thousand of the estimated one million dollars needed to carry off the celebration. Even worse, no parade organizer had been hired, invited guests would have to pay their own way to the festivities, and labor and the military, considered sure parade participants, were balking at the expense of the event. Atlantans, long accustomed to King celebrations organized entirely by the King Center seemed uninterested in participating and part of the parade route, down Auburn Avenue, was, in the words of journalist Tom Teepen, "a disaster." At the last minute the Atlanta Chamber of Commerce and the city's Division of Natural Resources jumped in to plan the parade and budget for the holiday. But just eleven days before King's birthday, only sixty thousand dollars had been raised for the parade (the parade's budget was one hundred sixty thousand dollars), and forty-five thousand of that had come from the city of Atlanta. And as of 7 January 1986, the commission had raised only 296, 760 dollars. Only a burst of *pro bono* advertising work and the efforts of the King Center made the first King Holiday successful.[44]

The 1986 celebration contained all of the elements that had come to be expected from King Week. Ronald Reagan expressed his appreciation for King, but did not attend any Atlanta ceremonies, sending George Bush in his place. Coretta King played her usual mediating role, while Jesse Jackson took up the attack on Reagan, saying that Reagan and the media had portrayed King as a "non-threatening dreamer" when actually King's mission was to "disturb the comfortable and comfort the disturbed." Mrs. King set the broad parameters for the celebration with the annual theme, "Living the

Dream: Ending the Violence of Poverty, World Hunger, and Apartheid Through Creative Nonviolent Action," a theme broad enough to include speeches by Joseph Lowrey (who said that Ronald Reagan signed the King Holiday bill "with his pen, not his heart") and George Bush, the presentation of the Nonviolent Peace Award to South African Archbishop Desmond Tutu and "Salute to Greatness" awards to Coca-Cola CEO Donald Keough and Japanese billionaire philanthropist Ryoichi Sasakawa, a teach-in by William Bennett, and a parade that included an Air Force fly-over and gay rights advocacy groups.[45] The gathering wasn't wide enough, though, to include Hosea Williams or Ralph Abernathy, who spent the holiday at a commemoration in Anchorage, Alaska. Abernathy was particularly upset by the snub, protesting that "He [King] died in my arms. . . .I want to be participating." The King Center responded that Abernathy was not being overlooked, but honored by being sent to Alaska.[46]

The breadth of the celebration swallowed up the complaints by Williams and King, but opened space for a new criticism of the King Center—that its focus on memorializing King forced it to overlook the real history of the Civil Rights Movement.[47] The criticism took two forms—the first a generalized sense that it was impossible to both commemorate King and call for grandiose changes in national policy, and the second a more specific complaint that the King Center's emphasis on celebration and ties to the federal government led it to overlook King's true place in American history. The first observation, offered by several Atlanta journalists, focused on Coretta King's dual role as a booster for King's memory and an activist in King's mold. Frederick Allen, the *Atlanta Constitution*'s political columnist, wondered how Mrs. King could reconcile the celebrations of her husband, dead for a generation, and her contemporary complaints about politics, government, and race relations. In Allen's words, the King holiday was an exhibit of "the clash between history and the future." The *Constitution*'s editorial page took a slightly different tack, noting that King had died long ago enough that any celebration of his life would be tinged with both nostalgia and neglect. And Priscilla Painton, the *Constitution*'s lead writer on the King holiday, noted that the King Center itself was riven by a conflict between the past and the present. It justified its existence, in part, by the services it provided to Atlantans, but those services were of poor quality because the King Center ran in

the ad hoc style of a 1960s civil rights organization. The King Center's Chief Operating Officer, Chip Wheeler, characterized the problem this way: "When you're working with community people [on the King Center's staff], you don't try to impose a business ethic."[48]

The second reproach, directed by Jesse Jackson against Ronald Reagan, but offered to all Atlanta by Benjamin Chavis in 1986 and Clayborne Carson and David Garrow in 1987, argued that the holiday's focus on King neglected the contribution of thousands of other people while its frequent mention of the "dream" weakened King's radical critique of the United States in the last years of his life.[49] The comments of Chavis, Garrow, and Carson, though superficially like those proffered by the SCLC in the early 1970s, diverged on one major point; what to do with the knowledge that King was a radical. The SCLC had argued that King's radicalism obligated them to carry out radical protests. The critics of the late 1980s, more scholars than activists, held that King's radicalism demanded a change in the historical content of King celebrations. This focus on King's place in the past separated Garrow, Carson, and Chavis from both the tributary style of the SCLC and the memorial style of the King Center, linking them with an unlikely ally, the National Park Service.

The Park Service had been a part of the local King commemorative scene since 1980 when federal legislation created the Martin Luther King, Jr. National Historic Site, and, surrounding it, the Martin Luther King, Jr. Preservation District. From the beginning the Park Service's focus was local and historical. It had been charged to preserve and interpret the King-related sites along Auburn Avenue—his birth-home, his church, his gravesite, and the neighborhood that surrounded them.[50] This mandate has had an important effect on both the type and content of the programs run by the NPS. The responsibility to preserve the area around King's home has forced the NPS to work closely with the residents, businesses, and civic groups on Auburn Avenue. In a series of public hearings held in 1983, residents told the NPS that their most pressing interest was not historical commemoration but the deterioration of the neighborhood. In response to that worry, and to the chance that a national park would raise the cost of living on Auburn Avenue (by 1980 a fairly poor district), the Park Service purchased the homes surrounding King's on Auburn Avenue from their absentee owners, refurbished their exteriors,

and continued to rent them to tenants at controlled prices. The NPS has carried out a similar program with businesses in the neighborhood.[51]

The NPS has brought a similar local and historical approach to the site's interpretation. Recognizing the limits that the enabling legislation and King's Atlanta inactivity placed on them, the NPS crafted a limited interpretation of King's life focusing on the effect King's upbringing in Atlanta's premier black neighborhood had on his life and philosophy. The focus on King's family, church, and neighborhood as the source of his later activism has two great strengths. First, it represents the leading trends in King scholarship, and second it grows out of, and is limited by, the historical resources on hand.[52] This view of King, anchored in place and time, is in sharp contrast to the commemorative efforts of the SCLC and the King Center, both of whom have paid more attention to King's national importance in the present than his local importance in the past.

But there are problems with the Park Service approach to the past. The largest among them was raised implicitly by the activism of the SCLC and the King Center and explicitly by the King site's legal foundation. Federal law required that the site "protect and interpret for the *benefit, inspiration, and education* of present and future generations (italics added)." But nothing about the protection and interpretation of King's home ground guaranteed that it would benefit and inspire visitors, especially if one accepts the SCLC and King Center position that education about King's legacy is most beneficial when it inspires people to civil rights activity. Faced with a possible conflict between the means (protect, interpret) and ends (benefit, inspire, educate) of its mission, the Park Service charted a careful course. By eschewing protests, marches, and commemorations of its own, the Park Service essentially argued that educating visitors about King was enough to benefit and inspire them. The NPS simply sought to make that education more accessible by improving the environment in which visitors were taught. The improvements not only included fixing up run-down houses, but building parking lots, providing guides for tours, and, most recently, constructing a visitors' center. The Park Service worked with residents and the City of Atlanta to survey and preserve larger and larger chunks of the area surrounding the King Center. Historic preservation has thus become its own type of activism. Finally, the Park Service reached an understanding with the King Center

and Ebenezer Baptist. They would control and interpret the most inspirational sections of the area—King's church and gravesite—while the Park Service helped with maintenance.[53]

Though a response to a specific situation, the Park Service's King commemoration is an example of a more general way of remembering—the scholarly style. It is a style of limits, one that is bound to place and time, one that recognizes that much of the past is past, one that sees preservation and education as the key to making the past meaningful in the present. In this way, the Park Service's work at the Martin Luther King, Jr. Historic Site is typical of mainstream historical scholarship. But King's popularity and the existence of the King Center and the SCLC led the NPS to two further conclusions. First, the NPS, by avoiding political activism and leaving overt inspiration to others, recognized that certain public acts fell beyond its powers. Second, though unwilling to protest and pray itself, the NPS acknowledged the value of other styles of remembrance. Without the King Center, the SCLC, Ebenezer Baptist, and the memories stored in individual minds, the King historic site would have little public value. Without the memorial and tributary styles, the scholarly style has little value in public life.

Though the park has slowly grown since the first national King day, its style of memory had changed little. Nor have the styles of the SCLC and the King Center evolved. The SCLC still focuses its commemorations on April 4, and, the Drum Major Awards notwithstanding, tends to protest and criticize more than the King Center. The Center has maintained its King Week celebrations, lobbying efforts, and fundraising drives, while Mrs. King still acts as official representative of her husband's legacy.[54] Given the complementary roles that the King Center and NPS play, the popularity of King celebrations in Atlanta, and the détente between the SCLC and Mrs. King, one might expect the years since 1986 to have been peaceful ones in the competition between Atlanta's King interpreters.[55] They have not. The discord between the King Center and the NPS during the 1995 holiday is but the latest in a series of disputes over the meaning, interpretation, and viability of King's legacy.

A constant theme in celebrations since 1986 has been the worsening condition of black life. This lament, pronounced by the SCLC, Mrs. King, Jesse Jackson and others, has several themes. First,

problems in the black community are due both to rising racism and declining morality. During King Week 1987, Hosea Williams led a march through Forsyth County, Georgia. Members of the Ku Klux Klan pelted the marchers with rocks and bottles, eventually bringing the march to halt. That event, coupled with the murder by whites of a black man in Howard Beach, New York spread a pall over King celebrations. Every speaker at the King Ecumenical Service mentioned the attack on Forsyth marchers. Most tied them to a growing number of bigoted acts in the U. S. By 1990, the fear of racial violence had led event organizers to place metal detectors at the door of Ebenezer Baptist. But racism was not the sole cause of danger for blacks. The SCLC, as part of its commemoration of King's Death in 1987, held a conference on the black family. Speakers there decried the role drugs and guns played in the black community. By 1993, the SCLC offered to give fifty dollars to any person willing to give up their gun on the date of King's death.[56]

Second, the federal government has failed at its task of sustaining the quality of life for blacks. Jesse Jackson drew a sharp line tying the Reagan administration with the events of Forsyth County and Howard Beach. "Acts of bigotry are breaking out all over the land," Jackson argued, because blacks were denied opportunities common to whites. Blacks, he continued were "locked out" of the White House, the Justice Department, and corporate America. Coretta King went further in 1990, urging the federal government to spend more on social programs. Otherwise, "it will be business as usual in the barrios and ghettos of America for a long time to come."[57]

Third, a proper appreciation of Martin Luther King, Jr.'s teachings would resolve many of the problems facing blacks. Andrew Young visited Africa in 1987 to commemorate King. He spoke to students, urging them to use nonviolent tactics to overcome political and economic oppression. The students laughed, both because they favored Malcolm X's teachings over those of Dr. King and because the United States, King's own nation, was demonstrably violent. In 1991, Young and Coretta King pressed the United States to break off its preparations for war against Iraq, citing King's opposition to violence and the dangerous influence that militarism had within the U. S. as reasons.[58]

Fourth, the fact that life had worsened for many blacks in recent years, in spite of a spate of King commemorations, meant that King had not been commemorated correctly. Clayborne Carson, the editor of King's papers, made this point in a 1987 editorial. He claimed that America mistook King for a peaceful dreamer when he was really an exponent of a tradition of "vigorous political dissent" as well as a real human being who recognized his own flaws. Jesse Jackson argued the same point three years later. Jackson said, "Somehow we've forgotten that 'I Have a Dream" was the poetic climax of a great speech whose substance was economic justice."[59]

Fifth, both declining black prospects and flawed King celebrations met in the federal government, which both ignored King's teachings and commemorated him incorrectly. The conjunction of Bill Clinton's inauguration and King week in 1993 led King boosters to vent their anger at twelve years of Republican government and misapprehension of King's message. John Lewis called for "massive intervention by the federal government" to solve the problems facing minorities and the poor in America; Coretta King reminded listeners that King Day should be " a day of peace, a day in which there is a cessation of all forms of violence."[60]

On a national level, the solution to the problems of race, poverty, and the memory of Dr. King seemed clear—influence the federal government, through protest or politics, to invest more in the black community and less in war. In Atlanta, the problem was different, one more of style than substance. The question was not one of how to influence the government, but how to best represent King. The federal government had largely allowed Atlantans to craft King's memory—the King Center designed the holiday, ran the commemorations, provided the messages that marked his birth. And so failure fell at the feet of the King Center. Hosea Williams was quick to raise his voice to decry the "black elitists" like Coretta King and Maynard Jackson for "prostitut[ing]" King Day with parades and banquets. Always quick with the pithy remark, he asked, "Why go take money and buy a float when guys are begging for food?" And always quick to align himself with Dr. King, he stated, "Dr. King would condemn black leaders all across America who are misusing his birthday to raise large sums of money under the disguise of helping the poor when, in fact, that money will be used to further the cause of the black elitists."[61]

But more than Williams, it was the Martin Luther King, Jr. Historical Site which threatened the legitimacy of the King Center's way of thinking about King. For years the King Center had made huge claims about the potential of King's legacy to change America, and for years things had gotten worse. Williams had responded by blaming the Center. The Center, in turn, blamed the government. But the Historic Site offered another response, one more logical but also more frightening. By lashing its interpretation of King to the past and to Atlanta, the King site not only limited what it could do; it limited what King could do. For the unwritten message of the scholarly style is that the past, though worth preserving, is also worth ignoring.

An understanding of the implications of the scholarly style for the present is, at some level, behind Dexter King's remark that opens this essay. He, as the new president of the King Center, was charged by his position and philosophy to assert that King mattered, directly, in the present. The commemorative style of the historic site partially rejects that view. And so, King took the offensive, exclaiming that the NPS had a biased view of his father because it failed to teach about his opposition to the Vietnam War, and that its plans for a visitors' center were flawed. Why? Because the visitors' center exhibits, like those now in place at the King Center, would be the typical fare of history museums. In the place of a historical point of view, Dexter King sought to keep alive his family's memorial tradition of bringing people to King so they would act like him. The museum he favors, is in the words of one of King's aides, Phil Jones, an attempt to make the past live. "Imagine walking into a room with holographs of King and images of the marches of the 60s. We could zoom people in and make them feel as if they were there. It would get people beyond the idea of a King holiday and the 'I have a dream' speech."[62]

At present, the dispute has been resolved, but the deeper problem remains. The NPS continues with its plans for a visitors' center, the King Center has reopened the birth-home, gaining a few more dollars in the process. But the conflict between the style of the site and that of the Center continues. That battle, in turn, hints at broader battles in the United States about the meaning and the use of the past. In many ways, though, a battle about the meaning of the past is better than victory of one style over another. In Atlanta, both the King Center and the NPS have been forced to sharpen their justifications for existence. And that

debate, while unpleasant, has at least presented us with clear and defensible rationales for thinking about King in one way or another. Unfortunately, in the United States, there is more often agreement than disagreement about how to see the past. The result is almost always bad history, a disregard for what happened and a willingness to use the past without limits. The implications of such agreement are laid out in the next two chapters.

Notes

1.. Williams is quoted in Scott Thurston, "King Center Nearer its Goal of Establishing True Identity," *Atlanta Constitution*, 9 Jan 1983, 1, 14.

2. Department of the Interior, National Parks Service, *Martin Luther King, Jr. National Historic Site: Historic Resource Study (August 1994)*, by Robert W. Blythe, Maureen A. Carroll, and Steven H. Moffson, (Atlanta, Cultural Resources Planning Division, Southeast Regional Office, 1994), 5-6.

3. King is quoted in John Greenwald, "Not Fit for a King," *Time*, 16 Jan 1995, 37.

4. On the rare occasion where King opponents do appear, his supporters have drawn together. In 1987, for example, Ku Klux Klan members threw bottles at marchers led by Williams in Cumming, Forsyth County, Georgia. Williams was a King associate in the 1960s but had long been a critic of the King Center and Coretta Scott King. When his march came under attack during King Week, most King Week speeches mentioned the march, and 20,000 people, recruited from the throngs of celebrants, returned to Cumming and carried out another march. See John Brody and Joe Earle, "Klansmen throw Bottles and Rocks at Demonstrators," *Atlanta Constitution*, 18 Jan 1987, A1, 14; Priscilla Painton, "Forsyth Events Sober Celebrants," *Atlanta Constitution*, 18 Jan 1987, A14; Sandra McIntosh, "March is Still on in Forsyth County as Negotiations Fail," *Atlanta Constitution*, 16 Jan 1988, B1, 3.

5. David Garrow has collected most of the scholarly essays on the Atlanta sit-ins in David J. Garrow, ed., *Atlanta, Georgia, 1960-1961: Sit-Ins and Student Activism* (Brooklyn, N.Y.:Carlson, 1989). See especially the essay by Lionel Newsome and William Golden, "A Stormy Rally in Atlanta," 105-112; and Vincent D. Fort's, "The Atlanta Sit-In Movement, 1960-1961, and Oral Study," 113-182.

6. For a brief description of King's involvement in the Scripto strike, see National Park Service, *Historic Resource Study (August 1994)*, 43-4.

7. The designations "memorial," "tributary," and "historical" styles of commemorating the past are mine. At least two other ways of categorizing the past are in current use. By far the most common is the division into "history" and "memory" with "history" standing in for scholarly appraisals of the past and "memory" for recollections by non-academics. See, for example, T. H. Breen, *Imagining the Past* (N.Y.:

Addison-Wesley, 1989), George Lipsitz, *Time Passages* (Minneapolis: University of Minnesota Press, 1992) and the journal, appropriately titled *History and Memory*. The division into "history" and "memory" is most useful for uncovering and explaining popular views of the past, and, especially in Lipsitz, for criticizing the stodginess of the academy and its place in creating "official" ways of seeing history. However, by dividing understandings of the past by the profession of their holders, the "history-memory" formula overlooks the similarities between academic and popular history, especially as one moves closer to the present. One way of resolving this dilemma is to lump all evocations of the past together under one heading. This is the tactic of Michael Kammen, who in *Mystic Chords of Memory*, uses the term "tradition" to refer to scholarly and popular representations of the past alike. In a similar vein is Merrill Peterson's *Lincoln in American Memory*, where scholarly, poetic, material, and popular perceptions of Lincoln all fall under the rubric "memory." The all-in-one approach allows for inclusiveness and, in Kammen's hands, comparison with other countries. But one wonders if scholarship and doggerel are so easily placed together, given their different sources, goals, and audiences. Another approach to the dilemma of what to call the past has been suggested by David Lowenthal, who in *The Past is a Foreign Country* (N.Y.: Cambridge University Press, 1985), and more explicitly in a letter to the editor of the American Historical Association's newsletter *Perspectives*, Jan 1994, 17-8, differentiates between "history" and "heritage" based on the place of criticism in understanding the past. "History" grows out of a thorough, distanced, complete reading of the sources. Its purpose is to inform about the past. "Heritage" favors identification with the past, not distance from it, and is based on a partial reading of the sources. By basing his distinction on approach to the past instead of professional training, Lowenthal is able to point out that many professional historians practice "heritage" to the detriment of "history." But Lowenthal's view that "history" does not "bend the past to present agendas" runs contrary to reality. *Perspectives*, 17.

8. "King Memorial Today Will Center at Ebenezer, " *Atlanta Constitution*, 15 Jan 1969, 5; Alex Coffin, "Spare King's Killer, Rev. Abernathy Asks," *Atlanta Constitution*, 16 Jan 1969, 1, 10; Duane Reiner, "Senate Applauds Tribute to King," *Atlanta Constitution*, 16 Jan 1969, 1, 11.

9. Alex Coffin, "Honor King Memory, Allen Asks Atlantans," *Atlanta Constitution*, 4 Apr 1969, 1, 7.

10. Alex Coffin, "Widow, Mayor Start King Memorial Drive," *Atlanta Constitution*, 5 Apr 1969, 1, 3; "Official Opening of Martin Luther King Memorial Center," *Atlanta Daily World,* 18 Jan 1970, 10; "Black World Institute in Operation at A.U.," *Atlanta Daily World,* 20 Jan 1970, 1; Robert DeLeon, "1,000 Honor King at Church Service," *Atlanta Constitution*, 16 Jan 1970, 1, 20.

11. Don Winter and Richard B. Matthews, "City Striker Shot in Fight," *Atlanta Constitution*, 5 Apr 1970, 1, 4; Aaron Taylor, "Speakers Pay King Tribute," *Atlanta Constitution*, 5 Apr 1971, 1, 13.

12. Coffin, "Widow," 1, 3; DeLeon, "1,000," 1, 20. The 1970 calls for a holiday were at least partially successful. By the 1971 anniversary, Atlanta had declared Jan 15 a holiday. John L. Davis, "King's Birthday Hailed as Legal Holiday by City and Local Schools," *Atlanta Daily World*, 15 Jan 1971, 1.

13. Note, for instance, Martin Luther King, Sr.'s response to the SCLC march on behalf of Atlanta's garbage men. The King family had asked the SCLC not to carry out a rally at King's gravesite on the anniversary of his death, and, that failing, that they not gather until the family had held its own small service. When strikers arrived during the family service, King, Sr. spoke with them but allowed them to remain. When the Kings left, the SCLC held a full rally. Winter and Matthews, "City," 4.

14. Coffin, "Widow," 1, 3.

15. "Martin Luther King Medal Sought by Senator," *Atlanta Daily World,* 2 Apr 1970, 8.

16. "King Center is Focus Here," *Atlanta Daily World*, 16 Jan 1972, 1.

17. "M.L. King Tribute Slated Here," *Atlanta Daily World*, 14 Jan 1973, 6. See also the advertisement for the event on page 7 of the same issue. See also Rex Gramm, "City Pays Tribute to Dr. King," *Atlanta Constitution*, 15 Jan 1973, 1, 13; Howell Raines and Colleen Teasley, "King Benefit Grosses $75,000," *Atlanta Constitution*, 16 Jan 1973, 1, 15.

18. Raines and Teasley, "King Benefit," 1, 15. The advertisement in the *Atlanta Daily World* appeared on 14 Jan 1973, p.9.

19. On King Center commemorations, see Jim Merriner and Gregory Jaynes, "Concert Brings King Birth Observance," *Atlanta Constitution*, 15 Jan 1974, 11 and "Plan for $10 Million King Center Unveiled," *Atlanta Daily World*, 13 Jan 1974, 1. On the SCLC's 4 Apr ceremonies, see Jim Merriner, "SCLC Soup Line Opened," *Atlanta*

Constitution, 5 Apr 1974, 6 and "SCLC Plans Seminar on April 11," *Atlanta Daily World*, 4 Apr 1974.

20. William M. Johnston, *Celebrations: The Cult of Anniversaries in Europe and the United States Today* (New Brunswick: Transaction Publishers, 1991), 11-2, 18.

21. This is not a criticism of the memorial style for it does not claim to have an unchanging message. Rather, it argues that it can always provide a message that fits the moment. It does again illustrate the link between commemoration and forgetting. A shift in the focus of a commemoration leaves the previous topic open to oblivion. It should be noted also that the tributary style can also lead to forgetting, for its unchanging devotion to the object it commemorates can leave it completely outside the public debate. For the SCLC, its attachment to the King of the late 1960s left it outside the public policy debates of the 1970s.

22. "Plan for $10 Million King Center Unveiled," *Atlanta Daily World*, 13 Jan 1974, 1; Jim Merriner and Gregory Jaynes, "Concert Brings King Birth Observance," *Atlanta Constitution*, 15 Jan 1974, 11.

23. "Gala Festivities to Kick-Off Two-Day Commemoration of King Birthday," *Atlanta Daily World*, 11 Jan 1974, 1.

24. "Gala," 1; Clarissa Myrick, "King Followers Told to Retain Leader's Dream," *Atlanta Daily World*, 17 Jan 1975, 1; "King's Dream," *Atlanta Constitution*, 15 Jan 1976, 4.

25. The "bricks and mortar" attack is found in Fay Joyce, "Passage of Jobs Bill Predicted," *Atlanta Constitution*, 15 Jan 1976, 2.

26. Portia S. Brookins, "Senators, Rights Leaders Back Extension of Voting Act," *Atlanta Daily World*, 16 Jan 1975, 1, 4; Joyce, "Passage," 2.

27. This is not to say that local issues played no role in King commemorations, or that local figures no longer participated in the ceremonies. The King Center inaugurated an award for service that went to Atlantans who had provided community aid in 1974, and it frequently proclaimed its interest in applying the Center's expertise to Atlanta's problems. But local issues never returned to the fore of the Center's agenda. See Thomas Stokes, "Solemn Ceremonies, Speeches Highlight King Services Here," *Atlanta Daily World*, 17 Jan 1974, 1, 4; "King Mobilized Forces of Goodwill, Young Argues," *Atlanta Daily World*, 17 Jan 1974, 12.

28. Brookins, "Senators," 1; Joyce, "Passage," 2.

29. There is some question as to how big the rally was to be. The *Atlanta Daily World* said Mrs. King expected the rally to be as

large as the March on Washington thirteen years earlier. The *Atlanta Constitution* reported that march organizers expected ten thousand participants. Whatever the number expected, around five thousand people attended the march, and about half that number stayed for the speeches that followed. The comparison with the March on Washington is in "Mrs. King Calls Full Employment 1976 Key Issue," *Atlanta Daily World*, 11 Jan 1976, 2; the estimate of ten thousand and the actual attendance figures appear in Fay S. Joyce, "Five Thousand March in Demand for Jobs," *Atlanta Constitution*, 16 Jan 1976, 1, 26.

30. Peter Davis, "March, Jobs Rally Recall King Dream," *Atlanta Constitution*, 16 Jan 1977, 1, 4; Dorothy Carr, "Hubert H. Humphrey Receives Honors with King," *Atlanta Constitution*, 15 Jan 1978, 2; Frederick Allen and Alexis Scott Reeves, "King Had a Dream, Still Not Fulfilled," *Atlanta Constitution*, 4 Apr 1978, 1, 8.

31. "SCLC Plans MLK, Jr. Birthday Fete," *Atlanta Daily World*, 11 Jan 1976, 3; Dorothy Carr, "Playing King a Lesson for Winfield," *Atlanta Constitution*, 15 Jan 1978, 14B; Angelo Lewis, "800 Protesters Demands Jobs Push by President," *Atlanta Constitution*, 15 Jan 1979, 14.

32. Brooks, when asked about a split between Coretta King and the SCLC in January 1979 said "I couldn't call it a split. Its a difference of ideology, philosophy." Lewis, "800," 14. Only months later, he had been drummed out of the organization, later forming the Martin Luther King Movement along with others ousted from the SCLC. The Movement's goal was to push for a "black agenda." Gregory Huskisson, "Alternative Group to SCLC Called by Williams Backers," *Atlanta Daily World*, 5 Apr 1979, 7; "12th Anniversary of MLK Death to Be Commemorated in Macon," *Atlanta Constitution*, 4 Apr 1980, 5.

33. Ibid.; Sharon Bailey and Tyrone Terry, "SCLC Honors 9 on Anniversary of King Death," Atlanta *Constitution*, 5 Apr 1980, 11; Beverly J. Moore, "Mrs. King Vows to Carry On Husband's Rights Struggle," *Atlanta Daily World*, 6 Apr 1980, 1, 4.

34. Brenda Mooney, "Celebration of King Day: Keeping the Dream Alive," *Atlanta Constitution*, 16 Jan 1980, C1, 21; Charlene P. Smith-Williams and Chester Goolrick, "Mrs. King Urges Struggle to Defeat 'Triple Evils'," *Atlanta Constitution*, 13 Jan 1981, C1, 2; "Black Caucus Asks Holiday," *Atlanta Daily World*, 15 Jan 1981, 1, 4; Sam Hopkins, "Call for Holiday Marks King Service," *Atlanta Constitution*, 16 Jan 1982, B1, 3.

35. A longer account of the legislative debate over the holiday can be found in Chapter 5 below.

36. On the expanding holiday, see "8 Day Fete for Dr. King is Underway," *Atlanta Daily World*, 12 Jan 1982, 1, 6; Scott Thurston, "Packed Ebenezer Service Launches King Week '83," *Atlanta Constitution*, 10 Jan 1983, 8; Michael Szymanski, "King Week Schedule Expanded," *Atlanta Constitution*, 30 December 1983, 7.

37. "King Week Celebration Brings Many to City," *Atlanta Daily World,* 13 Jan 1983, 1, 4; "I Have a Dream," *Atlanta Daily World*, 12 Jan 1984, 6.

38. Szymanski, "King Week," 7.

39. Smith-Williams, "Mrs. King Urges," C1, 2; Szymanski, "King Week Schedule," 7; "King Week Celebration," 1, 4; Portia Scott-Brookins, "HUD Secretary Pierce Wins Special King Award," *Atlanta Daily World*, 15 Jan 1984, 1, 7; Connie Green, "Bennett Finds 3rd Graders Did Their Homework," *Atlanta Constitution*, 15 Jan 1986, 7.

40. See, for example, Charlene P. Smith-Williams, "Ivan Allen Receives Peace Prize," *Atlanta Constitution*, 15 Jan 1981, C1, 7, for Lowrey's attack on Republican America, Deric Gilliard, "Progress for Blacks Lies in Economic Arena, Says Jackson," *Atlanta Daily World*, 14 Jan 1983, 1 for Jesse Jackson's comments, Hopkins, "Call," B1, 3 for general attacks on Reagan, and Reagan's evocation of King's "dream," Scott Thurston, "MLK, Sr., 'Gandhi' Director get Prizes," *Atlanta Constitution*, 16 Jan 1983, 1, 11 for more of Reagan's praise of King, Scott Thurston, "Bush Says American Owes Elder King for Son's Ideas," *Atlanta Constitution*, 16 Jan 1983, 10, and "Reagan and Bush Praise Kings," *Atlanta Daily World*, 18 Jan 1983, 1, 6 for Bush's tribute to King, Sr., and for tributes to corporate contributors, see, Michael Szymanski, "King Center Donors Honored," *Atlanta Constitution*, 14 Jan 1984, B3, and Ann Weak Kimbrough, "Businesses Help King Center's Fundraising," *Atlanta Constitution*, 7 Jan 1985, C2.

41. Thurston, "King Center," 1, 14; Michael Szymanski, "King Center Struggles to Stay Afloat Financially," *Atlanta Constitution*, 8 Jan 1984, B2; Priscilla Painton, "King Center Struggles to Meet Social Needs, Be a Memorial," *Atlanta Constitution*, 17 Jan 1986, 1, 12.

42. Michael Szymanski, "King Center Offering Kit for Birthday," *Atlanta Constitution*, 2 Jan 1984, 1, 7; Kevin Harris, "Commission Gives Pointers on Celebrating King Holiday," *Atlanta Constitution*, 16 December 1985, D1.

43. Szymanski, "King Center Donors," B3; "MLK Center Gets $500K Pledge," *Atlanta Constitution*, 18 December 1984, C2; Kimbrough, "Businesses Help," C2.

44. Priscilla Painton, "Setbacks Plague Planners 11 Weeks from King Holiday," *Atlanta Constitution*, 3 November 1985, 1, 12; John O. Hansen, "Chamber to Help Out With King Holiday," *Atlanta Constitution*, 7 November 1985, 31; Connie Green, "DNR Will Seek Funding to Assist King Center," *Atlanta Constitution*, 8 Jan 1986, 13; Priscilla Painton, "King Parade Planners Run Short on Funds," *Atlanta Constitution*, 4 Jan 1986, 1, 17; Priscilla Painton, "After a Sluggish Start, King Holiday is on a Roll," *Atlanta Constitution*, 7 Jan 1986, 1, 8.

45. Bob Dent, "Reagan Marks King Birthday," *Atlanta Constitution*, 16 Jan 1986, 1; Priscilla Painton, "Follow King by Helping Poor, Jesse Jackson Urges Audience," *Atlanta Constitution*, 16 Jan 1986, 7; "Lowrey Critical of Reagan on King Bill," *Atlanta Daily World*, 12 Jan 1986, 2; "Vice-President Among Leaders Paying Tribute," *Atlanta Daily World*, 23 Jan 1986, 1; Priscilla Painton, "Fly the Flag MLK Day Organizers Urge," *Atlanta Constitution*, 29 October 1985, 17; Priscilla Painton, "King Holiday Stirs Thanksgiving at Big Bethel Services," *Atlanta Constitution*, 13 Jan 1986, 1, 4; Karen Harris and Bill Montgomery, "Coca-Cola's Keough Given Top King Award," *Atlanta Constitution*, 19 Jan 1986, D2; Painton, "King Parade," 1, 17.

46. Connie Green, "Two King Aides Visibly Absent from Activities," *Atlanta Constitution*, 18 Jan 1986, 10.

47. One further evidence of the variety of the 1986 commemoration. Each day during King week had its own title—15 January was "Peace and Justice Day," 16 January "National Observance Day," 17 January "Labor/Management/Government Day," 18 January, "Poverty and World Hunger Day," 19 January "United Nations Day," and 20 January, "Dr. King's Day." See *Atlanta Daily World*, 14 January 1986, 2. Interestingly, the absence of Williams and Abernathy received no coverage in the *Atlanta Daily World*, the city's most prominent black newspaper.

48. Frederick Allen, "Can We Memorialize King While Calling for Change," *Atlanta Constitution*, 21 November 1985, 2; "In Time, More Will Honor King," *Atlanta Constitution*, 3 December 1985, 10; Priscilla Painton, "King Center Struggles to Meet Social Needs, Be a Memorial," *Atlanta Constitution*, 17 January 1986, 1, 12.

49. Benjamin Chavis, "How Dr. Martin Luther King Changed His Mind," *Atlanta Daily World*, 23 Jan 1986, 4; Keith Graham,

"Author Examines the Psyche of MLK, Jr.," *Atlanta Constitution*, 15 Jan 1987, B1, 4; Priscilla Painton, "King's Role in History Revised by Scholars," *Atlanta Constitution*, 18 Jan 1987, 1; Clayborne Carson, "Celebrate King's Achievements by Lifting Shroud of Myth," *Atlanta Constitution*, 19 Jan 1987, 11.

50. The history of the King National Historic Site can be found in National Park Service, *Historic Resource Study*, 7. It should be noted that although the site's enabling legislation charged the NPS with interpreting King's gravesite, the King Center carries out that task. The NPS, as of 1994, does maintain the gravesite and the birth-home, both of which belong to the King Center. Until early 1995 the NPS also conducted free tours of the birth-home. The tours were halted by the King Center as part of their dispute with the NPS over the interpretation of King's life there, but have begun again, though there is now an entrance fee that goes to the King Center. "King Shrine to Reopen," *New York Times*, 19 Jan 1995, 16.

51. On district preservation efforts, see Department of the Interior, National Parks Service, *General Management Plan, Development Concept Plan, and Environmental Assessment: Martin Luther King, Jr. National Historic Site and Preservation District (May 1985)*, (Atlanta, Cultural Resources Planning Division, Southeast Regional Office, 1985), 3-23.

52. On the park's interpretation of King see ibid., 51-61. On current King scholarship see Chapter 7 below.

53. On choosing education as a means of inspiration, see, National Park Service, *General Management Plan*, 105-6, on community improvements, see ibid., passim, but especially, iii-v, 106, 112-6; and National Park Service, *Historic Resource Study*, 95-7. The Park Service's work with the City of Atlanta to expand the park's boundaries is detailed in the *Historic Resource Study*, 5, note 2, and 7, note 5. Its agreements with the King Center and Ebenezer Baptist are mentioned in the *Historic Resource Study*, 7, and the *General Management Plan*, 53-5.

54. For examples of the SCLC's still-confrontational style, see Donna Williams-Lewis, "SCLC Officials are Banned From Governor's Office," *Atlanta Constitution*, 16 Jan 1987, 15. On Mrs. King's "official" role, see Priscilla Painton, "King Era Would Get Video-Age Touch at Memphis Museum," *Atlanta Constitution*, 15 Jan 1987, 19, 20, wherein Mrs. King professes not to care how the Civil Rights Movement is interpreted in a Memphis museum, as long as the museum was not named after her husband.

55. On the popularity of King celebrations, see Scott Thurston and Ron Taylor, "A Mood of Protest Accompanies Floats, Bands at Holiday Parade," *Atlanta Constitution*, 20 Jan 1987, D1; Cynthia Durcanin, "Jackson Blisters Reagan," *Atlanta Constitution*, 17 Jan 1989, 1, 6; Cynthia Durcanin, "King Day Speakers Mark Political Gains Amid Rise in Racism," *Atlanta Constitution*, 16 Jan 1990, 1, 6; Cynthia Durcanin, "Freedom Rings Amid War," *Atlanta Constitution*, 22 Jan 1991, C1, 6.

56. Priscilla Painton, "Forsyth Events Sober Celebrants," *Atlanta Constitution*, 18 Jan 1987, 14; Durcanin, "King Day Speakers," 1, 6; "8th Black Family Conference Today," *Atlanta Daily World*, 3 Apr 1987, 1; "SCLC Activities," *Atlanta Daily World*, 1-2 Apr 1993, 5.

57. Priscill Painton, "'Dark Joy' Marks Celebration of King Holiday," *Atlanta Constitution*, 20 Jan 1987, 1, 6; Cynthia Durcanin, "Mrs. King: Spend More on Social Programs," *Atlanta Constitution*, 15 Jan 1990, 1, 6.

58. Jim Galloway, "Unrest Erodes King Legacy of Nonviolence in Africa," *Atlanta Constitution*, 16 Jan 1987, 1, 12; Cynthia Durcanin, "Missiles Not Part of 'Dream' King's Widow Says," *Atlanta Constitution*, 21 Jan 1991, D1; Cynthia Durcanin, "Freedom Rings Amid War," *Atlanta Constitution*, 22 Jan 1991, C1, 6.

59. Carson, "Celebrate," 11; Durcanin, "Mrs. King: Spend," 6.

60. Ellen Whitfield, "New Civil Rights Chapter Opens on Subtleties of 90s," *Atlanta Constitution*, 10 Jan 1993, 1, 6.

61. Michelle Hiskey, "Williams Lashes Out," *Atlanta Constitution*, 16 Jan 1990, D1, 5.

62. Ronald Smothers, "Son Envisions a Multimedia Martin Luther King," *New York Times*, 3 Oct 1994, B12.

4
Paying Tribute to a Villain: Joseph R. McCarthy and the National Media

> A modern McCarthyism is going to have to concentrate on other things besides the Big Lie and the Red Menace. In fact, if we examine even a brief selection of people who should be tarred and feathered and run out of town on a rail (or, to be more contemporary, oat branned and goose downed and jogged out of the condominium complex on an exercise track) we see that they are not necessarily Marxist or even socialist in their thinking because that would presuppose thinking in the first place.
>
> P.J. O'Rourke[1]

This chapter is a history of two processes. It is the story of how the national media have made the history of Joseph McCarthy—the events that have evoked his memory, the powers that have been ascribed to him, the lessons drawn from his career. But it is also the story of the unmaking of McCarthy's history—the disregard for history that has characterized the remarks about McCarthy and McCarthyism printed in national media outlets since his death.

The chapter's argument is this: during McCarthy's life, his campaign against communism in government opened many questions about the proper behavior of public officials and the extent of McCarthy's influence. McCarthy's censure not only quieted McCarthy but also provided compromise answers to the queries McCarthy's investigations had raised. In the years following McCarthy's death, the questions about correct behavior of public officials shrank into discussions of McCarthy's behavior while those about the extent of McCarthy's power tended to accept the arguments that came from the extremes in the 1950s—that McCarthy was incredibly powerful. This was largely due to the motives of those who commemorated McCarthy

after his death when his opponents and supporters both sought personal vindication. Rather than assess McCarthy, then, remembrances focused on those who had supported or opposed him. This focus on personal feelings about McCarthy is a hallmark of the tributary style. In the case of Martin Luther King's legacy in Atlanta, the tributary style led some of his followers to adopt a radical image of King, partial to be sure, but one that was filled out by partisans of the memorial and scholarly styles. But in McCarthy's treatment in the national media, memorial and scholarly views are absent. As a result, there have been no checks on those wishing to pay McCarthy the tribute of brickbats and bad history. I should make it clear that by noting the absence of other commemorative styles in the national media I am not condoning McCarthy's behavior. Instead, I am arguing that a figure as vindictive as McCarthy and behavior as destructive as McCarthyism require accurate treatment in the media, both to preserve the integrity of the past and avoid its excesses in the present.

The tributary style of commemoration sheared McCarthy from the anti-communists that preceded him, unlinked McCarthy from the events that surrounded him in the 1950s and hitched him to events that followed—the rise of the new right, Watergate, and the cultural politics of the 1980s. This is clearest in the constant invocation of McCarthyism and its extension to cover situations, times, and people with no historical connection to McCarthy. One result of this process has been shoddy historical presentations and faulty historical analogies in the media—a problem, but one hardly on the level of war and famine. But this chapter argues also that the lack of historical content accompanying the use of "McCarthyism" has contributed to a decline in the quality of public discourse. The poor quality of McCarthy commemorations in the media today, then, revitalizes the kind of behavior that led McCarthy to his richly deserved downfall forty years ago.

McCarthy was neither the first nor the most influential anti-communist in American political history. Those honors must go to Attorney General A. Mitchell Palmer, who in 1919 began the first government crusade against American communists, and J. Edgar Hoover, who either personally or through the FBI underwrote most major persecutions of American leftists between 1920 and 1972. McCarthy did not give birth to the network of patriotic and business

organizations that were the source of rumor and funding for the anti-communist crusade. The National Association of Manufacturers, American Legion, Daughters of the American Revolution, and National Civic Federation all dated from the battles against radical unions and political parties in the first two decades of the twentieth century. Even the problems that brought McCarthy to his knees—lying, exaggerating, granting the status of truth to wild rumor—were long-standing characteristics of radical anti-communists. In one notorious case, Ralph M. Easley, president of the National Civic Federation, acquired a set of documents that purported to be evidence that the Soviet Union had bankrolled American radicals. He gave them to Representative Hamilton Fish (R-NY), who, on the basis of the information therein called for a congressional investigation of Soviet influence in the United States. The investigation began in 1930 and was almost immediately discredited by evidence that the documents were forgeries. Not to be deterred, Easley bought information from Gaston Means, a well-known con artist, that proof of Soviet influence was hidden in a vegetable warehouse in New York City. Easley called Fish, and together with the New York Police Department, raided the warehouse. They discovered crate after crate of lettuce. The media scoffed at the raid, Fish's reputation was destroyed, and Easley found his bankroll and influence much diminished.[2]

The Fish/Easley debacle was the first step in the decline of anti-communism in the United States. The 1920s had been a banner decade for opponents of radicalism, but the depression turned many Americans to the political left, while American communists obliged their new adherents by forming an alliance with the non-communist left to support the New Deal. This popular front led many Americans to join cultural organizations sponsored by the communists while opening federal employment to leftists. The alliance lasted until the end of World War Two, when international disagreement between the Soviets and America opened up the left to renewed attack. Anti-communists, led by ex-leftists, the House UnAmerican Activities Committee, the courts, and the resurgent Hoover, opened a withering attack against the American Communist Party and its cultural allies. By 1950, the Communist Party was weaker than it had ever been, names of leftist film-makers were appearing on blacklists, and leftists were off the government's payroll. Then came McCarthy, late and loud to the party,

attacking Owen Lattimore, George Marshall, and Irving Peress because there was almost no one else to go after.[3]

The story of Joseph R. McCarthy's rise to fame is a familiar one. Elected by Wisconsin to the United States Senate in 1946, McCarthy was an undistinguished legislator for the first three years of his term, only rarely drawing national attention.[4] Early in 1950, he accepted anti-communism as a route to re-election and greater national influence. He drew much wider attention when, on 9 February 1950, he claimed in Wheeling, West Virginia, that he had a list of State Department employees who were communists. Over the following week he gave similar speeches in Denver, Salt Lake City, and Reno, always alleging to know of subversives in the government. When he returned to Washington, the Senate summoned him for an accounting of the loyalty risks he had mentioned. His rambling, often incoherent, often interrupted speech listing 78 cases (without names) won him widespread press coverage, new friends and enemies, and a hearing before a subcommittee headed by Millard Tydings (D-MD).[5] In the summer of 1950 the majority report of the Tydings Committee called McCarthy's charges a "fraud and a hoax."[6]

McCarthy was undaunted. He continued to press the communists-in-government issue, threw his weight against Tydings in his bid for re-election (Tydings lost to a shady campaign engineered in part by McCarthy), antagonized the Truman administration, and became a celebrity. In 1951 he called General George Marshall (of World War II and Marshall Plan fame) a member of a conspiracy to give China to the communists. In 1952 he slowly came to support Dwight David Eisenhower (Marshall's friend) in his bid for the presidency, ran for re-election himself, and won.[7]

His election earned him the chairmanship of the Government Operations Committee and he used that position to continue his investigations into the subversion of the American government by communist agents. In spring 1953, two of McCarthy's staffers, Roy Cohn and David Schine, became renowned themselves, traveling to Europe on a slipshod whirlwind investigation of the contents of American overseas libraries. By the fall of that year McCarthy was at loggerheads with the Eisenhower administration over Joe's constant attacks on the executive branch and his new investigation into subversion in the Army Signal Corps at Ft. Monmouth, New Jersey. February 1954 found McCarthy investigating the promotion of Major

Irving Peress, an Army dentist, suspected communist, and frequent invoker of the Fifth Amendment. In March, the nationally-televised Army-McCarthy hearings began, pitting McCarthy's claim that the Army had deliberately obstructed his investigations of subversion in its ranks against the Army's assertion that McCarthy and his staff had tried to curry special favor for Schine, recently drafted. The hearings pressed into the summer. In July, Ralph Flanders, a Republican Senator from Vermont, moved that the Senate censure McCarthy. In the fall a committee headed by Arthur Watkins (R-UT) heard the charges and recommended censure. In the November elections, the Democrats gained control of the Senate, guaranteeing that McCarthy would no longer chair any senatorial committees. In December, the lame-duck Senate voted to censure McCarthy on the counts of contempt of committee and abuse of fellow senators. McCarthy disappeared from the press, and from most Senate action. He drank more heavily, married, and adopted a daughter. A bad liver killed him in May 1957. By the time of his death his name evoked witch-hunts, red-baiting, the "big lie," outrageous rhetoric, and, in a few, deep devotion.

Rather than work chronologically through the press coverage of the major events in McCarthy's life, a task already taken up by others,[8] I would like to focus on the divisions and unities that underlay that coverage. The mainstream press and politicians on both sides of McCarthy's accusations concurred on a number of points. First, they all agreed that Communism was a danger to the US, that there was some internal subversion, and that avowed communists did not belong in the service of the United States government. Even the *New Republic* accepted this position, though it downplayed the potential danger of internal subversion.[9] Second, all sides saw the brouhaha over McCarthy in a governmental context. McCarthy's attack was almost always aimed at those in government whom he thought were soft on communism.[10] The partisan appeal of McCarthy's words was always in the foreground between 1950 and 1952, and once he turned against Ike in the winter of 53-4, his attacks were framed in terms of damage to the party.[11] His sporadic forays against those outside government were sometimes reported, but never given much credence.

The list of disagreements is much longer, but can be grouped into two categories, the first dealing with the proper behavior of those associated with the federal government, and the second with the amount

of power wielded by McCarthy. In the first group fell the following fissures:

Who can be doubted? Dean Acheson, Harry Truman's Secretary of State, argued that questioning the loyalty of State Department employees was itself a disloyal act, one that "destroy[ed] the confidence of people in their foreign office and in their government at one of the most critical hours in this nation's history."[12] Eisenhower placed members of the military beyond the pale of doubt, especially those like George Marshall who had worked with Ike, but also folks like Gen. Ralph Zwicker, who could be suspected of haplessness but not disloyalty. In March 1954 he said, "All of us know that our military services and their leaders have always been completely loyal and dedicated public servants, singularly free of suspicion of disloyalty.[13] McCarthy rejected both of these sets of arguments, holding that those most responsible for foreign policy should be most open to questioning about their loyalty and competence. For McCarthy, incompetents always seemed to be powerful, and incompetence in international relations was always a sign of disloyalty. Elsewhere, incompetence merited from McCarthy only a rebuke (for Senators) or complete ignorance (for those involved in the Internal Revenue scandals, for example). The Senate's response to McCarthy's investigation of the Army and, later, McCarthy's censure upheld the loyalty of the military while allowing some doubt about that of bureaucrats.[14]

Who can do the doubting? Both the Truman and Eisenhower administrations preferred to carry out loyalty screening on their own, with little congressional oversight or meddling. Most Senators supported this position as long as their party controlled the White House. McCarthy always rejected executive control of loyalty programs, though more out of bile towards the bureaucracies than loyalty to the Senate. The wrangling of the Army-McCarthy hearings and McCarthy's censure resolved the problem by allowing congressional oversight of the executive and permitting the executive to hide certain information from congress.[15]

On what evidentiary basis could loyalty be doubted? Throughout the period two positions remained constant. One argued that courtroom standards should be the benchmark for measuring loyalty. The other held that departmental policy should be supreme, and that a person could be punished even if no law was broken. But while the positions remained constant, their supporting armies were constantly shifting

from one standard to another. McCarthy, for example, argued that State Department employees should be dismissed if there was any doubt as to their loyalty—doubt that could be occasioned by an unwillingness to answer questions under oath, long-past association with a subversive organization, policy positions that appeared to buttress the communist cause, or sworn testimony linking the suspect with communism with or without corroborating evidence. When it came to accusations against him, though, McCarthy demanded that he be held to the legal standard, not the traditional rules of Senatorial conduct. Not surprisingly, after a brief attempt to convict McCarthy on perjury charges, McCarthy's opponents in the Senate pushed for his censure on the less demanding standard of Senate policy. The confusion over evidentiary standards is clear in the procedure that ultimately led to McCarthy's censure. The Watkins Committee, charged with investigating McCarthy in the fall of 1954, followed courtroom procedure in barring cameras from the hearing room, disallowing all hearsay testimony, demanding that all evidence be relevant to the charges (thus restricting McCarthy's ability to justify his actions by dramatizing the communist threat to America or noting similar behavior on the part of other Senators), and permitting only McCarthy's counsel to make objections. When it had considered all of the evidence, though, the Committee recommended censure on the grounds that McCarthy engaged in unsenatorial conduct by failing to appear before a committee that was investigating him and later badgering a witness before his subcommittee, neither of which were punishable under U.S. law.[16]

What rhetorical standards should the combatants uphold? McCarthy knew few rhetorical boundaries—he provoked, insinuated, implied, impugned, and falsified. McCarthy once ransacked the *Congressional Record* for negative references about journalist Drew Pearson and then read them on the Senate floor, adding at the end that Pearson was "the most valuable of all radio commentators and writers from the standpoint of the Communist party." Of course his opponents could match McCarthy jibe for jibe. Harold Ickes, a former member of Franklin Roosevelt's cabinet and during the McCarthy years a columnist for the *New Republic,* wrote that McCarthy was worse than the Nazi propaganda minister Joseph Goebbels. Senator Ralph Flanders compared McCarthy with Hitler.[17] But because McCarthy reveled in the battle while his opponents appeared to enter only in defense of decency, McCarthy came to be much more closely associated with

rhetorical abuse than did, say, Ralph Flanders. McCarthy's image was exacerbated by the disorganization and zeal of his speeches. His logic was notoriously hard to follow; only his invective was lucid. He had no range in his public rhetoric. He was not occasionally self-deprecating like Flanders, or high-spoken like Senator Harry Byrd, or tender like Joseph Welch—his only public style was bluster. It is interesting, though, that off the public stage, McCarthy was relentlessly friendly, even to those he accused of subversion, while his opponents reserved their greatest anger and most brutal rhetoric for private conversation.[18] McCarthy and his opponents, then, had exactly opposite senses of rhetorical decorum—McCarthy was rude in public and decent in private, his antagonists were civil in public and ill-mannered in private. In the censure, the defense of civility became the position that allowed the mixing of legal and behavioral sanctions. Senators were unwilling to censure McCarthy for his attacks on Zwicker, as the Watkins Committee had suggested. But they did censure McCarthy for attacking its highly legalistic proceedings and dry-as-dust members.

As surprising as it may seem today, the extent of McCarthy's power was a subject of great doubt in the 1950s. Discussion about McCarthy's influence broke down along the following lines:

How dangerous was McCarthyism? For those who opposed McCarthy, McCarthyism was a style of politics that, without regard for civil liberties, used lies, innuendoes, and bullying in a futile search for subversives in the federal government. But for McCarthy and his followers, McCarthyism was nothing less than a crusade to save America from the dangers of communist subversion. Because communists were deceitful, secretive conspirators, ultimately seeking to destroy all freedom, the tactics used to uproot them had to be harsh.

Most politicians and journalists publicly espoused a position on McCarthy mid-way between the definitions of McCarthyism. They argued that McCarthy's focus on the dangers of communism was useful but his tactics were "unAmerican" and therefore hurt the national effort to oppose Communism in all of its forms. But there was wide variation on exactly how dangerous his tactics were. For some, McCarthy's efforts were enough to bring constitutional government near collapse. Others thought he might do great damage to some parts of the government—the State Department, the Army, the Republican party—but that the government as a whole was still strong. Some held that the

potential effects of McCarthy's crusade were nil; McCarthy partisans felt his crusade had not accomplished enough. McCarthy himself was of two minds on the subject. He delighted in creating turmoil, in seeming dangerous, but he also claimed to be misunderstood, a decent guy who only looked scary because his opponents made him look that way.[19]

How powerful was McCarthy? Entwined with worries about the dangers of McCarthyism were assessments of the sources and extent of McCarthy's power. For those who saw his power rooted in his speechmaking, McCarthy had two types of power. He could silence free speech by claiming that certain ideas were "communist" and therefore untenable, and he could draw to himself voters who would put his partisans in office. Speculation abounded on how many supporters McCarthy had in America (especially around election time), with most polls agreeing that he had a wide base of popular support. Others saw McCarthy's power rooted in his ability to control portions of the government—the Senate by default, his committee by right, and the executive by threat. McCarthy's true power, then, was his ability to impede appointments, intimidate witnesses, and influence dismissals. McCarthy frequently claimed that his power was quite limited; that he had to fight every step of the way to get someone fired, for example. Surprisingly, his opponents, with a few exceptions, agreed. While the media was concerned about McCarthy's power at the ballot box, and Dean Acheson about his ability to influence the State Department, the claims that McCarthy ran the government, or that he had ruined thousands of careers, or that he was leading America towards fascism either came from the European press or appeared long after McCarthy's death.[20]

It is perhaps not surprising that there were divisions over the trustworthiness of the federal government and the scope and seriousness of McCarthy's communist chase in the 1950s—one would expect at least two positions on all of the issues while McCarthy was still active in politics. But it is surprising that in the years following McCarthy's censure, while the questions about the behavior of public officials remained pertinent, rarely was the McCarthy episode consulted for guidance. Instead, the positions that won the day in 1954, those compromise stances that opposed McCarthy's tactics and communism, that blended legal and traditional sanctions, that peppered polite language with piquant phrases, shrank away. When McCarthy's career

did come up, only McCarthy's behavior received sustained attention. And the reasonable perspective that looked closely at McCarthy's power and found it neither omnipresent nor entirely absent, disappeared. In their stead stood only the extremes, a few solo voices in McCarthy's praise, a mass choir in opposition.

Moderates can be blamed, in part, for the demise of their positions on McCarthy, for people like Dwight Eisenhower were more interested in shutting McCarthy up than considering the broader issues he raised. Nor would their answers stand up to close inspection, for they were momentary solutions, cobbled together to stop McCarthy.[21]

But moderates were not the only ones responsible for the disassociation of McCarthy and the questions he raised about democratic government. Wrapped up with the demise of compromise positions on McCarthy was the frequent presentation of McCarthy's specter in the media following his death. Rather than assure historical accuracy, the regular invocation of McCarthy's name untied it from historical reality. McCarthy's censure, public diminution, and death led people like William F. Buckley, a McCarthy speechwriter and apologist, to believe that conservative views could not get fair coverage in the mainstream media. In response he founded the *National Review*, the premier national conservative publication. To the present, Buckley has been the most consistent voice in McCarthy's favor, though not averse to criticizing McCarthy on occasion. Similarly, right wing political organizations flourished in the decade after McCarthy's death, many, in one way or another dedicated to paying tribute to McCarthy's vision and good name. Groups like the John Birch Society and the Christian Crusade, while drawing supporters from the Republican Party, worked outside the party system. Both the belief that conservatives could not get a fair hearing in the national media and the anti-GOP alienation of far right organizations preserved the extreme pro-McCarthy positions from the mid-1950s. The far right's embrace of McCarthy made any reference to him dangerous for moderates. A position too close to that of the John Birch Society would ally the speaker with the far right; a repudiation of the Birch position on McCarthy would alienate an important constituency.[22]

Republicans were not the only ones to face this problem— Democrats who had not distanced themselves from McCarthy while he lived scrambled to do it after his death. The most prominent Democrats to face this problem were the Kennedy brothers. John Kennedy had been

a Senator at the time McCarthy was censured, but was ill on the day of the vote. Robert Kennedy had been minority counsel on the McCarthy subcommittee that investigated subversion at Fort Monmouth. John's silence and Robert's complicity were complicated by their Irish-Catholic background and their father's outspoken support of McCarthy. These ties to McCarthy stood in the way of the Kennedys' national aspirations, and so each, in the early 1960s, tried to prove that he had not favored McCarthy during his heyday.

The Wisconsin primaries provided the Kennedys and other contenders for national office the perfect occasion to claim innocence, and regularly brought McCarthy's name before the public. In the 1960 election, prominent liberals questioned Kennedy's devotion to liberalism. The most damning criticism came from Eleanor Roosevelt who saw Kennedy's absence from the censure vote as a sign of his uncertainty on civil liberties and civil rights. John Kennedy responded in Wisconsin, producing a copy of an anti-McCarthy speech he had written (but not delivered) in 1954 and telling reporters that he had participated in behind-the-scenes meetings that resulted in McCarthy's censure. Nelson Rockefeller, stumping for the Republican nomination the same year, told journalists that he had opposed McCarthy, and had he been a Senator in 1954, would have voted for censure. In 1964, Hubert Humphrey used a stop in Wisconsin to link the Republican presidential nominee, Barry Goldwater, to McCarthy. And that same year George Wallace, in his quixotic pursuit for the White House, stopped in Wisconsin to *praise* McCarthy.[23]

Presidential elections and commemorative celebrations play similar roles in keeping historical information in the press—they occur regularly and have something of a ritual nature. But while commemorations demand the passage of time to be taken seriously, in election cycles, the further in the past something occurred, the less likely it is to matter. Kennedy's candidacy in 1960 and that of Barry Goldwater in 1964 kept McCarthy's name before the public, but by 1968 McCarthy was a non-issue and his presence waned in electoral haggling.

While McCarthy faded from importance in national elections, the passage of time was making other McCarthy retrospectives possible— 1966 marked the twentieth anniversary of his election to the Senate, 1969 the fifteenth of his censure, and 1970 the twentieth of his famed Wheeling speech. But the retrospectives were strange, both because of

their sparseness in a commemoration-crazed age and their tangential relation to McCarthy. With the exception of a couple of short articles noting McCarthy commemorations in 1959, and a few in the early 1980s emphasizing the backwardness of latter-day McCarthyites, no reporting focused on those who esteemed McCarthy.[24] Instead, anniversaries provided McCarthy foes the same sorts of opportunities that presidential elections had given John Kennedy, Nelson Rockefeller, and Hubert Humphrey. They were able to gather, relive the worries of the time when McCarthy served in the Senate, reminisce about their roles in his downfall, and compare present dangers (especially campus radicalism) with past threats. In 1970 Margaret Chase Smith, a Republican Senator who, twenty years earlier had penned a "Declaration of Conscience," blasting McCarthy's behavior, told journalists that the New Left was the worst thing to hit the United States since McCarthy. Nathan Pusey, president of Harvard University, ex-resident of Appleton, and one-time recipient of a McCarthy broadside, echoed Smith, adding the Nazi Youth to the organizations equivalent to McCarthy and the New Left. The *New Yorker* chimed in, arguing that McCarthy was worse than the New Left because McCarthy wielded the power of the Senate. (The *New Yorker*'s statement provoked an incredulous response from William F. Buckley, who wondered when McCarthy had ever closed down a college campus, carried a gun, or killed anyone.)[25] In 1982 producers, directors, and actors who had worked in the 1953 film, *Salt of the Earth* gathered in New Mexico to relive the times when their film, about a Hispanic-led strike at a New Mexico mine, was virtually banned in the United States. They chose 1982 not because of any ties to the making of the film, but because it marked the twenty-fifth anniversary of McCarthy's death.[26]

The rarity of events marking significant points in McCarthy's life and their generally anti-McCarthy tone are interesting not because they point to liberal domination of the media (after all, one of America's most esteemed conservative columnists, George Will, penned the sharpest critique of the McCarthy faithful in 1984) but because they emphasize the self-congratulatory nature of American commemorations, especially those in the tributary style. Negative events tend to be memorialized by those who can claim to have survived them (Margaret Chase Smith and Nathan Pusey in 1970, the *Salt of the Earth* crew in 1982) or replaced by alternative events that allow celebration.[27] More often than not, commemorations that evoked McCarthy took the latter

tack, most commonly by recalling the work of journalists opposed to McCarthy.

The focus on journalists instead of McCarthy was not simply a response to the difficulties of commemorating an unhappy event, but also an attempt to bolster the reputation of the media. Such steps were necessary because, until the early 1970s, the typical story of the media's relationship with McCarthy cast doubt on the abilities of the reporters who covered him. From 1950 to mid-1953, McCarthy cowed the media. The wire services reported McCarthy's remarks on communists in government uncritically, either out of a desire to be "objective" or a lack of time. Press outlets then picked up the McCarthy stories from the wire and gave them front page space. Any criticism of McCarthy was shunted to the editorial page. In this period, McCarthy appeared to be a master media manipulator, calling press conferences at exactly the right time to ensure favorable coverage in the evening news, threatening a boycott against those outlets who dared criticize him.

Over the rest of McCarthy's life the media took its revenge. Newspapers began to rethink the policies that kept reporters from questioning McCarthy's assertions in their stories. A few brave journalists, like Drew Pearson, Elmer Davis, and Edward R. Murrow openly antagonized McCarthy, and took time in their work to lay out a well-researched attack on McCarthy's methods and ethics. Television outlets, especially, played an important part in this process, both by running Murrow's *See It Now* attack on McCarthy and by broadcasting the entire Army-McCarthy hearings so the world could see Senator Joe's dark, angry, heartless tactics in action. Finally, after the Senate censured McCarthy, the press refused to cover his speeches or print his press releases, in effect banning him from public discourse.

Since the mid-1970s, scholars and journalists have corrected some of the errors in this account of McCarthy's ties to the media.[28] Fred Friendly and Edwin R. Bayley have both argued that a large and influential section of the press, including the *New York Times*, *Washington Post*, *Time*, *Life*, *Newsweek*, *New Republic*, *Nation*, and the famed columnists Drew Pearson and Walter Lippmann, was always anti-McCarthy. Bayley has added the insight that much of the media was indifferent to McCarthy, skipping many of the wire service reports, or failing to provide any editorial comment on McCarthy even when it

seemed an obvious responsibility, as at election time in Wisconsin, for example.[29]

The range of commemorations that falls into the restoration of the media category is quite broad. It starts with commentaries on Edward Murrow's work. In 1972, a retrospective of Murrow's *See It Now* program appeared on public television. The final episode shown was Murrow's report on McCarthy, and it garnered much of the press coverage. In 1979, the twenty-fifth anniversary of McCarthy's censure and of Murrow's program, the *New York Times* and *Good Morning America* chose to commemorate the documentary. The *Times* claimed that *See It Now* was the "first and most deadly blow" to McCarthy. *Good Morning America* staged a debate between Fred Friendly (the show's producer) and Roy Cohn. And in 1994, forty years after McCarthy's censure, CBS broadcast a documentary that compared the biographies of McCarthy and Murrow, with Murrow of course the victor.[30]

Other journalists received similar, though quieter, notice. The *Nation* memorialized its retiring editor, Carey McWilliams, with a long article outlining his opposition to McCarthy and defense of civil liberties. Tommy McIntyre, a press aide to Republican Senator Charles Potter, received kudos from *Newsweek* for urging Potter to publicly call for Roy Cohn's resignation at the end of the Army-McCarthy hearings. The *National Review* praised Paul Hughes, a freelance journalist and con man, for exposing liberal disregard for civil rights. Hughes told the *Washington Post* that McCarthy was plotting a revolution and had an arsenal of weapons hidden in the Senate Office Building. The *Post* believed Hughes, paid $11,000 for the information, and considered tapping McCarthy's phone and publishing an article outlining Hughes' charges. Only the diligence of last minute fact-checkers uncovered the hoax.[31]

Not only individual journalists but entire media outlets sought the benefits of such remembrances. *Esquire*, in honor of its fortieth anniversary, reprinted a 1958 article about McCarthy by Richard Rovere (but not a long 1968 piece by Roy Cohn which praised McCarthy). In its fiftieth anniversary edition, the Catholic journal *Commonweal* ran a 1951 editorial urging its readers not to be taken in by McCarthy. And in July 1984, *The Progressive*, under the headline "McCarthy Unmasked: How *The Progressive* Helped Ground Tailgunner Joe," told readers that its April 1954 edition, devoted to exposing McCarthy, was

a seminal event in American history. *"The Progressive's* exposé prompted a reappraisal of Joseph R. McCarthy and his witchhunt. 'People were scared of McCarthy and up until then, nobody had really been writing against him, says Sidney Lens, Senior Editor of *The Progressive.*' This was the first important piece in any major publication."[32]

There is nothing inherently wrong with a little journalistic horn blowing. Barbie Zelizer in *Covering the Body*, a study of media response to the John F. Kennedy assassination, has argued that such claims to important roles in major events has been part of the overall professionalization of the American media, certainly not a bad thing.[33] Nor were journalists the only ones to raise their own status by attacking McCarthy. There is a whole shelf of memoirs written by Senators, cabinet officers, and lawyers that do the same thing.[34] But the trend towards commemorating the media in the guise of remembering McCarthy has had four negative effects. First, it has diverted discussion of McCarthy away from means and ends (Is lying to stop communism acceptable?) and politics and law (How should dishonesty and incompetence (on both sides) be punished?) towards style and civility (How mean was McCarthy?). This is to be expected, as journalists played no role in the loyalty programs, investigations, or committee hearings, where McCarthy ran afoul of traditional practice and law, but had plenty of opportunities to comment about McCarthy's looks, his speaking voice, and his tactics.[35]

Second, it has made commemorations of McCarthy into simple recollections of right and wrong. Again, the Army-McCarthy hearings are instructive. Originally a showcase for executive interference, bureaucratic bumbling and the misguided use of senatorial power (and a hearing that produced a final report equally critical of McCarthy and the Army), it became over time the most powerful proof that McCarthy was wrong.[36]

Third, commemorations focusing on the press have diverted attention from what McCarthy really did to what journalists said he did. Up to 1954, the press often ran verbatim transcripts of press conferences, speeches, and hearings.[37] But McCarthy's penchant for untruths made this style of reporting suspect. Since McCarthy, such primary source material rarely appears anywhere in the press. On television uninterrupted coverage of public speeches, hearings, and ceremonial events is more common, but still rare (the Watergate, Iran-

Contra, and Clarence Thomas hearings being the exceptions that prove the rule.) In the place of live, full-length coverage has risen analysis in the form of news—journalists summarizing and explaining key documents for the public.[38]

Fourth, it has created terrible history, full of distortions and errors. Claims of journalistic prowess like that of *The Progressive* mentioned above, are now common. Even more common are instances where journalists link McCarthy to events, like the Hollywood blacklists, that took place before his rise to power, after his fall, or outside the Senate.

The cumulative impact of the events that recall McCarthy's life—the creation of a right wing press originally dedicated to preserving McCarthy's heroic standing, the Wisconsin primaries, and the commemorations—is clear as well in the history of the term "McCarthyism." In many ways its history is richer than that of the McCarthy commemorators, for "McCarthyism" has been more common, more pliable, and less attached to actual historical events than McCarthy's life story. Its broad use implies that users feel no need to convince others that an incident is actually a case of McCarthy-style politics, an aspect of the tributary style that appeared also in Atlanta remembrances of King. Because this is so, the term has become a window onto the place of history in the discourse of American institutions—the national media and the federal government. But it has also become a powerful, *nonpartisan* rhetorical tool. Today, people on the American right and left shut off debate and claim the moral high ground by linking their opponents with McCarthyism.

There has always been a certain amount of rhetorical opportunism associated with the use of the term "McCarthyism," but during the 1960s only liberals could use it to any advantage and the already liberal political atmosphere made even that advantage slight. The reason for this is simple—McCarthyism was still associated with Joseph McCarthy and, by extension, conservative Republicanism.

In 1964 the film "Point of Order," a 97 minute condensation of the 188 hours of the Army-McCarthy hearings, appeared on American movie screens. It was greeted by an odd mixture of fascination and indifference. Reviewers agreed that the shortened hearings made excellent theater, but wondered if such theater was necessary. *Time*'s reviewer argued that the hearings proved that "McCarthy was finished as a force in American political life," and Bosley Crowther, writing in the

New York Times, noted that for anyone who had not experienced them first-hand, the hearings were almost meaningless, "a bewildering look-in on a freakish political event." Irrelevance is hardly a positive recommendation for a film, as Daniel Talbot, the movie's co-producer well knew. In a *Times* essay, Talbot held that his film was relevant because it commemorated ten years of television news, a high point in the small screen's public service. But even more important, the film mattered because of the rise of "new radical right movements and figures."[39]

Talbot was most likely referring to the presidential candidacy of Barry Goldwater when he warned of the dangers of the "new radical right." Goldwater had voted against McCarthy's censure in 1954, and as a candidate espoused a hard-line policy on the Soviet Union. As Goldwater campaigned in 1964, he often met with accusations that he was tainted by McCarthyism. Wisconsin's Democratic governor, John Reynolds, told audiences that if Goldwater was elected "a new McCarthyism would return to Wisconsin." Hubert Humphrey warned that Goldwater would return America to the "witch-hunting days of McCarthyism."[40] Such warnings were clearly pointed at Goldwater's policy positions, not his public behavior, for Goldwater was renowned for his plain-spoken but fair manner. The threat then came not from wild accusations and indiscriminate lying, but from the ascendance of the conservative wing of the Republican Party.

Ironically, the actions of another member of the GOP's right wing—Richard Nixon—divorced McCarthyism from its partisan connections for a time, leaving it to float free in the realm of bad behavior. Nixon's fabled "ping-pong diplomacy" with China and his efforts towards détente with the Russians mooted the policy concerns that had sustained conservative foreign policy since the end of World War II. Even more, rapprochement with the Chinese led to a reassessment of the role of the "China hands"—those foreign service officers whose support for the Chinese Communists brought their loyalty into question in the 1940s and 50s. The State Department restored John Paton Davies' security clearance in 1969; in 1973 it feted the rest of his colleagues.[41] The *New Republic* grasped the irony of Nixon, a one-time communist hunter, reaching out to China in a fictional conversation between the ghost of Joseph McCarthy and a *New Republic* reporter. The reporter informed Joe that the president was planning a trip to China. The following exchange resulted:

"But about this trip to China, take this down for your afternoon edition and I'll have Roy telephone you a follow-up for overnight. 'The senator from Wisconsin said the China trip confirms his charges that the Democrats, ah, are the party of cowardly Communist appeasement . . .'

"But Joe, it isn't the Democrats, its *President Nixon* who's going."

There was a pause. "No?" he said. "Our Dick— going to China?" He seemed nonplused. "Why he was one of the most patriotic ones we had!—on the UnAmerican Activities Committee; knocked off Jerry Voorhees and Helen Douglas as pinkos; you'll be telling me we're trading with Moscow next."

"Why sure, Joe; just last week the Commerce Department approved licenses for what may be a billion-dollar deal with Moscow with Mack Trucks, Inc."

He stood there weaving a minute like a pug who had taken a bad one on his jaw and is praying for the bell.[42]

While his diplomacy undermined the international policy concerns that McCarthy drew on, Nixon's domestic agenda refocused attention on the link between behavior and McCarthyism. Nixon's call for law and order re-enthused the ghostly Joe of the *New Republic* piece. The journalist told McCarthy that the Attorney General's list of subversive organizations had been expanded under Nixon to include

"totalitarian, fascist, Communist, subversive and other groups." Opponents call it the new Inquisition; the new era of McCarthyism.

"No! Do they really!" said Joe, rubbing his hands. "What an opportunity; what a hunting license."[43]

But even more than his campaign against subversives, it was Nixon's role in Watergate that freed "McCarthyism" of its historical

boundaries. Liberals harped on Nixon's disregard for civil liberties as an example of McCarthy-like tactics. Matthew Josephson, reviewing Cedric Belfrage's book, *The American Inquisition* in the *Nation*, argued that one of the central lessons of the McCarthy era was that "the politics of a nation of 200 million people was too serious a business to be entrusted to amoral buccaneers. We are now learning the same lesson over again."[44]

Conservatives and Republicans fretted that the congressional attack on the executive branch during Watergate was exposing them to a "new McCarthyism." Barry Goldwater, who only a decade earlier had appeared as McCarthy's heir, went on record as a victim of the new McCarthyism. In his eyes, Watergate had unleashed a torrent of liberal attacks on conservatives. By associating Nixon with conservatism, liberals used a McCarthyist tactic (guilt by association) to imply that Watergate was the natural outcome of conservative ideology. Goldwater rejected this notion, of course. For him, Watergate was a symbol of the decadence of American society, an emblem of a system of beliefs that accepted almost any sort of behavior in the pursuit of political goals. Liberals, after all, were the ones who applauded Daniel Ellsberg's theft of the Pentagon Papers, and countenanced the behavior of activists like Angela Davis and the Berrigan brothers. Archibald Cox, the former Watergate special prosecutor also lambasted liberal behavior during Watergate, noting that leaks from the committee investigating impeachment charges were a deliberate attempt to convict Nixon not on evidence but on public opinion—a throwback to McCarthy.[45]

One would expect liberals to continue pointing out examples of McCarthyism as long as they could, but I have gone on at some length about the relationship of conservatives and the new McCarthyism to make clear that the right, more than the left, is responsible for disassociating McCarthyism from its political and legal context. The role of the right in declaring a new McCarthyism abroad in the land is also significant because it allowed unchallenged claims of victimhood rather than politics or law to be the starting point for comparisons of the 1950s with the 1970s and 80s.[46] Even McCarthy defenders as staunch as William F. Buckley and Roy Cohn delighted in proving that liberals were as nasty and unprincipled as they claimed McCarthy to have been.[47] This is not to say that people on the right were the most frequent claimants to suffering from McCarthyism, for they were not. But before Barry Goldwater and Richard Nixon shared their suffering

with the press, being a victim of McCarthyism was an impersonal thing, the result of political affiliation more than personal bile.[48] After Goldwater, Nixon, and Watergate, though, McCarthyism came to be synonymous with spite directed against an individual, an attack on a person's character, not his ideology.

This is an important shift, both because it paralleled a broader move towards individual self-absorption in American society and because it shows the dangers of the tributary style triumphant. Since almost no one would question the accuracy of claims to be the victim of McCarthyism, sufferers could announce their victimhood without rejoinder. A raft of survivors of the 1950s told their stories in the 1970s, stretching McCarthy's influence beyond its original impact and paving the way for the coming, in the 1980s, of a flotilla of politicians, activists, and intellectuals—all suffering at the hands of the new McCarthyism.

Take for example the foreign service officers fired in the 1950s because of doubts about their loyalty. The *New York Times* report of a 1973 dinner thrown in their honor by the American Foreign Service Association quoted John Paton Davies' diary on the leadership of the Chinese communists. Davies noted that Mao and Chou-en Lai were friendly men and predicted that Chou would make an excellent foreign minister some day. Eric Pace, the *Times* reporter, added that "history has shown that Mr. Davies was right when he wrote in Yenan that 'the Communists are in China to stay. And China's destiny is not Chaing's [Chaing Kai-Shek, the leader of the Chinese nationalists] but theirs.' But because of his opinions, Mr. Davies was reviled during the McCarthy era." Later, Pace repeated himself, arguing that Davies' predictions of eventual communist victory were not heeded because of the "anti-communist witch-hunt of the McCarthy era." The *Times* editorial that day followed Pace's tack, noting that John Singer Service, another China hand, was dismissed by Secretary of State Dean Acheson in 1951 "after a loyalty review board had found a 'reasonable doubt' about his loyalty to the U. S." The *Times* took Service's dismissal as a sign that the bearers of bad news always get hurt. The careers of the China hands were "ruined or tarnished because they correctly predicted the victory of the Chinese communists over the ineffective Kuomintang government of Chaing Kai-shek," the *Times* argued. But in both articles the China hands and the *New York Times* talked past the ghost of McCarthy, who had argued not that the Nationalists were destined to

win in China, but that the leftist orientation of the China hands caused them to over-estimate the goodness of the Chinese communists. The positive reports on the communists, in turn, led the US government to take a too-sanguine approach to the Chinese civil war.[49]

Following close behind the rehabilitated China hands came survivors of the Hollywood blacklists. The mid-1970s saw a spate of film, theater, and literary reconstructions of the 1950s focused on the politics of the movie business and the actions of the House UnAmerican Activities Committee. Films like *The Front*, and *Hollywood on Trial*, the plays *Thirty Years of Treason* and *Are You Now or Have You Ever Been. . .* , and memoirs by Dalton Trumbo and Lillian Hellman all appeared in 1975 and 1976. All highlighted the personal experiences of blacklisted people and minimized the dangers of communism but played up the damage done by anti-communism in the United States.[50] Press coverage often linked the blacklists to McCarthyism, in spite of the fact that McCarthy took only passing interest in Hollywood and played no actual role in the investigation or blacklisting of actors, directors, and producers.[51]

Universities followed the leads of the foreign service and the film industry, beginning in the early 1980s to rehabilitate professors fired during the 1950s. The trustees of the City University of New York moved in 1980 to restore the pensions of professors dismissed "in a spirit of the shameful era of McCarthyism during which the freedoms traditionally associated with academic institutions were quashed." In the next three years Temple University, Reed College, and the University of Vermont also publicly repented for firing "subversive" professors in the 1950s. In each case, press coverage sought links between McCarthy and those fired, even when they didn't exist. In one case, a subheading in the article promised the account of a confrontation between McCarthy and Professor Alex B. Novikoff, of the University of Vermont. What followed, though, was the story of a battle between Novikoff and Senator William Jenner of Indiana. None of the articles stopped to ask if those fired were Communists, instead praising their unwillingness to name names before congressional committees.[52]

All of these rehabilitation stories share two tendencies. They ascribed to McCarthyism positions McCarthy never held and powers McCarthy never had, thus subsuming several anti-communist tendencies under one heading. And having placed responsibility on McCarthyism for all of the ills suffered by these people in the 1950s,

they focused on the pain of the victims, never asking about their politics or wondering if their behavior merited the response it elicited.[53] Blacklisting was wrong; professors should never have been fired for their politics; foreign service officers were not willing conspirators in the spread of communism. But the rehabilitation of the China hands, blacklisted directors, and university professors seems to have been carried out with little regard for the historical context in which they were originally punished, a context that would add depth, nuance, and civility to discourse about the American past.[54]

Where mentions of McCarthyism in the 1970s were dominated by those caught up in the effects of 1950s anti-communism, those in the 1980s came largely from people who sought the rhetorical advantages of claiming to be victims of McCarthyism, regardless of how much their particular situation had to do with communism, subversion, or the abuse of senatorial powers.

As in the time of Watergate, conservatives were not above invoking McCarthyism to skewer liberals. Representative Vin Weber (R-MN) rose on the floor of the house to accuse House Speaker Tip O'Neill of McCarthyism after O'Neill had referred to Republicans who had attacked his management of the House as "regressives" and "John Bircher types." Weber's Republican colleague James Sensenbrenner used the same approach in a hearing about Reagan Administration policy in Central America. After several groups opposed to Reagan's funding the Contras claimed to have been the subject of investigations and harassment by the FBI ("McCarthyism" they called it) Sensenbrenner said that their accusations were "McCarthyism in reverse." And in *Commentary*, Peter Collier and David Horowitz argued that the use of "McCarthyism" was a widespread but lightweight phenomena in America, pointing to a *Playboy* editor's attack on the "sexual McCarthyism" of the Meese Commission and conservative claims that Oliver North suffered an attack of McCarthyism from the Iran-Contra committee, as evidence. But for Collier and Horowitz, liberals were much more dangerous than conservatives both because they tended to use "the big lie and the reckless smear" when writing about conservatives and used "McCarthyism" to close off debate on the merits of anti-communism. They titled their piece, "McCarthyism: The Last Refuge of the Left."[55]

Collier and Horowitz were, to a certain extent, right. Liberals did use claims of McCarthyism to close off debate and tarnish their opposition. Collier and Horowitz reported, for example, that when conservatives questioned Michigan Democrat George Crockett's fitness to chair the House Subcommittee on Western Hemisphere Affairs because Crockett had refused to condemn the Soviet Union for downing KAL flight 007, the first questions journalists asked was if conservative opposition was "sort of McCarthyism." But Collier and Horowitz were too quick to dismiss the effect of McCarthyism's common use in American culture, for it was exactly that sort of use that turned otherwise serious political debate into theatrics, allowed personal attacks, and weakened meaningful historical allusions.

Consider Abraham Brumberg, a former editor of the journal *Problems of Communism*, whose well-considered response to Reagan's rhetoric about the Sandinistas appeared two years before Collier and Horowitz's piece. Brumberg argued that Reagan deliberately lied about the extent and danger of the power of the Sandinistas in order to successfully draw support to his policies. As an example Brumberg noted Reagan's dubious claim that the Sandinistas were carrying out a policy of genocide against the Miskito Indians. But he couldn't help but get in a few personal jabs at Reagan and McCarthy. He pointed out that Reagan had yet to call anyone a "dupe" (as McCarthy so often did) but expected that Reagan would do so soon. And he claimed that under Reagan, the United States was similar to the 1950s when "dissent came perilously close to being identified with treason and rational discussion of communism was virtually impossible."[56]

One wonders what purpose other than rhetorical one-upsmanship such comments serve. The remark about "dupes" is gratuitous—Reagan was interested in stopping international communism and paid much less attention to American radicals than Nixon, Lyndon Johnson, or McCarthy ever had. The declaration that dissent was close to treason was simply wrong. In the 1980s dissent flourished (partly in response to Reagan's Central American policy) and American academics gave leftist philosophies a more serious look than ever before.

That Brumberg could argue that dissent equaled treason under McCarthy and Reagan is testament to the tendency over the preceding fifteen years to overestimate McCarthy's actual impact. That he could joke about Reagan calling people dupes is evidence of the blithe tone which accompanied the everyday use of "McCarthyism."[57] That he

would do both in the context of a serious intellectual argument suggests that he had imbibed at the fountain of rhetorical opportunism that characterized McCarthy references (like that to "sexual McCarthyism") that Horowitz and Collier had termed "just another weapon in the language of combat." In turn, those references played a much more serious role in crafting political discourse about communism and civil liberties than Horowitz and Collier allowed.

Indeed, since the fall of communism, the links between "McCarthyism" and government have almost completely disappeared, while its role as a rhetorical tool in American culture continues. Witness the rather nasty exchange between Tom Wicker, a columnist for the *New York Times*, and William F. Buckley of the *National Review*, over the meaning of Owen Lattimore's life. McCarthy had been a persistent Lattimore critic, charging that he was the top Soviet agent in the U. S. and was responsible for the loss of China. Lattimore denied all the charges, struck back hard at McCarthy, and after a period of investigation, returned to his career as an educator, lecturer, and expert on China. In spite of Lattimore's assertion that his run-in with McCarthy was a minor part of a long and productive life, in a written eulogy, Wicker chose to focus almost entirely on Lattimore's battle with McCarthy, writing that McCarthy's accusations had permanently tainted Lattimore. Not content at this point, Wicker went on to argue that "McCarthyism' was still alive and well in the GOP, as witnessed by a recent Republican-born rumor that House Speaker Tom Foley was gay. Buckley responded by reprinting part of a 1979 column in which he had written, "I don't approve of anybody's demagoguery, but I find it less objectionable when used to the disadvantage of communist tyrants than to their advantage which, roughly, was the difference between Lattimore and McCarthy."[58]

A couple of weeks later Wicker shot back, accusing Buckley of "smearing the dead" and comparing Buckley with McCarthy. He then went on to argue that Lattimore was a real victim—a true patriot who, in the words of Lattimore biographer Robert Newman "was skewered because he was the most prominent and most vocal heretic on one of the most crucial issues of the mid-century." Buckley responded in the same guise, making McCarthy out to be the victim. "Nothing McCarthy ever did, and he did many indefensible things—can ever compare with the lengths to which his enemies went and continue to go," Buckley wrote.[59]

The tendency is still towards overestimating McCarthy's power, celebrating his victims, and unhinging "McCarthyism" from its historical context. The *New York Times* wrote that "in a case dating to the McCarthy era" a man jailed in 1961 (McCarthy had been dead four years) for failing to appear before HUAC (McCarthy was a Senator) was seeking to have his conviction overturned. In an op-ed in the same paper, Kathleen Quinn argued that American nostalgia for the 1950s was certain to bring with it McCarthyism in the 1990s (how nostalgia could do it is never made clear). "Let Madonna rob the grave of Marilyn Monroe and what pops up is Orrin Hatch reading aloud from 'The Exorcist'."[60]

The conservative humorist P. J. O'Rourke has best grasped the inanity and appeal of references to McCarthyism since the Cold War. In 1989 he called for a "New McCarthyism"—a list of people who deserved punishment for their leftist politics even though the Communist threat was gone ("the distinguishing feature of this cluster of dunces is not subversion but silliness"). He bemoaned the lack of punishments; blacklists would not work because they "would guarantee them a MacArthur Genius Grant and a seat on the ACLU national board of directors." O'Rourke thought perhaps Dan Quayle might be able to find an appropriate penalty, but in the meantime suggested that readers of *The American Spectator* write in with their own lists. The responses filled four annual articles.[61]

The humor in O'Rourke's Joe McCarthy Memorial New Enemies List dried up quickly. O'Rourke complained in 1991 that that year's Enemies List was "about a quart low on yellow bile," due, he thought, to the fact that conservatives "rule the world" and that the listmakers had run out of new names. "This is the fifth Enemies List. Evildoers with any kind of public name, we've publicly named them," he wrote before scraping up four pages of retread bad guys. The following year's Los Angeles riots brought in a few new names, but the gag was clearly dead.

What is interesting about O'Rourke's list is not its longevity so much as its perfect representation of the trends in the use of "McCarthyism." Joe McCarthy was a bilious attacker of individuals, a man who named names, made lists, and harassed heretics, O'Rourke's articles argue. O'Rourke was clever enough to make such behavior funny. But take away the laughs, and what remains is a McCarthy

caricature matching the one used by liberals and conservatives since Watergate.

One might argue that McCarthy lent himself to cartooning, or that he deserved to be caricatured, or that he merits ignorance. But historical honesty, rhetorical accountability, and the continuing appeal of the term "McCarthyism" demand that McCarthy's image come down through time and that it carry a historical context. Without it public figures, working in the tributary style, can continue to act like martyrs with spray paint, standing on their victimhood in order to better brand their opponents as McCarthyites. And because they are victims operating in a context of remembrance that gives credence to emotion and personal ties, their victimhood and emotions are not even up for discussion. That lack of discussion leads to others, and so we do not ask the questions that might make the battle meaningful, those queries about McCarthy's actual power and the proper behavior of public officials, that go on not just unanswered but ignored.

Notes

1. P.J. O'Rourke, *The American Spectator's Enemies List: A Vigilant Journalist's Plea for a Renewed Red Scare* (N.Y.: Atlantic Monthly Press, 1996), 4.

2. Richard Gid Powers, *Not Without Honor: The History of American Anticommunism* (N.Y.: Free Press, 1995), 85-90.

3. Ibid., 117-233; Kenneth O'Reilly, *Hoover and the Un-Americans: The FBI, HUAC, and the Red Menace* (Philadelphia: Temple University Press, 1983), 13-74.

4. In 1946 McCarthy suggested that striking coal miners be drafted and then forced to work the mines or face imprisonment. In 1948 he sponsored a housing bill that rejected calls for government-constructed public housing and provided instead government assistance so private builders could construct more low-cost housing. Later, it was learned that McCarthy received $10,000 from Lustron, a pre-fabricated housing manufacturer, for writing a pamphlet extolling the virtues of pre-fab housing. While he technically broke no laws, he certainly stepped into a conflict of interest. After his rise to national prominence, his opponents frequently cited the Lustron affair as an example of McCarthy's basically corrupt nature.

5. McCarthy had promised to outline 81 cases of subversives employed by the State Department, but mentioned only 78. The text of his speech, complete with interruptions can be found in *Major Speeches and Debates of Senator Joe McCarthy* (Washington, D.C.: Government Printing Office, 1953), 5-60.

6. "Weighed in the Balance," *Time*, 22 Oct 1951, 21.

7. The Eisenhower-McCarthy marriage in 1952 was never a happy one. The first rift came over McCarthy's treatment of Marshall. When Eisenhower stumped in Wisconsin for the GOP, his advisors convinced him to leave out of a speech a defense of Marshall in deference to McCarthy. Ike was never happy about having taken this step, and later defended Marshall on many occasions. Many thought that McCarthy would help Eisenhower's prospects in 1952, but when the votes were tallied, McCarthy polled fewer votes than any other Republican competing for statewide office in Wisconsin.

8. The most complete work on this topic is Edwin R. Bayley, *Joe McCarthy and the Press* (Madison: University of Wisconsin Press, 1981). On the Army-McCarthy hearings, see Michael Straight, *Trial by Television* (Boston: Beacon Press, 1954).

9. See, for example, "The Battle of Loyalties," *Life*, 10 Apr 1950, 29-32; "McCarthy at the Barricades," *Time*, 27 Mar 1950, 20-1; and "Super Spy Hunt," *The New Republic*, 3 Apr 1950, 14.

10. The exception to McCarthy's focus on government subversion was his anger at journalists and media outlets that he thought impeded his progress either by criticizing him or failing to cover him sufficiently. See Bayley, *Joe McCarthy and the Press*, passim.

11. On McCarthy's partisan role see "Super Spy Hunt," *The New Republic*; "Charge and Countercharge," *Time*, 10 Apr 1950, 17-9; "Returned in Kind," *Time*, 24 July 1950, 16; "The Battle of Loyalties," *Life*; "McCarthy on the Loose," *Atlantic*, May 1950, 4; "Democrats Fume at McCarthy, But He has Them Terrorized," *Newsweek*, 20 Aug 51, 19; and "The Senate Contests," *Newsweek*, 31 Mar 1952, 34. On McCarthy's damage to the party after 1952 see "Who Will Stand Up Against McCarthy," *The New Republic*, 12 Jan 1953, 5; "Senator McCarthy, Investigations," *U.S. News and World Reports*, 2 Jan 1953, 30-3; "Capitol Hill—Faggots on the Fire," *The New Republic*, 29 June 1953, 10-1; and "He Says He Doesn't Want to be President," *Newsweek*, 7 Dec 1953.

12. "The Administration Replies to McCarthy, " *The New Republic*, 8 May 1950, 5-6.

13. "Ike vs. McCarthy: Another Round," *U. S. News and World Report*, 12 Mar 1954, 101-104.

14. On the report presented by the committee hearing the complaints in the Army-McCarthy hearings, where McCarthy and the civilian leadership of the Army receive rebukes, see "McCarthy vs. Stevens: Committee's Conclusions, " *U.S. News and World Reports*, 10 Sept 1954, 76-87. The Watkins Committee, charged with deciding which charges McCarthy ought to be censured on, voted to censure him for abusing General Ralph Zwicker, in spite of McCarthy's assertion (backed up, I believe, by the transcripts of the hearings) that Zwicker was an evasive, hostile witness. The Senate later decided to drop this charge.

15. On the Eisenhower Administration's decision to withhold certain documents from McCarthy during the Army-McCarthy hearing, see William Bragg Ewald, *Who Killed Joe McCarthy?* (N.Y.: Simon and Schuster, 1984), 162-223.

16. The classic statement of the punish for disloyalty position comes from William F. Buckley and L. Brent Bozell, in *McCarthy and His Enemies* (Chicago: Regnery, 1954), 9-17, 245-264. Senator William Benton, one of McCarthy's earliest and best critics called for

his censure on perjury charges in 1951. When the Watkins committee met three years later they avoided the perjury charge. See "The McCarthy Issue: Pro and Con," *U. S. News and World Report*, 7 Sept 51, 24-42; "A Stickler for the Law Takes an Unwelcome Job," *U. S. News and World Report*, 20 Aug 1954, 82-5; "Six Senators Try a 'Censure' Case," *U. S. News and World Report*, 10 Sept 1954, 132-47.

17. McCarthy responded by calling Flanders "senile" and recommending that someone drag Flanders away in a net. "Six Senators," 140. McCarthy's remarks about Pearson are in *Speeches and Debates*, 161-186, quote from 172; Ickes compared McCarthy with Goebbels in Harold Ickes, "McCarthy Strips Himself," *The New Republic*, 21 Aug 1950, 8.

18. This was particularly true of Eisenhower who vilified McCarthy privately long before he spoke publicly against him. See Ewald, *Who Killed*, 33.

19. The most apocalyptic rhetoric came from the *New Republic*, Harold Ickes, "A Decoration for McCarthy," *The New Republic*, 10 Apr 1950, 17-8; Karl Meyer, "McCarthyism: Rovere is Too Sanguine," *The New Republic*, 15 June 1959, 8-9. More moderate comments came from Joseph Rauh, head of Americans for Democratic Action. Joseph Rauh, "The McCarthy Era is Over," *U. S. News and World Report*, 26 Aug 1955, 68-70.

20. For McCarthy assessing his own power see, "The McCarthy Issue: Pro and Con," 24-42. On the polls see "McCarthyism: Is it a Trend?" *U. S. News and World Report*, 19 Sept 1952, 21-2. For assessments of McCarthy's relatively modest power at election time see, "Primaries: Those for Joe Go," *Newsweek*, 27 Sept 54, 28; and in general, "A Myth Exploded, " *Time*, 13 Dec 1954, 12-4. For European reactions to McCarthy, see "Comment Abroad Scores McCarthy," *New York Times*, 4 May 1957, 12.

21. McCarthy tried to introduce evidence that other Senators treated witnesses like he did, but was rebuked by the Watkins Committee and the full Senate. "What McCarthy told Watkins Committee," *U. S. News and World Report* , 17 Sept 1954, 130-143; "Senator McCarthy's Bill of Exceptions," *U. S. News and World Report*, 8 Oct 1954, 142-3. The few attempts to consider McCarthy's censure in terms of the questions he raised about behavior came from his conservatives supporters. David Lawrence, "Forget It's McCarthy—Remember the Constitution!" *U. S. News and World Report*, 8 Oct 1954, 144.

22. For an excellent overview of the new radical right, written in the heat of the moment, see Richard Dudman, *Men of the Far Right* (N.Y.: Pyramid Books, 1962).

23. "Kennedy on McCarthy," *Newsweek*, 6 July 1959, 25-6; Austin C. Wehrwein, "Kennedy Appeals for Farmer Vote, " *New York Times*, 15 Jan 1959, 68; "Rockefeller Ready to Give Up Stocks, " *New York Times*, 17 Dec 1959, 43; Fendall W. Yerxa, "Humphrey Sees a Rise in Strife if Goldwater Policies Prevail," *New York Times*, 27 Oct 1964, 21; Claude Sitton, "Wallace Asserts Popular Response Calls for Serious Bid in Wisconsin," *New York Times*, 18 Mar 1964.

24. "400 at Unveiling of McCarthy Bust," *New York Times*, 3 May 1959, 80; "2nd McCarthy Memorial," *New York Times*, F1; Peter W. Kaplan, "Senator McCarthy's Legacy," *Washington Post*, 3 May 1982, C1, 11; George F. Will, "The Fall of Joe McCarthy," *Washington Post*, 14 June 1984, A23.

25. All of the commemorations are cited in William F. Buckley, "McCarthy to the Rescue," *National Review*, 28 July 1970, 804-5.

26. "Reunion Recalls Movie on Hispanic Strikes Made a Time of Film Blacklist," *New York Times*, 3 May 1982, A16.

27. This tendency is clear in the recent dispute over the Smithsonian's proposed exhibit linking the Enola Gay and the bombing of Hiroshima with the growth of the Cold War. Veterans groups demanded that the link be severed rather than consider the two together. The Smithsonian finally capitulated.

28. See Bayley, *Joe McCarthy and the Press*; Fred Friendly, "McCarthyism Revisited," *Washington Post*, 13 Feb 1977, C1, 5.

29. Though the story of media-McCarthy relations during McCarthy's life is largely settled, that story has not been well-placed in the broader history of the American mass media. Such an outlook would provide the following insights. First, the focus on the media's role in McCarthy's downfall in the pre and post 1975 narratives was a latecomer, a symbol of the media's growing sense of its own importance in American public life. Until the mid-1970's Murrow's documentary and the gavel-to-gavel coverage of the Army-McCarthy hearings rarely received credit for bringing McCarthy to his knees. Much more often, McCarthy's fall appeared as the result of the Senate's censure or the elections of 1954 which gave the Democratic party control of the Senate, depriving McCarthy of a committee chair and investigatory power. His post-censure power was also limited, not by press indifference, but by the national GOP's unwillingness to associate with him, perhaps best exemplified by President Eisenhower's request that Joe and Jean McCarthy not be invited to any state function after

Dec 1954. See, "Myths Exploded" for the old view, "McCarthyism: The Turning Point," *New York Times*, 1 Apr 1979, F22. Second, the pro-McCarthy portion of the media, the Hearst and (for a time) Knight chains, the *Chicago Tribune*, the columnists George Sokolsky, Walter Winchell, David Lawrence, and the radio man Fulton Lewis, Jr. all declined in reputation and importance on the national scene because of their favorable response to McCarthy. In turn, those outlets that opposed McCarthy have used that opposition to bolster their own claims to national importance.

30. Joseph Morgenstern, "See It Now," *Newsweek*, 17 Jan 1972, 83-4; Joseph Wershba, "Murrow vs. McCarthy: See it Now," *New York Times*, 6 Mar 1979, D31, 38; "Echoes of the Old, Still Unsettled, McCarthy Battle," *New York Times*, 6 Apr 1979, C22; "Murrow vs. McCarthy," *CBS*, 15 June 1994.

31. Norman Redlich, "McCarthy's Global Hoax," *Nation*, 2 Dec 1978, 593, 610-13; "Point of Order," *Newsweek*, 8 Nov 1965, 62; William F. Buckley, "Remember Paul Hughes," *National Review*, 1 Apr 1977, 403.

32. Richard Rovere, "The Last Days of Joe McCarthy," *Esquire*, Oct 1973, 186-91; Roy Cohn, "Believe Me, This is the Truth About the Army-McCarthy Hearings, Honest," *Esquire*, Feb 1968, 59-63, 122-131; "The McCarthy Question," *Commonweal*, 16 Nov 1973, 171-2; Roger Pollack, "McCarthy Unmasked: How the *Progressive* Helped Ground Tailgunner Joe," *Progressive*, July 1984, 56.

33. Barbie Zelizer, *Covering the Body* (Chicago: University of Chicago Press, 1992).

34. Dean Acheson, *Present at the Creation* (N.Y.: Holt, Rinehart and Winston, 1959) Charles Potter, *Days of Shame* (N.Y.: Coward-McCann, 1965); Arthur Watkins, *Enough Rope*, (N.Y.: Bobbs-Merrill, 1969), John Adams, *Without Precedent* (N.Y.: Norton, 1983), Roy Cohn, *McCarthy* (N.Y.: New American Library, 1968).

35. The most visible symbol of this change is the shift in treatment of the Army-McCarthy hearings. In the immediate aftermath of the McCarthy censure, the Senate received most of the credit for stopping McCarthy. But beginning in the 1960s and accelerating through the 1970s, the televised coverage of the hearings began to get that praise. At the same time, the hearings were shorn of any issue except McCarthy's behavior, symbolized by Joseph Welch's plaintive "at long last, have you no decency?" Having seen McCarthy and heard this cry, the public rejected McCarthy as a thug, and his power was broken.

36. Compare "McCarthy vs. Stevens," *U. S. News and World Reports*, 10 Sept 1954, 76-87 with "McCarthy's Last Stand," *Time*, 17 Jan 1964, 49.

37. The king of transcript publishing was *U. S. News and World Reports* which ran over 100 pages of transcripts from the Army-McCarthy hearings, complete speeches for and against McCarthy, a lengthy interview with McCarthy on the proper role of congressional investigators in the last few months of 1954. See *U. S. News and World Reports*, 19 Mar, 30 Apr, 7 May, 14 May, 21 May, 4 June, 11 June, 18 June, 25 June, 6 Aug, 10 Sept, 17 Sept, and 8 Oct 1954.

38. For a perceptive essay outlining the problems with analysis presented as news, see Adam Gopnik, "Read All About It," *New Yorker*, 12 Dec 1994, 84-89.

39. "McCarthy's Last Stand," Bosley Crowther, "Screen: Point of Order, Mr. Chairman," *New York Times*, 15 Jan 1964, 27; Daniel Talbot, "On Historic Hearings From TV to the Screen," *New York Times*, 12 Jan 1964, B7.

40. Austin C. Wehrwein, "A Wisconsin Race By Wallace Seen," *New York Times*, 12 July 1964, 59; Yerxa, "Humphrey," 21.

41. Bernard Guertzman, "John Paton Davies, Jr. is Cleared, Was Ousted in the McCarthy Era," *New York Times*, 15 Jan 1969, 1; Eric pace, "Honor Comes a Bit late," *New York Times*, 4 Feb 1973, IV 5;"Vindication on China," *New York Times*, 4 Feb 1973, IV 14.

42. "The Spook," *The New Republic*, 21 Aug 1971, 6.

43. Ibid.

44. Matthew Josephson, "The Time of Joe McCarthy," *Nation*, 9 Mar 1974, 312-15.

45. Barry Goldwater, "Needed: Conservatives at the Top," *New York Times*, 12 Sep 1973, 47; "Cox Scores Erwin Panel on McCarthy-Like Tactics," *New York Times*, 12 June 1974, 23; William Safire, "The New McCarthyism," *New York Times*, 9 Jan 1975, 35.

46. The ironies in the right's use of McCarthy are delicious—long before "deconstructionism" and "culture of victimhood" were conservative whipping boys, conservatives were deconstructing McCarthy in order to be able to claim the advantages of victimhood.

47. See Buckley, "McCarthy," 804-5; John Cosby, "About New York: the Metamorphosis of Roy Cohn," *New York Times*, 13 May 1974, 36 (Cohn after a run-in with District Attorney Robert Morganthau— "If I didn't know what McCarthyism was all about, I certainly do now"); Jeffrey St. John, "The New McCarthyism," *New York Times*, 3 Nov 1975, 35 (St. John argues that the victims of the new McCarthyism are big businessmen and their allies).

48. McCarthy himself was notoriously impersonal about attacking people. He would often deliver a blistering denunciation of a fellow senator, only to afterwards throw his arm around say, Senator Benton, and tell him that the attack was nothing personal. Journalists also found him obnoxious when speaking publicly, but a great companion for drinks.

49. Pace, "Honor," 5; "Vindication," 14. The State Department also took this tack, rejecting congressional attempts to obtain documents about disputes among foreign service officers in 1975 because the department was "just now—after 20 years—overcoming the legacy of that bitter question who lost China?" John Herbers, "McCarthy's Poisonous Legacy is Still Felt," *New York Times*, 26 Oct 1975, D2.

50. See Thomas Meehan, "Woody Allen in a Comedy About Blacklisting? Don't Laugh," *New York Times*, 7 Dec 1975, B1; Hilton Kramer, "The Blacklist and the Cold War," *New York Times*, 3 Oct 1976, D1, 16-7. There was a similar explosion of films on the 1950s in the 1980s. See Aljean Harmetz, "Films About Blacklist: Hollywood's Bad Old Days," *New York Times*, 20 Oct 1987, C18.

51. Meehan, "Woody Allen," B1; "Stage Role Recalls Experience of the McCarthy Era," *New York Times*, 25 Dec 78, 28.

52. E. R. Shipp, "The 'Shameful Era' Begins to End for Professors Dismissed by City U.," *New York Times*, 26 Mar 1980, B1; Dudley Clendenin, "Vermont U. Honors McCarthy Era Victim it Ousted," *New York Times*, 22 May 83, 22.

53. For particularly clear cases of this "don't ask" treatment see Vonne Godfrey, "Just Small Fry Flattened By McCarthyism," *New York Times*, 19 Jan 1980, 33 where Godfrey, a South African who arrived in Hollywood to become an actress in 1946 describes her experiences with the blacklist. She says she was "very naive when it came to politics, in government or industry," was mistakenly added to a blacklist, and had to produce an affidavit to clear her name whenever she appeared for an audition. This made her feel "dirtied and cheated and inconsequential." She complains that the Statue of Liberty no longer pulls her heartstrings. See also the articles cited in notes 45-47 above. Almost all of the articles dealing with the China hands, blacklisted members of the movie industry, and fired academics both claim victimhood for their subjects and point out that the victims have overcome whatever suffering their brushes with anti-communism caused them, often quite quickly. On this, see also the testimony of Irving Peress, "Dr. Irving Peress," *New York Times*, 5 Sep 1976, 29; Fred Fisher (a lawyer associated with the Army's counsel during the Army-

McCarthy hearings and the subject of a McCarthy attack in which McCarthy pointed out that he had belonged to a subversive organization), "Fred Fisher," *New York Times*, 17 Oct 76, 41; and Owen Lattimore, "An Old China Hand Will Explain Why it Just Ain't So," *New York Times*, 12 May 79, 11.

54. Again, I want to make clear that I am not condoning the firing of leftist university professors, but simply pointing out that in the 1970s their firing was wrongly ascribed to McCarthy. New Left historians have made the sme point in their writings on McCarthy—that McCarthy was a minor player in American anti-communism. See Chapter 6 below.

55. "Partisan Clashes in Congress," *New York Times*, 1 June 1984, 20; "Critics of U. S. Policy Testify at House Panel," *New York Times*, 20 Feb 1987, II 5; Peter Collier and David Horowitz, "McCarthyism: The Last Refuge of the Left," *Commentary*, Jan 88, 36-41.

56. Abraham Brumberg, "Reagan's Untruths About Managua," *New York Times*, 18 June 1985, 27.

57. Consider the case of Garry Wills' rejection of an award given him by the Sons of the Revolution, a patriotic group. Wills was honored for his book *Inventing America*, accepted an award, and then returned it after disagreeing with the keynote speaker, Samuel Farber. Wills returned to the podium, called the remarks "An incredible McCarthyite speech" and "the kind of stock McCarthy rhetoric which I have not heard since the 1950s." Farber's offending words? That the "air has been poisoned by journalists," "they have taken patriotism out of the schools," and "As long as I have breath, I will have no difficulty denouncing repressive regimes or in praising democracy." Howard Blum, "Author Rejects Sons of Revolution Award, Terming Group Rightist," *New York Times*, 29 Apr 1979, 33.

58. Tom Wicker, "Lessons of Lattimore," *New York Times*, 9 June 1989, 31; William Buckley, "Owen Lattimore, RIP," *National Review*, 30 June 1989, 18-20.

59. Tom Wicker, "Smearing the Dead," *New York Times*, 11 July 1989, 19; William Buckley, "Lattimore and Wicker," *National Review*, 18 Aug 1989, 54-5.

60. "Case Dating to McCarthy Era Takes a New Twist," *New York Times*, 5 Apr 1989, 19; Kathleen Quinn, "Joe McCarthy, Back in Style," *New York Times*, 2 Nov 91, 23.

61. P. J. O'Rourke, "A Call for a New McCarthyism," *American Spectator*, July 1989, 14-5; O'Rourke, "A New McCarthyism: The List Continues," *American Spectator*, Oct 1989,

14-6; O'Rourke, "Shoot the Wounded," *American Spectator*, Nov 1990, 14-20; O' Rourke, "Commies—Dead but too Dumb to Lie Down," *American Spectator*, Nov 1991, 12-5; O'Rourke, "1992 New Enemies List Third Annual Readers' Update," *American Spectator*, Nov 1992, 35-46.

5
The Making of a Hero: The Memorial Style and the National Memory of Martin Luther King, Jr.

King was a thoroughly good man who achieved greatness by showing forth the Negro cause at its best. His was the old American cause of equal rights for all men, and King put it in the form in which this generation of Americans must face it. His death may help or hinder that cause; perhaps both. But all of us owe him the honor of not letting ourselves distort, becloud, or belittle the cause he brought to such noble purity of expression.

Life, 12 April 1968

A disturbing revisionism threatens the memory of Dr. Martin Luther King, Jr. whose 64th birthday Americans celebrate today. In life he was the passionate voice of a civil rights revolution, an apostle of civil disobedience and a speaker of uncomfortable truths to power. In memory, some now cast him as the unthreatening "Moderate Alternative," an integrationist whose nonviolence can be favorably contrasted to more militant strategies of black empowerment. To remember Dr. King this way denies his vitality and blurs his legacy for a new generation of Americans. . . . Let him be remembered as he was: a nonviolent revolutionary and a tireless fighter for peace and racial justice.

New York Times, 18 January 1993[1]

Since the time of his murder, the American mass media have worked to perpetuate the memory of Martin Luther King, Jr. That they have done so is unsurprising, given the mass media's role as information providers to the nation. Nor is it surprising that they have done so in the memorial style, a commemorative style that with its close links to Coretta King and its tendency to generalize in search of a broad audience is both popular with and appropriate for a national audience. But, this chapter argues, the way in which the national media and national politicians have crafted Martin Luther King's history in the memorial style may have limited the usefulness of King's legacy.[2]

In simplest terms King's legacy is this: inspired by the promise of his religion and his country, King acted locally and nationally to seek moral, political, and economic change. But as it appears in the mass media, the legacy has shrunken to include only the national, political, and (occasionally) economic thrusts of King's life. This reduction is typical of the memorial style—the King Center used a similarly appealing image of King to buttress its commemorations. But the style also grows out of the characteristics of the national news that give it its particular "slant"[3]: its focus on the words of politicians, its liberal, reformist bias[4], its equation of national life with national politics, and its consequent ignorance of local or non-political issues,[5] and its urge to educate the public.

These characteristics carry over into the making of heroes in national life, for it is journalists, interest groups, and national politicians who are the most voracious followers of the national media, and it is journalists, interest groups, and politicians who make history official, either overtly, through creating memorials, or quietly, by saying the same thing again and again, year after year, until it has the ring of truth and the approval of tradition.[6] In King's case, the master memorial narrative, crafted in the communion of journalists, civil rights organizations, and politicians, began with King's portrayal sometimes as a rabble-rouser, other times as a moderate influence on the more radical NAACP.[7] While King's calls for nonviolence were generally applauded, the violence that accompanied him brought fear to many in the national community of politicians and press, including the Kennedy administration. Those fears were quieted by the 1963 March on Washington and King's "I Have a Dream" speech given there. From that time forward, the national press judged King and the Civil Rights Movement against their reading of King's dream. King's assassination

only strengthened this practice, as the press, mainstream civil rights activists, and the federal government, amid the chorus of calls for Black Power and revolution (and in the years thereafter), have sought to hold King up as an example of a good American leader.

This essay argues that King's image has been so generalized by its protectors, and so dominated by the memorial style, that the growing national disinterest in King and civil rights may actually be a good thing. For, if nothing else, the sinking influence of the national King legacy may allow alternative versions of King's history to emerge, versions which would encourage debate while improving the quality of King's history.

In the national memory, the March on Washington was a mammoth reunion of peaceful people, marching in favor of equality and brotherhood. In its original incarnation, it had more specific goals. The march was titled the "March on Washington for Jobs and Freedom." Its organizers demanded a two dollar an hour minimum wage, school desegregation, a federal jobs program, governmental action against discrimination in employment, and the passage of the Civil Rights Bill then before Congress.[8]

What seems today a benign list of goals seemed, when linked with the prospect of hundreds of thousands of demonstrators in Washington, a distinct threat to national stability in 1963. The Kennedy government feared that a mass march in favor of such goals would cause lawmakers to reject its Civil Rights Bill. Accordingly, the administration moved to mute the march. John Kennedy refused to endorse the March on Washington until leaders reassured him that marchers would not lobby Congress en masse. Kennedy also received assurances that demonstrators would perform no acts of civil disobedience. In a final bow to government pressure, the six black march organizers permitted the addition of four whites to the organizing committee.[9] In this way, march leaders and the Kennedy administration assured the worried that the march would have little negative effect on congressional civil rights deliberations.[10]

While Kennedy feared political problems from the march, the press predicted violence. In 1967, Martin Luther King answered critics who claimed that his non-violent marches were but provocations to violence. In reference to a series of Chicago marches that were met with Nazi flags, racial epithets, stone throwers, and riot police, King

wrote that, to succeed, non-violent marches had to bring tension to the fore. He added, "we did not cause the cancer, we merely exposed it." King's biographer David Garrow has located the birth of this "coercive nonviolence" at Albany, Georgia in 1961-62. There, King's efforts to end segregation failed, largely due to the decency shown demonstrators by local police. Without shocking scenes of brutality, the national media grew tired of the event, and the impulse for change died. King applied the lessons of Albany in Birmingham, Alabama the following year. He and his lieutenant James Bevel inspired Birmingham protesters to disobey a court order and march to certain confrontation with Bull Connor's police dogs and fire hoses, creating national media attention.[11]

The nation expected similar results from the March on Washington, held only a few months after the nationally televised Birmingham clashes. *Newsweek*, in a 6 May 1963 article entitled, "I Like the Word Black," noted a more militant mood among blacks. The article mentioned Malcolm X's approval of violence in certain instances, and cited King's statement that, "The Negro in the South can now be non-violent as a stratagem, but he can't include loving the white man. . . . Nonviolence has become a military tactical approach." *Time* magazine, in its 30 August 1963 issue (written before but distributed after the March), warned of a violent Civil Rights future. In an article titled "The Awful Roar," the publication quoted Reverend Gardener Taylor's prediction that "the streets are going to run red with blood." Below Taylor's grim words stood Mel Landson's assertion that when a man discriminated against him, he wanted to "non-violently beat the hell out of him." *Time* characterized these voices as part of a "Negro Revolution" and added, "That revolution, dramatically symbolized in this week's massed march in Washington, has burst out of the South to engulf the North."[12] Editorials written on 28 August 1963 pleaded for a peaceful march. The *Washington Post* proclaimed that every citizen had an interest in the march, and that all of the marchers were on a national stage. The paper expressed its confidence that the gathering would be "remembered as an outpouring of goodwill, understanding, and tolerance."[13]

March organizers and Washington D.C. police saw things the same way. Every officer in the nation's capitol was assigned to the gathering. Speeches planned by the American Nazi party were forbidden, and officers kept the few counter-demonstrators far from the

main march. Protest organizers maintained strict self-censorship. The organizing committee required all speakers to submit a copy of their speeches to the committee and the press one day before the march. When SCLC's John Lewis proposed a speech critical of Kennedy's Civil Rights Bill, Archbishop Patrick O'Boyle, one of four white march leaders, threatened to withdraw from the program. A. Philip Randolph, chairman of the organizing committee, finally convinced Lewis to tone down his remarks. In case Lewis reneged on his promise, the Kennedy administration had two men ready to cut power to the public address system.[14] King did not submit a speech until the morning of August 28. That he was not required to turn in his remarks earlier testifies to King's busy schedule and to the organizers' confidence that the "moral leader of the nation" would do nothing to lead the event from its destined course.

Hindsight and memory teach that the March on Washington was a colossal success. They do not recall that the victories won on 28 August 1963 were different from those of any other Civil Rights protest. The Montgomery bus boycott resulted in the desegregation of that city's bus lines. The effort in Birmingham produced desegregated stores and pledges to improve black employment. The march from Selma to Montgomery in 1965 yielded a national voting rights bill. All of these demonstrations were protests against obvious discrimination and were accompanied by violence. In comparison, the March on Washington produced only scenes of racial unity and huge sighs of relief that the blood spilled in Birmingham and promised by the "Negro Revolution" did not flow in the streets of the nation's capitol. It is ironic that the most influential event in creating the national community's conception of Martin Luther King was an atypical event in the history of the Civil Rights Movement. It lasted only one day, was free of violence, and was explicitly organized for a national audience.

By the time King stepped to the podium at the foot of the Lincoln Memorial, Joan Baez had already led the crowd in singing "We Shall Overcome." One man had prayed, and seven had spoken from the same podium. King was to be the concluding speaker. He addressed the crowd, and, reading from a prepared text, began. "I am happy to join with you today in what will go down in history as the greatest demonstration, for freedom, in the history of our nation."[15] He continued, recalling Lincoln, "in whose symbolic shadow we stand today." He spoke of the Emancipation Proclamation, a "great beacon

light of hope to millions of Negro slaves who had been seared in the flames of withering injustice," and added sadly that its promise had been denied. "The Negro still is not free . . . the life of the Negro is still sadly crippled by the manacles of segregation, and the chains of discrimination." He mentioned the poverty in which most blacks lived and exclaimed, "we've come here today to dramatize a shameful condition." What followed was an indictment of modern America, an America which had given its black citizens "a bad check, a check which has come back marked insufficient funds."

Having set the stage, King rejected the idea that the nation needed a cooling-off period, an end to protest. He warned America that it would be "fatal for the nation to overlook the urgency of the moment," and promised that "those who hope that the Negro needed to blow off steam and will now be content will have a rude awakening if the nation returns to business as usual. . . . The whirlwinds of revolt will continue to shake the foundations of our nation until the bright day of justice emerges."

King followed with a few lines of counsel to his black followers. They were not to seek to "satisfy [their] thirst for freedom by drinking from the cup of bitterness and hatred. . . . And the marvelous new militancy which has engulfed the Negro community must not lead us to a distrust of all white people." After this calming interlude, he returned to his earlier theme, blasting those who asked "when will you be satisfied?" He responded, "We can never be satisfied as long as the Negro is still the victim of the unspeakable horrors of police brutality . . . as long as our bodies, heavy with the fatigue of travel cannot gain lodging in the motels of the highways . . . as long as the Negro in Mississippi cannot vote and the Negro in New York believes he has nothing for which to vote."

Then, after denouncing discrimination, after warning that revolt would continue, after urging his followers to avoid bitterness but to never give up, King departed from his text and began the "I Have a Dream" section of his oration.

He told his listeners that in spite of "the difficulties of today and tomorrow" he still had a dream "deeply rooted in the American Dream." He dreamed that the nation would uphold its creed, "We hold these truths to be self-evident, that all men are created equal," that in Georgia, "the sons of former slaves and the sons of former slave owners will be able to sit down together at the table of brotherhood," and that

Mississippi would become "an oasis of freedom and justice." King continued, dreaming that his children would live in a nation "where they will not be judged by the color of their skin, but by the content of their character." He dreamed that in Alabama "with its vicious racists, with its governor, having his lips dripping with the words of interposition and nullification . . . little black boys and black girls will be able to join hands with little white boys and white girls as brothers and sisters." He concluded with a quotation from Isaiah, that valleys would be exalted, mountains made low, crooked placed straightened, "and the glory of the Lord will be revealed, and all flesh shall see it together."

After closing this section of his speech, King pleaded with listeners to let his dream animate their faith. He asked them to "work together, to pray together, to struggle together, to go to jail together, to stand up for freedom together, knowing that we will be free one day." When Americans had this freedom then they could sing "with new meaning: My country 'tis of thee, sweet land of liberty of thee I sing. Land where my fathers died, land of the pilgrims' pride, from every mountain side, let freedom ring." Only when his dream was fulfilled, only when his people were free, would America become a "great nation."

King ended his remarks by begging that "freedom ring" from mountains and high places in the North and in the South, "from every village and every hamlet from every state and every city," and that only when freedom rang across the nation would all people "be able to join hands and sing in the words of the old Negro Spiritual: Free at last, free at last, thank God Almighty we are free at last." With this, King left the podium.

Perhaps because their fears of violence had been unfounded, because John Lewis had toned down his remarks,[16] or just because it was such a nice, peaceful day, the press published the most complimentary sections of King's speech.[17] There was surprising agreement among *Time*, *Newsweek*, the *New York Times*, and the *Washington Post* on what part of King's speech was important.[18]

Suppose that King's speech, as it exists in the collective memory, is composed of the parts of that speech quoted by at least three of the elite media mentioned above. Such a speech would encompass 26 of the 191 lines of the original speech. The condensation of King's prepared remarks would read as follows:

> There will be neither rest nor tranquillity in America
> until the Negro is granted his citizenship rights. . . .
> Let us not seek to satisfy our thirst for freedom by
> drinking from the cup of bitterness and hate. . . . And
> the marvelous new militancy which has engulfed the
> Negro community must not lead us to a distrust of all
> white people. For many of our white brothers, as
> evidenced by their presence here today, have come to
> realize that their freedom is inextricably bound to our
> freedom.

King's extemporaneous remarks would be remembered in this way:

> I have a dream that one day this nation will rise up
> and live out the true meaning of its creed: "We hold
> these truths to be self-evident, that all men are created
> equal." I have a dream that one day even the state of
> Mississippi, a state sweltering with the heat of
> injustice, sweltering with the heat of oppression, will
> be transformed into an oasis of freedom and justice. I
> have a dream that my four little children will one day
> live in a Nation where they will not be judged by the
> color of their skin but by the content of their
> character.

Of course this is an intellectual fiction. No memory of King's
address would be composed solely of quotes from three of four major
print media outlets. Yet this fiction proves an important point. In the
aftermath of a surprisingly peaceful event, King's remarks were shorn
of any inflammatory power that they might have had. Gone was the
promise of continued revolt, absent the presence of slavery. America
had offered no bad check to its black citizens. Those citizens were not
suffering. The dream had no time for "Alabama with its vicious racists,
with its governor having his lips dripping with the words of
interposition and nullification." It was too busy sitting down "at the
table of brotherhood." King's speech, which was part American dream
and part church sermon lost its religious language. The lines from

Isaiah and the words of the "old Negro Spiritual" simply disappeared. Only the memorial to America remained.[19]

Press coverage of the entire March on Washington took its cue from journalists' nationalist reading of King's remarks. *The New York Times*' news analysis on 29 August 1963 displayed the national media's tendency to favor the political over the religious in King's message. Headlined, "I Have a Dream . . . Peroration by Dr. King Sums Up a Day the Capital Will Remember," the article noted that few congressmen would be swayed by the march, but "it will be a long time before it [congress] forgets the melodious and melancholy voice of the Reverend Martin Luther King Jr., crying out his dreams to the multitude." King's dreams, according to James Reston of the *Times*, were promises "out of our ancient articles of faith: phrases from the constitution, lines from the great authors of the nation, guarantees from the Bill of Rights, all ending with a vision that they might one day all come true." Reston thus subsumed King's remarks (and indeed the whole event) into an all-American dream, full of promise, free from sin. The *Washington Post* wrote that the "hope" of the march "was one for brotherhood—'I have a dream' the Reverend Martin Luther King Jr. cried again and again as he forecast a nation living up to its creed that all men are created equal." Again, an American dream free of criticism. *Newsweek* and *Time* both echoed the view that King had set the tone for the day. *Time* concluded that because the march was peaceful, blacks had proved their ability to "accept the responsibilities of first-class citizenship."[20]

The processes that created the King myth and tied it to the memorial style are clear. March organizers, influenced by the Kennedy administration, guaranteed that the march would be peaceful but politically safe. The press, surprised by the good-natured gathering, neutered King's already dilute remarks, and then used them as the theme of the day. Out of the March on Washington came a Martin Luther King whose dream of biracial brotherhood was founded in America's political documents, not King's religious heritage, or the suffering of American blacks. It was against this standard of commemoration that King would be judged in the years following the March on Washington. And it was to this myth that the press would return after King's assassination.

Between September 1963 and April 1968, King distanced himself from his Dreamer persona, though not from the religious sources of the dream.[21] The media, rather than accept this change, chose to judge King's actions against the model of the March on Washington.

The summer of 1964 saw SCLC marchers meeting violence in Tuscaloosa, Alabama and St. Augustine, Florida. The civil rights climate in the South was much closer to that of Birmingham than Washington. Yet having seen the peaceful March on Washington, and having remembered King's words about whites and blacks "sit[ting] down together at the table of brotherhood," the press now blamed both whites and blacks for continued racial disharmony. *Newsweek* exhibited this new spirit in its coverage of the protests in Tuscaloosa and St. Augustine. Though it noted that marchers in Alabama had been injured by police and that those in Florida were held in "a sun-broiled chicken-wire stockade," the magazine concluded that "only the special grand jury impaneled to investigate the [St. Augustine] crisis seemed actively interested in restoring the broken dialogue between the races."[22]

Publications on the political right were especially adept at this line of reasoning. When the Nobel Institute announced that its 1964 Peace Prize would go to King, *U.S. News and World Report* answered with an article entitled "Man of Conflict Wins a Peace Prize." The Nobel Institute declared that "Martin Luther King has consistently asserted the principle of nonviolence," but *U.S. News* responded "In many of Dr. King's campaigns, violence has resulted. Hundreds have been arrested." Though the article quoted the *New York Herald-Tribune* which favored the award, its sentiments obviously lay with Birmingham's *Post-Herald* which wrote, "The people in the South know that violence and conflict follow in his trail."[23]

One year later Frank S. Meyer, writing in the *National Review*, rejected the characterization of King as a man of nonviolence. Earlier in 1965, the *Review* called King the "source of violence in others." Meyer picked up this theme. He outlined King's tactics, in which demonstrators took to the streets to provoke racists, who then attacked the marchers under the watchful eye of the national media. Media coverage of the violence inspired Americans of conscience to press for federal intervention, which resulted in the federal government's acquiescence to protesters' demands. For Meyer, this brand of nonviolence was guilty of three sins. First, it provoked violence.

Second, it employed force against civil society. Third, it was an assault against representative, constitutional government. Meyer concluded his article by comparing King to Freidrich Engels, who reportedly challenged oppressors with the words, "bourgeois gentlemen, you shoot first." In Meyer's eyes, King's tactics constituted a "program for government by force and the threat of terror." Clearly, Meyer favored a peaceful nonviolence, one shorn of its political force. Inasmuch as he accepted that blacks had the right to protest, he could only have been calling for protests like the March on Washington.[24]

Besides rejecting King's brand of nonviolence, most in the national press frowned on his growing radicalism. King's move to the North after the successes of Selma brought with it an acute appreciation of the economic difficulties that blacks faced in the ghettos. King called for a guaranteed annual income and adequate housing for all. When he attempted to implement his housing goal in Chicago, *Time* attacked. An article snidely titled "Render unto King," told of King taking trusteeship of a Chicago slum, quoted him as saying that he knew it was "supralegal," and then gave the last word to Chicago Judge James B. Parsons, "the first Negro ever appointed to a federal district bench in the continental U.S.," who called King's trusteeship "theft."[25]

When King opposed the Vietnam War by comparing U.S. actions in Vietnam with Nazi actions against the Jews and calling the U.S. the "greatest purveyor of violence in the world today," the press pounced. King's political and moral stand against the war was "a curse of confusion," a "sign of erosion," and a "disservice to his cause." *Newsweek* noted that King's opposition allied him with a peace movement whose "command is laced with political extremists," while *Life* warned that if the civil rights movement faltered, it would be because King had betrayed that cause.[26]

King's ambiguous stance towards Black Power also bothered the media. King chided Black Power for being "a slogan without a program," but defended it from those who called it racist. Black Power was not racist, King argued, because racism was "a doctrine of the congenital inferiority and worthlessness of a people." *Newsweek* and *U.S. News and World Report*, failed to draw the distinction. Both linked King to the Black Power movement, the latter impugning King for sharing the podium at a Chicago rally with CORE's president Floyd McKissick, who had endorsed the new movement.[27]

King's rhetoric on civil disobedience, when coupled with his stance on economic compensation, Vietnam, and Black Power, sent the press into fits. *U.S. News and World Report*, in an article titled, "New Negro Threat: Mass Disobedience," reported King's call for a march on Washington by the unemployed, a "hungry people's sit-in" at the Labor Department, and a weekly school boycott. His goal to create a movement which would "forcefully cripple the operations of an oppressive society" struck fear in the heart of the media. The *National Review* predicted that King's civil disobedience program would do no less than destroy constitutional government.[28]

Newsweek summed up these concerns in May 1967. It predicted another "long hot summer," worsened by the death of the civil rights movement. "The Movement won its memorable victories marching in unison, the reformers side by side with the revolutionaries, the nation and the government behind them." Some black leaders (King notably absent) still hoped for an interracial coalition, "but the coalition began crumbling years ago as marches, riots, and anti-white sloganeering moved ever closer to home." It is a somber article, one colored by gloom. It is also unmistakably tinted by nostalgia for the mythical March on Washington, when King was a dreamer, and the Movement "march[ed] in unison, the reformers side by side with the revolutionaries, the nation and the government behind them."[29]

The King that James Earl Ray murdered was, in some ways, not the man the mainstream press wanted him to be. He was too confrontational, too radical.[30] The only consistent press support for King came from magazines like the *Nation* which approved of King's move to the left, and *Ebony* which, in the turmoil of Black Power and ghetto violence, found solace in the Dreamer King.[31] But, on the other hand, in the last years of his life, King had sought to extend his crusade to the entire nation, first by setting up housekeeping in a Chicago ghetto, and then by planning a national political coalition to press for liberal reforms in Washington, D. C. So while journalists and politicians could not have been comfortable with King's upcoming Poor People's Campaign, it at least confirmed for them that King could best be interpreted in the context of national politics.[32] It is not surprising, in light of the riots and angry denunciations that followed King's assassination, that the mainstream press would resurrect the King they created at the March on Washington four years earlier. The media acted to make King a national hero and a symbol of racial unity.

To do so they had to overlook the last four years of his life, but not the context in which they had interpreted those years. The years following King's assassination were ones in which the media sought to educate readers about the "official" King through retelling his story, recapping the highlights of his life, and, finally, joining with his family in making the anniversary of his birth a national holiday. In so doing the mass media, national politicians, and mainstream civil rights groups acted in the memorial style, seeking converts to their version of King.[33]

I do not wish to imply that the outpouring of grief and love in the media after King's death was disingenuous, or that journalists were consciously trying to mislead the public. Rather, in their natural desire to remember a man who mattered, members of the national press and political communities recalled the event in his life that mattered most to them, the March on Washington. At no other occasion in civil rights history had more Americans been united in support for the Movement. No other King speech had been heard by more people, or more closely associated with his name, or more widely covered by the national media. The march was not a radical event (though it could have been), King's address was not a fiery one (though it could also have been). It is only reasonable that his violent death would recall a peaceful past.

But the choice of the memorial style was more than just an act of journalistic memory. The day after King's death Americans were presented two responses to King's assassination and the events that led to it. One came in the words of Black Power advocates Floyd McKissick and Stokely Carmichael and the photos of riots in Washington, Harlem, Newark, Memphis, Raleigh, Jackson, and Tampa: it proclaimed nonviolence dead. In those riots, in the cries of "burn, baby, burn" there was more than just anguish and anger. There was a tributary commemoration, one that expressed personal suffering, that rejected official behavior, that bothered little with efforts to persuade, or even to reason.

The other, more hopeful commemoration of King harkened back to his dream. The main *New York Times* article, written by Murray Schuman bore the title, "Martin Luther King, Jr.: Leader of Millions in Non-violent Drive for Racial Justice." Schuman crafted a peaceful King, one who rejected Black Power and had a "profound faith in the basic goodness of man and the great potential of American democracy." As an example of that faith, he cited the March on Washington, watched by "scores of millions of Americans—white as well as Negro."

These people "stirred when Dr. King, in the shadow of the Lincoln Memorial said: Even though we face the difficulties of today and tomorrow, I still have a dream. I have a dream that one day this nation will rise up and live out the meaning of its creed: we hold these truths to be self-evident that all men are created equal'."[34] By evoking the national side of the March on Washington, Schuman was able to draw on its most relevant themes, peaceful protest and faith in government. He created a chronology of the major civil rights events in King's life. It began with the Montgomery Bus Boycott and ended with the Selma march of 1965. In between were events which recalled a King who withstood instead of provoked violence. In a nation racked by riots, the *Times'* message could not have been clearer. Violence was unacceptable because King was free from violence.

The *Washington Post* took the same tack. Its main article, "Dr. King, Apostle of Nonviolence, Drew World Acclaim," began by quoting the "I Have a Dream" section of his March on Washington speech (again omitting the lines about Alabama's vicious racists) and ended with an excerpt of King's remarks at the funeral of four young girls killed in a 1963 Birmingham bomb blast. "Forgive our white brothers."[35] The *Post* also covered Coretta Scott King's reaction to the assassination. The civil rights organization that Martin Luther King founded, the Southern Christian Leadership Conference, asked Mrs. King to speak in an effort to quell the riots in the nation's cities. In her remarks, titled by the *Post* "Mrs. King Pleads for All to Fulfill Husband's Dream," she explained that "nothing hurt him [King] more than violence," and called on all Americans "who loved and admired him to join us in fulfilling his dream." The dream would be fulfilled when racism and violence disappeared from America, when "the Negro and others in bondage are truly free."[36] The victory of the memorial style, then, was not just the result of the power of the media, but of the lack of workable alternatives. Supporters of the tributary style were beyond the pale; there was no organized scholarly response. King's legacy demanded that he be remembered, the memorial style made mass memory possible.

Between 1968 and 1978, King commemorations evolved in three directions. First, in the national press, King became associated with "the dream" as it was defined in the aftermath of his death. Second, "the dream," became the standard by which the press judged the

success of civil rights. Third, civil rights organizations and liberal politicians of both races called for government-sponsored remembrances of King, based, of course, in the dominant style of commemoration.

Ebony's May 1968 issue set the tone for the memory of King as a man of peace. It called him the "prince of peace," and lectured its readers that a turn to violence would invalidate everything King preached. The article concluded, "The prince of peace is dead. It is up to the millions who still live to see that his dream is brought to pass."[37] Eleven months later the same magazine published a survey of King memorials created in the year after his death. One such memorial was a medallion offered for sale to *Ebony* readers. On the back of the coin stood two men, arm in arm. On the front were the words "I Have a Dream" and "Peace, Justice, Brotherhood," encircling an eagle.[38]

But "the dream" was not used just to sell commemorative coins. In the year following King's assassination, a spate of books hit the market, most of which mentioned "the dream." In 1968, Grosset and Dunlap published *I Have a Dream: The Quotations of Martin Luther King, Jr.*, while Time-Life Books proffered *I Have a Dream: The Story of Martin Luther King, Jr. in Text and Pictures*. The following year Negro University Press published Lenwood Davis' book on King simply titled, *I Have a Dream*. Periodicals followed suit, frequently using the word "dream" in the title of their articles, nearly always mentioning "the dream" in their texts.[39]

Given King's role in the civil rights movement and the way that King's life and teachings could be rendered in shorthand by mentioning "the dream," it is not surprising that discussion of civil rights between 1968 and 1980 were often judged in comparison with the memories evoked by the words "I have a dream." Yet at the same time, the issues associated with the dream changed. Where it had once referred to legal equality, by the early 1970's journalists were equating the dream with economic equality. These evocations of King's dream in discussions of economic well-being did not guarantee a favorable evaluation of minority life in America, but they did solidify the association, created in 1963 and resurrected in 1968, between King and the dream and strengthened the memorial version of King commemorations.

In August 1973 the *New York Times* ran five articles evaluating the changes that had taken place in the black community over the preceding ten years. The first article, on the front page of the 26 August

1973 *Times*, was accompanied by a photo of King speaking at the March on Washington. The article opened, recalling that march, its peace and brotherhood. Jon Nordheimer, the author, then noted that for many, the peace of that day had long since been destroyed. He then stated his thesis: "despite the agony of the intervening years, the decade since the March on Washington has produced tangible results that in many respects have exceeded specific goals set by the men and women who organized the mass demonstration." Nordheimer documented improvements in education and standard of living among blacks. These improvements were tempered, he wrote, by a growing disparity between the rich and the poor, and between the earnings of blacks and whites. The author found this distressing, but was still able to conclude that King's dream of a nation that would "live out the true meaning of its creed," was valid. Over the next four days, reporters covering the psychology of the black community, the state of the civil rights movement, and civil rights in two specific cities, used the same benchmark. Though life in America was not perfect, it was moving towards King's dream. There was little discussion of the rest of King's 28 August 1963 speech, no recognition of King's efforts to alleviate the poverty and divisions in the black community. He was his dream.[40]

There were some dissenting voices. In 1973, Roger Wilkins, nephew of NAACP leader Roy Wilkins, wrote in "The Innocence of 1963," that America had rejected the spirit of the March on Washington. On 28 August 1963, "when Martin King got up and spoke about his dream it all seemed possible. 'I have a dream,' he said and close to a quarter million black and white Americans jammed tight there by Lincoln's feet could believe." Wilkins argued that such belief was long gone, that in 1973, "the country doesn't seem to know how to deal with these problems [poverty, unemployment], nor does it seem to care . . . [that] black cynicism about American purposes and the moral core of the country grows at an astonishing rate." Novelist James Baldwin echoed Wilkins' remarks five years later. He wrote sadly of the failure of King's dream. "To look around the United States today is enough to make prophets and angels weep, and, certainly, the children's teeth are set on edge. This is not the land of the free, it is only very unwillingly and sporadically the home of the brave." The title of his piece summed up his feelings, "The News From All the Northern Cities Is, To Understate It, Grim; the State of the Union is Catastrophic."[41]

It was the sense of gloom voiced by Wilkins and Baldwin, coupled with a wistful evocation of better times while King still lived, that sparked the calls for a holiday in his memory. Much of the space the *New York Times* gave to King after his assassination was associated with attempts to make his birthday a holiday.[42] Of course, in reporting on King birthday celebrations, the *Times* was simply covering the news. But the *Times* articles always made a point of reporting calls for an official King holiday, listing places that had already answered that call, and noting sources of opposition to a King holiday. And, throughout the 1970's *Times* articles commonly mentioned his dream and his contributions to national politics. By the late 1970's, the *Times* began to frame calls for a King holiday as referenda on King's dream. As state and local debates over the holiday received more coverage, the politics of the holiday took precedence over its substance. The desire for reform shifted into the desire for commemoration, in just the way they had in Atlanta. In the shift, the last vestiges of religious meaning were lost from King's message, to be replaced by squabbles over the cost and date of the holiday.[43]

The effect of the media's insistence on a King holiday and its association of King with his dream became clear in the early 1980s. Before Ronald Reagan's election, conservatives and Republicans had either ignored King or opposed a King holiday because of its cost to government coffers. The states and communities that celebrated a King day did it because blacks, liberals and Democrats could outvote their conservative opponents. But with Reagan's ascension to the presidency in 1981, conservatives began to find the King holiday a useful forum for their civil rights policies. In the early 1980s, the civil rights establishment would continue the equation of the dream with economic equality, claiming that they were fulfilling King's mandate by supporting affirmative action and social programs for the poor. The Reagan administration likewise saw economics as the heart of civil rights, but argued that the very government programs favored by liberals were responsible for black poverty. Thus, Reagan and his supporters argued that King dreamed of equality of opportunity and "color-blind" laws.[44] Both sides saw King as a national hero, one whose elevation to federal status would strengthen their political causes. It is not surprising, then, that the coalition in support of the holiday won its passage by using King's "dream" as a metaphor for his entire life, or that the passage of the King holiday became a symbol of

being right on the problems of race in America. Only a memorial commemoration could encompass these divisions, as it did in Atlanta at the same time.

The push for a national King holiday began in earnest in 1981. That January, approximately 100,000 people marched on Washington. Jesse Jackson, Dick Gregory, Marion Berry, and Stevie Wonder addressed the march while in Atlanta, Coretta King and Andrew Young led a similar demonstration. Wonder set the tone for the rally, calling for a reaffirmation of King's values: "justice, honor, dignity, and freedom." Wonder added "To honor him [King] through a national holiday would . . . bestow a great honor on Black America by implicitly recognizing him as a symbol of the tremendous contribution Black people have made to this country's historical development." If King were to be such a symbol, he would have to be pure. The following year Wonder guaranteed King's "noble purity" by equating a King holiday with the cherished 1963 memory of King. He wrote, "I believe in King's dream. I encourage all of us who believe in the fulfillment of that dream to be present January 15, 1982, in Washington D.C. Then we will march again to . . . make the Dr. Martin Luther King, Jr. Birthday Bill a reality."[45]

The 1983 Senate debate over the King bill and its coverage in the press demonstrated the extent to which national politicians were prepared to accept Wonder's recapitulation of the national media's view of King. Republican Senator Jesse Helms opposed the bill because he thought it incorrect to honor with a national holiday a man who consorted with Communists and cavorted with concubines. Senators (and the media) were quick to assail him. Bill Bradley spouted that Helms was "playing up to old Jim Crow and all of us know it," while Daniel Moynihan called Helms' accusations "filth." *Time* magazine echoed Bradley and Moynihan, labeling Helms an "echo of [Joseph] McCarthy."[46] In a 1983 article on the debate over the proposed King holiday, *U.S. News and World Report* summarized King's life in this way: "The effort to honor King comes 20 years after he led a march on Washington to give the 'I have a dream' speech that fanned the civil rights revolution. Five years later, in 1968, he was murdered in Memphis."[47] The historical errors are obvious. The civil rights revolution was well under way by August 1963, and King did not lead the March on Washington in order to give the "I Have a Dream" speech. More telling is the disappearance of King's religion and the last

four years of his life. There is no mention of his efforts in Chicago, his call for guaranteed employment and a guaranteed annual wage for all Americans. His opposition to the war in Vietnam is missing, as is the invasion of Washington by the poor that King was planning for April 1968. Also worth noting is the pedagogical intent of this type of press coverage. Why else include a thumbnail biography, if not to draw people to King, to honor him with a memorial?

Such dreamy views of King's life were not unique to *U.S. News.* On 27 January 1986, *Time* published an article which, though recounting events in King's life up to 1965, managed to attribute the passage of the 1964 Civil Rights Act and the 1965 Voting Rights Act to the March on Washington and the "majestic Whitmanesque imagery" of the "dream" speech.[48] Even more pervasive than such shrunken biography were photos of King delivering his 28 August 1963 speech, which accompanied many articles on civil rights in the 1980's.[49] Also common were advertisements placed by major American corporations in black magazines such as *Jet* and *Ebony* which sold products based on King's dream. American Express offered credit packages in these words: "The children that Martin Luther King, Jr. dreamed would one day be judged 'not by the color of their skin but by the content of their character,' have emerged. . . . The American Express companies are proud to offer them a chance to live out their dreams. And to make them a reality."[50]

When the muck from the debate settled, the U. S. House and Senate voted in favor of a King holiday to be held the third Monday in January.[51] Ronald Reagan signed the bill authorizing a national Martin Luther King Day on November 2, 1983. By the first national celebration, in 1986, the King holiday and the meaning of King's legacy had become subjects of great partisan ferment. Indeed, the breadth and vagueness of the holiday's justifications almost guaranteed dispute over its specific meaning. The Reagan administration used the dreamer King as a foundation in remodeling federal civil rights policy. Reagan demanded "color-blind" law enforcement, a rollback of "benign" discrimination, and an end to racial quotas. The head of the civil rights division of the Justice Department, William Bradford Reynolds, warned that unless affirmative action was curbed, America in 1996 would look like the "separate but equal" America of 1896. Reynolds speculated that King would approve of this action, for he "dreamed aloud" of a nation where his children would "not be judged

by the color of their skin, but by the content of their character." If the nation rejected Reagan's proposals, "we will advance no closer to the realization of the dream of Dr. Martin Luther King, Jr."[52] Attorney General Edwin Meese used the same logic, when on the first national celebration of King's birthday he called for the government to eliminate its rules on minority hiring for government contracts. Meese maintained that his proposal "was very consistent with what Dr. King had in mind when he spoke of a color-blind society."[53]

Civil rights advocates assailed the "especially scandalous" timing and message of Meese's speech, and claimed that King's dream supported an entirely different political agenda.[54] The outline of the anti-Reagan agenda is perhaps clearest in the 1983 commemoration of the March on Washington. There, scores of liberal groups used the anniversary of King's "I Have a Dream" speech to both recall King's remarks and protest Reagan administration policies. Marchers called for jobs programs, disarmament, gay rights, and an end to foreign interventions and Reagan's "color-blind" policies. This program, as much as Reagan's, illustrates how far lost King's legacy was to "the dream" and to the "national is political" mindset. For instead of recalling that King stood also for jobs programs, disarmament, and an end to foreign interventions, and that his stance was based on a particular moral and religious view of human relations, marchers used him as a convenient talisman for liberal politics. And while some parts of the press assailed the marchers' politics, none questioned their assumption that King's legacy was primarily political.[55]

Partisan wrangling over King's legacy continued through the Reagan administration and into that of his successor, George Bush. Republicans continued to argue that King's legacy stood on the side of their "color-blind" policies. William Bennett, Secretary of Education under Reagan and Bush's first drug czar, in a 1991 call for a "New Civil Rights Agenda," noted that Americans believed in "equal opportunity, efforts to expand opportunity for the disadvantaged, reward for merit and hard work, and fairness in the workplace." The American public did not associate these with the civil rights establishment. Why? Because the descendants of King had rejected King's emphasis on a color-blind society. "Martin Luther King's dream was moored to American principles, and the most basic promise of American life—equality. It judged individuals by, in King's own words, 'the content of character' and not the 'color of skin'. . . . The

current civil rights agenda undercuts the principle of equality; it judges individuals on the color of the skin, not the content of their character."[56] In response to positions like that of Bennett, the civil rights establishment reasserted its opposing view of King. But while debate about the political meaning of King's dream continues, the debate has become insignificant precisely because of its memorial context. King comes up only around the holiday, while the holiday, in its drive for inclusiveness, invites misues of King's legacy. Thus ex-KKK leader David Duke's use of the language of colorblindness in his 1991 entrance to national Republican politics has spoiled that rhetoric for the rest of the Republican party. George Bush's use of the "Willie Horton" ads in his 1988 election campaign and his nomination of Clarence Thomas to the Supreme Court have shown that Republicans can be color-conscious. On the other side of the debate, the president is now a moderate Democrat with an uncertain civil rights policy, while massive white opposition (and some vocal black opposition) to affirmative action and busing have stalled those programs. And above all this, civil rights legislation in the United States has sunk into a morass of legalese, where both sides claim policy victory and the grandeur of Martin Luther King's dream can shed no light.[57]

Though myopia has made Martin Luther King's dream almost useless in national politics, the existence of a national holiday in King's honor requires that King continue to play a role in national life. To fill the gap left by the dream image, the media have sought alternative ways of remembering King.[58] They have most willingly accepted them from academia for two reasons.[59] First, thirty-four years have now passed since the March on Washington, and twenty-nine since King's assassination. The temporal distance of those events makes them somehow historical and thus "academic". Second, the political battles over free speech on campus, academic radicalism, and multiculturalism, have made academic viewpoints "hot" and their public expression a sign of the media's dedication to diversity. But though the academics covered in the media have furnished a variety of new King images, those images fit the format of national discussion set by the mainstream media, bounded by the memorial style, and ratified by the holiday in King's memory.

The earliest academic efforts to provide a new way of thinking about King came in response to the creation of the King holiday. At a symposium held at the installation of a bust of Martin Luther King in

the Capitol in 1986, David Garrow, the editor of King's papers Clayborne Carson, and historian John Hope Franklin, sought to rebut "the simplistic figure of legend and popular myth, the hallowed image of the martyred national hero that now so profoundly shapes the memory of Martin Luther King, Jr."[60] Though nearly every speaker at the conference mentioned the King myth, it was Claiborne Carson who most directly addressed it. In his remarks he claimed that the King behind the holiday was too "innocuous . . . a black counterpart to the static heroic myths that have embalmed George Washington as the Father of His Country and Abraham Lincoln as the Great Emancipator." He then summarized academic approaches to King which variously sought to uncover the origins of his thought in liberal Protestantism and the black church tradition, place King in the context of a mass movement for social change in which King was important but not essential, and emphasize the last years of his life, when King became more radical. Carson concluded that such studies supported the belief that "participants in social movements can develop their untapped leadership abilities and collectively improve their lives."[61] Each of these research trends has appeared in the national media since 1986. There, they have been joined by Carson's own discovery that King plagiarized part of his dissertation.[62] Yet none of these new images has received the in-depth coverage that they were afforded at the 1986 symposium. Instead, each has been generalized, changed, and incorporated into the King holiday.

Of the alternate images outlined by Carson, the least common has been that of King as a part of a mass movement and not its leader. David Garrow made that argument in an essay titled, "The Age of the Unheralded," published in the April 1990 issue of *The Progressive*. There, Garrow argued that the popular pressure leading to the fall of communism in Eastern Europe was similar to that employed for civil rights in the U. S. Just as Vaclav Havel and Lech Walesa rose from popular organizations to political prominence, King rose from a coalition of local organizations to become the national symbol of the Civil Rights Movement. King was simply the most well known exponent of civil rights, not the savior of the United States. And while King did much hard labor for the movement, the real work came from men and women who sought change in their own communities.[63] Garrow's goal, to shift the emphasis from King to other participants in the movement was repeated in an essay by Denton L. Watson, one-time

director of public relations for the NAACP. Published first in the *Chronicle of Higher Education* and then in *Education Digest*, Watson's essay, "Did King Scholars Skew Our View of Civil Rights?" also sought to take the spotlight off of King, in this case placing it on the legal maneuvers of the NAACP.[64]

Both Garrow and Watson's essays appeared in journals with relatively small readerships. In larger media outlets, neither their emphasis on King's role or their focus on local efforts appeared with any frequency, though Blackside Productions and PBS made a strong first step at it with the "Eyes on the Prize" documentaries. In fact a more common approach to the question of King's place in a mass movement has been to interview civil rights activists and students about their opinions of King. Thus, instead of raising public appreciation for the members of the movement by lowering King's status, as Garrow had hoped, the mass media have raised King's status by getting testimonials from the masses about his greatness.[65]

In the place of the "King as first among many" image have appeared evaluations of King as a political radical, and, most recently, as a counterpart to Malcolm X. Writing in the *Nation* in 1985, Garrow commented on King's radicalism. He predicted that the King holiday would obscure the revolutionary aspects of the Movement and decried Reagan's conversion to King's sanitized past, reminding readers that, in the last years of his life, King said that his dream had turned into a "nightmare."[66] Similar ideas have been expressed frequently in the mass media since, becoming a handy companion to reports that chronicle pay disparities between blacks and whites or opinion poll evidence of racism. On Martin Luther King Day, 1993, Michael Eric Dyson of the University of North Carolina, noted in the *New York Times* that King had fallen out of the Gallup Poll's list of the ten most admired people in America in 1967 because of his opposition to the Vietnam War and his calls for a guaranteed annual income and "temporary segregation" to preserve black economic power. In its unsigned editorial on King Day, 1993, the *Times* agreed with Dyson, noting also that King had opposed the Vietnam War and had died in a struggle for economic rights for sanitation workers in Memphis. King's memory was in danger from those who cast him as "an unthreatening ''Moderate Alternative,' an integrationist whose nonviolence can be favorably contrasted to more militant strategies of black

empowerment." King was not a moderate alternative, but instead a "nonviolent revolutionary".[67]

Though academics have long noted King's growing radicalism in the last years of his life, that view has entered the national community only in response to rising African-American interest in Malcolm X, especially as epitomized by Spike Lee's film.[68] According to Dyson, the image of Malcolm X as a revolutionary black nationalist held commonly by African-American youth has devalued King's legacy and led to a misunderstanding of both King and Malcolm X. Dyson argues that the elevation of Malcolm X above King sprouts from the continued influence of the "narrow, dualistic" ideology of 1960's-style black nationalism, where one is either a black separatist or a white pawn; and a lack of understanding about King's intellectual development. For Dyson, the last years of King's life teach that King was no instrument of white power but rather a "trumpet for moral and social revolution." King's growing disillusionment with white liberals, his view that the weight of the Vietnam War fell unfairly on blacks, and his plan for an occupation of Washington D.C. by an army of the poor lead Dyson to conclude that "no one who lived, fought, and died as [King] did can be accused of selling out black people or compromising the principles of racial and economic justice."[69]

As I write, then, there are four major images of King at play in the national realm, all typical of the memorial style. The dreamer King still survives, though with the exception of Coretta Scott King's non-partisan efforts and her annual "State of the Dream" speech, it has been largely given over to headlines ("An unfulfilled dream," "Poll: Racial equality still a dream"), advertisers, and politicians on the stump.[70] The view, articulated by David Garrow, that King was only a player in the movement, not the movement incarnate, crashes up against a national holiday that is Martin Luther King Day, not Local Civil Rights Hero Day, and the fact that most towns in America do not have local civil rights heroes. It is, I believe, destined to secondary status. Comparisons of King and Malcolm X will fade as Lee's movie moves onto the "drama" shelves at the local video store. That leaves only the radical King, among the four, as a viable national image. It will continue to receive some attention as journalists and parliamentarians seek to link racial hatred to something they understand and academics continue to make racism an important analytical category. But the radical King image seems a nostalgic one in the national media, a wistful evocation

of the late 1960s when Martin Luther King was proposing changes in America that are today politically impossible. Who, after all, in either major party or the Perot insurgency, is calling for a guaranteed national income, or full employment, or an end to military expenditures so that billions more can be spent on federal social programs, as did King in 1967 and 1968?[71]

Notes

1. "Editorial," *Life*, 12 Apr 1968, 6; "Reflecting on King's Legacy," *New York Times*, 18 Jan 1993, A16.

2. By "mass media" I mean those media outlets that provide first-hand coverage of national events and are distributed nationally. For the purpose of this study, I have relied largely on the print media, for both practical and theoretical reasons. First, there is little evidence of substantive differences in emphasis or ideology between print and visual news media. Back issues of magazines and newspapers are much more readily available than are archives of television programs, and many of the print media outlets have been in existence through the entire period covered by this book, (while television outlets have not). More importantly, the print media are better creators of history than are television networks, for they allow certain reporters to cover a beat for a long period of time, permit (especially in magazines) lengthy expositions on important topics, are more readily archived than broadcasts, and have a greater effect on policy-makers. On the effect of print versus visual media on American audiences, see James L. Baughman, *The Republic of Mass Culture: Journalism, Filmmaking, and Broadcasting in America Since 1941* (Baltimore: Johns Hopkins University Press, 1992), chapters 4-8. The fifth chapter of David Garrow's *Protest at Selma* (New Haven: Yale University Press, 1978) is also suggestive, for it argues that while the American public was heavily influenced by television coverage of the civil rights movement, national politicians relied more heavily on the print media. Finally, there is some research data showing that readers retain more information, for a longer period of time, than do viewers. See Doris A. Graber, *Mass Media and American Politics* (4th ed., Washington, D.C.: Congressional Quarterly Press, 1993), 202. For this chapter, I have relied on the national opinion journals cited in *Reader's Guide to Periodical Literature*, but especially the *National Review*, *New Republic*, *Nation*, *Ebony*, *Jet*, *Time*, *Newsweek*, and *U.S. News and World Report*. Among newspapers, I have looked most closely at the *New York Times*, but also the *Washington Post*, and *Wall Street Journal*.

3. Robert Entman defines media "slant" as the tendency of journalists to "provide partial accounts that assist some causes while damaging others" even as they avoid obvious ideological bias. He cites the heightened influence of lead stories and the media's focus on the Iowa caucus and New Hampshire primary as examples of slanted coverage without bias. Robert Entman, *Democracy Without Citizens:*

Media and the Decay of American Politics (New York: Oxford University Press, 1989), 36, 39-74.

4. Entman (note 3 above) argues that liberal bias is difficult to define and measure, and is less important than slant. However, in the case of the national media, its slant, and particularly its emphasis on politicians and life in Washington, D.C. is liberal; that is, it focuses on the power of the federal government. This convergence of slant and bias is particularly important in understanding the place of conservatism in national life. Conservatives are supposedly opposed to centralized, expansive, intrusive federal power, yet the media focuses particularly on those conservatives who work within the federal government. See Paul H. Weaver, "The Intellectual Debate," in David Boaz, ed., *Assessing the Reagan Years* (Washington, D.C.: The Cato Institute, 1988), 413-422, on the effect of national life on conservatism.

5. On the mass media's hyper-attention to the words of politicians and bureaucrats, see Graber, *Mass Media*, 2-3, 129-30. Graber notes that media attention turns to non-office holders most commonly when they are engaged in political protest (130). This may help explain how King gained entrance to the media and why the media easily translated King's style of protest into a wholly political program. There is a wide-ranging debate about media bias which is often clouded by disagreements over what constitutes "liberal" and "conservative" points of view. While most critics of collusion between the media and government argue that the media are overwhelmingly conservative, commentators who view the media and government as two separate parts of national democracy tend to see the media as liberal. On the "conservative" media see Edward Herman and Noam Chomsky, *Manufacturing Consent*, (N.Y.: Pantheon, 1988) and the journals *Lies of our Times* and *In These Times*. On the "liberal" media see S. Robert Lichter, *The Media Elite* (Bethesda, Md.: Adler and Adler, 1986), W. Lance Bennett, "Toward a Theory of Press-State Relations," *Journal of Communications*, Spring 1990, 110, and Graber, *Mass Media*, 104-6. Herbert Gans may be closest to the truth when he argues that the mass media have a "reformist" bias, and as reform has generally been associated with liberal programs, journalists are likely to give more credence to liberal than conservative views. See Herbert Gans, *Deciding What's News* (N.Y.: Pantheon, 1979), 69. On national and local coverage, see Graber, *Mass Media*, 124, Gans, *Deciding*, 8-38, and Joel Meyrowitz, *No Sense of Place* (N.Y.: Oxford University Press, 1985).

6. There is general agreement that the mass media have a huge effect on most Americans, but that effect is exceedingly difficult to

uncover. For a good discussion of attempts to measure media impact on society, see Stanley Rothman's introduction to, Rothman, ed., *The Mass Media in Liberal Democratic Societies* (N.Y.: Paragon House, 1991). Cecilie Gaziano has argued that people of high socioeconomic status (SES) know more about national and foreign policy issues than do those of low socioeconomic status, and that while high SES people gain most of their knowledge from the media, low SES people gain theirs from rumor or folklore. Cecilie Gaziano, "The Knowledge Gap: An Analytical Review of Effects," *Communications Research*, Oct 1983, 458, 477. On the impact of the national media on journalists and politicians see Graber, *Mass Media*, 108, 129. On journalists' roles as self-conscious creators of history see Zelizer, *Covering the Body*, 30, and Michael Schudson, *Watergate and American Memory* (N.Y. : Basic Books, 1992), 103-126.

7. On King's image in newsmagazines during his life, see Richard Lentz, *Symbols, the News Magazines, and Martin Luther King* (Baton Rouge: Louisiana State University Press, 1990). On King and the NAACP, see Denton L. Watson, "Did King Scholars Skew Our Understanding of Civil Rights?" *Education Digest,* Sept 1991, 56-8.

8. David J. Garrow, *Bearing the Cross: Martin Luther King, Jr., and the SCLC* (N.Y.: William Morrow and Co., 1986), 284-285.

9. Ibid., 272-280.

10. James Reston, "I Have a Dream...," *New York Times*, 29 Aug 1963, 1. David L. Lewis, *King: A Critical Biography* (N.Y.: Praeger, 1970), 210-230 also points out how marchers toed a line laid down by the Kennedy administration, but adds that even without intervention by the president, the march would have been peaceful and non-confrontational.

11. Martin Luther King, *Where Do We Go From Here? Chaos or Community* (Boston: Beacon Press, 1968), 91; David Garrow, *Protest at Selma* (New Haven: Yale University Press, 1978), 221-2.

12. "I Like the Word Black," *Newsweek* 6 May 1963, 27-28; "The Awful Roar," *Time*, 30 Aug 1963, 9.

13. *Washington Post*, 28 Aug 1963, 16.

14. *New York Times*, 29 Aug 1963, 20; Garrow, *Bearing*, 282-3.

15. The excerpts from King's speech are taken from Alexandra Alvarez, "Martin Luther King's 'I Have a Dream': The Speech Event as Metaphor," *Journal of Black Studies*, Mar 1988, 350-356.

16. Immediately following the march, Lewis' toned down remarks got as much press coverage as King's speech. See Susanna McBee, "Restrained Militancy Marks Rally Speeches," *Washington*

Post, 29 Aug 1963, 14A; Reston, "I Have a Dream," 1; "The Meaning of the March," *Time*, 6 Sept 1963,13-15.

17. King's entire speech was televised, while major press outlets printed excerpts. See *Washington Post*, 29 Aug 1963, 14A; *New York Times*, 29 Aug 1963, 6, 22; "The Meaning of the March," *Time*, 6 Sept 1963, 15; *Newsweek*, 9 Sept 1963, 19.

18. Using line numbers taken from Alvarez's article (note 19 above), *Time* published lines 17-18, 56-60, and 124-136 of King's speech. *Newsweek* ran lines 24-28, 33-35, 41, 46-51, 65-87, 108-113, 116-117, 119-136, and 141-146. The *Washington Post* printed lines 62-66, 72-75, 82-88, and 123-127. The *New York Times* ran lines 48-55, 65-73, 79-86 92-97, 98-103, 108-136, 141-147, and 191-193.

19. Keith Miller, *Voice of Deliverance* (N.Y.: Free Press, 1992), 142-158.

20. Reston, "I Have a Dream," 1; McBee, "Restrained Militancy," 14; *Newsweek* 9 Sept 63, 19; "The Meaning," *Time*, 6 Sept 1963, 15.

21. Near the end of his life, King often said his dream had turned into a nightmare. See James H. Cone, *Malcolm and Martin and American: A Dream or a Nightmare?* (Maryknoll, N.Y.: Orbis Books, 1991): 215-240. On the continued religious basis for King's actions see Smith and Zepp, *Search*, 132-140.

22. "King's Targets," *Newsweek*, 22 June 1964, 26. See also Lentz, *Symbols*.

23. "Man of Conflict Wins Peace Prize," *U.S. News and World Report*, 26 Oct 1964, 24.

24. "Why They Riot," *National Review*, 9 Mar 65,178-80; Frank S. Meyer, "The Violence of Nonviolence," *National Review*, 20 Apr 1965, 327.

25. King, *Where*, 130, 162-5; "Render Unto King," *Time*, 25 Mar 1966, 18-19.

26. Ernest John Hughes, "A Curse of Confusion," *Newsweek*, May 1967, 17; "Signs of Erosion," *Newsweek*, 10 Apr 1967,32; "Dr. King's Disservice to His Cause," *Life*, 21 Apr 1967, 4.

27. King, *Where*, 17-8, 48; "Lord of the Doves," *Newsweek*, 7 Apr 1967, 44; "As Negro Unrest Continues to Spread," *U.S. News and World Report*, 25 July 1966, 30.

28. On fears of civil disobedience, see "Now, a New Kind of March on Washington," *U.S. News and World Report*, 22 March 1965, 8; "New Negro Threat: Mass Disobedience," *U.S. News and World Report*, 28 Aug 1967, 10; "Memo to MLK," *National Review*, 12 Dec

1967,1368; Frank S. Meyer, "Showdown with Insurrection," *National Review*, 16 Jan 1968, 36

29. "Which Way for the Negro?" *Newsweek*, 15 May 1967, 27-28, 30, and 33-34.

30. See King's last book, *Where Do We Go From Here*, which lays out the state of King's thinking in the years preceding his death. Also, see King's last article, published posthumously: Martin Luther King, "U.S. Plays Roulette with Riots," *Washington Post*, 7 Apr 1968, B1, 3.

31. "With But One Voice," *Nation*, 24 Apr 1967,515-516; "Dr. King Carries Fight to Northern Slums," *Ebony*, Apr 1966, 94-96.

32. On King finally moving towards the leadership of a national political movement, see Lewis, *King*, 374.

33. It is a measure of the media's secular nature that when faced with the challenge of presenting a calming image of King, it failed to recall the Christian vision of the beloved community that drove King's crusade and dignified his late radicalism. Of the journals cited in *The Reader's Guide to Periodical Literature*, only the *Christian Century* has faithfully considered King's religion as well as his politics. See, most recently, Jerry Gentry, "Celebrating and Exploiting King Day," *Christian Century*, 14 Mar 1990, 268-70; Martin Marty, "MLK: The Preacher as Virtuoso," *Christian Century*, 5 Apr 1989, 348-50; and Preston N. Williams, "Remembering King through His Ideals," *Christian Century*, 19 Feb 1986, 175-77. The best full-length works on the religious context of King's life are Lewis Baldwin, *There is a Balm in Gilead* (Minneapolis: Fortress Press, 1991) and *To Make the Wounded Whole* (Minneapolis: Fortress Press, 1992). See also Cone, *Malcolm and Martin and America*. See also Neuhaus, *The Naked Public Square*, 78-93, and *American Against Itself* (Notre Dame, IN.: University of Notre Dame Press, 1992), 53-72.

34. Murray Schuman, "Martin Luther King, Jr.: Leader of Millions in Nonviolent Drive for Racial Justice," *New York Times*, 5 Apr 1968, 25-26.

35. "Dr. King, Apostle of Nonviolence, Drew World Acclaim," *Washington Post*, 5 Apr 1968, A12.

36. "Mrs. King Pleads for All to Fulfill Husband's Dream," *Washington Post*, 7 Apr 1968, A2.

37. "The Prince of Peace is Dead," *Ebony*, May 1968, 172.

38. "A Year of Homage to Martin Luther King," *Ebony*, Apr 1969, 31-42.

39. Lottie Hoskins, ed., *"I Have a Dream": The Quotations of Martin Luther King, Jr.* (N.Y.: Grosset and Dunlap, 1968): *I Have a*

Dream: The Story of Martin Luther King, Jr. in Text and Pictures (N.Y.: Time-Life Books, 1968); Lenwood G. Davis, *I Have a Dream* (Westport,: Negro University Press, 1969). For examples of periodical articles incorporating "the dream," see C. Nuby, "He Had a Dream," *Negro History Bulletin*, May 1968, 21; "He Had a Dream: Excerpts from *My Life with Martin Luther King, Jr.*," *Life*, 12 Sept 1969, 54 passim; "Keeper of the Dream," *Newsweek*, 24 Mar 1969, 38, and "Dream, Still Unfulfilled," *Newsweek*, 14 Apr 1969, 34-35.

40. John Nordheimer, "'The Dream' 1973: Blacks Move Painfully Toward Full Equality," *New York Times,* 26 Aug 73 1, 44; Ronald Smothers, "Uneven Gains Deepen Pressures on Blacks," *New York Times,* 27 Aug 73 1, 22; B. Drummond Ayres, "Two Cities, North and South, Show Progress by Blacks," *New York Times*, 28 Aug 1973, 1, 26; Paul Delaney, "Civil Rights Unity Gone in Redirected Movement," *New York Times,* 29 Aug 1973, 1, 16; Ernest Holsendolph, "63 March in Retrospect: Many Strata of Meaning," *New York Times,* 30 Aug 1973, 35, 54.

41. Roger Wilkins, "The Innocence of August 1963," *Washington Post,* 28 Aug 1973, A20; James Baldwin, "The News From all the Northern Cities is, to Understate It, Grim; The State of the Union is Catastrophic," *New York Times,* 5 Apr 1978.

42.Trailing far behind articles on the King holiday were articles commemorating his assassination, and those covering the hijinks of James Earl Ray, King's killer. On assassination memorials, see "Memphis March Marks Murder of Dr. King, " *New York Times,* 5 Apr 1973:, 47; and "2,000 Memphis Marchers Honor Dr. King, " *New York Times,* 5 Apr 1978, A18. On James Earl Ray, see Martin Waldron, "James Earl Ray to Move to U. S. Prison," *New York Times,* 28 Dec 1973, 26; and "Author Wins Right to Talk to Brother of Dr. King's Slayer," *New York Times,* 4 Jan 1974:, 41.

43. There are dozens of articles on birthday celebrations, most of which give prominent play to King's "dream". For those where celebrants mention "the dream" see Barbara Campbell, "Ali Delights Students Here at a Tribute to Dr. King," *New York Times* 13 Jan 1973, 20; Ronald Smothers, "Dr. King and the Movement are Recalled as His 44th Birthday is Observed Here," *New York Times*, 16 Jan 1973, 29; "Memory of Dr. King is Marked in Church Services Around City," *New York Times,*13 Jan 1975, 32; and, "Dr. King is Honored on 46th Birthday," *New York Times,* 16 Jan 1975, 44. At other times, journalists added the phrase "the dream". See Frank J. Frial, "King and Dream Recalled Across U. S.," *New York Times,* 16 Jan 1974, 53; Sheila Rule, "Youngsters Sing of a Dream on Dr. King's Birthday," *New York*

Times, 16 Jan 1980, B1; Sheila Rule, "On King's Anniversary, Reflections on His Dream," *New York Times,* 15 Jan 1982, B4. On calls for a holiday as referenda on King's dream, see N.Y. State Senator Carl McCall's remarks, quoted in "Memory of Dr. King is Marked in Church Services Around City," *New York Times,* 13 Jan 1975, 32; and the comments of United Food and Commercial Workers Union President William Wynn, quoted in "Union Honors Dr. King by Declaring a Holiday, " *New York Times,* 12 Jan 1980, A25. Early in the 1970's, those who had worked with King interpreted his labors in religious and moral terms. Andrew Young held that "the immoral conduct of this nation's activities in Vietnam over the past years is bankrupting us," Smothers, "Dr. King and the Movement," 29; while Jesse Jackson chided white religious leaders for not joining in King's crusade or seeking moral and religious answers to racism, poverty, and hate. Jesse Jackson, "White Religious Leaders and Black Social Justice," *New York Times,* 11 Apr 1973, 46. By the late 1970's, this moral and religious language was gone See Richard D. Lyons, "Lobbying Goes on to Shift Holidays," *New York Times,* 4 May 1975, 16; Alfonso A Narvaez, "Legislature Lacks Power to Summon Special Session," *New York Times,* 5 June 1975, 34; "South Carolina March," *New York Times,* 16 Jan 1976, 34; Martin Waldron, "Trenton Topics," *New York Times,* 3 Feb 1977, 71; Howell Raines, "Pressure Rises for Day in Georgia Hailing Dr. King," *New York Times,* 10 Jan 1979, A12; and Martin Tolchin, "House Sets Back a Plan to Make Dr. King's Birthday a U. S. Holiday, " *New York Times,* 6 Dec 1979, A1. Occasionally, individuals suggested that the King holiday be held on a Sunday, either to save money or to properly recall King's religious legacy. Calls for a Sunday holiday were routinely dismissed by civil rights leaders and legislators who supported King Day. See Narvaez, "Legislature Lacks Power," *New York Times,* 5 June 1975, 34; Martin Tolchin, "House Sets Back a Plan," *New York Times,* 6 Dec 1979, A1; "A Sunday for Dr. King," *New York Times* ,30 Jan 1981, A36.

 44. Reagan's linkage of civil rights and laissez-faire economics explains some of his administration's "insensitive" actions on King Day, such as Edwin Meese's declaration that the federal government would no longer support minority set-asides for government contracts. See note 50 below. Reagan assiduously courted blacks who shared his view on economics and race, frequently meeting with the Council for a Black Economic Agenda, a group of black academics, activists, and businessmen who advocated "self-help, not government aid." See Gerald M. Boyd, "President Meets with 20 Blacks, Intent Disputed," *New York Times,* 16 Jan 1985, A1, D21; Bernard Weintraub, "Reagan

Opens Observances Leading to Dr. King's Birthday," *New York Times,* 14 Jan 1986, A16. For a sympathetic look at the proposals of these black conservatives, see Joseph G. Conti, *Challenging the Civil Rights Establishment: Profiles of a New Black Vanguard* (Westport: Praeger, 1993). The phrase "color-blind", though associated with civil rights since *Plessy v. Ferguson,* was given a slightly different twist by Reagan. In the 1960's, a "color-blind" law was one that did not discriminate against blacks. Such laws were inherently "color-conscious." In Reagan's usage, though, "color-blind" meant "without regard to color." The implications of this change are clearer in the context of King's dream speech. In that speech, King dreamed of a day when *his* (black) children would be judged "not by the color of their skin, but by the content of our character." In a 1982 commemoration, Reagan said that King had dreamed a day when *our* children (presumably, those of all Americans) would be evaluated on character, not race. By shifting the object of king's dream, Reagan was opening King's legacy to white Americans (a good thing), but detaching it from its historical roots. See "In Snow and Icy Winds, a Nation Honors Dr. King," *New York Times,* 16 Jan 1982, 9; and, on the popularity and results of Reagan's blend of laissez-faire economic rhetoric and race relations, Edward G. Carmines and W. Richard Merriman, Jr., "The Changing American Dilemma: Liberal Values and Racial Policies," in Paul M. Sniderman, et al. eds., *Prejudice, Politics, and the American Dilemma* (Stanford, CA: Stanford University Press, 1993), 237-255.

45. *Ebony* magazine had called for a King holiday as early as 1968. See "A Hero to be Remembered," *Ebony,* Apr 1975, 134. "Birthday Celebration for Martin Luther King," *Ebony,* Mar 1981, 126-129; "For Dr. King," *Essence,* Jan 1982, 116.

46. "A National Holiday for King," *Time,* 31 Oct 1983, 32.

47. "Martin Luther King Will Have His Day," *U.S. News and World Report,* 7 Oct 1983, 16.

48. Jacob V. Lamar, Jr., "Honoring Justice's Drum Major," *Time,* 27 Jan 1986, 24-25. The *Nation* magazine recognized the dual nature of such rhetoric, noting that it both honored and co-opted King's memory. See "The March Goes On," *Nation,* 1 Feb 1986, 99-100.

49. For photos of King at the March on Washington, see *Ebony,* Jan 1980,83; *Newsweek,* 31 Oct 1983, 32; *Ebony,* Nov 1985,70; and *Newsweek,* 27 Jan 1986,17.

50. For the American Express ad, see *Ebony,* Jan 1989, 47. For other ads which banked on "the dream," see *Ebony,* Jan 1986, 42; *Jet,* 3 Feb 1986, 6-7; *Ebony,* Jan 1987, 31; *Ebony,* Jan 1988,19, 33, 39, and 47; *Ebony,* Jan 1989, 43.

51. In their coverage of the holiday debate, the media painted Jesse Helms as the chief antagonist to the holiday, thus intimating continued white southern opposition to King and by extension civil rights. When the votes were counted, though, most opposition to the holiday came from western states with small black populations. On the other hand, many white, Southern Republicans supported the holiday. For a breakdown of the voting, see *New York Times,* 20 Oct 1983, B9.

52. William Bradford Reynolds, speech given before the Current Domestic Politics Class, University of California, Berkeley, 30 Nov 1983 (speech in possession of Professor Raymond Wolters, University of Delaware).

53. Lamar, "Honoring," 25. See also note 41 above.

54. *Washington Post,* 16 Jan 1986, A 11.

55. Dudley Clendinen, "For Rights Rally, Nostalgia Edged with Disillusion," *New York Times,* 27 Aug 1983, 1, 27; Michael T. Kaufman, "Over 20 Years, the Mood Has Changed Markedly," *New York Times,* 28 Aug 1983, 28; Kenneth T. Noble, "Rights Marchers Ask New Coalition for Social Change," *New York Times,* 28 Aug 1983, 1, 30; "Remembering the Dream," *Newsweek,* 5 Sept 83, 16-17; "I Have a Daydream," *National Review,* 16 Sept 83; "March to Nowhere," *New Republic,* 19-26 Sept 83, 7-10.

56. William J. Bennett, "A New Civil Rights Agenda," *Wall Street Journal,* 1 Apr 1991.

57. The debate over the meaning of the 1990 Civil Rights Act illustrates this point. President Bush signed the bill, swearing he had not signed a "quota" bill. Democrats claimed the same bill was a historic advance for civil rights. More recently, the uproar over Lani Guinier's nomination to the civil rights branch of the Justice Department shows the same confusion. Few in the national community were sure where she stood on voting rights and affirmative action,. most were unable to fathom her scholarly writings.

58. The image now left out entirely from national discussion of King's legacy is that held by Jesse Helms, that King did not deserve a holiday because he was tainted by communism. By now, the holiday is an almost entirely inoffensive idea. But see the view of a self-described paleo-conservative, Samuel Francis, "The Cult of Dr. King," in *Beautiful Losers: Essays on the Failure of American Conservatism* (Columbia, Mo.: University of Missouri Press, 1993), 152-160, where Francis argues that the King holiday has been used as a tool to squelch conservative disapproval of King.

59. While the bulk of new images of King have come from the academy, there have been a few attempts to gather the opinions of

regular folks. See, "What Martin Luther King, Jr. Means to Me," *Ebony*, 3 Jan 1992, 76-80 and "What Did We Lose?" *Life*, Apr 1993, 56-67. On the way academic work is interpreted in the national media, see Carol H. Weiss and Eleanor Singer, *Reporting of Social Science in the National Media* (N.Y.: Russell Sage Foundation, 1988).

60. Peter J. Albert and Ronald Hoffman, eds., *We Shall Overcome* (N.Y.: Pantheon Books, 1990), 4.

61. Clayborne Carson, "Reconstructing the King Legacy: Scholars and National Myths," in Albert and Hoffman, *We Shall Overcome*, 248.

62. "Plagiarism and Originality: A Roundtable," *Journal of American History*, June 1991, 11-123.

63. Garrow, "Age of the Unheralded," 38-43.

64. Watson, "Did King Scholars," 56-8.

65. Mary Breasted, "Pupils at P. S. 180 Wonder If Dr. King Were Alive . . . " *New York Times,* 15 Jan 1974, 39; "What Martin Luther King, Jr. Means to Me: Ten Prominent Americans Reflect," *Ebony*, 31 Jan 1986, 74-78; "What Martin Luther King Means to Me," *Ebony*, 3 Jan 1992, 74-80.

66. Jesse Jackson's remarks on the King holiday are reported in P.L. Goldman, "Dr. King's Last Victory," *Newsweek*, 27 Jan 1986, 16-17. Garrow's are found in his review of James Farmer's book, *Lay Bare the Heart*, in the *Nation*, 4 May 1985, 535, 537.

67. Michael Eric Dyson, "King's Light, Malcolm's Shadow," *New York Times,* 18 Jan 1993, A17; "Dr. King, Peaceful Disturber," *New York Times,* 18 Jan 1993, A16.

68. Lewis, *King*, 354-389; Smith and Zepp, *Search*, 132-137; Vincent Harding, "Beyond Amnesia: Martin Luther King, Jr. and the Future of America," *Journal of American History*, Sept 1987, 468-477. On Spike Lee, Martin Luther King, and Malcolm X, see Henry Lewis Gates, "Generation X: A conversation with Spike Lee and Henry Lewis Gates," *Transition* 56: 176-190.

69. Dyson, "Martin's Light"; Peter Ling, "More Malcolm's Year than Martin's" *History Today*, Apr 1993, 13-16; Reverend Darren Cushman-Wood, "Martin Luther King, Jr. and Malcolm X: Economic Insights and Influences," *Monthly Review* 45, 21-35; Michael Eric Dyson, "Martin and Malcolm," *Transition* 56, 48-59.

70. The headline "An unfulfilled dream" is from "An Unfulfilled Dream," *U.S. News and World Report*, 21 Jan 1991, 8. The headline, "Poll: Most say racial equality still a dream," is from Howard Goldberg, "Poll: Most Say Racial Equality Still a Dream," *Wilmington News Journal,* 27 Aug 1993, A6. For an attempt by a white politician to

curry black votes by evoking King, see Peter Applebome, "Racial Lines Seen as Crucial in Mississippi Runoff," *New York Times*, 12 Apr 1993, B10.

71. For example, the last serious effort at legislated full employment, one of King's most liberal proposals, came in 1978. See B. Drummond Ayres, "New Jobs Law Is Urged as Humphrey Honor, " *New York Times*, 15 Jan 1978, A27. For a particularly nostalgic look at King's late economic proposals, see Stuart Burns, "Martin Luther King's Empowering Legacy," *Tikkun*, Mar/Apr 1993, 49-53, 67-68.

6
Joseph McCarthy and the Traditional Scholarly Succession

McCarthyism, we are saying, has narrowed the limits within which political proselytizing can safely go forward in the American community. The assertion that there is a "reign of terror" directed at all who disagree with Senator McCarthy, we are saying further, is irresponsible nonsense. But something is abroad in the land, and we have no objection to its being called a "reign of terror" provided it is clear that a metaphor is being used, and that the victims are the Communists and their sympathizers.

—William F. Buckley and L. Brent Bozell[1]

A preoccupation with status has been a persistent element in American politics and...McCarthyism as a social phenomenon [can] best be explained as a form of "status anxiety" in groups that have been "tormented as a nagging doubt as to whether they are really and truly and fully American."

—Daniel Bell[2]

Joseph McCarthy was a hard man to pin down, an upsetter of expectations, a leader and a follower, at once passing and permanent, important and inconsequential. Those who sought to make sense of his life while he still lived found that recounting its outline sometimes made McCarthy less comprehensible.[3] And so, metaphors marked the point of origin for scholarly work on McCarthy.

The phrases that have surrounded him—Buckley and Bozell's "reign of terror", Bell's mention of "status anxiety," the ubiquitous "McCarthyism"—do several things. They define McCarthy and his actions, they judge McCarthy's impact, they direct attention to

particular portions of McCarthy's life, and they relate McCarthy to something more understandable.[4] Combined with McCarthy's unsettled persona, the metaphorical approach to his life and times has yielded a wide variety of definitions, judgments, and assessments of McCarthy's relevance to American life. Thus, for Buckley and Bozell, McCarthyism was a political and cultural "call for conformity" that was mostly good and widely popular.[5] Others, of course, have seen him in a less kindly light.

But metaphorical descriptions of McCarthy have their own history. Attempts to describe McCarthy's import as a crusade for conformity or an example of status politics were common during and shortly after McCarthy's life. By the 1970s the metaphors for McCarthy were replaced by factual descriptions. Then, in the late 1980s and early 1990s, metaphors reappeared. This time, though, instead of finding metaphors for McCarthy, McCarthy became the metaphor. Witness the most recent assessment of McCarthy, by psychiatrist and historian Joel Kovel. Kovel called McCarthy the "beast of anticommunism," the most well-known spokesman for a national infirmity that had its roots deep in American history—"The trail of repression that ended as anticommunism began as Indian hating: the first red scare against the first of our communists."[6]

The birth, disappearance, and return of McCarthy metaphors mirrors changes in scholarly interpretations of McCarthy, changes that cannot be accounted for by the inconsistencies in McCarthy's behavior. Nor does a recurrence to the politics of scholars writing on McCarthy (they were overwhelmingly liberal) or a turn to national political trends entirely explain the shifts in the meaning of his life.[7] Indeed, given McCarthy's reputation as a "bad guy," the almost universal use of "McCarthyism" as a term of opprobrium, and the Cold War's tenure over most of the McCarthy scholarship, one would expect a fairly static McCarthy to emerge from the academy. That McCarthy's legacy has not been set in stone is a remarkable fact, then; one due to a waning constellation of tendencies in American scholarship—rigid disciplinary boundaries,[8] the belief that certain academic disciplines are better suited than others to interpret the present, the conviction that the tools of scholarly history are best applied to events at some temporal remove, the idea that the passage of time allows clearer vision of the past. These beliefs, and the very specific results they occasioned in the work of historians writing on McCarthy epitomize the scholarly style of

historical remembrance. This chapter traces the emergence, after the interest of sociologists and political scientists had waned, of the scholarly style in writing about McCarthy, and highlights the difficulties that the scholarly style has in making itself relevant in public life.

The first scholars to examine McCarthy were sociologists and psychologists. But soon, sociology and psychology gave way to political science, which in turn acquiesced to history. I will call this succession from sociology and psychology to political science to history—this shift from the importance of the present to the importance of the past—the traditional sequence of scholarship.[9] This sequence has been severely criticized of late, both because it is parochial (each discipline stakes out its own territory, interdisciplinarity is discouraged), and because it supposedly makes the past irrelevant (either by dividing up knowledge in discreet compartments or by gathering so much technical information that no one can digest it all). Such criticisms overlook three important points. First, scholars cannot *make* the past relevant by themselves. Events outside the academy and scholarship must match, or the past is simply past. Second, time and disciplinary boundaries deepen knowledge. Then, if the past still matters, it can be both relevant and correctly understood. Third, there are varieties of relevance—a historic event can be politically relevant and not resonate outside Washington D. C., or it can be historically relevant, a must-know fact from the past, without mattering in the course of elections. Contemporary calls for relevance, though, often overlook these distinctions, seeking or bewailing the politicization of scholarship.

In concrete terms, the shift from sociology to political science to history matched the narrowing of McCarthy's relevance from national politics to political theory to historical analogy. And together, the passage of proprietorship from one discipline to another and the reduction of McCarthy's relevance accompanied diminishing assessments of McCarthy's power. As time passed and historical analysis deepened, McCarthy shrank from a position as the leader of a mass social movement, to a powerful national politician, to a star of the conservative wing of the GOP, to a latecomer in the battles over domestic communism, to a rather unexceptional, hard-working, belligerent midwestern confidence man manipulated by his superiors and flummoxed by his fame.[10] This does not mean that McCarthy has been

rehabilitated, or his actions excused. Rather, the passage of time, the emergence of evidence, and the recession of relevance made scholarly interpretations of McCarthy's life less passionate and more (dare I say?) objective.[11] Only at this point did McCarthy metaphors re-emerge and with them, new claims that knowing about McCarthy mattered, not for changing national politics, but for understanding why people in the United States act the way they do.

The typical starting point for assessments of McCarthy scholarship is *The New American Right*, a collection of essays by renowned American social scientists published in 1955. Its fame requires that it appear at the outset of this essay as well, but I wish to couple it with another work on McCarthy published at about the same time—Buckley and Bozell's *McCarthy and his Enemies*. This is, on the surface, a strange comparison, for the two books are quite different. Buckley and Bozell praised McCarthy, the authors of *The New American Right* condemned him, Buckley and Bozell's work rarely receives comment, except as a sort of historical freak—a scholarly work on McCarthy's behalf—*The New American Right*, though its thesis has been largely rejected, still elicits respect as the foundation from which most McCarthy scholarship has grown. But there is good reason to consider the books together, for they share an assumption—that McCarthyism was a mass social movement, and a goal—to influence contemporary politics—that place them together at the beginning of the scholarly succession.

Among the authors of *The New American Right* were two historians, Richard Hofstadter and Peter Viereck, and five sociologists, Daniel Bell, David Reisman, Nathan Glazer, Talcott Parsons, and Seymour Martin Lipset. McCarthyism inspired their papers, but none of the papers was explicitly concerned with it or McCarthy. Rather, they sought to understand the social origins of the new right, a political movement which included McCarthy, but which existed before him and continued after his demise. Though the essays varied in emphasis, each argued, in Daniel Bell's words, that the new right "cannot be explained in conventional political terms." In place of typical interest group politics, the authors identified "status politics" as the central force behind the emergence of the new right.[12] That is, they believed that in the absence of economic turmoil, the political upheaval of the mid-1950s was symptomatic of mass psychological strain, in turn

occasioned by insecurity about one's standing in society. Several of the authors suggested that groups whose statuses were in flux, such as the new rich, assimilating ethnic groups, small businessmen, and members of the old middle class, would be particularly likely to feel status anxiety, as would "authoritarian personalities," die-hard isolationists, and people ill-at-ease in the highly organized, bureaucratic American system. These citizens would assuage their anxieties by supporting political attacks on established leaders of American society—eastern businessmen, intellectuals, and New Deal politicians. Thus, the anticommunist crusade of the new right was not about foreign policy or Communist subversion. Instead it was an attempt to soothe insecurities brought on by the increasing complexity of American life—newly-assimilated Germans assured their American-ness by attacking the loyalty of the White Anglo-Saxon Protestants, small businessmen denigrated the New Deal for introducing excessive government planning and regulation, independent doctors and lawyers found fault with the economists, sociologists, and engineers who had replaced them in the leading professions of the middle class.[13]

The essays in *The New American Right* still impress for a number of reasons. First, they are written in the witty, wide-ranging, acerbic, off-the-cuff style characteristic of the *Partisan Review* and other magazines of the New York intelligentsia.[14] Second, though written by scholars, the essays are not scholarly. A few lack footnotes; the notes that do appear feature parenthetical comments as often as references to other works. Third, inasmuch as the essays are undergirded by research, it is in psychology (Hofstadter, Reisman, Glazer), sociology (Parsons), political theory (Bell), and public opinion (Lipset), not voting records, interviews, or archives. Fourth, though they contain no explicit call for a political response to the far right, the essays hope to alert American leaders to the weaknesses of American political institutions. Fifth, the essays address the present and the near future. The context is always the role of the far right in contemporary American politics. The two historians offer only a few references to the past, but their works are grounded in social theory, not American history. Sixth, the book's heart was with the establishment—it implied that only big business and big government had the organizational capacity to beat Soviet communism *and* manage American capitalism. Meanwhile, the far right came off as hopelessly provincial (Viereck called them "hick Protestants") and potentially dangerous, but ultimately doomed to recede

before the passage of time. Reisman and Glazer wrote that "the new right . . . wants at best an atmosphere: it really has no desire to change the face of the nation; it is more interested in changing the past."[15]

William F. Buckley and L. Brent Bozell strongly disagreed with Reisman and Glazer, and indeed, with the rest of the contributors to *The New American Right*. Buckley and Bozell claimed that the majority of Americans supported McCarthy, that McCarthyism was squarely within the American mainstream, and that liberals, not "the far right," were the source of America's instability. Further, they argued that McCarthy's attacks on the State Department, Owen Lattimore, General George Marshall and Dean Acheson (among others) were generally correct, for even if they were not Communists (an accusation McCarthy often resorted to because he was at heart a propagandist, not an intellectual), they were risks to national security. For Buckley and Bozell, the issue was not loyalty, but competence. If government employees contributed to policies that advanced the power of the Soviet Union, either out of disloyalty or incompetence, they deserved to be fired.

Buckley and Bozell understood the implications of this argument for Washington, D. C. and the rest of America. They held that the government had no need to retain workers whose opinions differed from those of the administration. They should be fired, but without passing judgment on their loyalty, a policy that had, in the past, unjustly ruined some careers. To continue to employ those with differing opinions was to thwart democracy, for the people had elected the president with certain policy expectations in mind.

Opinion outside of government did not need such tight strictures. Freedom of expression was fine, as long as that expression did not uphold communism. Support for the Soviet Union fell outside the pale for three reasons: it threatened the survival of the United States, it overlooked the evils of communism, and it contradicted American orthodoxy.[16] A certain conformity of opinion was a good thing, a necessary part of any successful society, and the goal of McCarthyism. Buckley and Bozell denied that McCarthyism was stifling the country in the 1950s. Indeed, there had never been a time more conducive to "partisans of the Brennan Plan, of socialized medicine, of continued and increased federal preemption of state functions, of the closed shop, of doctrinaire international philanthropy" and other "Liberal and Socialist activities."[17] Rather, McCarthyism was restoring hard-headed sanity to America's reigning consensus.

The differences between *McCarthy and his Enemies* and *The New American Right* are obvious—one was pro- the other anti-McCarthy, one trusted, the other distrusted McCarthy's followers, one found McCarthyism rational, the other irrational. But the similarities between the two are as important as the differences. Both considered McCarthyism a mass movement. Both argued that a national consensus should exist, that it should be rational, and that its bulwark should be a strong executive branch well able to resist communism and domestic heresy. Both books lacked a strong scholarly apparatus, were meant to have wide public appeal, and sought to be immediately relevant.[18] Both also lacked a sense of history and a good understanding of McCarthy. *The New American Right* overlooked McCarthy, *McCarthy and his Enemies* sought to make his thought rational and organized, something it never was. Neither book provided any biographical information about the man purportedly at the head of America's main mass movement of the 1950s.

The absence of biographical information and in-depth research is important, for it hints at the place of these two books in the nonfiction spectrum. They were serious works, shorn of common, extraneous information, dedicated to improving government and crafting cold war political practice. But they were also popular books, strong on ideas, provocative in language, and bound to the present. Their research came from the public record, not the (almost entirely inaccessible) archives. In short, they were the works of public intellectuals. Russell Jacoby has argued that the New York intellectuals, among whom were many of the authors of *The New American Right*, were the last generation of public intellectuals, the last scholars writing for a wide public audience. He blames their demise on suburbanization, the advent of television, and the rise of the university as the core of knowledge.[19] But Jacoby overlooks three points. First, the 1950s marked the last generation of liberal public intellectuals, but the first of conservative public intellectuals, many of whom gravitated to William F. Buckley.[20] Second, it was academic training in presentist disciplines that equipped intellectuals to address contemporary public concerns. Third, though public intellectuals wrote, by definition, for the public, their works were always the starting point for further scholarly research; that is, they were always tied to the university. Thus, the location of knowledge in the university was not a new thing, it had always moved there after it slipped from public relevance.

In McCarthy's case, the links between the public, government, public intellectuals, and the academy are clear in the first work to explicitly challenge *The New American Right*. In 1960, Nelson Polsby, a political scientist, published an article that challenged the "status politics" metaphor. Polsby's essay, "Towards an Explanation of McCarthyism," began with an expression of the traditional succession of scholarship that is worth quoting at length.

> The recent appearance of an apparently definitive journalistic post-mortem on Senator Joseph McCarthy [Richard Rovere's *Senator Joe McCarthy*] underscores the rather striking professional inattention of political scientists to one of the most spectacular political phenomena of our time. For those of us who view political science as a potentially powerful weapon in the cause of rational political decision-making, this lost opportunity seems especially poignant. If it is too late to assist politicians in determining the extent to which they should have allowed themselves to be imprisoned by the demands and the rhetoric of McCarthy and his followers, it is not too late to ask more academic questions about who McCarthy's followers really were, and about the sources and extent of his power.[21]

Polsby's sense of his place in the scholarly enterprise is striking. Given that a journalist had published a good biography of McCarthy, and that the time for political action had passed, "more academic questions" about McCarthy's strength had become appropriate. In other words, McCarthy's recession into the past made his movement more easily understandable.

The passage of time is clear in the organization of Polsby's evidence as well. Where the authors of *McCarthy and his Enemies* and *The New American Right* had provided only the vaguest reference to previous interpretations of McCarthyism, Polsby began his manuscript with a list of three—that McCarthyism was a reassertion of American isolationism in the face of an ever more dangerous world, that McCarthy appealed to the "authoritarian personality," and that McCarthyism was "status politics." Though essayists in *The New American Right* at one time or another referred to each of these

explanations, Polsby associates them only with the status politics explanation in his text. "The authors of *The New American Right* have advanced this hypothesis [status politics] in its most full-blown and persuasive form," he wrote.[22]

Polsby dealt only briefly with the isolationist and authoritarian personality theses (and not at all with Buckley and Bozell), before dismantling the status politics edifice with the tools of political science. Several factors account for Polsby's focus on status politics. First, the other explanations were largely untestable in the absence of precise definitions and complete data. Thus, for authoritarianism, Polsby wrote, "This hypothesis has gained some confirmation, but contrary evidence [the lack of racism and anti-semitism among McCarthyites] suggests the need for more precise specification of the personality characteristics which are supposed to have caused pro-McCarthy sentiments."[23] Second, they lacked broad explanatory power. Polsby wrote that even had the isolationist explanation been entirely correct, it would have identified "only a small portion of McCarthy's followers."[24] Third, the available data suggested that as far as they went, the isolationist and authoritarian theses were at least partially correct.

Had the status politics explanation been precisely defined, accompanied by reams of data, and completely wrong, then these three explanations alone would have justified Polsby's focus on status politics. But where Polsby shied away from vague definitions, missing data, and certain measures of truth in the isolationist and authoritarian personality explanations, he reveled in them when discussing status politics. Polsby's first table displayed the panoply of groups supposedly suffering status anxiety. He castigated major polling outlets for failing to take complete information, and offered an explanation that was more complete than status politics, but did not rule it out entirely.[25]

Polsby's attention to *The New American Right* and his identification of that book with status politics require further explanation, then; explanation that focuses on *The New American Right*'s style, its explicit attack on Polsby's discipline, and Polsby's desire to defend political science by showing its relevance. Polsby noted that *The New American Right* was an unscholarly book, that it predicted who would be attracted to McCarthy, but failed to "check these predictions against the available evidence." This was a particular affront

to political science because the status politics explanation clearly made traditional political science outmoded. Polsby put it this way—"The nature of American politics has changed, they say, so as to render the McCarthy movement unintelligible to conventional forms of political analysis." Polsby's task was to use a "conventional form of political analysis" to refute that argument, thus reasserting political science's relevance *in the academy.*

To do so, Polsby turned first to *The New American Right*'s main metaphor. He subsumed the book's arguments under the general heading of "status politics" (a logical step given the book's scattershot offering of explanations) and then implied that the authors of *The New American Right* had argued that status politics caused McCarthyism.[26] Having made status politics stand for *The New American Right* and McCarthyism, Polsby then demonstrated that political affiliation, not membership in a group suffering from status anxiety, was the best predictor of support for McCarthy. Quite simply, Republicans were more likely to support McCarthy than any other group of Americans, and McCarthy wielded power in Washington because he met the needs of the GOP.[27]

Polsby's refutation of the status politics argument and his defense of the methods of political science returned him to his essay's first themes—relevance and the passage of time. Polsby hoped that the McCarthy episode could teach "policy scientists" that they had at their disposal tools that could explain present politics and help politicians to make rational decisions. Had political scientists used their tools correctly during the early 1950s they could have shown McCarthyism to be a weak, disorganized political force, not a mass social uprising, and encouraged politicians to resist. Political science could affect the present, not just theorize about the past.[28]

Polsby had a powerful influence on subsequent McCarthy studies. His equation of *The New American Right* and status politics has held to the present, his argument that McCarthyism was a political phenomena is still dominant, and his appropriation of McCarthyism for political science inspired several major studies. Only his wish to keep the political interpretation of McCarthyism relevant has faded. Polsby's was the last study to use McCarthyism as a primer on the practice of political science. Two studies that followed his, Earl Latham's *The Communist Controversy in Washington* (1966) and Michael Paul

Rogin's *The Intellectuals and McCarthy* (1967) both stepped back from practice to theory. And though neither paid close attention to McCarthy's life, both did avail themselves of historical research, a tactic that would eventually lead to a better understanding of McCarthy even while he slipped from political science into the realm of history.

Polsby's impact on McCarthy studies is clear in the first few pages of Latham's book. Like Polsby, Latham mentioned the passage of time as a significant reason for his book's existence, "There is a new generation of people who have no memory of the tensions about communism in the years from the confrontation of Hiss and Chambers to the condemnation of Senator McCarthy of Wisconsin by the U. S. Senate," and like Polsby, Latham argued that the typical workings of the American political system explained McCarthyism. Latham's innovation was to take Polsby's insights and put them in historical context.

Between 1932 and 1954 the United States government responded to communism in two ways: it sought out and dismissed employees whose politics made them security risks, and it battled over the exact danger that communism posed to American government. The first response, the dismissal of political liabilities, Latham deemed the "communist problem." Though there had been some communists in government, and though they had carried on some espionage through World War Two, Latham argued that the problem was largely over by 1950, "dealt with (not inadequately) by agencies of the federal government." The second response to communism, the blow-up over domestic subversion that took place in the early 1950s, Latham named the "communist issue." It was a result of the weakening of the New Deal coalition that had run the country since 1932. The final years of that coalition, 1948-1952, saw the communist issue rise because the president, Democrat Harry Truman, represented the old party system, while the Republican-led congress represented the new. The divided government allowed allegations of softness on communism and committee investigations to be partisan tools. It was this opportunity that McCarthy exploited from 1950 to 1954. Eisenhower's election in 1952 lessened the pressures that fueled McCarthy. By 1954 Eisenhower had consolidated power in the Republican party and the office of the executive, thereby removing the structural supports for McCarthy. With McCarthy's fall came the fall of the communist issue.[29]

Around this thesis, Latham wrapped a history of the Communist Party of the United States of America, communists employed by the federal government, and McCarthy's role in hunting them down. McCarthy came to the issue late, after almost all communists had been fired, Latham argued. And though he was a rhetorical leader on the communist issue, he played a decidedly unimportant role in solving the communist problem.[30] This context was Latham's most important contribution to understanding McCarthy, for it began to move the focus of McCarthy studies from the states to Washington, and from mass psychology and voting records to the limits of anticommunism. In transit, McCarthy was transformed from the driver of a mass movement to a passenger in the inexorable shift from one party system to another.

While Latham focused Polsby's insight that McCarthyism was political, Michael Rogin sharpened his attack on the authors of *The New American Right*. Polsby chided them for failing to support their contentions with evidence from contemporary opinion polls. Rogin assailed them for lacking historical understanding. Rogin opened his book with a plea that Americans not forget McCarthy because he dominated public policy during the 1950s and because McCarthyism "changed the tone of intellectual discussion about politics in general and about American politics in particular."[31] More specifically he argued that many influential intellectuals considered McCarthyism to be an irrational popular movement. Fearing the irrationality of the people, these intellectuals drifted away from their own radical pasts into support for the established institutions of American society.[32] By so doing, liberal intellectuals had become conservatives—people who favored practicality over idealism. Ironically, the move to pragmatic conservatism placed liberal intellectuals firmly in the tradition that actually gave birth to McCarthyism.[33]

Though Rogin's target was clearly the whole body of Cold War liberals, his specific targets were several of the writers of *The New American Right*—Daniel Bell, Richard Hofstadter, David Reisman, and Seymour Martin Lipset. Rogin maintained that they unveiled their true anti-democratic natures by linking the midwest's agrarian radicalism of the 1890s through the 1930s with midwestern support for McCarthy in the 1950s.[34] The heart of Rogin's book was a long, careful investigation of voting patterns in Wisconsin, North Dakota, and South Dakota. He uncovered no continuity between the people and places that supported midwestern populism and those that supported McCarthy.

Rather, McCarthy's support came from areas that had traditionally supported conservative Republicans, while those who had once voted for Populists either drifted out of politics or supported the Democratic party in the 1950s.[35]

Rogin drew four conclusions from this information. First, because McCarthy neither garnered agrarian radical support nor attracted a significant number of new supporters to the GOP, his was not a mass movement.[36] Second, any links between populism and McCarthyism were rhetorical. His opposition to liberalism and eastern elites not only echoed populist language, but also followed traditional conservative denunciations of political opponents.[37] Third, the few new voters that McCarthy attracted to the Republican party came because of fears of communism, not out of status anxiety.[38] Fourth, *The New American Right*'s equation of agrarian radicalism, irrationalism, and McCarthyism masked its authors' deep contempt for populism, radicalism, and democracy.[39]

This final conclusion deserves some comment. Rogin's attack on Bell, Hofstadter and company was part of the broader anti-establishment, pro-populist, New Left offensive against Cold War liberalism in the late 1960s. Seen in this light, Rogin's revision of the McCarthy orthodoxy may seem to be motivated by politics, not the traditional scholarly succession, as I have argued. But while Rogin's politics may have inspired him to write *The Intellectuals and McCarthy*, it was not a political book in the sense that *McCarthy and his Enemies* and *The New American Right* were—it lacked political immediacy and piquant writing while overflowing with scholarly effluvia. Rogin's main political goal was to rehabilitate domestic radicalism, to prove that Populism was not the parent of McCarthyism. If Rogin and the New Left had been leaders of a renascent Populist movement, then his work might have had some direct influence on the workings of American government. But the New Left was hardly a populist movement—it sprouted no lasting political party, elected no officials, rallied few mass audiences. If anything, the New Left stood in the place of Populism's traditional foes among the educated eastern elites. (George Wallace and Richard Nixon saw this clearly, as they crafted their 1968 presidential campaigns as an attack on the radical eastern elites who were destroying America.) Given this distance between the New Left and historical Populism, New Left history could

be relevant only through analogy and could challenge only previous scholarship, both hallmarks of scholarly succession.[40]

 The Intellectuals and McCarthy received great praise. It was both imaginative and deeply researched. Its publication, together with that of *The Communist Problem in Washington*, marked an important turning point in studies of McCarthy.[41] By discrediting the theory and evidence behind the status politics and mass movement arguments, Rogin (and Latham) forced scholars to ask anew whence came McCarthy's power, and sent the most powerful McCarthy metaphors packing. By explaining McCarthy's rise in terms of rational politics, Rogin, Latham, and Polsby stripped from him the aura of evil omnipotence that he had previously carried. Rogin made him almost an anti-hero, concluding his book thus, "When McCarthy became a real antagonist of the institutions which conservatives respected—the Republican party, the Senate, and the Army—he lost influence both among the moderately conservative political leaders and among the population at large. As McCarthy became 'radical,' he lost his hold on American politics." And by turning to the past for explanations, they moved the grounds of the debate from sociology and political science to history.

 Certain types of publications mark the entrance of the past into the scholarly style of commemoration. For McCarthy, two of those publications emerged in the years 1970-71. In 1970, historian Allen J. Matusow produced the first edited collection of documents related to McCarthy's life. The following year the first historiographical essay devoted solely to the literature on McCarthyism appeared, marking both scholarly accumulation and the exile of the metaphorical McCarthy. Robert Griffith opened that survey by rejecting the view that McCarthy epitomized the anti-communism of the 1950s.

> The books under review in this essay concern McCarthyism, or, more accurately, America's second great Red Scare. The distinction is important, for the two are not synonymous. The term McCarthyism was coined during the early 1950s to describe the politics of anti-communism. The politics did not begin with Joe McCarthy's famous speech at Wheeling, West Virginia, nor did it end in 1954 with his censure by the Senate. Indeed, the term itself vastly exaggerates the Senator's importance and distorts the past of which he was only a part.[42]

Griffith both chronicled and contributed to the reassessment of McCarthy. He was the author of *The Politics of Fear: Joseph R. McCarthy and the Senate* (1970), the first academic biography of McCarthy. Granted, Griffith's book was not a full-blown biography. It provided no new information about McCarthy's life before politics, was built solidly around a thesis, and devoted its energies predominantly to McCarthy's career in the senate. But it was a biography nonetheless. Its narrative opened with McCarthy's birth, traced his ascent, and closed with his fall. It was concerned not with the characteristics of McCarthy's followers but with McCarthy's own behavior, not with testing theory or measuring metaphor, but with fixing facts.

Griffith opened his book seeking to understand how McCarthy rose to power. He found the answer by combining a study of McCarthy's behavior before 1950 with Rogin's argument that McCarthy was a product of traditional conservative Republican politics. Long before McCarthy ran for the U. S. Senate he demonstrated the characteristics that would lift him to that office. He was an astoundingly hard worker, ambitious, ingratiating, hyperbolic. He was rarely concerned with established procedure. He switched his allegiance from the Democrats to the Republicans after sensing that the road to political influence in Wisconsin led through the GOP. He misled voters about his opponent's age in the election that won him a judgeship in 1939. While a judge he earned praise for his alacrity (he made short work of a 250-case backlog and cheerfully dispensed "quickie divorces" to consenting couples) and condemnation for his audacity (he once destroyed transcripts from a case he decided while an appeal was still pending, an action the statue supreme court called "highly improper.") He volunteered for the Marines during World War Two, retained his judgeship while in the South Pacific, exaggerated the importance of his exploits there, campaigned in 1944 for the U. S. Senate in spite of military and judicial rules that forbade it, left the Marines in 1945 to make another run at the Senate, and won the GOP nomination in 1946 by sidling up to the conservative GOP machine. He beat the last of the famed La Follette clan in the 1946 primary election, and, in November, won a Senate seat.

While a Senator, McCarthy continued the course he had set. His politics were typical of centrist Republicans. Griffith called him a "moderate internationalist" on foreign policy and a conservative on domestic issues. It was not McCarthy's politics but his behavior that

distinguished him before 1950. Griffith wrote that in a debate over sugar decontrol McCarthy demonstrated a "disregard for truth and accuracy" and, in general, attacked "men, not ideas." His willingness to lie, to flout the rules, and to levy personal attacks on other Senators won him in 1948 a demotion from the Banking Committee to the Committee on the District of Columbia.[43]

By concluding that McCarthy's rise to the Senate grew from his own hard labor and unscrupulous behavior, Griffith raised other questions. Why would a junior senator, widely disliked by his colleagues in 1948, become by 1950 one of that body's most powerful members? And, more generally, was McCarthy's eminence after 1950 a fluke or a natural result of the American political system? Griffith responded that McCarthy's celebrity and power came because of the on-going national debate over communism, which he joined, late but loud, in 1950. Further, he argued that McCarthy rose on anti-communist rhetoric made palatable by a decade of domestic subversion investigations and the Democratic Party's establishment of loyalty review boards.[44] In spite of these concessions to anti-communism, the Republican party continued to paint the Democrats as soft on communism. Once McCarthy picked up these cries, then, he found himself in a congenial atmosphere, one where his histrionics would advance, not retard his career.[45] Republicans tolerated him, Democrats despised him (quietly) during the final two years of Truman's presidency. When Eisenhower came to office in 1952, McCarthy's attacks on the executive branch and his despicable behavior made him a liability once again. But this time, McCarthy's fame and the traditions of the Senate made punishing him more difficult than it had been in 1948.[46] Finally, under pressure from moderate Republicans, some Democrats, lobbyists from the National Committee for an Effective Congress,[47] and, at the end, the Eisenhower administration, the Senate censured McCarthy.[48]

In his conclusion, Griffith was careful to differentiate between McCarthy and McCarthyism. The Senate censured Joseph McCarthy, it did not repudiate McCarthyism, he wrote. But McCarthy's censure allowed senators to claim that McCarthyism was dead, even while they continued supporting anti-communist policies. For Griffith, as for Rogin before him, the lesson of McCarthy's life was that practical politics did not work. Practical politics permitted McCarthy's rise, the Republicans seeing in his energy and partisanship a tool to advance

party interests, the Democrats fearing for their jobs (and half-believing him anyway). In the face of McCarthy's challenge, the Senate had compromised its integrity in order to move slowly, cautiously, to preserve Senate tradition. "The politics of the possible were also the politics of fear," Griffith concluded.[49]

From Griffith's biography, scholarly writing about McCarthy grew in two directions. No longer able to blame McCarthyism on the American masses, scholars had turned their attention to American elites. But while the studies by Latham, Rogin, and Griffith established that national parties and the federal bureaucracy abetted McCarthy in pursuit of an effective anti-communist position, they failed to explain his influence, or the influence of anti-communism, outside Washington. During the 1970s and early 1980s a number of historians responded to this gap in the literature, investigating the role of powerful institutions in perpetuating anti-communism. At the same time, Griffith's focus on what McCarthy actually did while a senator led historians to pay more attention to McCarthy as a person and less to the phenomenon of McCarthyism. During the 1970s and early 1980s, scholars produced solid monographs that examined the role of anti-communism in the ACLU, the labor movement, the Catholic church, and the motion picture industry, and filled holes in McCarthy's biography.

A collection of essays edited by Robert Griffith and Athan Theoharis provided examples of the new focus on anti-communist institutions. Published in 1974, *The Specter: Original Essays on the Cold War and the Origins of McCarthyism* contained works by young scholars, all of whom accepted the "McCarthyism-as-elite-politics" thesis. Griffith and Theoharis both contributed papers, recapping their positions on McCarthy and the politics of the early 1950s. Donald F. Crosby provided an essay arguing that there was little mass support for McCarthy among Catholics. The backing he did receive came because Catholic leaders, long opposed to communism and radicalism, used their positions to sound an alarm about domestic subversion. Catholic intellectuals at least partially undermined this warning by alerting Catholics about the dangers of McCarthy's behavior. Ronald Lora argued that conservative intellectuals helped create an atmosphere where McCarthy could thrive by promoting a sharply divided world view that lumped God, good, and America on one side and communism, evil, and the Soviet Union on the other. Mary McAuliffe looked closely at skirmishes in the ACLU over whether communists belonged in its

leadership or deserved its defense. Again, national leaders bowed to the pressures of anti-communism, at times in direct conflict with the wishes of local ACLU chapters. Les Adler found a similar anti-communist consensus in Hollywood, as film-makers hewed to the image of dangerous communist subversives that emanated from Washington in the 1950s.[50]

The editors of *The Specter* strove mightily to find ties between the essays in their book and contemporary politics. And indeed, by shifting the grounds of the debate from mass social psychology to the politics of anti-communism, they had improved their chances. Robert Griffith, in the book's introduction, argued that the old interpretation of McCarthyism as a mass movement had justified limiting debate over policy in Vietnam to a few insiders. The old view also implied that public surveillance of administration policy hurt the national interest. In contrast, the insight that anti-communism was an elite creation demanded more public debate of foreign and domestic policy. Whether or not that was the case, by the time *The Specter* was published, the passage of time had made it irrelevant. Without accepting the New Left analysis of Cold War America, American anti-communists had begun a rapprochement with China and the Soviet Union. The Vietnam War was almost over, Richard Nixon's colossal attempts to cover up Watergate had led to greater public oversight of administration policy, and the ACLU, the Catholic church, Hollywood, and university professors had, in general, become more liberal. Even more to the point, the 1970s witnessed a flowering of interest in McCarthy and the 1950s in mainstream culture. A spate of memoirs, movies, and plays appeared, Watergate elicited accusations of McCarthyite tactics all around, but the insights of the New Left were absent.[51]

The strain of scholarship that had begun to focus on the details of McCarthy's life was equally detached from American politics. Both McCarthy's pre-Senate life and his career in Washington came under close scrutiny. Robert Griffith illuminated the origins of McCarthy's relationship with Dwight Eisenhower in an article on Eisenhower's 1952 campaign visit to Wisconsin.[52] Michael O'Brien presented a case of McCarthy red-baiting a Wisconsin journalist in 1949, placing the origins of McCarthy's use of anti-communism as a publicity-gathering tool before his Wheeling speech.[53] Thomas C. Reeves took a careful look at McCarthy's service in the Marine Corps, finding that McCarthy was both a good soldier (McCarthy's claim) and an unscrupulous self-

promoter (the claim of McCarthy's opponents).[54] Michael O'Brien capped off this period of scholarship, publishing in 1980 a long article on the early part of McCarthy's life and a book analyzing McCarthy's effect on Wisconsin.[55] O'Brien found that McCarthy had a normal upbringing—he was neither abused by his father or coddled by his mother—and had distinguished himself with his hard work and energy, if not with his dedication to the truth. McCarthy had a good memory and used it to advantage in the classroom (he rarely studied for law exams) and on the campaign trail (he seemed to know everybody's name, and greeted them all with a handshake and a smile). But he had no sense of propriety and no commitment to truth. Wisconsin Republicans admired his energy in 1946; that was enough to get him elected. His standing fell almost immediately, though, because he failed to address the concerns of his mostly rural supporters. His turn to anti-communism drew him new acclaim between 1950 and 1952, but he ran behind the ticket in the 1952 elections, fell under suspicion in the Wisconsin press, and by 1954 was widely disliked in his home state. O'Brien concluded that while McCarthy may have damaged civil liberties on a national level, his antics strengthened support for them in Wisconsin and gave new life to the Wisconsin Democratic party.[56]

Together, the biographical studies and the examinations of American anti-communism created a picture of McCarthy as a driven man who caught the anti-communist tone of American institutions only to offend them with his off-key behavior. But they also represented a phase in the evolution of McCarthy scholarship. Michael Rogin, Robert Griffith, and Athan Theoharis crafted an interpretive framework in the early 1970s. The scholarly commemorations that followed fleshed out that framework, filling the gaps with narrow studies of certain aspects of McCarthy's life. It was of uniformly high quality—based in primary research, well-organized, concise, well-written—certainly more scholarly than *The New American Right* or *McCarthy and his Enemies*. It was also detached from the present, irrelevant.

Of course, the move from general statements to specific inquiries is a common one in historical scholarship. At the same time that the view of McCarthy was shrinking from broad to narrow perspectives, the same transformation overtook scholarship on the ideology of the American Revolution, slavery, and Reconstruction.[57] This specialization of historical study has been greeted with dismay in may quarters. It is assumed that such specialization keeps historians from

communicating with each other, that it reflects the politicization of the university (each minority gets its own area of study, fragmenting knowledge, the story goes), and that it renders history irrelevant, meaningless, to its consumers. But McCarthy scholarship shows these concerns to be not all true. Specialization is not necessarily an outgrowth of the politicization of the campus. In McCarthy's case, specialization arose in the mainstream of historical scholarship. Specialization is also part of the logic of traditional scholarship, wherein history provides details to revise or fill out theories provided by other disciplines.[58] And relevance does not spring from the existence of a unified historical narrative, nor is it a creation of the politics of certain scholars. Indeed, it is forces outside the university—changes in the American presidency, economic disaster—that make the past meaningful in the present. Further, the definition of relevance has narrowed in recent discourse, with both conservatives and radicals linking it to national politics.[59] With relevance determined on such narrow grounds, much of history becomes automatically irrelevant.

The academic response to fragmentation is synthesis.[60] In McCarthy studies, synthesis took the form of full-length biography—two biographies, actually—of Joseph McCarthy. Thomas Reeves' *The Life and Times of Joe McCarthy* and David Oshinsky's *A Conspiracy So Immense: The World of Joe McCarthy* appeared in 1982 and 1983.[61] They were both massive books, combining dozens of interviews, years of archival research, and the immense literature on McCarthy and McCarthyism. And with a few exceptions (Oshinsky thought that by the time of his death, McCarthy was a true believer in the cause of anti-communism, while Reeves saw McCarthy's anti-communism as political expediency to the end), they told the same story.[62] McCarthy's early life was normal, he worked hard, first as a successful chicken farmer then as a grocery store manager. His ability to complete four years of high school in one year was remarkable. But McCarthy learned early not to let decorum get in the way of his ambition. He played an intimidating game of poker, boxed with great energy and little finesse, and ran hard, negative political campaigns.[63] Oshinsky summarized his pre-Senate behavior this way: McCarthy was "capable of unscrupulousness and loyalty, cruelty and understanding, [he was] destructive and generous without showing personal confusion."[64]

Reeves and Oshinsky argued that by the time McCarthy entered the Senate he was a mature provocateur, a wily politician, and a

budding anti-communist. He rose to power in the Senate because he
alternately flaunted and defended the rules of the Senate and because
many senators were willing to let him continue his attacks as long as
they hurt the other side. His speeches were full of distortions, his
questioning of hostile witnesses brimmed with rancor. He feared no
one, befriended those he attacked, sought fame, and, when it came,
accepted defeat. He was neither the first, the smartest, or the most
powerful anti-communist, only the best known.[65]

 The best historical syntheses hope to summarize old works and
inspire new inquiries. The biographies by Reeves and Oshinsky seem
only to succeed on the first count—they are compendious books, but
they offer no suggestions for further research.[66] The trajectory of
McCarthy studies also points to the biographies as an end point.
McCarthy had become a less important, less unusual person since *The
New American Right*, and scholarly studies had followed this
deflationary course, focusing more and more narrowly on McCarthy. A
glance at works related to McCarthy written after 1983 seems to
confirm this view. A historiographic essay penned in 1987 mentions
only one book written after the biographies, Ellen Schrecker's *No Ivory
Tower: McCarthyism and the Universities* (1986).[67]

 But since *No Ivory Tower* there has been a doubling back of
McCarthy scholarship, a turn from the narrow focus and archival
research on McCarthy. Accompanying this turn has been a new hunt for
relevance, new interest from non-historians, and new metaphors.
Ironically, the very common-ness of McCarthy in the works by Reeves
and Oshinsky, coupled with his continued fame has reinvigorated the
hunt for relevance, though the quarries now are students, not
politicians. Richard Fried's *Nightmare in Red: The McCarthy Era in
Perspective* (1990) and Ellen Schrecker's *The Age of McCarthyism: A
Brief History with Documents* (1994) both target college
undergraduates, a group unattended by McCarthy scholarship since
Allen Matusow's 1970 collection *Joseph R. McCarthy*.[68] William
Hixson's *Search for the American Right: An Analysis of the Social
Science Record* (1992) urges social scientists to ask broader questions of
and pay closer attention to right-wing politics in the U.S. Hixson does
his part, noting that several insights in *The New American Right* have
been overlooked by subsequent scholars (mostly political scientists)
who failed to seek the cultural basis of support for McCarthy.[69] The
linguist Harold Barrett devoted a large section of his 1991 book

Rhetoric and Civility: Human Development, Narcissism, and the Good Audience to McCarthy's rhetoric and his public's unwillingness to resist it on behalf of decency. Joel Kovel's *Red Hunting in the Promised Land* (1994) places McCarthy in a series of renowned American anti-communists to make a general argument that anti-communism in America is a sort of pathology based on the fear of outsiders. And professor of communication Thomas Rosteck has applied film theory to Edward R. Murrow's *See It Now* documentaries that attacked McCarthy.[70] Conservative scholars, absent since Buckley and Bozell, have reentered McCarthy studies as well, finding the new, less dangerous McCarthy more congenial than his earlier threat-to-the-nation incarnation.[71]

These post-1987 works, though scattered through the disciplines, hold in common several points. They are based on the historical scholarship of the 1970s and early 1980s, they use a historically accurate McCarthy as a metaphor for the topic at hand, and they argue that McCarthy is culturally relevant in spite of not being politically relevant. Thus, for Fried, McCarthy ought to matter to college students because he was historically important, not because McCarthyism might re-emerge under Reagan. For Barrett he matters because his relationship with Americans is "a case study of rhetorical pathology." For Kovel McCarthy is important because he was the "Caliban" of anti-communism, a man who, when compared with the staid national security state, made the latter seem acceptable, necessary. Kovel outwardly mourns the passing of liberation movements and the weakness of socialism after the fall of the Soviet Union, but he does not argue that anti-communism proves that socialism is best, only that anti-communism has coarsened American culture regardless of the merits of Marx.[72]

One may choose to question these characterizations of McCarthy, to doubt that he is relevant in these ways, but one must do it on the evidence, not on the author's politics. This is the strength of the traditional succession of scholarship—it may not always produce relevant scholarship, but if it does, that scholarship requests reasoned response.

Notes

1 William F. Buckley and L. Brent Bozell, *McCarthy and his Enemies* (Chicago: Regnery, 1954), 340.

2. Daniel Bell, ed., *The New American Right* (N.Y.: Doubleday, 1955), xi. The book was reprinted in 1964 as *The Radical Right* (N.Y.: Doubleday, 1964). The 1964 edition contained all but one of the original essays as well as several new ones in which the original authors updated their assessments of right wing politics in the U. S. All citations in this chapter are from the 1964 edition.

3. McCarthy's political ideology is a case in point. He entered politics as a New Deal Democrat, jumped to the GOP where some speculated he would be a liberal Republican. His anti-communist rhetoric allied him with the most conservative members of the GOP yet he sometimes took "liberal" positions on domestic policy, once calling for 100% of parity farm subsidies.

4. See, for example, Dennis Wrong, "Theories of McCarthyism—A Survey," *Dissent*, Autumn 1954, 385-392. Wrong states that because most discussions of McCarthy "amount to little more than manifestoes of denunciations or documented exposés" he was poorly understood. In order to come up with a list of "theories of McCarthyism" Wrong had to extrapolate from metaphor, or in his words, "the very terms in which McCarthy is castigated imply certain 'theories' about him."(385)

5. Buckley and Bozell admitted that McCarthy lied often and wrongly accused some people (most notably George Marshall) of being communists. Nonetheless, they argued that his was a movement "around which men of good will and stern morality can close ranks." Buckley and Bozell, *McCarthy and his Enemies*, 335.

6. Joel Kovel, *Red Hunting in the Promised Land* (N.Y.: Basic Books, 1994), 14.

7. Charges of political bias and presentism on the part of scholars have, of course, been staples for all sides in the public discourse about academia over the last fifteen years. If the author's politics explained his approach to McCarthy, one would expect conservatives and anti-communists to line up on his side, liberals and anti-anticommunists against him. But conservatives have been divided on McCarthy since the mid-1950s, Buckley and Bozell generally writing in his favor, Peter Viereck writing scathingly against him. See Peter Viereck, "The Revolt Against the Elite," *The Radical Right* (N.Y.: Doubleday, 1963), 135-154; and, on conservatives in general John Patrick Diggins, *Up From Communism* (N.Y.: Harper and Row,

1975), 434-443. Anticommunist liberals were among the most critical assessors of McCarthy, while members of the New Left attacked McCarthy less harshly than they did Harry Truman, who they saw as the architect not only of domestic anticommunism but also the national security state, the driving force, they believed, behind the political evils of the 1950s. For an example of the concerns of the New Left, see Robert Griffith, ed., *The Specter* (N.Y.: Franklin Watts, 1974). If national political events could explain changes in McCarthy's status, then given the liberal politics of most McCarthy scholars, one would expect harshly anti-McCarthy works, perhaps comparing him with Ronald Reagan, to be written during the 1980s. Instead, liberal scholars turned out works less opposed to McCarthy than ever before, with nary a mention of contemporary politics, during Reagan's tenure.

8. William Hixson, in a very careful study of scholarship about the American right, wrote that "the debates between scholars covered in this book are often less 'ideological' than methodological and reflect disciplinary rivalries as much as anything else." "This book" is William B. Hixson, *Search for the American Right: An Analysis of the Social Science Record* (Princeton: Princeton University Press, 1992), xxii.

9. Jane Sherron DeHart, "Oral Sources and Contemporary History: Dispelling Old Assumptions," *Journal of American History, Sept* 1993, 582. DeHart writes, "We still tend to believe in the superiority of chronologically distant, document-driven history, preferring our sources, like our wine, properly aged and stored." That the traditional approach is on the wane seems clear in the rise of oral history and in DeHart's assertion that "contemporary topics, even those imbedded in intense controversy, and the research techniques that contemporaneity make possible pose far fewer problems of perspective, sources, and evidence than is generally assumed." Ibid. For a case where the traditional sequence did not hold out see the following chapter on scholarly interpretations of Martin Luther King's life.

10. The same trajectory appears if one considers McCarthy's treatment in biographies, both journalistic and scholarly. The first book-length McCarthy biography, Jack Anderson and Ronald May, *McCarthy: The Man, the Senator, the Ism* (Boston: Beacon Press, 1952) painted him as the victim of an abusive father and an overprotective mother, a demagogue, a man who held much of the destiny of the United States in his hands. In the following biographies, McCarthy's power shrank, while attempts to understand and explain him grew. See Richard Rovere, *Senator Joe McCarthy* (N.Y.: Harcourt, Brace, and World, 1959), Lately Thomas, *When Even Angels Wept:*

The Senator Joseph McCarthy Affair—A Story Without a Hero (N.Y.: Morrow, 1973). By the time historians Thomas Reeves and David Oshinsky published their scrupulously researched biographies of McCarthy in the early 1980s, he had become an understandable if not entirely explicable American politician. Thomas Reeves, *The Life and Times of Joe McCarthy* (N.Y.: Stein and Day, 1982); David Oshinsky, *A Conspiracy so Immense: The World of Joe McCarthy* (N.Y.: Free Press, 1983). Mark Landis, *Joe McCarthy: The Politics of Chaos* (Susquehanna, PA.: The Susquehanna University Press, 1987) and Kovel, *Red Hunting*, have taken up the explaining, Landis through psycho-biography, Kovel through collective biography.

11. Richard Fried, in a review of Reeves' biography of McCarthy put it this way: "McCarthy is hardly rehabilitated. The wild charges, the contempt for rules and civility, the "Indian Charlie" tactics, the mountain of lies stand out for all to see. By stripping away the fantasies with which Joe's critics enshrouded his life, Reeves has "revised" the latter at least as heavily as he has McCarthy.... Reeves corrects the record, noting that the treatment of McCarthy has been so severely imbalanced as to make him "our King John." In Reeves' calmer assessment, the reality is bad enough." Richard Fried, "McCarthyism Without Tears: A Review Essay," *Wisconsin Magazine of History*, Winter 1982-3, 145.

12. Daniel Bell, "Interpretations of American Politics," in Bell, ed, *The New American Right*, 48.

13. The most strident attacks against these groups come from Peter Viereck, "The Revolt Against the Elites," in Bell, ed., *The New American Right*, 135-54, and for a slightly calmer approach, Talcott Parsons, "Social Strains in America," in Bell, ed., *The New American Right*, 175-192. The two essays that drew most of the attention were Richard Hofstadter, "The Pseudo-Conservative Revolt," 63-80, and Seymour Martin Lipset, "The Sources of the 'Radical Right'," 259-312 both in *The New American Right*. See also William Hixson's analysis of the book. Hixson, *Search*, 10-16.

14. Hixson, *Search*, 10.

15. David Reisman and Nathan Glazer, "The Intellectuals and the Discontented Classes," in *The New American Right*, 108.

16. Buckley and Bozell, *McCarthy*, 311.

17. Buckley and Bozell were quick to point out that three of the people McCarthy attacked in a 1952 speech, Archibald MacLeish, Bernard DeVoto, and Arthur Schlesinger, Jr. were granted major honors shortly after running afoul of McCarthy. Ibid., 312.

18. Both seem to have met their goals. Both were widely reviewed, and while Bell's book became a staple of scholarly interpretation (and was reissued and updated ten years later), Buckley became a leader in the newly revived ranks of conservative intellectuals while Bozell served on McCarthy's staff during the final years of his life.

19. Russell Jacoby, *The Last Intellectuals* (N.Y.: Basic Books, 1987).

20. The omission of a generation of conservative intellectuals is also part of a more recent series of essays on the resurgence of public intellectuals. See Michael Berube, "The New Black Intellectuals," *New Yorker*, 9 January 1995, 73-79, and Robert S. Boynton, "The New Intellectuals," *Atlantic Monthly*, March 1995, 53-70.

21. Nelson W. Polsby, "Towards an Explanation of McCarthyism," *Political Studies*, October 1960, 250.

22. Ibid., 254. In his notes, Polsby does mention *The New American Right* in association with the isolationist and authoritarian theses.

23. Ibid., 253.

24. Ibid., 252.

25. Ibid., 255, 268, 260. On the last point, that the Bell book was at least partially right, see Richard Hofstadter's 1962 comment that, "After six or seven years of additional observation of the extreme right, it now seems more probable that our original approach [to focus on underlying, mass psychological tensions to explain the rise of the far right] was correct." Richard Hofstadter, "Pseudo-Conservatism Revisited: A Postscript," in Bell, ed., *The New American Right*, 82.

26. Technically, they did not argue that status politics caused McCarthyism, but only that it tended to explain the rise of the new right in post-war America. Of course, the book's publication within a year of McCarthy's heyday made the connection seem obvious between status politics and McCarthy. But in the 1964 edition of the work the distinction between the new right and McCarthy is clearer, especially in the essays that push into the 1960s and discuss the rise of the John Birch Society. See, for example, Seymour Martin Lipset, "Three Decades of the Radical Right: Coughlinites, McCarthyites, and Birchers," 313-377, and Alan F. Westin, "The John Birch Society," 201-226. Westin did not have an essay in the 1955 edition.

27. Polsby, "Towards," 263.

28. Ibid., 271.

29. Earl Latham, *The Communist Problem in Washington; From the New Deal to McCarthy* (Cambridge, Harvard University Press, 1966), 3-7.

30. Ibid., 371.

31 Michael Paul Rogin, *The Intellectuals and McCarthy* (Cambridge: MIT Press, 1967), 2.

32. Ibid., 16-27.

33. Ibid., 44.

34 Ibid., 4-6. Rogin's assumption that Bell, Hofstadter, Reisman, and Lipset linked Populism with McCarthyism deserves comment. He derived this assumption largely from Hofstadter's *Age of Reform* (N.Y.: Vintage Books, 1955), Daniel Bell's *The End of Ideology* (Cambridge: Harvard University Press, 1960), and their essays in *The New American Right*. I can find no instance where any of the people Rogin mentions argued for continuity between agrarian radicalism and McCarthyism as political movements. Rather, they made the general argument that there is a long tradition of moralistic, alarmist, political rhetoric in the United States and that populism and McCarthyism both availed themselves of it. Indeed, Bell and Hofstadter were at pains to make clear that McCarthyism was unique because it arose during a time of economic prosperity, when the rhetoric condemning eastern elites, intellectuals, and political conspiracies had no economic basis, hence the status politics thesis. See *The Age of Reform*, 272-329, and *The End of Ideology*, 103-123, for Hofstadter and Bell's formulation of the American tradition of irrational rhetoric, and *The New American Right*, 47-8, 70-1 on the non-economic basis of McCarthyism. Interestingly, one writer in *The New American Right* did explicitly link Populism and McCarthyism (and displayed plenty of conservatism and anti-democratic feeling as well)—Peter Viereck. Viereck called McCarthyism "Populism gone sour" because it lacked the idealism and generosity that fueled the Populist movement. Viereck, "The Revolt," 137-8. Rogin overlooked Viereck, an avowed conservative, attacking liberals instead.

35. Ibid., 96-103, 131-5, 162-7.

36. Ibid., 247.

37. Ibid., 230.

38. Ibid., 242.

39. Ibid., 4-7.

40 There is today a consistent willingness on the part of conservatives and radicals to assume that the political impact of scholarly works (especially those dealing with well-known topics) matches the politics of the work's author. Thus, both conservatives and

radicals claim that a book written by a Marxist (for example)is a radical book, and, conversely, that the author of a book that arrives at conclusions matching conservative politics must be a conservative. Rogin's book seems to argue against this view, and for a view that a book's place in the literature, not its author's politics, largely determine the book's political utility.

 41. Rogin's book also marked an interesting shift in the relationship between intellectuals and politics. The authors of *The New American Right* offered theory that was intended to support practical (as opposed to idealistic) politics. In contrast, Rogin provided practical information—evidence—to support the idealistic politics of the New Left. This shift can be accounted for, in part, by Rogin's desire to revise orthodox theory. His evidence trumped *The New American Right*'s theory in a way that a new theory, on its own, could not. But his turn to evidence also brought New Left political theory into question. What hope did the New Left have of crafting a democratic mass political movement if the groups of people who had supported the Populists (the New Left's historical movement of choice) were either politically moribund or had long-since joined to the Democratic party?

 42. Robert Griffith, "The Politics of Anti-Communism: A Review Article," *Wisconsin Magazine of History*, Summer 1971, 299.

 43. Robert Griffith, *The Politics of Fear: Joseph R. McCarthy and the Senate*, 2d ed., (Amherst, MA.: University of Massachusetts Press, 1987), 1-19, quotes from pp. 16-7.

 44. Ibid., 31-8. In making this argument, Griffith followed the New Left's revision of Cold War historiography, which placed a great deal of the blame for the Cold War on the belligerence of the United States, and specifically on Harry Truman. This argument is best made by Athan Theoharis in *The Yalta Myths: An Issue in U. S. Politics* (Columbia: University of Missouri Press, 1970) and Theoharis, *Seeds of Repression: Harry S. Truman and the Origins of McCarthyism* (Chicago: Quadrangle Press, 1971).

 45. Griffith, *Politics*, 27-51.

 46. Ibid., 197-99, 221-3.

 47. An organization established in 1948, the NCEC realized before many other observers that McCarthy's power came not from deep support but apathy in the Senate. Early in 1953, the NCEC began pushing for McCarthy's removal. Its members found support in the Democratic party and also among Republicans bothered by McCarthy's antics. When Ralph Flanders proposed McCarthy's censure in the summer of 1954, the NCEC provided research support, called press conferences, and lobbied senators. Griffith's move to add the NCEC to

the story of McCarthy's censure is one of the strongest parts of a strong book. See especially pp. 224-240, 280-3.

48. Ibid., 271-317.

49. Ibid., 318-320. Quote is from p. 320.

50. Robert Griffith and Athan Theoharis, eds., *The Specter: Original Essays on the Cold War and the Origins of McCarthyism* (N.Y.: Franklin Watts, Inc., 1974). The following essays are mentioned above. Robert Griffith, "American Politics and the Origins of McCarthyism," 2-17; Athan Theoharis, "The politics of Scholarship: Liberals, Anti-Communism, and McCarthyism," 264-280; Donald F. Crosby, "The Politics of Religion: American Catholics and the Anti-communist Impulse," 20-38; Ronald Lora, "Conservative Intellectuals, the Cold War, and McCarthy," 42-70; Mary S. McAuliffe, "The Politics of Civil Liberties: The ACLU During the McCarthy Years," 152-170; Les K. Adler, "The Politics of Culture: Hollywood and the Cold War," 242-260. Crosby's essay became a larger work, *God, Church, and Flag: Senator Joseph R. McCarthy and the Catholic Church, 1950-1957* (Chapel Hill: University of North Carolina Press, 1978). For two more books in the same vein as the essays in *The Specter* see David Oshinsky, *Senator Joseph R. McCarthy and the American Labor Movement* (Columbia: University of Missouri Press, 1976). In this work, Oshinsky refutes the argument made by journalists that communists in the labor movement helped elect McCarthy in 1946 because they hated his opponent, Robert LaFollette. He then turns to the national labor movement's response to McCarthy while he was a senator, finding that the national AFL and CIO both rejected McCarthy on partisan and behavioral grounds, but not on anti-communism or civil liberties. By 1954, the attempts by McCarthy and other senators to investigate labor pushed most union members into the ranks of the Democratic party. See especially pp. 161-184. Edwin R. Bayley was a Wisconsin journalist during McCarthy's tenure and later became a professor of communications. In 1981 he published *Joe McCarthy and the Press* (Madison, University of Wisconsin Press, 1981) a book which examines the press' treatment of McCarthy. With the mass movement explanation of McCarthyism dead, suspicion turned to the press as the agent of McCarthy's power. But Bayley found that most of the press was either indifferent or opposed to McCarthy. See Chapter 3 of this work for further discussion of the press and McCarthy.

51. See Chapter 3 above.

52. Robert Griffith, "The General and the Senator: Republican Politics and the 1952 Campaign in Wisconsin," *Wisconsin Magazine of History*, Autumn 1970, 23-29. Eisenhower had planned to give a

speech supporting General George Marshall, his former boss and a recent victim of a McCarthy attack. At the last moment, Eisenhower withdrew the section of his speech that favored Marshall. Word of the recision leaked to the press, which portrayed the episode as an example of McCarthy's power. Griffith argued that the reality was more complex. Eisenhower hated McCarthy, but withdrew his Marshall comments under advice from leaders of the national GOP who feared a party split. Ike spoke in support of Marshall elsewhere in the campaign, while the Wisconsin episode soured him on McCarthy permanently.

53. Michael O'Brien, "McCarthy and McCarthyism: The Cedric Parker Case, November 1949," in *The Specter*, 226-238.

54. Thomas C. Reeves, "Tail Gunner Joe: Joseph R. McCarthy and the Marine Corps," *Wisconsin Magazine of History*, Summer 1979, 300-313.

55. Michael O' Brien, "Young Joe McCarthy, 1908-1944," *Wisconsin Magazine of History*, Spring 1980, 179-232; Michael O'Brien, *McCarthy and McCarthyism in Wisconsin* (Columbia: University of Missouri Press, 1980).

56. O'Brien, *McCarthy and McCarthyism*, 26-41, 48, 121-3, 158-163, 172.

57. For examinations of these shifts from broad to narrow, see, on the American Revolution, Robert Shalhope, "Republicanism and Early American Historiography," *William and Mary Quarterly*, 1982, 334-356; on slavery see Peter J. Parish, *Slavery: History and Historians* (N.Y.: Harper and Row, 1982) and on Reconstruction, see the Preface to Eric Foner, *Reconstruction* (N.Y.: Harper and Row, 1988), xix-xxvii.

58. Nor is it a recent addition to the university. The shift from political science to general history to specialized historical studies took place in scholarly approaches to the Constitution in the first half of the Twentieth Century. See Forrest McDonald's Introduction to Charles Beard, *An Economic Interpretation of the Constitution of the United States*, 1986 edition, (N.Y.: Free Press, 1986), vii-xl.

59. This has been true in McCarthy studies, where, from the beginning scholars have defined the relevance of their works on the grounds of politics. This is in contrast to the treatment of McCarthy in the national media, where he has been more intimately linked with culture—movies, books, journalism—than with politics.

60. It is important to note, though, that synthesis is not simply a response to complaints about over-specialization (though it is often at

least that) but also a culmination of specialization. Specialization fills gaps, synthesis recognizes that the gaps are filled.

61. Thomas Reeves, *The Life and Times of Joe McCarthy* (N.Y.: Stein and Day, 1982); David Oshinsky, *A Conspiracy So Immense: The World of Joe McCarthy* (N.Y.: Free Press, 1983).

62. Oshinsky, *A Conspiracy*, 506.

63. Reeves, *Life and Times*, 1-108; Oshinsky, *A Conspiracy*, 3-52.

64. Oshinksy, *A Conspiracy*, 12-4.

65. On the quality of McCarthy's speeches, see Oshinsky, *A Conspiracy*, 113-4; Reeves, *Life and Times*, 235-243. On McCarthy's questioning of witnesses, see both accounts of the Peress hearings, Oshinsky, 358-377; Reeves, 538-559.

66. Oshinsky does suggest that the supreme court decisions weakening sedition laws in 1956 created a bridge between states' rights and anti-communism, and, had McCarthy lived longer or his censure come later, he might have formed a coalition with Southern Democrats in opposition to the reigning liberalism of the 1960s. The intellectual links between states rights and anti-communism deserve a closer look, if only because they hint that McCarthyism was not simply a manifestation of conservative Republicanism but part of a broader anti-statist philosophy that had many adherents in the Democratic party. Oshinsky, *A Conspiracy*, 497. Reeves and Oshinsky also note that McCarthy's public speaking style was fixed before his Senate days, but they pay little attention to where he learned how to mass facts and pseudo-facts into an effective verbal barrage, assuming that it was simply part of his personality. McCarthy, though, was a debater in college and was a trained lawyer. A study that considered how debate and legal presentations were taught in the 1930s would add a great deal to understanding the context for McCarthy's speech style. On McCarthy's experience in public speaking at Marquette, see Reeves, *The Life and Times*, 11-16.

67. The essay appears as the introduction to the second edition of Robert Griffith's *The Politics of Fear*, ix-xxv. Schrecker's book is *No Ivory Tower: McCarthyism and the Universities* (N.Y.: Oxford University Press, 1986). Along the same lines, see, Lionel S. Lewis, *Cold War on Campus: A Study of the Politics of Organizational Control* (New Brunswick, N. J.: Transaction Books, 1988). After Schrecker's book, several others appeared focusing on specific cases of professors fired for their politics. See David R. Holmes, *Stalking the Academic Communist: Intellectual Freedom and the Firing of Alex Novikoff* (Hanover, VT.: University Press of New England, 1989), and

Charles H. McCormick, *This Nest of Vipers: McCarthyism and Higher Education in the Mundel Affair, 1951-52* (Urbana: University of Illinois Press, 1989). McCarthy was not directly involved in any of the cases mentioned in these books, though he spoke against leftism on campus, his investigations never reached there.

68. Richard Fried, *Nightmare in Red: The McCarthy Era in Perspective* (N.Y.: Oxford University Press, 1990), Ellen Schrecker, *The Age of McCarthyism: A Brief History with Documents* (N.Y.: St. Martin's Press, 1994).

69. Hixson, *Search*, 1-48. See especially pp. 25-6, 33. Hixson argued that the insight that support for McCarthy was an assertion of anti-modernist localism has been a particularly fruitful area of research, see pp. 41-6.

70. Harold Barrett, *Rhetoric and Civility: Human Development, Narcissism, and the Good Audience* (Albany: SUNY Press, 1991), 103-120, 177-9; Kovel, *Red Hunting*; Thomas Rosteck, *See it Now Confronts McCarthyism* (Tuscaloosa: University of Alabama Press, 1994).

71. See Allan Bloom, *The Closing of the American Mind* (N.Y.: Simon and Schuster, 1987), 322-5; Samuel Francis, "The Evil that Men Don't Do: Joe McCarthy and the American Right," in Francis, *Beautiful Losers: Essays on the Failure of American Conservatism* (Columbia: University of Missouri Press, 1993), 139-51; and, on a related topic Marvin N. Olansky, "Liberal Boosterism and Conservative Distancing: Newspaper Coverage of the Chambers-Hiss Affair, 1948-50," *Continuity*, Fall-Winter 1991, 31-44. The conservative argument merges the Buckley and Bozell, and Peter Viereck strains—McCarthy wasn't that bad, especially when compared with either Stalin or the excesses of the American Left in the 1960s, and McCarthy and his critics misunderstood true conservatism.

72. Fried, *Nightmare*, 201; Barrett, *Rhetoric*, 146; Kovel, *Red Hunting*, x-xii, 135-6.

7
Against the Common Knowledge: Biography, the Scholarly Style, and the Legacy of Martin Luther King Jr.

Martin Luther King's status as the main symbol of the modern African-American freedom struggle has now been sanctioned by the creation of a federal holiday honoring his birth. Given this formal recognition of his historical importance, it becomes more difficult, yet also more necessary, for those of us who study and carry on his work to counteract the innocuous, carefully cultivated image that we honor in these annual observances.

Contemporary biographers, theologians, political scientists, sociologists, philosophers, social psychologists, and historians . . . are in the process of constructing a more balanced, comprehensive assessment of King. . . . Their probing research and critical analyses serve as a necessary corrective to the mythmaking.
—Clayborne Carson[1]

Clayborne Carson's taxonomy of scholars working on Martin Luther King, Jr. attests to King's popularity as a subject of scholarly inquiry. The fact that "contemporary biographers, theologians, political scientists, sociologists, philosophers, social psychologists, and historians" worked on King at the same time is equally impressive, because it hints at a major change in the way that academics consider their vocations, disciplines, and relationships with other fields of study. Scholars from most of these fields wrote on Joseph McCarthy, but not all at the same time. Rather, they wrote in turn, each with a scholarly goal and a particular type of relevance in mind. The decline of the traditional scholarly succession has been accompanied by changing ideas

187

of relevance. Historians writing on McCarthy hoped for relevance through analogy, disciplinary standards or through the liberal arts nostrum that all knowledge builds character. Historians studying King had another type of relevance in mind, one hinted at by Carson (a historian himself) when he wrote, "it becomes more difficult, yet also more necessary, for those of us who study and carry on his work to counteract the innocuous, carefully cultivated image that we honor in these annual observances." This chapter is about historians' attempts to "counteract the innocuous, carefully cultivated image" of King that the public supposedly holds and the impact of those attempts on King scholarship and the scholarly style. I am making no arguments about how influential King scholarship is on the general public, only that in the absence of the traditional scholarly succession, King scholars used public opinion about King to justify the existence of their work.

My description of academic history as being, "Against the Common Knowledge" should be understood in two ways. First, historians often work to correct what they see as public misperceptions of the past. But, second, they also write at the end of long strands of scholarship often too recondite to translate into public historical belief. That one of these roles is of public interest (history overturning "common knowledge" is frequently newsworthy[2]) and the other is not, opens academics to the criticism, most frequently voiced by conservatives, that historians constantly rewrite the past in an attack on cherished national beliefs. Clayborne Carson's remarks, standing recent scholarship against the "innocuous, carefully cultivated" holiday image of King, and, later, praising the shift of King biography from "laudatory accounts written by his acquaintances" to a "critical assessment of King's leadership and intellectual qualities" would seem a perfect example of the sort of scholarly activity conservatives decry.[3] Yet in King's case both the conservative criticism and academic rhetoric stop short of the truth, for they focus on the role of history as a public corrective, ignoring the slow changes and tiny advances that constitute the "revisions" trumpeted by scholars and declaimed by their critics. They overlook also scholarship's inability to change public perceptions when the memorial and tributary styles are absent.

After warning about the distortions inherent in the national King holiday, Clayborne Carson led readers through a brief tour of King scholarship. He began by deeming early biographies "hagiography,"

("biography of a saint" according to the *American Heritage Dictionary*), and lacking sufficient grounding in primary sources to be truly scholarly.[4] By the end of King's life, though, biographers had moved beyond simple praise, and were able to note King's limitations as well as successes, criticize his skills and decisions, and place King as part of a "large movement which included factions forcefully challenging his leadership."[5] These biographies lacked a sufficient understanding of the sources of King's thought, though, a defect cleared up by several specialized works written in the 1970s and early 1980s.[6] The culmination of this work came in biographies by Stephen Oates, David Garrow, and Taylor Branch, published in the 1980s.[7] According to Carson, these last books were a vast improvement over the first, for they examined the origins of King's thought, explained the nature of his leadership, measured his effect on other civil rights leaders, uncovered divisions within the movement, gave credit to local participants, and, in sum, "challenged the notion of King as the modern black struggle's initiator and indispensable leader." For Carson, it is these qualities that make the scholarship of the 1980s a "necessary corrective to the mythmaking" of the holiday.[8]

But Carson overestimates the newness of the newer works and overlooks the completeness of the old ones. The themes Carson lauds in the later biographies appear from the beginning of King biography, Lawrence Reddick's 1959 *Crusader Without Violence* and Lerone Bennett's *What Manner of Man?*, published in 1964. The changes come in emphasis, and the emphases change in order to speak against the common knowledge. It is not King scholarship that has been transformed since 1959—the accretions of fact have done little to change the overall interpretation of King's life—as much as what scholars think the public knows about him.

Before turning to this last theme, that scholarly perceptions of the public's opinion of King underlie the shifting emphases in King biography, let me outline the common paths of narration and evaluation followed by King biographers from Reddick to James Cone, whose *Malcolm and Martin and America* appeared in 1991.[9] Chronology has dictated the outline of all King biographies.[10] King was born to a family ensconced in the black middle class of Atlanta, Georgia. He grew up in a loving home headed by a stern father. He attended school, entering Morehouse College at age 15. At age 17, after a period of

doubt, King decided to enter the ministry and preached his first sermon from the pulpit of his father's church. After graduating from Morehouse with slightly above-average grades, he entered Crozer Theological Seminary in Chester, Pennsylvania. He left there in June 1951, valedictorian of his class, and chose Boston University as the site for his Ph.D. studies. In Boston he met Coretta Scott, married her in June 1953, accepted the pastorship of Montgomery, Alabama's Dexter Avenue Baptist Church in April 1954, moved to Montgomery that summer, finished his thesis there, and graduated from Boston University in the spring of 1955. End of the biography's first section.

The following chapters take their outline from the course of the civil rights movement—one on the Montgomery bus boycott, the next on the foundation of SCLC and its fallow period from 1959 to 1961, then a look at the Albany campaign, then Birmingham, the March on Washington, and the Nobel Prize, followed by St. Augustine, Selma, Chicago, King's turn to the peace movement and his growing concern with economic justice, and, finally, Memphis. Clayborne Carson has criticized early King scholarship for being too King-centered (as opposed to movement-centered). But after the obligatory opening chapters on his education, King biography, ostensibly about King's life, has always been about Martin Luther King's role in the movement.[11]

Beyond sharing the same chronological perspective on King, the biographies often rely on the same stories to make the same points about King's development. To argue that King was susceptible to deep guilt from very early in his life, biographers note his two feeble attempts at suicide in response to the deaths (one of them imagined) of his grandmother.[12] That racism touched King as a youth is made clear through the story of young Martin's being forced to stand on a long bus ride from a "South Georgia town" to Atlanta after winning a prize for oratory.[13] That he learned from his father to withstand it is the message of the oft-repeated story of Daddy King refusing to be called "boy" by a white policeman.[14] Much later in his life, we read how a *Ramparts* article on the suffering of children in the Vietnam War steeled King to loudly oppose the war.[15] King's final speech ("I've Been to the Mountaintop") intimated his coming death. Even King's difficult whiskers and his struggle to shave them appeared in the two longest biographies.[16]

In spite of academia's outward fascination with the new, it is not surprising that several biographies of one person would follow the same outline, or make points with the same anecdotes. There are only so many things that happen to a person, and they happen in a particular order. Even more, with the passage of time facts fade. Tales disappear with their tellers. But it is unexpected that this would happen with King, a man whose fame opened him to a huge range of criticism and praise during his lifetime, a man whose circle of still-living acquaintances must reach into the thousands. Perhaps it is the fame that accounts for the similarities in King biographies—the story of his life is well-known, the outline set by outside forces. And perhaps it is the immense number of anecdotes about King that accounts for the selection of a "typical" few. But, while King's fame can explain the narrative similarities between biographies, it ought not explain the common evaluations of King. Presumably everyone from the white supremacist to the black separatist could know the outlines of King's life yet differ over its meaning. But among King biographies, there is as little difference between assessments of King's life as there is about its contours.

The biographers' agreement on which events in King's life were successful makes a neat list: the Montgomery bus boycott, the Birmingham campaign, the March on Washington, the Selma protests. What made them successes? Each of the events shared at least two qualities—it boosted King's national prominence and it led to federal involvement in civil rights.[17] This is not to say that there were no other reasons that the individual events succeeded. The Montgomery boycott was the result of a powerful, dedicated, non-violent local mass movement and had the support of NAACP lawyers. At Birmingham, the SCLC fully employed nonviolence that was both provocative ("coercive" King called it) and loving. The March on Washington allayed fears of unrest and radicalism that followed Birmingham, while giving King a truly national forum for his vision. In Selma, the protests bested the concerted efforts of the state government to limit voter registration by inspiring national legislators to pass the Voting Rights Act.[18] Improved local race relations or the establishment of local institutions to solve racial disputes or the ascendance of powerful local black politicians were not sufficient indicators of success.[19]

The failures—the Albany movement, the push in St. Augustine, the James Meredith March Against Fear[20], the Chicago campaign, the

Memphis movement, and the Poor People's Campaign—all appear as failures for the same reason that Montgomery and the others are successes. In each case, the protests lacked specific goals and either garnered bad press or no press at all. Biographers look at King's life through national eyes, even when they pay a great deal of attention to local nuances.[21] The chronology of the civil rights movement drags biographers along at the expense of long-term evaluation. None of the works returned to Montgomery in 1967, say, to see how the success of the boycott was holding out a decade later, or to Albany that same year, to see if failure was still failure in southwestern Georgia.

That the standard for success is raised on national ground may also hint at why authorial criticisms of King, one of Carson's hallmarks of good King biography, are so narrow. David L. Lewis, author of *King: A Critical Biography*, takes King to task for giving a speech too heavy on imagery and too light on concrete demands at the March on Washington, for accepting too little in the settlements he helped negotiate in Birmingham and Chicago, for failing to understand the differences between blacks living in Northern ghettos and those living in the South, and for being naive about the popularity and utility of nonviolence.[22] David Garrow echoes all of Lewis' misgivings and adds, in *Bearing the Cross*, that King was a poor administrator and the SCLC, consequently, an inefficient organization.[23] The sum of Lewis and Garrow's remarks is this: King was personally too soft and politically too conservative. The first scholar to make the last remark was August Meier in an oft-cited 1965 essay, "On the Role of Martin Luther King." The most recent is James Cone, who extends the critique of King's political conservatism to include classism and sexism and amends it to cover only the first half of his career, roughly from Montgomery through St. Augustine.[24]

The flip side of Meier, Lewis, Garrow, and Cone's dislike for King's conservatism is their positive response to the proposals of the last years of King's life, epitomized by the Poor People's Campaign, a mass occupation of Washington D.C. to demand from the federal government jobs and a living wage for all. (The campaign was to begin shortly after King's death made it untenable.) Though in his last years, King supported economic equality, and eventually the occupation of Washington, with rhetoric calling for a "reconstruction of the entire society" and the "radical redistribution of economic and political power", his policy recommendations largely matched those of the left

wing of the Democratic Party. That King's program was left-liberal (he eventually described himself as a democratic socialist) is important because it places him, and his biographers, in a small plot of the political landscape, more sparsely populated now than in 1968.[25]

I make this point not to call attention to the leftward leanings of many academics (a point already verging from well-done to done-to-death), but rather to make another. King's biographers have criticized him on very narrow grounds, those lying roughly between Robert Kennedy and Students for a Democratic Society. This is unfortunate because it has allowed a sameness of tone to follow the sameness of information that pervades King biography. Even more, it ignores other criticisms of King that might lead to fuller evaluations of his life and legacy. Three follow.

1. Southern whites argued that King was an outside agitator whose campaigns destroyed delicate communal ties. King biographers have noted that SCLC's presence often exacerbated divisions in the black community. Were these criticisms accurate? Did SCLC campaigns divide communities more than campaigns run by other national organizations or by local groups? Were the divisions long-standing? Given King's commitment to the creation of the "beloved community" did his campaigns promote his vision on a local level?

2. When King began to publicly question the war in Vietnam, many civil rights leaders opposed him, claiming that his opposition would alienate supporters in Washington D. C. and divert attention from civil rights. King responded that his opposition to the war was consistent with his opposition to racial oppression in America, that the war drew dollars away from programs to alleviate poverty in America, and that his attack on the war was motivated by moral, not practical political concerns.[26] Biographers have left the question there, perhaps believing that King's position was so self-evidently right that it needed no defense. But a defense might strengthen their position. For while contributions to SCLC did decline after King opposed the war, they had already begun to ebb before King spoke out. And contrary to the predictions of Whitney Young and Roy Wilkins, King's opposition to the war did not shrink his national effectiveness. If anything it made him more popular among the portion of the Democratic Party that was rallying round Bobby Kennedy and Eugene McCarthy. (In 1968, even Richard Nixon called for an end to the war.) Nor does it seem that King's hostility to the war hurt the civil rights movement. In the years

following King's death, the extension of welfare benefits and the creation of the earned income credit began to move toward King's demand for a guaranteed annual wage for poor Americans.[27] Far from being a position defensible only on moral grounds, then, King's opposition to the war may have been a tactical success for the movement.

 3. Stephen Oates and David Garrow both note that King was sexually promiscuous.[28] Oates excuses King's actions as the result of a passionate nature; Garrow makes no critical comment. King's adultery needs to be confronted, both because today it compromises his moral authority (the parallels with Jimmy Swaggert are instructive) and because in the late 1960s it did not. One of the processes at work in King's branch of the civil rights movement from 1955 to his death was secularization. As King and the SCLC became more prominent they became more political. Did this public move towards the political mirror an interior exile from God? If not, then, how did King understand the relationship between religious profession and religious behavior?[29] Did King believe his promiscuity (and that of other SCLC workers) to be a private matter, one unrelated to his call for a moral regeneration of the nation? If not, how profoundly did his sin affect his psyche? Garrow, Oates, and Cone argue that King's despondency late in life came from despair (mostly) over the slow pace of racial reform and (a little) over guilt over his own behavior. Is the balance in this equation right? Finally, if King's attachment to Coretta was unstable while King was alive, why has she emerged as the primary representative of his legacy since his death? Might not Mrs. King deserve more attention in biographies of her husband than she has, to now, received?

 At the beginning of this essay, I argued that scholars work against the common knowledge both by criticizing public perceptions and by creating knowledge in a non-public setting. The largely private production and transfer of knowledge can result in a slow pace of revision, as scholars fill a long-established outline. I have described that outline for biographies of Martin Luther King, Jr., remarking on their organizational, anecdotal, and critical similarities. The biographers' approach to the public has also followed a general outline. They have begun by assessing the state of King's reputation and its level of unreality. In response to King's public reputation scholars have followed two courses: they have either attempted to make King seem

more human, or they have tried to explain the forces that have made King a hero. L. D. Reddick pioneered the first of these approaches in *Crusader Without Violence*. Lerone Bennett initiated the second in *What Manner of Man?* Since Bennett's 1964 book, King biography has swayed back and forth between emphasizing King's humanity and explaining his heroism. These shifts have come because scholars have tried to match their slowly expanding knowledge of King with their perceptions of public need. Such changes in emphasis—often couched in the language of discovery, usually grown from long-held interpretation—are the subject of the next section of this chapter.

Purdue University librarian Abraham Barnett had only one qualm about L. D. Reddick's *Crusader Without Violence*, the first biography of Martin Luther King, Jr.—it was loaded with unnecessary information.[30] For Barnett, particularly troublesome were the descriptions of Morehouse College's history, and the explanation that King's "socks do not hang down over the upper edges of his shoes in the collegiate fashion but have elastic tops or supporters." Indeed, for the person already acquainted with King or convinced of his fundamental importance to race and nation, the opening chapter of Reddick's book, a smorgasbord of King's tastes ("On TV he prefers the quiz programs, where he tries to beat the contestants to the answers"[31]), is off-putting. But it is also essential for understanding Reddick's response to the common knowledge. In 1959, King was widely, but not universally known. His importance to the nation was a thesis, not a conclusion. The Montgomery bus boycott was behind him, the SCLC was organized but floundering, and inasmuch as the public's attention was directed towards race relations, it looked to Arkansas, not Alabama. In this context, Reddick's first chapter was truly an introduction, a "let me acquaint you with Martin Luther King." But even in 1959, Reddick, a historian at Alabama State University, shared the concern voiced by Clayborne Carson thirty years later, that the public did not know the real King. Reddick wrote, before describing King's socks and TV schedule, "The image of the hero or monster [as applied to King] scarcely reveals the man. Or satisfies the human heart that asks how the man came to be as he is—and may become. . . . Above all, they search his life as they search his own, seeking after that which is real and rejecting that which is false."[32]

Reddick's exposition of the real King took two courses. First, he sought a context for King that could explain his beliefs and actions without making him seem otherworldly. He found it in King's family, and, by extension, the black community. Reddick began with a few of King's comments about the makeup of a good family—"Two people absolutely devoted to each other, he [King] maintains, bring out the best in marriage by attaining a high standard of mutual understanding and self-fulfillment." Divorce is "a court of last resort." Then, he turned to King's ideology. He listed a few of King's heroes—Socrates, Luther, Lincoln, Frederick Douglass—and noted that King attributed his philosophy to Jesus (the Sermon on the Mount), Thoreau (the principle of non-cooperation with evil), and Gandhi (nonviolence, the use of soul-force and sacrifice). But why did these teachings attract King? Reddick opined that "Gandhianism fits in with the strong Christian traditions of the Negro people" and then turned again to the place where King obtained his "strong Christian traditions"—his family.[33]

As an entree to King's family, Reddick toured Atlanta, its industries, colleges, government, and finally, its middle-class black community, centered on Auburn Avenue. He listed the major businessmen, the strongest businesses, noted the NAACP and the Urban League, counted the churches, peered at their pastors. One of them was Martin Luther King, Sr., who had traveled from sharecropping in Stockbridge, Georgia to preaching in Atlanta. King, Sr. married into the family of Ebenezer Baptist's preacher Adam Daniel Williams. On 15 January 1929, his second son, Martin Luther King, Jr. was born.

In the King household, Reddick argued, young Martin developed the qualities that helped him adopt nonviolence. His father was stern, his mother loving, the children generally well-behaved (when they were not, their father whipped them). Ebenezer Baptist was the center of their lives. But the idyllic home life could not insulate King from racism. He lost some white friends when their mother stopped allowing them to play with a black child. Later, he watched as his father refused to buy shoes at a store that seated black patrons at the back. On another occasion he saw his father stand up to a white police officer who called him "boy." Though young Martin felt angry when he was forced to stand so a white man could sit on a bus, he never contemplated violence. Reddick held that Martin "never liked violence" and noted that "Martin never wanted to strike the other children of the family, even

when commanded to do so by his father." Reddick concluded, "by nature and by choice he was opposed to physical violence as an instrument of dealing with fellow human beings."[34]

To this point, Reddick's focus on King's family was not that unusual, though he placed more credence in King's believing in nonviolence as a social philosophy than subsequent biographers. But Reddick complemented his full discussion of Martin's family with one nearly as complete on Coretta's family. She came from Perry County, Alabama, of families who owned hundreds of acres of farm land. She spent a rambunctious youth in a loving home, according to Reddick. She attended Lincoln High School, founded by the Methodist Church's American Missionary Association, in Marion, Alabama. There she developed her love for music (she directed the choir at her home church, sang, and played trumpet), and, in a school with an integrated faculty, a hopeful attitude towards race relations. She attended Antioch College on scholarship, studied English and music, eventually winning a scholarship to the New England Conservatory of Music. Along the way she gave several voice recitals, and continued them after marrying Martin and moving to Montgomery. Her education, quiet self-esteem, and powerful voice served her well as a pastor's wife at Dexter, where she quickly won the respect, if not the all-embracing love of the women in Martin's congregation.[35]

Reddick's descriptions of Coretta are reminiscent of those of Martin he offered earlier. His tone is chatty, informal, his purpose introductory. But the pages on Coretta are unique among King biographers. No other book pays as much attention to her as Reddick's. Why? Because in the late 1950s she seemed, at least to Reddick, King's equal, his better half. And, she provided a context in which to place her husband. He grew out of a strong family, she helped him create another, one able to withstand the pressures of the pastorate, one that tied him to the members of his church, and through them, to the rest of Montgomery. It is telling that the first few pages of the chapter on the origins of the Montgomery Bus Boycott, "Decision at Montgomery," describe the Kings' relationship with the church-going members of the community, for they are the bridge that carried King to civil rights.[36]

The first half of Reddick's analysis of the Montgomery Bus Boycott, is, according to the scholarly standards of the 1990s, perfect. Reddick made clear that King was not the source of the idea for the boycott ("credit for that must go to an unidentified professional man and

a teacher"), and he did not found the Montgomery Improvement Association (MIA), the organization that administered the protest. Reddick credited much of the MIA's success to the women who answered phones, mimeographed pamphlets, and distributed leaflets. He duly noted the divisions in the MIA's leadership, the doubts about King's ability to be a good president, and the incredible number of blunders made by the city of Montgomery. The boycott succeeded because of the city's ineptitude, and the "impulse and stamina" of the regular bus riders. For Reddick, "if there ever was an indigenous mass movement, this [the boycott] was it."[37] King's role was small, but important. He was the "spokesman, philosopher, and the symbol" of the boycott, the person to whom outsiders turned, bearing or seeking advice, praising or condemning the efforts of black Montgomery.[38]

But while Reddick's rendering of the boycott's opening themes anticipates current scholarly strains, his finale sought the attention of a 1959 audience. Though he mentioned the Supreme Court decision that outlawed segregation on Montgomery's buses, Reddick was much more concerned with the press coverage of the boycott. He gathered both the praise and opprobrium heaped on King, noting the awards King won, the international praise of the boycott (and a little international grousing, led by Alistair Cooke's essay favoring the city over the protesters), the response in Alabama's press, and, finally, the efforts of full-blown segregationists to discredit King and the MIA. Reddick's focus on the press' perception of King returned the book to its earlier purposes, to introduce King as a man, not a hero, to demonstrate King's broad importance and his mortal nature.[39]

Reddick's attention to the press continued through the end of the book, as did his attempt to place King the man at the heart of black and American society. He covered King's pilgrimage to the celebrations of Ghana's independence, and his speech at the 1957 Prayer Pilgrimage to Washington D.C. He argued that King and the other co-planners of the event, Roy Wilkins of the NAACP and A. Phillip Randolph of the Brotherhood of Sleeping Car Porters, represented the main branches of black leadership—intellectual, labor, and religious—implying that King was an actor in the civil rights movement, but not its producer, director, and star. In King and Wilkins' acceptance of the compromise Civil Rights Bill of 1957, Reddick saw a realistic King, one who opened himself to attack from the black press for asking too little, and from the white South for asking too much. Finally, Reddick closed

with a meditation on Izola Curry, the black woman who almost stabbed King to death at a book signing at Blumstein's in Harlem. For Reddick, the attack from a deranged woman represented the dangers of King's moderation. As a "bourgeois leader of the masses," he crossed class boundaries. As a critic of the United States but an ardent American he threatened patriots while dismaying radicals. As an integrationist he tormented segregationists of both races. It was King's willingness to be in the middle that made him human. It was his humanity, his family, his love for others, his appreciation for socks that stayed up, that made him respectable. And it was his respectability that made him dangerous, and thus, endangered.[40]

Between 1959 and 1964, in spite of Reddick's hopes that he be considered a man, King became a hero. Lerone Bennett, a graduate, like King, of Morehouse College and a journalist for *Ebony* magazine, could have attacked that heroic image in his biography *What Manner of Man? A Biography of Martin Luther King, Jr.*, but it is hard to see how he would have made much of an impact. So instead Bennett considered what made King a hero. This was in part an old question, calling for an examination of King's upbringing and his role in the civil rights movement. But Bennett saw that heroism was not just the result of King's behavior, it also grew out of the public's response to that behavior. So Bennett looked as well at the public, at what made King attractive to black and white Americans. This shift in perspective often made King look wonderful, almost saintly.[41] But it did not make the book uncritical, for it opened the public to censure for failing to take enough responsibility in advancing civil rights.

In addition to giving Bennett a new viewpoint from which to examine him, King's fame made the introductions that opened Reddick's book unnecessary. So, in place of a discussion of King's taste in music, Bennett opened his book by placing King in the context of the history of black leadership. This focus on King's place in black culture continued through the book (and foreshadowed another scholarly innovation of the 1980s—the emphasis on King's roots in black culture).[42] He wrote that black leaders since the Civil War fit four types—the militant (Frederick Douglass), the accomodationist (Booker T. Washington), the moderate (W.E.B. Du Bois[43]), and the nationalist (Marcus Garvey). These leadership types in turn responded to black powerlessness through varying combinations of submission, protest,

"an attitude of non-acceptance based on sustained contention via political and legal tactics," and activism, "a program of direct action based on revolt on the edges or outside the system." In the Atlanta of King's birth, black leaders hewed closest to the tradition of protest, but made their protest more acceptable by adopting the values of the white middle class—hard work, punctuality, a desire for wealth and respectability. It was into this world of "Black Puritan" protest that King was born, and it was against this tradition that he reacted, rejecting the love of money and distance from the masses characteristic of Atlanta's black leadership, while maintaining their devotion to hard work and respectability. In addition to King's social style, his approach to racism grew out of his Atlanta upbringing. At home, Martin learned to get along by listening to what his father said and then doing what he (Martin) felt best. This ability to "resist . . . by apparent submission" served King well at home, but Bennett is quick to note that in so doing he was tapping into a response to power that had deep roots in the black experience. King learned from his parents to be both "intellectually respectable and socially relevant." The talent, honed in his Atlanta youth, to bridge submission, protest, and activism, made King susceptible to Gandhism (Bennett's term). But once he accepted nonviolence, he typically changed it to conform to his upbringing. Bennett argued that "King's genius . . . was not in the application of Gandhism to the Negro struggle but in the transmuting of Gandhism by grafting it onto the only thing that could give it relevance and force in the Negro community, the Negro religious tradition."[44]

But just as King did not wholeheartedly accept the values of Atlanta's Black Puritans, he embraced only a portion of the "Negro religious tradition." The emotionalism of the black church dismayed him, as did the unintellectual presentation of many black preachers. These qualms almost persuaded him to avoid the ministry. When he did accept the call to the pulpit, he did it with a devotion to raise the low quality of preaching. The urge to intellectualism drew King to Crozer Theological Seminary, and then to Boston University. Bennett's account of King's education mentions all of the typical stories—his excellence in class, his interest in (but not conversion to) Gandhi, and his attraction to Hegel, Rauschenbusch, and Coretta Scott. King's views on race relations were those of the NAACP while he was in school, Bennett contends, offering in support another of the common anecdotes, the story of King's double date at a restaurant in Maple

Grove, New Jersey.[45] When the proprietor refused to serve King's party, the party turned to the law for redress, their case failing when all of the other diners refused to testify on their behalf. In all, King emerged from his sojourn in the North married, more intelligent, leaning towards nonviolence, but otherwise unchanged. King's return to the South, to stand at a pulpit in a black Montgomery church, reflected, for Bennett, the enduring strength of King's upbringing, "the Black Puritan heritage of *noblesse oblige.*"[46]

It was that heritage that cast King along the course to heroism, though Bennett is careful to recognize, as Reddick did before him, that King was not perfect. As the boycott got underway, a year after King arrived in Montgomery, Martin proved to be a poor administrator. He also learned that while intellectualism might have animated professors of theology, emotion, not learning, inspired the boycotters of Montgomery. He swung his speaking back to the black tradition, and brought with it, over the course of the protest, larger and larger portions of philosophical nonviolence, tentative steps into civil disobedience, and a conviction, revitalized by the voice of God urging him to continue in the MIA (the "vision in the kitchen"), that he was acting at heaven's behest. Bennett is clear, though, that emotion, protest, and conviction did not win black Montgomery the right to choose seats on the bus. That victory came from the courts, proving, for Bennett, the NAACP's point that "lawyers are the Negro's best friend."[47]

Beyond Montgomery, King, not the NAACP's lawyers, became the symbol of black protest. And in the years that followed the bus boycott, the influence of that symbol spread first through the black South, and then the nation. Bennett attributed the sit-ins that filled the college towns of the South to King's influence. He made King the instigator of the freedom rides, if only because he was the spiritual father of the resurgent civil rights movement. King gave John F. Kennedy the 1960 election. The failed Albany protest received one page (a "set-back"), but the successes of Birmingham fell to King. Those protests happened because King wanted to push the movement forward, not because local activists had prepared the way. Bennett credited King for the decision to use high schoolers against Bull Conner's dogs and fire hoses, not because he came up with the idea, but because he was ultimately responsible for its outcome. Hundreds of thousands joined the March on Washington to hear King. In all of these ways, King, for

Bennett, was more than his actions, he was the civil rights movement incarnate.

But even the ability to stand in for everyone in the movement did not exhaust King's symbolic potential, for he was not just a symbol, but a moral symbol, not just the embodiment of the movement, but the embodiment of good. Bennett devoted his full attention to the "Letter From Birmingham Jail" and reprinted the "Commandments for Volunteers" in Birmingham to show the rightness, the consistency, the truth of the crusade for civil rights. He paid more attention to the opening of King's "I Have a Dream Speech" than any biographer since because King's outline of the place of black oppression in American history is true. King's was the voice to comment on John Kennedy's assassination because he had the moral authority to decry the "morally inclement climate" in America. And so though Bennett criticized the "dream" portion of King's March on Washington speech as too focused on "ends, not means" and noted that the public relations potential of the speech left America open to the disappointment of future events, the symbol of King he constructed was a heroic, giant-sized, wholly good one. King meditated, he guided, he spoke, he inspired, he garnered attention, he went to jail, he read the signs of the times.[48]

The distortions in this portrait are apparent, the overstatements obvious. But to Bennett's credit even as he exaggerated, he warned of the dangers of believing the exaggerations. For King the danger was that his public and private sides would disconnect, that the symbol of good would be obviously different than the man behind it. Bennett showed how, as early as 1964, that danger was mounting. He noted that there was a gulf between the public and private King, that his professed family values and puritan ties to home created "a feeling akin to guilt over his extended absences from his family," while his religious devotion brought him into conflict with those who wanted to run the SCLC like a business. King's Baptist background, his characteristic melange of inspirational talk and seat-of-the-pants protest, conflicted with the strategic need for a solid, planned program for change. Even more dangerous than King's potential belief in the symbol though, was its acceptance by the public. Bennett saw in King's appeal to blacks hope, promise, "and perhaps an opportunity to evade their own responsibilities." For whites, King drew on idealism, Christianity, the romantic notion of love, and "the never-dying hope that errors committed in the past will not have to be paid for." For both races,

then, the symbolic King risked creating excuses for inaction. If King stayed good, then he could do the work alone, if he failed, then his cause was never just.[49]

The first edition of *What Manner of Man* ended here. The second, published late in 1968, added a brief chapter on the events between Kennedy's assassination and Selma, and an epilogue, on King's own death. Bennett noted King's growing involvement in national politics (especially his attacks on Barry Goldwater and his call for a bill of economic rights) and the rising chorus of criticism from blacks who questioned King's devotion to protest, his philosophical nonviolence, his integrationism, and his willingness to negotiate with the powerful. The epilogue took as its theme the ultimate irony of being the symbol of non-violent good—King's agonizing last days at the head of a foundering movement, his violent death, and, then, the twin tributes to his passing, funereal grief and burning anger.[50]

David L. Lewis resolved *King: A Critical Biography*, as Bennett closed *What Manner of Man?*, with an epilogue on King's funeral. But while Bennett wrapped the final service of King's ministry in grief and blood ("After the screams, after the smashing of idols, after the purification of fire, there was a funeral in a red-brick Atlanta church . . . [with] the powerful and the famous sitting and standing shoulder to shoulder with the meek and unknown"),[51] Lewis chose hypocrisy and sweat for the funeral's drape. He wrote that the presence of "the Vice-President, the chief contenders for presidential nomination, fifty members of the House of Representatives, thirty Senators, a regiment of mayors, and at least a platoon of foreign dignitaries" had filled the service with "politically inspired commiseration" from those whose "cynicism, foot-dragging, and hypocrisy had fostered, condoned, or finesse[d] the rising opposition to Martin's activities during the past three or more years." But they had nearly paid the price for their sins by the time the service drew to a close. "Crushed together in the narrow pews, pinned against the walls, and sweating terribly in the sticky heat of the church, the white politicians and public figures almost earned the credibility they sought that day. But they were made to pay dearly for it, for, thanks to Ralph Abernathy, the service went along interminably."[52] The difference in tone reflects a difference in time. For as Bennett's burial scene was consistent with his 1964 portrait of King,

so was Lewis' funereal tableau in line with the etching of King's life
that he completed in 1970.

Many factors accounted for Lewis' picture of King's funeral.
Lewis announced at the beginning of his book that he was skeptical
about the Baptist trappings of King's life, and the philosophy of
reconciliation that accompanied them. But Lewis was not just
imagining hypocrisy. Between 1964 when Bennett outlined King's
symbolic import and King's death in 1968, King had stepped away
from his symbolic role and begun searching for a more substantive part,
one that would bring economic equality and end American imperialism.
As King renounced his symbolic persona, Americans renounced him—
liberals for standing too close to black power, potentates for opposing
the Vietnam War, radicals for clinging to faith and nonviolence. So
while many experienced true grief at King's passing, some experienced
it in spite of their recent dislike for the deceased.

Lewis did not divulge how he felt at King's death. Through the
book he cast himself as a reporter, an analyst. This distance attracted the
book's reviewers, who called it a "carefully dispassionate biography"
(America), praised its unwillingness to "heap praise or condemnation
lavishly" (NYTBR), and lauded Lewis' "sobriety of judgment"
(Christian Century). Even historian Louis Harlan, who noted that
Lewis shared "the skepticism of the student activists about King's
rhetoric and tactics," concluded that Lewis' criticisms of King were not
"carping" but "full of sympathetic insights."[53] The insights tended to
refute both King's position and that of his critics. For example, in
discussing the agreement negotiated by the SCLC to bring open
housing and slum improvements to Chicago, Lewis agreed with
activists from CORE and SNCC that King bargained away many
crucial demands, but then reminded the reader that even so, the
agreement was more complete than any other ever negotiated by King.
Failure came not because the SCLC gave in to the city government,
but because there was no effective local organization to ensure that the
city kept its promises. By writing against those who would uncritically
praise King and those who would unpraisingly criticize him, Lewis
avoided the still-thick emotion surrounding King's death, and
approximated the objectivity important to academics.

Objectivity is not the same as neutrality. Lewis was certainly
not neutral about King, in spite of the careful dispassion and balance
that runs through his book. Lewis was attracted to the last part of

King's life, when King pushed against the war and for an economic revolution in America.[54] In addition, Lewis was skeptical of King's intellect and doubtful about the efficacy of nonviolence as a way of life. After surveying King's education, Lewis concluded that King had a "derivative" intellect, that he was not a philosopher, but a preacher of philosophy. He wrote, "neither Crozer nor Boston University entirely wrenched him from the cast set by his parochial, advantaged Atlanta upbringing."[55] For Lewis, the Atlanta "cast" included a love of showmanship, intellectual narrowness, and a mixture of the tactics of Booker T. Washington and W. E. B. Du Bois. Tossed with King's appreciation of Thoreau, Gandhi, and Christ, King's Atlanta upbringing and the Montgomery boycott brought him to a philosophy of nonviolence that seemed quaint to many blacks, inured, as they were, to violence.[56]

Apart from deepening academic skepticism about King, Lewis contributed most to King biography by marshaling more information about him than anyone else. He was the first biographer to discuss King's attraction to the philosophy of personalism, he gave longer, fuller accounts of Montgomery (including more information on the role of women in the boycott) and Albany than Reddick and Bennett, he paid more attention to King's trip to India, his role in the sit-ins and freedom rides, and his uncertain place in black Atlanta than anyone else. His were the first full accounts of Selma, Chicago, Mississippi, Memphis, and King's deteriorating relationship with Lyndon Johnson. Lewis was the first to tell the story of the Poor People's Campaign, and, beyond, King's desire to build a national political base of blacks, latinos, poor whites, and peace activists. For Lewis, the disaster of King's death was not his assassination itself, but the stop it put to King's future, and, by extension the future of America. "To imagine a Martin King surviving the electoral summer of 1968, " he writes, "raises plausible speculations whose promise and pain are stupefying."[57]

Twelve years elapsed between the publication of Lewis' work and Stephen Oates' King biography, *Let the Trumpet Sound.* In those years, the memory of King moved, for most Americans, from the present into history. This passage was marked by worried comments that King was being forgotten and by the opening of several archival collections on King that had been closed to Lewis. Oates' book bore the marks of both changes. The new information exhibited itself in the

book's large size, the fear of forgetting in its avoidance of Lewis' analytical tone. In the place of analysis came storytelling of the sort calculated to persuade an uninformed listener. The message was simple, and similar to that offered by Bennett eighteen years prior—King was a man, but he was also a remarkably good man—able, intelligent, brave, heroic. Not surprisingly, academic reviewers found the book at times tasty, but rarely filling. Oates' harshest critic, J. Mills Thornton, chided him for always taking King at face value, thus overemphasizing King's role in the movement. Thornton accused Oates of "shirk[ing] his obligation to assess the accuracy of his subject's perceptions of events" and dismissed the book as "modern-day hagiography." The more sympathetic Clayborne Carson wrote that Oates "offers restatements of King's world view, and, at times, even retrospectively provides King with a defense against those who would criticize him."[58]

I doubt such criticism would bother Oates. At worst, it would confirm his opinion of academics. For, at the outset, Oates promised to avoid giving "an author-dominated lecture" and offer, instead "literature which conveys the warmth and immediacy of a life being lived."[59] He did so largely by letting King speak through his sermons and books. Oates delivered a seven-page exposition of the "Letter from Birmingham Jail," long quotes from King's "I Have a Dream," and "I've Been to the Mountaintop," speeches, and a summary of King's remarks to the Rabbinical Conference only ten days before his death. While Lewis downplayed the importance of King's public utterances, Oates afforded them great respect. He gave the same honor to King's books, discussing at length how King struggled to fit writing into his schedule and exposing the important roles of Stanley Levison, Bayard Rustin, and several other ghost writers in helping King explain his beliefs.[60] Several critics remarked that Oates' biography was too dependent on King's public pronouncements. That may be, but by placing the public King in a full biography, Oates at least provided a context for the snippets of knowledge non-specialists had of King.[61]

One may safely assume from his consistent support of King (even in instances, such as King's active sex life, where King did not merit it) that Stephen Oates was pleased at the creation of Martin Luther King Day. One may likewise assume from the epilogue to his book, *Bearing the Cross*, that David Garrow was less thrilled. The single page carried quotes from eight people close to King—his daughter, his sister, several of his co-workers—all decrying the

mythology growing around the King holiday. Three themes emerged: that King was a man, full of foibles, full of humanity; that King was a radical; and that King was a part of the movement, not the movement itself.[62] In support of these themes, Garrow offered 10 years of research, 625 pages of text, 100 pages of notes, and 50 pages of bibliography. The result is a massive chronology, an amplification of topics already broached by other biographers. The "vision in the kitchen," appeared throughout the book as a motif, signifying King's devotion to religion, God, and his sense of calling.[63] To support the contention that King was a man, Garrow delved deeper into King's sex life than Oates (and offered no excuses) and announced again the errors outlined by Lewis. To prove King's radicalism, Garrow mentioned anew King's reading of Marx, his criticism of capitalism, his demands for an end to the war and a beginning to real economic equality, and added a load of information on the FBI's vendetta against King.[64] To show that King was a part, not the whole, of the movement, Garrow recalled the origins of the boycott in Montgomery's masses, re-emphasized the divisions between King and other civil rights leaders, and reconstructed the chaotic inner workings of the SCLC.[65] The result is a book partly at odds with its purposes. It is probably too long and too detailed to sustain the general reader. But if one digs through the whole work, one finally gets a sense of King, though perhaps not the King Garrow wished the reader to grasp. For Garrow, like Lewis, likes the late King—the radical—better than the early one. But in Garrow's work, this late King appeals more to the readers' sense of compassion than political convictions. King near the end of his life was a man facing, in the hostile response to his Poor People's Campaign, the final failure of his grandest goal. He stood at the head of a disintegrating organization at the center of a fracturing movement. He was a devout Christian, surrounded by sin and secularism. He was committed to nonviolence in a world too full of bloodshed. He drank heavily, ate too much, slept too little. He was deeply depressed. He saw his own death rushing at him. He half-welcomed the relief it would bring.[66]

Though *Bearing the Cross* won a Pulitzer Prize, scholarly reaction to the book was lukewarm. Reviewers praised the massive amount of research behind the book. Many also acclaimed Garrow's unflinching reports of King's sexual habits, others Garrow's attention to King's conversion experience or his focus on the SCLC. But most complained of Garrow's unwillingness to interpret, to seek meaning in

King's life. Marshall Hyatt of Wesleyan University wrote in *The Historian* that, "those acquainted with both the movement and its historiography will find little that is new, and they still will have to apply their own analysis to the familiar mass of facts compiled here." David Lewis concluded his review in the *Journal of American History* with this: "In exhaustively recapitulating King's past, Garrow mistakenly believes it can speak for itself. In the final analysis, none of this information quite compensates for empathy, explanation, and judgment."[67]

The responses to the biographies of King written by Oates and Garrow indicate that by the mid-1980s scholars had reached an interpretive impasse. The explanation of what made King a hero, found in Oates (and Bennett before him) lacked the critical tone and distance from the perceived common knowledge appreciated by scholars. At the same time, attempts such as Garrow's to demythologize King, while valuable for providing much new information and criticizing the King holiday, offered little that was new in terms of interpretation. What was more, they seemed to have worked, for by the late 1980s skepticism greeted celebrations of the King holiday, and public admiration for King was sinking.

The low point in King's public image may have come in November, 1990, when news reports announced that King had plagiarized much of his doctoral dissertation. While journalists wondered if "plagiarism may be fatal to reputation," King scholars appeared to switch gears, offering a "new" interpretation of King's life to explain why King borrowed words belonging to someone else.[68] Though David Lewis would have none of it, others, including David Garrow, argued that King had to be understood as coming from the tradition of black Christianity, where borrowing sermons without attribution was common. When he arrived at graduate school, King began the difficult task of translating the black preacher tradition into the practices of the white academy. He was never entirely successful, and plagiarism was but one sign of this failure. He was hampered by the strength of his upbringing, his talents as a speaker, his many extracurricular responsibilities, and the not-quite-serious way he looked at life. Graduate school was for getting credentialed. Life was for bringing people, especially black people at white schools in the North, together. Theological study was to reinforce beliefs already developed in the black churches of Atlanta. When he returned to the South, King put

away much of the baggage he had acquired in Boston, getting it out of the closet from time to time, usually when he had to impress white audiences.[69]

This new way of seeing King's life fits the pattern set by earlier King biographies. It focuses on King's humanity, its announcement comes in response to the common knowledge, and it presents itself as new, but has deep roots in King scholarship.

It may be helpful to think about King scholarship over the last few years in two parts. The first deals with the blackness of King's thought. Both Reddick and Bennett emphasized that King came from the black community, Reddick by focusing on Atlanta, Bennett by discussing black traditions of protest. Both also noted that though King claimed to have gained his philosophy of nonviolence from reading Gandhi and Thoreau, his interest was piqued by a black man, Dr. Mordecai Johnson, who had visited India and returned with the belief that Gandhianism could help black Americans. Further, Bennett pointed out that nonviolence was particularly well-suited to the black Christian experience, and that King's genius came in connecting black Christianity with Gandhi. Bennett also made clear that King's return to the South after graduate school was a return to the oratory of the black pulpit.

The focus on King's graduate career as a source for his thought grew from King's own emphasis on Crozer and Boston University as the sources of his philosophy. In addition, theologians felt a need to respond to David Lewis' assertion that King was not an original thinker, and to elaborate on King's philosophy. The first major step in this direction came from Kenneth Smith and Ira Zepp, who, in 1974 published *Search for the Beloved Community: The Thinking of Martin Luther King, Jr.* Smith and Zepp sought to ground King's thought in Christ, not Gandhi, and to show that he was essentially a child of liberal Protestantism. Their complaint was with those who glossed over Niebuhr, Rauschenbusch, and Brightman, and they aimed to show that King reflected the theologies of these thinkers in his later life. They recognized that King's family, friends, and the black church were important influences on King (though they discounted the contention that King's religious optimism came from African-American sources), but said simply that such topics fell out of the scope of their admittedly "old fashioned" intellectual biography.[70]

In response to Smith and Zepp, black theologians began to argue in the early 1980s that King's appreciation for the giants of Western thought masked much deeper theological roots in the black experience. James Cone and Lewis Baldwin have been the most prolific defenders of this view, holding that Smith and Zepp were correct to focus on the Christian origins of King's thought, but wrong to assume that Christianity was the same thing for whites and blacks. Black Christianity had been shaped by slavery and oppression, and its emphasis on redemptive suffering, love, justice, and liberation had sprung from the pain of racism. Cone argued that King's growing radicalism late in his life was a sign that he was leaving Rauschenbusch and company behind. In their place King relied for sustenance on the religion of his youth, the black Baptist teachings of his father. The black tradition nourished him through the famine of 1967 and 1968. The ferment among young blacks that birthed "black power" inspired King to think more deeply than ever before about the connections between militarism, racism, and poverty.[71] Baldwin held that King's conception of the role of a minister was rooted not in the social gospel but in the black church. It was not just King's language that came from his Atlanta upbringing, but his style of leadership and his vision of blacks as the redeemers of the nation.[72]

Cone and Baldwin based their arguments on King's spoken as well as written words. This necessarily broadened their focus, moving it from the cache of graduate school essays mined by Smith and Zepp, to the entire spectrum of King's rhetoric.[73] It became clear that King, like preachers and politicians before him, used the same speeches over and over again, adapting them to fit the moment, rearranging them as the spirit moved him. It also brought their arguments about King's essential blackness in touch with studies of black folk culture. Among historians, interest in the history of black culture began in the 1960s, spurred by the civil rights movement and Stanley Elkins' book, *Slavery*. Elkins argued that slavery infantilized blacks, destroying any independent culture they may have developed and creating new, dependent personality types. *Slavery* set off a firestorm of responses, one of which sought to prove that slaves created and maintained their own independent cultural communities. Beginning with John Blassingame's *The Slave Community*, and continuing through the work of Lawrence Levine and Sterling Stuckey, among others, this chain of research established that there was a substantial black culture,

born largely in slavery, that continued to evolve into the twentieth century.[74] One of the foundations of black folk culture was its orality—that is, its reliance on the spoken word to convey information and establish relationship between people. As a group, preachers were some of the ablest wielders of the spoken word. In speaking to congregations, they drew on well-known phrases to link themselves to past preachers and the congregation's own experience. In such a culture, saying something new was less important than saying something old well.

When the media grasped the King plagiarism story in 1990, scholars, then, had, at their disposal, these two traditions. The argument that King was best understood as a product of the black South was at least thirty years old, the contention that using others' words played an important role in black oral culture at least fifteen. The announcement that King plagiarized large parts of his dissertation provided an opportunity to bring the two together. The scholar most adept at this argument was Keith Miller, who stated several times that King's plagiarism was of little import because, first, his graduate school training was unimportant in determining his philosophy, and second, King's word borrowing was really "voice merging," the typical way that black folk preachers used language. For Miller, King's actions were signs not of dishonesty, but traditional culture.

The varying interpretations of King's plagiarism tell us something about how scholars respond to the public. Two points deserve emphasis. First, though the announcement that King plagiarized portions of his *dissertation* was new, those familiar with the literature on King can not have been too surprised that King would borrow whole phrases from others. In 1970, David Lewis pointed out that King had used large portions of the "I Have a Dream" speech on other occasions. In 1971, Ira Zepp noted in his dissertation that King had taken, without citation, several passages in his first book *Stride Toward Freedom* from books he read while in graduate school. In 1984, Keith Miller elaborated on Zepp's point in his own dissertation, noting that King relied heavily on sermons of liberal Protestant preachers in his own collection of sermons, *Strength to Love*. David Garrow brought up Zepp's dissertation in his 1986 biography of King and added that whole sections of King's books came word-for-word from memos prepared by Bayard Rustin, Stanley Levison, and Harris Wofford. The same year, Miller published the first of several articles linking King's language to

the words of other black and white ministers. In 1990, just months before the official acknowledgment of plagiarism in King's dissertation, Miller published an article in the prestigious journal *Publication of the Modern Language Association* proving that King had plagiarized the words of at least seven authors in an essay, "Pilgrimage to Nonviolence" that had appeared as part of King's first book. There, Miller also contended that King's graduate school training added very little to his theology, a body of religious thought formed in his father's church.[75]

Another point should also be made. In spite of long-standing evidence that King borrowed the words of others, the outpouring of scholarly opinion came only after the media announced King's plagiarism. And when that opinion came, it came in typical forms. (The exception is David Lewis, who stated that the announcement made him doubt that he understood King, even after writing his biography.) Scholars immediately situated themselves against "common knowledge." David Thelen, editor of the *Journal of American History*, held that the public reaction to King's plagiarism made him uncomfortable. "I find it hard to escape the conclusion that commentators [on the announcement] were simply trying to decide how many points they should subtract from King's greatness score." Rather than attempt such judgments, Thelen suggested that scholars ask other questions—"probe how and why a great American used language in this way at this time and place." Garrow also suggested that questions raised in public were unproductive, recommending that scholars start "by gaining a clear understanding of the learning style King brought with him to both Crozer Theological Seminary and Boston University."[76]

The questions suggested by Thelen and Garrow are good ones. They are also typical of questions scholars have asked about King from the beginning. Thelan's petition that we seek to understand what made a "great American" use language the way he did fits neatly in the "explain King's appeal" trend of biography epitomized by Bennett and Oates, while his suggestion that King's power came because he sat on the boundary of two cultures mimics August Meier's assessment from 1965. Garrow's suggestion that we seek to understand King's learning style matches Garrow's own style of King biography—humanizing King. Bernice Johnson Reagon made the same point, opening her views on King's plagiarism with these sentences: "It is time for society to reckon with the fallacy of turning our heroes and heroines into godlike

inhuman figures. Martin Luther King, Jr., needs to become—through our work as historians—the human being he was."[77]

Finally, though working out of long traditions, scholars responded to King's plagiarism by proclaiming that their work was new and surprising. Keith Miller, after suggesting his own new question (scholars should understand "not why King plagiarized, but how his magisterial language developed") wrote

> Virtually an entire generation of researchers has repeatedly argued that King's intellectual development, ideas, and oratory grew from his philosophical and theological studies in graduate school. Biographers and academics have persistently claimed that King's reading of famous Euro-American philosophers . . . and theologians . . . inspired his thought and his language and thus the civil rights movement itself.
>
> This view is wrong.

Miller went on to add that "King's world view and discourse sprang from two major sources: the sermons of Harry Emerson Fosdick and other liberal white preachers, and the African-American folk pulpit of King's father and grandfather, both of whom were folk preachers." He continued, "Though systematically scorned, ignored, patronized, or dismissed by most King researchers and most other students of religion, African-American folk religion shaped King more than any other influence."[78] Miller's overstatements are obvious. No biographer has claimed that King's intellectual development or ideas came solely from graduate school. Certainly no one has claimed that King learned his oratorical style in the seminar rooms at Boston University (though he did preach many practice sermons while in graduate school). King biographers have pointed out that King read Euro-American philosophers, but none has claimed that Hegel made King, nor that Hegel inspired the civil rights movement itself. At most, biographers have noted that King applied some philosophical ideas to situations he faced in the civil rights movement. But biographers since Reddick have argued that that civil rights movement sprang from the black masses and that King served at most as a reluctant leader and symbol. Finally, while no King biographer has mentioned King's reliance on the

sermons of Harry Emerson Fosdick, all have acknowledged the important influence King's black church upbringing had on him.

Let me say in conclusion that I am not distressed by Miller's oversimplification of King scholarship. I am sure I have done the same in writing about the thousands of pages that make up King biography. Nor am I concerned that King scholarship is not as new as its practitioners make it appear when they confront outbursts of public interest in King. What does concern me is that King scholars, especially in the last ten years, have been unwilling to admit to the public that what is "new" comes at the end of a long, productive scholarly tradition. This bothers me because it is disrespectful to earlier scholarship, to people like Reddick and Bennett whose work is dismissed as "hagiography" but still frequently cited in "non-hagiographic" works. On a broader and more disturbing level, though, it points to a problem inherent in the scholarly style. To engage the non-academic public, historians may have to make their work appear to be new. But in so doing, they make it seen rootless, disconnected from anything that went before. We do not lack the new in America; we lack the traditions to make sense of the new. If historians will not talk about tradition, who will?

Notes

1. Clayborne Carson, "Reconstructing the King Legacy: Scholars and National Myths," in Peter J. Albert and Ronald Hoffman, eds., *We Shall Overcome: Martin Luther King, Jr., and the Black Freedom Struggle* (N.Y.: Pantheon Books, 1990), 241. Carson's essay is an amplification of an address he gave at a conference , entitled, "Martin Luther King, Jr.: The Leader and the Legacy" held in October 1986. Carson's remarks at that conference are published as "Martin Luther King, Jr.: Charismatic Leadership in a Mass Struggle," *Journal of American History* , Sept 1987, 448-454. Carson is the senior editor and director of the Martin Luther King, Jr. Papers Project.

2. See, for example, news coverage of a scholar's finding that Mark Twain drew Huck Finn's dialogue from African-American sources. "Was Huck Finn Black?" *Time*, 20 July 1992, 18; and "Huck Finn's Voice is Heard as Twain Meets Black Youth," *New York Times,* 7 July 1992, A1.

3. Carson, "Reconstructing," 241.

4. Especially Lawrence D. Reddick, *Crusader Without Violence: A Biography of Martin Luther King, Jr.* (N.Y.: Harper and Row, 1959); and Lerone Bennett, *What Manner of Man?: A Biography of Martin Luther King, Jr.* (Chicago: Johnson Publishing, 1964).

5. Ibid., 242. Here Carson refers largely to August Meier's essay, "On the Role of Martin Luther King," *New Politics*, Jan 1965, 1-8; and David L. Lewis, *King: A Critical Biography* (N.Y.: Praeger, 1970).

6. On the intellectual sources of King's thought, Carson referred to Kenneth L. Smith and Ira Zepp, *Search for the Beloved Community: The Thinking of Martin Luther King, Jr.* (Valley Forge, Pa.: Judson Press, 1974), and John J. Ansbro, *Martin Luther King, Jr.: The Making of a Mind* (Maryknoll, N.Y.: Orbis Books, 1982), and on the Southern, Black sources of King's thought, Lewis V. Baldwin, "Martin Luther King, Jr., The Black Church, and the Black Messianic Vision," *Journal of the Interdenominational Theological Center*, 1984-5, 93-108; and James H. Cone, "Martin Luther King, Jr., Black Theology—Black Church," *Theology Today*, 1984, 409-20.

7. Stephen Oates, *Let the Trumpet Sound: The Life of Martin Luther King, Jr.* (N.Y.: Harper and Row, 1982); David J. Garrow, *Bearing the Cross: Martin Luther King, Jr. and the Southern Christian Leadership Conference* (N.Y.: William Morrow, 1986); and Taylor Branch, *Parting the Waters: America in the King Years* (N.Y.: Simon

and Schuster, 1988). Because Branch's biography does not run to the end of King's life, I have not treated it at length in this chapter.

8. Carson, "Reconstructing," 243-5, 241.

9. James Cone, *Martin and Malcolm and America: A Dream or a Nightmare?* (Maryknoll, N.Y.: Orbis Books, 1991).

10. The only exception to this rule is in Reddick's *Crusader*, where he discusses King's ideology before describing King's education. The same tendency, to tell King's story in a chronological manner, emphasizing his acts with the civil rights movement, shows up in journalistic writing about King as well. See Chapter 4.

11. Ibid., 245-7. It is, of course, difficult to think of King apart from the vicissitudes of the civil rights movement, and chronology is always a safe way to keep a narrative going. But by playing King's story to the rhythms of the movement, biographers overlook other themes which might make the story clearer. Why not organize King's life around his changing relationship with his family, or his own sense of psychological well-being, or his ties to his own congregations? Why not group the events in his life according to success and failure, or local and national import, or their appeal to blacks and whites, or link them to changes in national political parties or ideologies? Some works have dealt well with these issues while still using the history of the movement to frame King's life. For example, James Cone's *Malcolm and Martin and America: A Dream or a Nightmare* tells King's story in two parts, the first, up to 1963, characterized by King's dream for success within the American political system, and the second, from 1964 on, by King's growing disillusionment with that system, and Richard Lentz, *Symbols, the Newsmagazines, and Martin Luther King* (Baton Rouge: Louisiana State University Press, 1989) uses the approval and disapproval of the press as an outline for King's life. But the bulk of biographical work on King measures him against the movement, not against any other standard, and this, in spite of trends in biography away from the consideration of a person's public role and towards their private lives. This move has been led by feminist biography. See, for example, Sara Alpern, ed., *The Challenge of Feminist Biography* (Urbana: University of Illinois Press, 1992) and Carolyn Heilbrun, *Writing a Woman's Life* (N.Y.: Norton, 1988).

12. Reddick, *Crusader*, 60; Bennett, *What*, 18; Lewis, *King*, 13; Oates, *Let*, 13; Garrow, *Bearing*, 35.

13. Reddick, *Crusader*, 58; Bennett, *What*, 25; Lewis, *King*, 16; Oates, *Let*, 16; Garrow, *Bearing*, 35.

14. See, for example, Oates, *Let*, 12; Garrow, *Bearing*, 35.

15. Oates, *Let*, 427; Garrow, *Bearing*, 543.

16. On the speech, see Lewis, *King*, 387; Oates, *Let*, 485-6; Garrow, *Bearing*, 620-1; on King's beard, Oates, *Let*, 55; Garrow, *Bearing*, 623.

17. August Meier made this point in 1965, arguing that "King's career has been characterized by failures that, in the larger sense, must be accounted triumphs" because the failures "dramatically focused national and international attention on the plight of the Southern Negro, thereby facilitating overall progress." Meier, "On the Role," 52-3.

18. David Garrow, *Protest at Selma: Martin Luther King, Jr. and the Voting Rights Act of 1965* (New Haven: Yale University Press, 1978).

19. If they were, Birmingham and (maybe) Montgomery would be off the success list, and Atlanta, Cleveland, Ohio (two little mentioned campaigns in which King and SCLC played small but significant roles), and perhaps Chicago would be on.

20. A march through Mississippi undertaken by the SCLC, SNCC, Core and others to dramatize racial oppression in Mississippi and commemorate Meredith's own march there, aborted when he was shot. The march occasioned the first open battles between King's SCLC and the black power advocates in SNCC and CORE.

21. This may also explain the inordinate amount of attention given to John Kennedy's phone calls on behalf of the imprisoned King just prior to the 1960 presidential election, and the subsequent claims that King's quasi-endorsement gave Kennedy the presidency. On the 1960 election see Garrow, *Bearing*, 146-9.

22. Lewis, *King*, 227-9, 209, 350-3, 116.

23. On the inefficiency of the SCLC, see Garrow, *Bearing*, 547.

24. Cone, *Martin*, 272-287.

25. On the Poor People's Campaign and King's growing radicalism, see Lewis, *King*, 297-389; Oates, *Let*, 357-462; Garrow, *Bearing*, 527-624; Cone, *Martin*, 213-243; and Vincent Harding, " Beyond Amnesia: Martin Luther King, Jr. and the Future of America," *Journal of American History*, Sept 1987, 468-476.

26. See, for example, King's remark to Whitney Young, head of the Urban League, that support of the Vietnam War "may get you a foundation grant, but it won't get you into the kingdom of truth." Garrow, *Bearing*, 546.

27. King scholars writing about King's economic program also need to confront the conservative critique of the Great Society—that government poverty programs like those envisioned by King may do more harm than good for poor people.

28. According to David Lewis, King's promiscuity was an open secret when he was researching his 1970 biography of King, but he decided not to pay much attention to it, though he does mention that the FBI was collecting compromising information on King. See Lewis, *King*, 257; and David L. Lewis, "Failing to Know Martin Luther King, Jr.," *Journal of American History*, June 1991, 81.

29. Lewis asks this question in a review of David Garrow's *Bearing the Cross*, the most complete account of King's "priapic hotel relaxation" (Lewis' phrase). David L. Lewis, review of *Bearing the Cross*, by David Garrow, in *Journal of American History*, Sept 1987, 482.

30. Abraham Barnett, review of *Crusader Without Violence: A Biography of Martin Luther King*, by L. D. Reddick, In *Library Journal*, Aug 1959, 2345.

31. Reddick, *Crusader*, 4.

32. Ibid., 1-2. Reddick's comment, that others search for meaning in King's life as they search for meaning in their own also anticipates Carson's "We Shall Overcome" remarks. Carson opined that a true understanding of King and the "black freedom movement," would help people involved in social movements know that they "can develop their untapped leadership abilities and collectively improve their lives." Carson, *Reconstructing*, 248.

33. Reddick, *Crusader*, 5, 9-23, 20.

34. Ibid., 24-62, quotes from 59-61.

35. Ibid., 90-107.

36. Ibid., 108-112.

37. Ibid., 112-145, quote from 113.

38. Ibid., 131.

39. Ibid., 146-174.

40. Ibid., 198-234, quote from 233.

41. Saintliness was not a foregone result of such an approach. Meier's short essay on King asks the same questions as Bennett about King's attractiveness, but Meier is less convinced than Bennett that King deserved the adulation he received. See Meier, "On the Role," 53-4. Carson's claim that early King biography tended towards hagiography fits Bennett's book best, but even here it is not completely right.

42. Johnson Publishing Company, the same firm that produces *Ebony* and *Jet* published Bennett's book. That Johnson Publishing marketed its magazines and books largely to black audiences may explain the strong focus on King's roots in black history in *What Manner of Man?*

43. Today, Du Bois is rarely regarded as a moderate, but Bennett placed him in that category because of his role in the NAACP whose focus on improving the plight of blacks through the courts lacked the public militancy of boycotts, marches, sit-ins, and freedom rides.

44. Bennett, *What*, 3-29. Quote on King's style, p.24, on his desire to be respectable and relevant, p.25, on his application of Gandhism to the black church, p.4.

45. On the close similarity between King's position on civil rights and that of the NAACP while King was at Boston University, see also David Thelen, "Conversation with Cornish Rogers," *Journal of American History,* June 1991, 46.

46. Ibid., 33-51. Bennett relates the story of King's brush with restaurant racism on p. 35, the quote about Black Puritan heritage is from p.49.

47. Ibid., 55-106. On King's shift to emotionalism see p.67, on the "vision in the kitchen" p.75, on King's poor administrative skills, p.79. The quote about NAACP lawyers is from p. 78.

48. Ibid., 111-167. On the freedom rides, see p.112, the quote on King's "dream" speech is from p. 163, the comments on Kennedy's assassination on p. 166-7.

49. Ibid., 177-193. The 'guilt" quote is from p.179, the quotes on King's appeal to blacks and whites are found on p. 199.

50. Ibid., 197-243.

51. Ibid., 233.

52.Lewis, *King*, 390-1.

53. Gerald Costello, review of *King: A Critical Biography*, by David L. Lewis, in *America*, 23 May 1970, 567-8; Charles V. Hamilton, review of *King: A Critical Biography*, by David L. Lewis, in *New York Times Book Review*, 5 Apr 1970, 14,16,18; Bruce Douglass, review of *King: A Critical Biography*, by David L. Lewis, in *Christian Century*, 15 Apr 1970, 452-3; Louis R. Harlan, review of *King: A Critical Biography*, by David L. Lewis, *American Historical Review*, Oct 1970, 1797-8.

54. See especially Garrow's *Bearing*, Cone's *Martin*, Darren Cushman-Wood, "Martin Luther King, Jr. and Malcolm X: Economic Insights and Influences," *Monthly Review* 45 (1): 21-35; Stuart Burns, "Martin Luther King's Empowering Legacy," *Tikkun* , Mar/Apr 1993, 49-53, 67-8; and Harding, "Beyond Amnesia," 468-476.

55. Lewis, *King*, 45.

56. Ibid., 105.

57. Ibid., 397.

58. J. Mills Thornton III, review of *Let the Trumpet Sound*, by Stephen Oates, in *Journal of Southern History*, Nov 1983, 640-1; Clayborne Carson, review of *Let the Trumpet Sound*, by Stephen Oates, in *Journal of American History* , June 1983, 202-3.

59. The only problem with such an approach is that, of course, King's is not a life being lived, but a life already lived. Reddick could get away with telling King's story in the same manner that Oates employs because King was still alive, and thus his story was not set in stone. Writing after King's death in the same manner, though, Oates misses the sense of contingency that makes life "immediate" if not "warm."

60. Oates, *Let*, 223-230 (Birmingham Jail), 256-263 ("I Have a Dream"), 484-487 ("I've Been to the Mountaintop"), and 473-6 (the Rabbinical Conference). On King's books (and their ghostwriters) see pp. 127-32, 302-4, 422-427.

61. See the reviews cited above, and Eric Foner, review of *Let the Trumpet Sound*, by Stephen Oates, in *New York Times Book Review*, 12 Sep 1982, 14, 82. Compared to the sloganeering of politicians and summaries of the press in the year before the passage of the King holiday, Oates book is a shining star.

62. Garrow, *Bearing*, 625. See also David Garrow, "The Age of the Unheralded," *Progressive*, Apr 1990, 38-43.

63. Garrow also emphasized the importance of the "vision in the kitchen" in his address at the "Martin Luther King, Jr.: the Leader and the Legacy" conference. See the text of his remarks, David J. Garrow, "Martin Luther King, Jr., and the Spirit of Leadership," *Journal of American History*, Sept 1987, 438-447. Most reviews praised Garrow for his emphasis on King's conversion story, but see Bill McKibben, review of *Bearing the Cross*, by David J. Garrow, in *New Yorker*, 6 Apr 1887, 102-112, esp. 107, where McKibben argues that Garrow used the "vision" as "convenient shorthand that removed the need to delve very deep into King's religious thought."

64. Garrow, *Bearing*, 527-74 on King's growing radicalism. Garrow was the first to expose the extent of the FBI's interest in King. David J. Garrow, *The FBI and Martin Luther King, Jr.*, (N.Y.: Norton, 1981).

65. Garrow, *Bearing*, 11-82. See also the memoirs of one of the women who masterminded the boycott: David J. Garrow, ed., *The Montgomery Bus Boycott and the Women Who Started It: The Memoir of Jo Ann Gibson Robinson* (Knoxville: University of Tennessee Press, 1987). Garrow argues that the SCLC's lack of organization seriously hindered its effectiveness, especially in Chicago, pp. 431-474.

Adam Fairclough, though, sees genius in the SCLC's lack of organization. Adam Fairclough, *To Redeem the Soul of America*, (Athens, GA.: University of Georgia Press, 1987), 2.

66. See especially the final two chapters of *Bearing the Cross* for King's mental state late in life. Garrow, *Bearing*, 527-625.

67. Marshall Hyatt, review of *Bearing the Cross*, by David J. Garrow, in *The Historian*, Aug 1988, 618; David Lewis, review of *Bearing the Cross*, by David J. Garrow, in *Journal of American History*, Sep 1987, 482-484.

68. The "plagiarism may be fatal" quote is from Lance Morrow, writing in *Time*, 3 Dec 1990, 126, quoted in David Thelan, "Becoming Martin Luther King, Jr.: An Introduction," *Journal of American History*, June 1991, 14.

69. Lewis expresses his doubts about this interpretation in David L. Lewis, "Failing to Know," 82. The outlines of this argument are clear in several articles published in a *Journal of American History* "round table" on King's plagiarism in vol. 78, June 1991. See David Thelan, "Conversation With Cornish Rogers," 41-62; David Garrow, "King's Plagiarism: Imitation, Insecurity, and Transformation," 87-92; Bernice Johnson Reagon, "'Nobody Knows the Trouble I See'; or, 'By and By I'm Gonna Lay Down My Heavy Load'," 111-119; and Keith Miller, "Martin Luther King, Jr., and the Black Folk Pulpit," 120-3.

70. Kenneth L. Smith and Ira Zepp, *Search for the Beloved Community: The Thinking of Martin Luther King, Jr.* (Valley Forge, PA.: Judson Press, 1974), 11-20.

71. James Cone, "Black Theology in American Religion," *Journal of the American Academy of Religion*, 1985, 759-765; and Cone, *Martin and Malcolm and America* , 213-243.

72. Lewis V. Baldwin, "The Minister as Preacher, Pastor, and Prophet: The Thinking of Martin Luther King, Jr.," *American Baptist Quarterly*,1988, 79-97, and, more generally, Baldwin's *There is a Balm in Gilead: The Cultural Roots of Martin Luther King, Jr.* (Minneapolis: Fortress Press, 1991).

73. Theologians were not alone in paying closer attention to King's speeches. Both Stephen Oates and David Garrow cited many of King's sermons in their biographies, written slightly before the works of Cone and Baldwin.

74. John Blassingame, *The Slave Community* (N.Y.: Oxford University Press, 1972), Lawrence Levine, *Black Culture and Black Consciousness: Afro-American Folk Thought from Slavery to Freedom* (N.Y.: Oxford University Press, 1977); Sterling Stuckey, *Slave*

Culture: Nationalist Theory and the Foundation of Black America
(N.Y.: Oxford University Press, 1987).

75. Lewis, *King*, 227; Ira Zepp, "The Intellectual Sources of the
Ethical Thought of Martin Luther King, Jr., As Traced in His Writings
with Special Reference to the Beloved Community," Ph.D. dissertation,
St. Mary's Seminary and University, 1971; Keith Miller, "Influence of
a Liberal Homiletic tradition on *Strength to Love* by Martin Luther
King, Jr.," Ph.D. dissertation, Texas Christian University, 1984;
Garrow, *Bearing*, 112; Keith Miller, "Martin Luther King, Jr. Borrows
a Revolution," *College English* 48 (1986): 249-265; "Composing
Martin Luther King, Jr.," *Publications of the Modern Language
Association* 105 (1990): 70-82; and see also Miller's *Voice of
Deliverance: The Language of Martin Luther King, Jr. and its Sources*
(N.Y.: Free Press, 1992).

76. Thelan, "Becoming," 14; Garrow, "King's," 87.

77. Reagon, "'Nobody,'" 111.

78. Miller, "Martin," 120-1.

8
History in Public Life

The heart of this book has been a series of paired chapters that have analyzed commemorations of McCarthy and King at home, in the national media, and among scholars. By choosing this order of chapters, I have sought to focus on the history makers themselves—the family members, journalists, and historians who have crafted the stories of McCarthy and King that we have today. I have also tried to show how specific events have led commemorators to choose certain styles of remembrance, and the effect those styles have had on later commemorations. Each of the chapters on McCarthy and King has been nearly self-contained. I have done this on purpose, because I have wanted to amass a certain bulk of information before looking to this book's ultimate goals—suggesting how history is made in contemporary America, and, ultimately, how information about the past can improve the quality of public life.

I would like to begin this pursuit by considering first what does not make history. Common today are claims of political bias in the making of history, suggestions that a history maker's political affiliation or ideology leads that person to treat certain aspects of the past more favorably than others. Using this logic, one would expect the generally liberal historians, journalists, and Atlantans concerned with Martin Luther King, Jr. to consider him favorably while their counterparts covering Joseph R. McCarthy would paint him in chiaroscuro. But while it is true that King is thought of more highly than McCarthy, only occasionally did the politics of the history makers have anything to do with it. In Appleton, members of the John Birch Society praised McCarthy because they liked his politics, but other conservatives—members of the Republican Party, local business leaders—evaluated him negatively. In Atlanta, only the Ku Klux Klan disliked King because of his politics. Other Atlantans, though divided over how King should be commemorated, were united in their positive assessments of him.

The chapters on McCarthy and King in the national media and the academic world show even more clearly that the link between political affiliation and assessments of the past is weak at best. In the national media everyone except William F. Buckley and Roy Cohn agreed that McCarthy was bad while all the writers about King except Jesse Helms praised him. Among academics, New Left historians have considered McCarthy dispassionately, while leftist historians have consistently criticized King.

Of course the "politics of the writer determines the assessment of the subject" school of bias claims is a crude (though popular) one. But other types of bias claims also fail to hold up. One might expect, for example, that the ideology of the history-maker would have something to do with the quality of the history produced—good research about those who the historian finds congenial, bad research on those espousing other points of view. This view of bias also fails to describe the history produced about McCarthy and King. In Appleton, no one has done particularly thorough research on McCarthy, while in Atlanta, King's closest admirers have overlooked huge portions of his life. The national media have done a consistently poor job of writing the histories of McCarthy *and* King—McCarthy and McCarthyism have become all-purpose bogeys for problems in American society, while King has been consistently linked only with the "I Have a Dream" speech. In both cases, falsifications and exaggerations are common, evidence of thoughtful consideration of the past rare. On the other hand, scholars have produced well-researched, thoughtful considerations of McCarthy and King. Again, the example of the New Left take on McCarthy is instructive. New Left historians were the first to consider McCarthy in historical context and the first to do serious research into his life and work. Their work has not been surpassed for thoroughness, and much of it, though twenty years old, is still definitive.

Finally, the examples of McCarthy and King give the lie to the assertion that academics and liberals have been overtaken by relativism. Neither the argument that history is rewritten to match the needs of the present, nor that assessments of the truth change with time adequately describe the ways that McCarthy and King have been interpreted. In McCarthy's case, the rise of conservatism did not change local, journalistic, or academic assessments of McCarthy, it only brought them more attention. Nor did the build-up to Martin Luther King Day

cause King to be seen in a more favorable light. Rather, lobbying for King Day only increased the power of the bulb.

Interpretations of McCarthy and King are characterized by significant continuities, across time and ideology.[1] The first of these continuities is the consistent acknowledgment that McCarthy was, ultimately, bad, while King, in the end, was good.[2] I am particularly interested in how "badness" and "goodness" relate to the number of McCarthy and King commemorations. Though equally renowned during a similar span of years on the national stage (McCarthy from 1950 to 1954, King from 1963 to 1968), King is far better known and commemorated far more often that McCarthy. McCarthy is on the path to obscurity, King on the way to long-term renown.[3] There are several explanations for McCarthy's disappearance from memory in the United States. Some have argued that McCarthy deserves to be forgotten because his actions were either so far outside the pale as to be worthless or so minor as to be insignificant. Both of these arguments appeared in Appleton, and the second is the end result of the logic of McCarthy scholarship. But the view that McCarthy ought to be forgotten fails to explain his slow fade from the national media. There, the view that McCarthy is irrelevant has not appeared. Instead, McCarthy seems to be suffering the fate of celebrity. Daniel Boorstin, in his classic work, *The Image: A Guide to Pseudo-Events in America*, has argued that the modern age has created a new type of famous person—a celebrity— whose fame is due to public relations and press attention, not inherent greatness. Boorstin wrote, "The celebrity even in his lifetime becomes passé: he passes out of the picture. The white glare of publicity, which first gave him his specious brilliance, soon melts him away."[4] This is a particularly apt description of McCarthy's fall from national prominence in 1954, and no doubt explains much of the forgetting of McCarthy. But it does not explain why McCarthy should disappear while King should remain prominent.

A look at the course of events since McCarthy and King's deaths begins to explain King's prominence. As time has passed since McCarthy's death, the issues that brought him to national attention have faded. Internal Communist subversion is no longer a threat (though its inverse, government subversion of private groups, still riles), and first détente and the end of the Cold War reduced the international threat that spawned McCarthy. On the local level, the death of McCarthy's generation and the urge to attract tourist dollars

have pushed McCarthy from public life in Appleton. Meanwhile, race relations continue to vex Americans and Atlantans, while studies of African-Americans still occupy scholars. Thus, the present still keeps interest alive in King, but it does not do the same for McCarthy.

Two other factors account for McCarthy's fading. The decision to commemorate is rarely controversial in the United States, because so few historical commemorations bear the official seal of government. Those that do rarely recall a still-disputed part of the American past.[5] The content of commemorations, though, is usually open to the criticism. This has certainly been the case in the creation of the national, academic, and local legacies of King. But outside Appleton, complaints about the content of McCarthy memorials have been rare. This is due, I think, to the difficulties of remembering villains in the United States. Our national memory lacks room for bad guys. Only Benedict Arnold and McCarthy are certainly there, though Lincoln, Jefferson Davis, FDR, and others have made periodic appearances. It is not that we lack evil in our history; we lack instead the knowledge of what to do with it.[6] The most common response has been forgetting, usually out of indifference, though occasionally on purpose.[7] In McCarthy's case some have suggested the appropriateness of forgetting. Also common has been a willingness to use McCarthy's image like a pawn shop for the broken past. Once a bit of Cold War misbehavior has been deposited, and a few cents of attention loaned, the past remains there, ignored.

The past is kept alive by people. This is the thrust of much recent scholarship on the reputations of various historical figures. Gladys and Kurt Lang, in their study of the reputation of English artists, *Etched in Memory*, argue that "the durability of reputation is linked to the artist's leaving behind both a sizable, accessible, and identifiable oeuvre and persons with a stake in its preservation and promotion. . . . More generally, any linkage to important artistic and literary circles or to a political and cultural elite adds to the artist's posthumous reputation."[8] Nowhere does McCarthy have supporters linked to artistic or political elites. In Appleton, the foundation organized to commemorate him has now floundered, lacking money and members. His wife will neither speak to reporters or open his papers. King's foundation flourishes, it has ties to the most powerful people in America. King's wife is his spokesman, his papers are public, his legacy is alive.

That followers of McCarthy and King have shaped their legacies is, to a certain extent, true—Coretta King has done much to mold King commemorations in Atlanta, for example. But it is not the whole story. History makers are limited by the information at hand and the style of commemoration they choose. It is these styles of commemoration that best explain the local, national, and scholarly interpretations of McCarthy and King.

Chapter 2 argues that in the move from the present into history, information is frequently lost, forgotten. Much of this forgetting comes naturally, with the death of people and the passage of time. But other items are forgotten in the act of making history, of ordering information into an understandable account of the past. In Appleton, the balance has tilted toward forgetting, and, as a result, Joseph McCarthy takes only a minor place in that town's public life. But when, as in Atlanta, history outweighs forgetting, history makers must decide how they wish to present that history. In Atlanta, King commemorators have chosen three styles of commemoration, which I have dubbed the memorial, tributary, and scholarly styles. This book suggests that these three styles are common not just in Atlanta, but in the rest of the United States as well.[9]

The tributary style is characterized by an intense personal tie between the commemorator and the person or thing being commemorated. The tie is akin to discipleship. Tributary commemorations, like those associated with Hosea Williams and (sometimes) the SCLC in Atlanta, and with McCarthy in the national media, are based in claims of personal experience. They tend to be activist, emotional, and less concerned with winning converts to the interpretation than with demonstrating loyalty (and, by extension, personal right-ness). In Atlanta, this style never competed well with the other styles—its adherents were too stand-offish. But it did provide a useful perspective from which to criticize other interpretations. Thus Williams could chide the King Center for the way it spent its money because he knew from experience that King would not spend his money that way. When not faced with an alternate style of commemoration, the tributary style tends to produce bad history—that is, history that disregards evidence, and, because based on personal experience unknowable to others, promotes acrimonious debate. In media representations of McCarthy, authority to speak about McCarthy and McCarthyism is accorded to those who can claim to have experienced it.

Thus, the scope of McCarthyism has expanded over time and place to include things that McCarthy did not do and people to whom he did not do it.

While the tributary style relies on personal experience for its authority, the authority of the memorial style comes from its official status. In Atlanta, that status was won by Coretta Scott King, who used it to present the past in a way that served to draw people to her version of her husband's legacy. The official status of the memorial style is supported by its ability to win others to its position and its close ties to those in power. In Atlanta, this meant that adherents of the memorial style made general comments about King in order not to alienate potential supporters. And, rather than turn to activism in pursuit of support for their view of the past, memorialists prefer lobbying and legislation. Both in Atlanta and in the national media this approach has been successful—it is the official style, ratified by corporate and government support. But at the same time, at least in King commemorations, the memorial style has invited criticism, from tributaries who see it as an abandonment of personal experience and scholars who decry its generalities.

The final interpretive style, the scholarly, is a style of limits. In Atlanta it is limited to the events that happened there, among academics writing on King and McCarthy, it is limited to evidence. Its goal is not the proof of personal worthiness or the acquisition of converts but rather the preservation of a specific, discernible past. The National Park Service has worked toward this goal in Atlanta by preserving King's birth house and basing its interpretation of King's life in local soil. Scholars writing on King and McCarthy have taken similar concrete steps—accumulating evidence, preserving information, limiting interpretation. But the scholarly style does not, in itself, attract a huge audience, a fact that leads many to question its relevance. McCarthy scholars have essentially conceded the point. King scholars have sought to influence other publics by commenting on King commemorations, but to do so have had to give up the subtlety of their own work. Only in Atlanta have proponents of the scholarly style maintained both an audience and scholarly standards.

The existence of these several styles raises the question of how they relate, of what happens when they come into contact. Asked another way, this question echoes one of the main concerns occupying American cultural historians in the past fifteen years—why does the

American culture look the way it does? Answers to this question range along a continuum. At one end are those who see American culture as a battle for power, and the dominant strains of the culture as exemplars of the hegemony of the powerful. That is, the producers of culture determine the shape of the culture. At the other end of the continuum are those who view culture as a creation of those who receive it. Here, culture is an act of reading, and every individual, by virtue of his own interpretive power, is a producer of culture.[10]

The evidence in this book falls in the middle of the continuum. There is clearly no hegemony in American interpretations of McCarthy and King; no one of the styles dominates the others. But there are hegemonies. The tributary style, for example, dominates recollections of McCarthy in the national media, while the scholarly style is most powerful in academic views of McCarthy and King. This does not mean, though, that history makers are free agents, crafting the past as they wish. Rather, the style in which they work sets limits on the history they produce, while the choice of style is often made more by outside forces (events, professional rules, family ties) than by those actually creating the history.[11] The use of the tributary style to remember McCarthy in the national media grew out of particular historical circumstances—the rise of ultra-conservatism, the silence of moderate voices, the importance of Wisconsin in the cycle of presidential primaries. Likewise, Mrs. King adopted the memorial style in response to her peculiar situation—she was the head of Dr. King's family, lived in Atlanta, and temperamentally stood closer to the King of the March on Washington than the King of the Poor People's Campaign (an image already associated with the SCLC anyway).

Nor did the history coming out of a particular commemorative style guarantee agreement over just what that history meant. When the interests of two sets of history-makers coincided, as in the creation of a national King holiday, or the placement of McCarthy's bust, the groups shared language, but not meaning. In Appleton, pro- and anti-McCarthy forces agreed that McCarthy was irrelevant, but he was irrelevant in vastly different ways. In the early 1980s, both Mrs. King and Ronald Reagan constantly evoked King's dream. For Ronald Reagan "the dream" meant a color-blind society, for Mrs. King devotion to her husband's legacy.

But if there is no hegemony, how do the different styles interact? In fact, they tend not to interact at all. The image of McCarthy in

Appleton owes only a little to that created by scholars and the national media. In turn, the national and academic views of McCarthy seem oblivious of each other. King's legacies, to a lesser but significant extent, also grew up in interpretive isolation. That is not to say that the images never met or that they did not share influences—academics have struggled mightily to influence the national view of King, for example. Instead, when the images did meet the outside image took on the qualities of the one on whose ground they met. Academics writing in the national press after 1986 adopted the national, political framework at use there. They also provided their remarks on the occasion of the holiday, the central creation of the national community. And when outside influences came to Appleton, they had to grapple with the local interests of the John Birch Society and the Friends of McCarthy. McCarthy commemorations in Appleton took on national themes in the 1980s, but they did not take on the themes of the national history of McCarthy.[12]

As the McCarthy and King stories have remained separate until the 1980s and have met only sporadically since then, so have commemorative styles stayed apart. That the three meet rarely is due to the types of events that demand historical allusion. Anniversaries, with their emphasis on celebration and unity naturally call forth a memorial style. This was true in Appleton, when after a few false starts, the Friends of McCarthy drew press coverage by trying to educate Appletonians about McCarthy on the anniversary of his death. In King commemorations the power of anniversaries is even more apparent. When King commemorators in Atlanta began to emphasize the importance of a King holiday, the influence of the memorial style grew. Journalists and politicians built the national image of King around commemorations of the March on Washington, and so the memorial style was already at the fore when their attention turned to celebrating the date of his birth. If, as Michael Kammen and William Johnston argue, anniversaries are becoming the central site of public history, then the memorial style will continue to be a major way of interpreting the past.[13]

If the memorial style is the style of anniversaries, then the tributary style belongs to controversies. In Appleton, debate over the placement of McCarthy's bust drew very personal responses from McCarthy supporters. At important times in the story of King commemorations in Atlanta—the opening of the fund drive for the

King Center, the Center's dedication, the first national holiday—partisans of the tributary style received their widest hearing. And throughout the history of McCarthy commemorations in the national press, debates about the New Right, Watergate, the culture of the 1950s, Reagan anti-communism, and political correctness elicited the most personal tributes to McCarthy. The link between controversy and the tributary style comes from debate's solicitation of a personal point of view. But the tendency to link the two has grown stronger of late. The highly personalized and emotional marketing of controversy (targeted mass mailings and specialized newsletters, for example) link individuals to major disputes in the search for money. The politicization of personal life accomplishes the same thing in the search for votes. And the therapeutic nature of our culture both validates personal opinion and accords it great attention. Because emotions cannot be disproved, they are particularly valuable tools in contemporary debate. The result are controversies fought less to convince than to display the validity of one's feelings.[14]

If anniversaries draw out the memorial style, and controversies the tributary style, what evokes the scholarly style of remembrance? The answer has two parts. Most simply it is the passage of time, coupled with at least one person's interest in seeing the past in limited, historical terms. The National Park Service was a latecomer on the scene in Atlanta, appearing almost fifteen years after commemorations started. Historians started considering McCarthy in earnest more than a decade after his death. And even those historians who wrote about King during his life did so in the most traditionally historical way—a narrative beginning with King's birth and continuing chronologically to the present.

But the passage of time simply leads to a historical perspective, it does not guarantee that that perspective will receive public attention. If the scholarly style is constantly engaged in a struggle to remain relevant, as the chapters on McCarthy and King in the academy suggest, then it must be drawn there by existing public interest in the past. This is exactly what has happened in Atlanta and in national commemorations of King. Stated another way, at least since the 1950s, the scholarly style has relied on the vitality of the memorial and tributary styles for its public role.[15] If the other styles of remembrance are not vital, then the scholarly style leads quickly to forgetting, as the example of McCarthy in Appleton demonstrates.

The typical response to this problem has been to reassert the relevance of general knowledge. Historians writing about McCarthy in the 1980s argued that their works provided information that, if not immediately relevant, was generally useful. This has been the thrust of multicultural revisions and conservative defenses of the canon, as well. Both have sought to redeem general education by making it more generally relevant—multiculturalists by adapting the canon to the ethnic composition of America, conservatives by arguing that citizenship demands a certain core of shared knowledge. Historians writing about King have adopted a variation of this approach, couching their works on King in terms designed to comment on general public perceptions of him.

The major outcome of emphasizing general knowledge has been a focus on the content of history, not the process of creating it.[16] This is wise, because without doubt the scholarly style produces more accurate history than either the memorial or tributary styles. But it is also dangerous in public confrontations about the past such as the squabble over the placement of McCarthy's bust or the content of the King visitor center. Only the scholarly style values accurate content above all else. For the memorial and tributary styles, content is less important than official status or correctness validated by emotion. When these different approaches to truth come into conflict, the scholarly argument that the best content is the most accurate does not hold sway. There is no evidence, for example, that scholars have convinced huge numbers of Americans that Martin Luther King was not an innocuous dreamer, in spite of their careful research and claims to be presenting "new" information. The result is often a standoff of unsupported evidence, each side asserting that its own content is best based on its own, usually unspoken, assumptions. In such situations, politicians jump in, incivility flourishes, and power will out.

The problem of keeping debate grounded in civility and evidence has confronted theologians for decades. The scholarly production of theology has long been an insular affair, with theologians writing abstruse treatises for the pleasure of other theologians. In the meantime, the theoretical basis of such work—the enlightenment view that truth is universal—collapsed, the churches dropped any latent interest in theology for social services and revival, and religion became embroiled in contentious public debates about abortion, ecumenism, education, public prayer, and electoral politics.[17]

In response to the invisibility of theology and the incivility of public religious life, several theologians have suggested ways to make theology more public and public life more civil. They have focused on making evidence verifiable, theses particular, interpretation transparent, and conversation decent. Paula Frederickson has recently argued that much of the scholarship on the historical Jesus is flawed because "the method we use creates the data we interpret." In response to such scholarship, Frederickson outlined a set of "fixed points by which we can measure whether we write, and read, good history or bad." She continued, "A good historical hypothesis should account for data coherently, plausibly, and parsimoniously. As theories go, simple, public, and falsifiable should be preferred to complex, non-public (such as 'sub-conscious' or 'repressed'), and non-falsifiable."[18] Of course, Frederickson is not the first person to urge that history live up to these standards. Most of the scholarship on McCarthy and King has done so. But it is interesting that she sets these standards for a topic about which little verifiable information exists. It is the paucity of data that encouraged other scholars to turn to non-public, non-verifiable explanations of what Jesus' life was like. Frederickson, by calling her colleagues back from the interpretive edge, urges them to accept the limits that the passage of time sets on their work.

Scholars writing about McCarthy and King face a similar challenge caused by an opposite problem. Historians of ancient Palestine lack data, historians of recent America are overwhelmed by it. In either case, though, the rules of scholarship demand that historians recognize the boundaries of their work. The daunting pile of available data has led to three responses among historians. First, one may overlook certain information because it is less important. Second, one may write only about a certain portion of the information (trusting that someone else will eventually write about the rest). Third, one may try to gather all the information and present it as best one can. Each alternative brings with it its own challenges. Deeming certain data unimportant leaves a scholar open to charges of bias, leaving other work aside brings complaints about over-specialization, gathering everything together invites either sprawl or incoherence. Scholars have wandered from one path to another—historians writing about McCarthy have generally followed the middle course, those writing on King the latter.

When considered solely in the context of scholarship, any of the alternatives will do. But in a public context, one where the memorial and tributary styles are common, the central alternative—recognizing limits and leaving other work to others—seems the wisest choice. It is wise both because it recognizes that scholars rely on the existence of other styles of remembering for their work to matter publicly and because it best sets the scholarly style off from the others. Judging other work inadequate is a hallmark of the tributary style, a guarantee that debates about history will be acrimonious and personal. Seeking to explain it all weakens the interpretive punch, a problem that the memorial style faces.[19]

In addition, only the willingness to leave some data for others to interpret brings civility and argumentative power together. It recognizes the importance of other ways of interpretation while being grounded in a tradition that brings it critical power. Linnell Cady has made exactly this point in discussing the place of theology in American public life. She argues that public theology must grow out of and publicly recognize a tradition of interpretation in order to avoid the error of the Enlightenment—the belief that truth is truth for all people—and the parochialism of religion—the claim that something is true because a particular authority has said so. In the place of Enlightenment theology and parochial religion she seeks theology that "self-consciously operates out of an identifiable tradition without thereby abandoning the commitment to open inquiry."[20]

As a first step towards this theology, Cady suggests that interpretation must be transparent—that is, that both the sources of evidence and the goals of interpretation must be evident to those who wish to see them. And though the nature of religion raises some question about how useful such theology can be, her suggestions about the transparency of interpretation are important for crafting a useful, civil public approach to the past.[21] For historians, transparency requires that evidence be present and sources available, a long-standing practice when historians write for other scholars, but one that rarely reaches into public debates on the past.[22] Further, it requires that the philosophy of interpretation be open to view as well. In particular, it asks that historians make explicit the links they see between the past and the present. Such links must be specific and disprovable in order to contribute to public discussion about history.[23]

To this point, the insights of theology seem best to fit the work of scholars. But Cady's emphasis on interpretive transparency is important because it also suggests a starting point for public debate about the past. When scholarly, memorial, and tributary styles of remembrance come into contact, Cady suggests that scholars lead the debate to questions of process and evidence, before discussing meaning. Without the first focus on procedure, talk about what the past was degenerates into a battle over whose interpretation is right, a battle on the grounds of power, not truth. The benefits of starting with procedure are numerous, but the most important is that debate starts on information open to examination by all. It draws attention to the making of history before focusing on its use. It makes it possible for people interested in the past to agree on what constitutes history, on why something should be remembered, and something else forgotten. It gives scholars a place in debates that are otherwise engaged before they are invited in as arsenals of information in public war. It is a pre-political step.[24] By recognizing that scholarly history relies on the existence of other ways of remembering to be publicly useful, scholars should be able to avoid the accusations of elitism and irrelevance that plague them. By turning debate to procedure, scholars give the best of what they have to offer—method, distance, tradition, evidence—to those who need it most. This is not to say that public debate on the past will become instantly peaceful, or that consensus will break out all over. But it is to hope that the quality of debate will improve, that the resolution of conflict will come without appeals to political power, that history in public will draw people to an understanding of the past, and that the present will improve because of it.

Notes

1. By noting the ways that the interpretations of McCarthy and King fail to conform to common assertions of bias I do not mean to argue that I have exhausted all of the possibilities. The scope of the study does not allow me to examine, for example, why particular authors chose particular topics for research. That choice undoubtedly has a great deal to do with the personal predilections of the authors, and could be considered bias. Nor have I tried to plumb the subconscious links between authors and subjects. Finally, I do not wish to argue that in history production, ideology fails to come into play. New Left historians, for example, downplayed the importance of McCarthy in part because they were engaged in a larger project that sought to discredit Cold War liberalism. Thus, their real targets were people like Harry S. Truman and Daniel Bell, not McCarthy. What I do wish to argue, though, is that ideology is not the principal source for historical interpretations. Rather, interpretations tend to conform to a style of commemoration, while variations within that style may be due to ideology.

2. Even McCarthy supporters like William F. Buckley and the Friends of McCarthy acknowledged that McCarthy lacked decency, decorum, and devotion to the truth. King's harshest opponents agree that he did much good for blacks in America.

3. Appletonians recently battled over whose explanation of McCarthy's irrelevance was most apt, the mass media largely overlooked the fortieth anniversary of McCarthy's censure, and after two massive biographies of McCarthy, scholarly interest is waning. On the other hand, King Week continues to be a major celebration in Atlanta, annual King celebrations continue to get widespread press coverage, and scholarly interest in the Civil Rights Movement endures.

4. Daniel Boorstin, *The Image: A Guide to Pseudo-Events in America* (N.Y.: Athenaeum, 1978, orig. pub. 1961), 63.

5. When the government does consider commemorating the recent past, that decision itself can become controversial, as the debates over the King holiday and, to a lesser extent, the Vietnam War memorial make clear.

6. Compare, for example, major American commemorations of the recent past, such as the victory over Germany and Japan, with those in Europe, of the holocaust and Stalin's purges. Or compare scholarship in the United States on memory, which grew out of studies of famous presidents with that in Europe, which grew out of the memories of the survivors of death camps. On commemorating the holocaust, see

Dominick LaCapra, *Representing the Holocaust: History, Theory, Trauma* (Ithaca: Cornell University Press, 1994), on remembering the Soviet police state, see Adam Hochschild, *The Unquiet Ghost: Russians Remember Stalin* (N.Y.: Viking, 1994).

7. Recently, Calvin Trillin wrote about one such case, where forgetting the past was a conscious position taken by some of the members and some of the victims of the Mississippi Sovereignty Commission, the investigative arm of Mississippi's segregationist governments in the 1950s, 60s, and 70s. Calvin Trillin, "State Secrets," *New Yorker*, 29 May 1995, 54-64. The best work on charting the legacy of a "bad" event in the recent American past is Michael Schudson, *Watergate in American Memory* (N.Y.: Basic Books, 1992).

8. Gladys Engel Lang and Kurt Lang, *Etched in Memory: The Building and Survival of Artistic Reputation* (Chapel Hill: University of North Carolina Press, 1990), 331.

9. This is not to say that there are no other styles of commemoration, or that the memorial, tributary, and scholarly styles are mutually exclusive. There are no doubt many variations on each of them. But I believe that this formulation covers most of the ways that history makers commemorate the past.

10. On the state of contemporary cultural history, I have found the following particularly helpful: "AHR Forum," *American Historical Review*, December 1992, 1369-1430, and Richard Wightman Fox and T. J. Jackson Lears, eds., *The Power of Culture: Critical Essays in American History* (Chicago: University of Chicago Press, 1993).

11. In the characterization of relations between different styles of commemoration, I have been influenced by the writings of anthropologist Arjun Appadurai, especially, Arjun Appadurai, "The Past as a Scarce Resource," *Man*, 1981, 201-19.

12 Appadurai's study, based in India, reported similar findings. He wrote that the pasts that exist among a community of temple worshippers in Triplicane, India "stand in a segmented relationship to one another." That is, they developed and exist separately from one another, much as do the different pasts at work in the legacies of McCarthy and King. Ibid., 216.

13. Michael Kammen, *Mystic Chords of Memory* (N.Y.: Knopf, 1991), 667; William Johnston, *Celebrations* (New Brunswick: Transaction Publishers, 1991), 3-31.

14. On the personalization of controversy, see James Davison Hunter, *Before the Shooting Begins* (N.Y.: Free Press, 1994), David Link, "Storyville," *Reason*, Jan 1995, 35-43, and Wendy Kaminer, *I'm Dysfunctional, You're Dysfunctional* (N.Y.: Addison-Wesley, 1992).

15. Until the 1950s, Russell Jacoby has argued, public intellectuals carried with them an ample enough audience to influence public opinion by themselves. Russell Jacoby, *The Last Intellectuals* (N.Y.: Basic Books, 1987).

16. This has been explicitly true of conservative arguments about the canon, many of which see a focus on the process of learning as one reason why American students know so little about the past. See Diane Ravitch and Chester E. Finn, *What Do Our 17-Year-Olds Know? A Report on the First National Assessment of History and Literature* (N.Y.: Harper and Row, 1987), 18; and Lynne V. Cheney, *American Memory: A Report on the Humanities in the Nation's Public Schools* (Washington, D.C.: National Endowment for the Humanities, 1987), 5-8. But multiculturalist approaches to the canon have also paid more attention to content than process as they attempt to add women, the poor, and minorities to the general story of the American past. See, for example, Carey Kaplan and Ellen Cronan Rose, *The Canon and the Common Reader* (Knoxville: University of Tennessee Press, 1988) on getting women into the canon. The one major exception to this trend is Afrocentrism, which both recommends new content and a new way of learning based on centering oneself in an African tradition to understand the African past. See Molefi Asante, "On Historical Interpretations," in Asante, *Malcolm X as Cultural Hero and Other Afrocentric Essays* (Trenton: Africa World Press, 1993), 17-24.

17. On the insularity of theology and the collapse of its enlightenment foundations, see Linnell E. Cady, *Religion, Theology, and American Public Life* (Albany: SUNY Press, 1993), 1-29. On the contentiousness surrounding religion's role in public life, see Richard John Neuhaus, *The Naked Public Square: Religion and Democracy in America* (Grand Rapids: Eerdmans, 1984) and Hunter, *Before the Shooting Begins*.

18. Paula Frederickson, "What You See is What You Get: Context and Content in Current Research on the Historical Jesus," *Theology Today*, April 1995, 77.

19. For example, the New Left attack on the scholarship of Cold War liberals took on some of the spiteful tone of debates girded by the tributary style, while King biographies have struggled to both convey a mountain of information and find anything to say. King scholars have tried to surmount this problem by having their work comment on public perceptions of King, but to do so, they have emphasized the newness of their work, not the traditions that underlie it, thus undercutting the authority of the past to comment on the present.

20. Cady, *Religion*, 31-3. Quote on p.33.

21. In particular, Cady seems to overlook the importance of faith in making religion live. The belief in an unseen deity who acts in human affairs, though central to most evangelical religion, would have no place in her scheme.

22. This is in part the fault of the media, which seems indifferent to evidence and sources. But there is a widespread belief among scholars that acting for a broad audience means dropping footnotes in favor of interpretation. By so doing, they abandon one of the central strengths of the scholarly style, and invite debate on interpretation, not evidence. When others join this debate, the result can be a circus, as the Enola Gay debacle shows.

23. Cady, drawing on the work of legal theorist Ronald Dworkin, argues that there are three ways that interpretations of the past can be useful in the present. The first, conventionalism, looks for precedents (in the law, previous decisions, in history, previous events) that fit the present context. If precedents exist that fit the case, then they are simply applied to the present and the case is closed. If there are no precedents, then the interpreter makes sense of the present based on his own "moral and political proclivities." The second, extensionalism, sees the present as the continuation of the past. The goal of the historian (or judge or theologian) is to create "an overall story worth telling now." The third, instrumentalism, looks first to the future, to an ideal community, and then uses whatever history exists that supports the creation of a new society. The standard, though, is not of fidelity to the past, but to "an external ideal of a just, perfect society." Cady, *Religion*, 42-7. Cady prefers extensionalism for public theology, but it seems to me that both extensionalism and conventionalism can be used by historians without making present-day goals more important than historical evidence.

24. By "pre-political" I mean that a focus on the process of making history would come before that history is employed in political debate, be it about civil rights or civil liberties. See the final section of Hunter, *Before the Shooting Begins*, for his discussion of how churches and civic organizations might play the same pre-political role in the debates on abortion.

Bibliography

"2,000 Memphis Marchers Honor Dr. King." *New York Times*, 5 Apr 1978, A18.

"2nd McCarthy Memorial." *New York Times,* F1.

"8 Day Fete for Dr. King is Underway." *Atlanta Daily World*, 12 Jan 1982, 1, 6.

"8th Black Family Conference Today." *Atlanta Daily World*, 3 Apr 1987, 1.

"12th Anniversary of MLK Death to be Commemorated in Macon." *Atlanta Constitution*, 4 Apr 1980, 5.

"400 at Unveiling of McCarthy Bust." *New York Times*, 3 May 1959, 80."

"About 50 Attend McCarthy Service." *Appleton Post-Crescent*, 5 May 1975, B1.

Acheson, Dean. *Present at the Creation.* N.Y.: Holt, Rinehart and Winston, 1959.

Adams, John. *Without Precedent.* N.Y.: Norton, 1983.

Adler, Les K. "The Politics of Culture: Hollywood and the Cold War." In Robert Griffith and Athan Theoharis, eds. *The Specter: Original Essays on the Cold War and the Origins of McCarthyism.* N.Y.: Franklin Watts, Inc., 1974, 242-260.

"The Administration Replies to McCarthy." *The New Republic*, 8 May 1950, 5-6.

"Advertisement Evoking 'The Dream'." Ebony, Jan 1986, 42.

"Advertisement Evoking 'The Dream'." *Ebony*, Jan 1987, 31.

"Advertisement Evoking 'The Dream'." *Ebony*, Jan 1988,19, 33, 39, and 47.

"Advertisement Evoking 'The Dream'." *Ebony*, Jan 1989, 43.

"Advertisement Evoking 'The Dream'." *Ebony*, Jan 1989, 47.

"Advertisement Evoking 'The Dream'." *Jet*, 3 Feb 1986, 6-7.

"Advertisement for King Center Fundraiser." *Atlanta Daily World*, 14 Jan 1973, 9.

"After McCarthy-Pentagon Row." *U. S. News and World Report*, 25 June 1954, 36-9.

"AHR Forum." *American Historical Review*, Dec 1992, 1369-1430.

Albert, Peter J. and Ronald Hoffman, eds. *We Shall Overcome.* N.Y.: Pantheon Books, 1990.

Allen, Frederick and Alexis Scott Reeves. "King Had a Dream, Still Not Fulfilled." *Atlanta Constitution*, 4 Apr 1978, 1, 8.

_____. "Can We Memorialize King While Calling for Change?" *Atlanta Constitution*, 21 November 1985, 2.

Alpern, Sara, ed. *The Challenge of Feminist Biography.* Urbana: University of Illinois Press, 1992.

Alvarez, Alexandra. "Martin Luther King's 'I Have a Dream': The Speech Event as Metaphor." *Journal of Black Studies*, Mar 1988, 337-57.

Anderson, Jack and Ronald May. *McCarthy: The Man, the Senator, the "Ism".* Boston: Beacon Press, 1952.

Ansbro, John J. *Martin Luther King, Jr.: The Making of a Mind.* Maryknoll, N.Y.: Orbis Books, 1982.

Appadurai, Arjun. "The Past as a Scarce Resource." *Man*, 1981, 201-19.

Applebome, Peter. "Racial Lines Seen as Crucial in Mississippi Runoff." *New York Times*, 12 Apr 1993, B10.

"Appleton Service Honors McCarthy." *Appleton Post-Crescent*, 8 May 1967, B1.

"As Negro Unrest Continues to Spread." *U.S. News and World Report*, 25 July 1966, 30.

Asante, Molefi. "On Historical Interpretations." In Molefi Asante, *Malcolm X as Cultural Hero and Other Afrocentric Essays.* Trenton: Africa World Press, 1993, 17-24.

"Author Wins Right to Talk to Brother of Dr. King's Slayer." *New York Times*, 4 Jan 1974:, 41.

"The Awful Roar." *Time*, 30 Aug 1963, 9.

Ayres, B. Drummond. "New Jobs Law Is Urged as Humphrey Honor." *New York Times*, 15 Jan 1978, A27.

_____. "Two Cities, North and South, Show Progress by Blacks." *New York Times*, 28 Aug 1973, 1, 26.

Bailey, Sharon and Tyrone Terry. "SCLC Honors 9 on Anniversary of King Death." *Atlanta Constitution*, 5 Apr 1980, 11.

Bailyn, Bernard.*The Ideological Origins of the American Revolution.* Cambridge: Harvard University Press, 1967.

Baldwin, James. "The News From all the Northern Cities is, to Understate It, Grim; The State of the Union is Catastrophic." *New York Times*, 5 Apr 1978.

Baldwin, Lewis V. "The Minister as Preacher, Pastor, and Prophet: The Thinking of Martin Luther King, Jr." *American Baptist Quarterly*, 1988, 79-97.

_____. "Martin Luther King, Jr., The Black Church, and the Black Messianic Vision." *Journal of the Interdenominational Theological Center*, 1984-5, 93-108.

_____. *There is a Balm in Gilead.* Minneapolis: Fortress Press, 1991.

_____. *To Make the Wounded Whole.* Minneapolis: Fortress Press, 1992.

Barnett, Abraham. Review of *Crusader Without Violence: A Biography of Martin Luther King*, by L. D. Reddick. In *Library Journal*, Aug 1959, 2345.

Barrett, Harold. *Rhetoric and Civility: Human Development, Narcissism, and the Good Audience.* Albany: SUNY Press, 1991.

"The Battle of Loyalties." *Life*, 10 Apr 1950, 29-32.

Baughman, James L. *The Republic of Mass Culture: Journalism, Filmmaking, and Broadcasting in America Since 1941.* Baltimore: Johns Hopkins University Press, 1992.

Bayley, Edwin. *Joe McCarthy and the Press.* Madison: University of Wisconsin Press, 1981.

Bell, Daniel, ed. *The New American Right.* N.Y.: Doubleday, 1955.

Bell, Daniel. "Interpretations of American Politics." In Daniel Bell, ed. *The Radical Right: The New American Right, Expanded and Updated.* N.Y.: Doubleday, 1963, 39-61.

_____. *The End of Ideology.* Cambridge: Harvard University Press, 1960.

Bennett, Lerone. *What Manner of Man?: A Biography of Martin Luther King, Jr.* Chicago: Johnson Publishing, 1964.

Bennett, W. Lance. "Toward a Theory of Press-State Relations." *Journal of Communications*, Spring 1990, 103-125.

Bennett, William J. "A New Civil Rights Agenda." *Wall Street Journal*, 1 Apr 1991.

Berube, Michael. "The New Black Intellectuals." *New Yorker*, 9 January 1995, 73-79.

"Birthday Celebration for Martin Luther King." *Ebony*, Mar 1981, 126-129.

"Black Caucus Asks Holiday." *Atlanta Daily World*, 15 Jan 1981, 1, 4.

"Black World Institute in Operation at A.U." *Atlanta Daily World*, 20 Jan 1970, 1.

Blassingame, John. *The Slave Community*. N.Y.: Oxford University Press, 1972.

Bloom, Allan. *The Closing of the American Mind*. N.Y.: Simon and Schuster, 1987.

Blum, Howard. "Author Rejects Sons of Revolution Award, Terming Group Rightist." *New York Times*, 29 Apr 1979, 33.

Bodnar, John. *Remaking America: Public Memory, Commemoration, and Patriotism in the Twentieth Century*. Princeton: Princeton University Press, 1992.

Boorstin, Daniel. *The Image: A Guide to Pseudo-Events in America*. N.Y.: Athanuem, 1978.

Boyd, Gerald M. "President Meets with 20 Blacks, Intent Disputed." *New York Times*, 16 Jan 1985, A1, D21.

Boynton, Robert S. "The New Intellectuals." *Atlantic Monthly*, March 1995, 53-70.

Branch, Taylor. *Parting the Waters: America in the King Years*. N.Y.: Simon and Schuster, 1988.

Breasted, Mary. "Pupils at P. S. 180 Wonder 'If Dr. King Were Alive...'." *New York Times*, 15 Jan 1974, 39.

Breen, T. H. *Imagining the Past*. N.Y.: Addison-Wesley, 1989.

Brinkley, Alan. *Voices of Protest*. N.Y.: Oxford University Press, 1982.

Brody, John and Joe Earle. "Klansmen Throw Bottles and Rocks at Demonstrators." *Atlanta Constitution*, 18 Jan 1987, A1, 14.

Brookins, Portia S. "Senators, Rights Leaders Back Extension of Voting Act." *Atlanta Daily World*, 16 Jan 1975, 1, 4

Brumberg, Abraham. "Reagan's Untruths About Managua." *New York Times*, 18 June 1985, 27.

Buckley, William F. and L. Brent Bozell. *McCarthy and his Enemies*. Chicago: Regnery, 1954.

————. "Lattimore and Wicker." *National Review*, 18 Aug 1989, 54-5.

_____. "McCarthy to the Rescue." *National Review*, 28 July 1970, 804-5.

_____. "Owen Lattimore, RIP." *National Review*, 30 June 1989, 18-20.

_____. "Remember Paul Hughes." *National Review*, 1 Apr 1977, 403.

Burns, Stuart. "Martin Luther King's Empowering Legacy." *Tikkun*, Mar/Apr 1993, 49-53, 67-68.

"Bush Says America Owes Elder King for Son's Ideas." *Atlanta Constitution*, 16 Jan 1983, 10.

Cady, Linnell E. *Religion, Theology, and American Public Life*. Albany: SUNY Press, 1993.

Campbell, Barbara. "Ali Delights Students Here at a Tribute to Dr. King." *New York Times*, 13 Jan 1973, 20.

"Capitol Hill—Faggots on the Fire." *The New Republic*, 29 June 1953, 10-1.

Carmines, Edward G. and W. Richard Merriman, Jr. "The Changing American Dilemma: Liberal Values and Racial Policies." In Paul M. Sniderman, et al. eds., *Prejudice, Politics, and the American Dilemma*. Palo Alto: Stanford University Press, 1993, 237-255.

Carr, Dorothy. "Hubert H. Humphrey Receives Honors with King." *Atlanta Constitution*, 15 Jan 1978, 2.

_____. "Playing King a Lesson for Winfield." *Atlanta Constitution*, 15 Jan 1978, B14.

Carson, Clayborne. "Celebrate King's Achievements by Lifting Shroud of Myth." *Atlanta Constitution*, 19 Jan 1987, 11.

_____. "Martin Luther King, Jr.: Charismatic Leadership in a Mass Struggle." *Journal of American History*, Sept 1987, 448-454.

_____. "Reconstructing the King Legacy: Scholars and National Myths." In Peter J. Albert and Ronald Hoffman, eds. *We Shall Overcome*. N.Y.: Pantheon Books, 1990.

_____. Review of *Let the Trumpet Sound*, by Stephen Oates. In *Journal of American History*, June 1983, 202-3.

"Case Dating to McCarthy Era Takes a New Twist." *New York Times*, 5 Apr 1989, 19.

Castonia, Don. "Recalling Joe." *Appleton Post-Crescent*, 8 May 1989, A1.

_____. "The Followers and the Curious." *Appleton Post-Crescent*, 3 May 1982, B3.

_____. "U. S. Must Renew McCarthy's Fight." *Appleton Post-Crescent*, 2 May 1983, B1.

"Charge and Countercharge." *Time*, 10 Apr 1950, 17-9.

Chavis, Benjamin. "How Dr. Martin Luther King Changed His Mind." *Atlanta Daily World*, 23 Jan 1986, 4.

Cheney, Lynne V. *American Memory: A Report on the Humanities in the Nation's Public Schools*. Washington, D.C.: National Endowment for the Humanities, 1987.

Clendenin, Dudley. "Vermont U. Honors McCarthy Era Victim it Ousted." *New York Times*, 22 May 83, 22.

_____. "For Rights Rally, Nostalgia Edged with Disillusion." *New York Times*, 27 Aug 1983, 1, 27.

Coffin, Alex. "Honor King Memory, Allen Asks Atlantans." *Atlanta Constitution*, 4 Apr 1969, 1, 7.

_____. "Spare King's Killer, Rev. Abernathy Asks." *Atlanta Constitution*, 16 Jan 1969, 1, 10.

_____. "Widow, Mayor Start King Memorial Drive." *Atlanta Constitution*, 5 Apr 1969, 1, 3.

Cohn, Roy. "Believe Me, This is the Truth About the Army-McCarthy Hearings, Honest." *Esquire*, Feb 1968, 59-63, 122-131.

_____. *McCarthy*. N.Y.: New American Library, 1968.

Collier, Peter and David Horowitz. "McCarthyism: The Last Refuge of the Left." *Commentary*, Jan 1988, 36-41.

"Comment Abroad Scores McCarthy." *New York Times*, 4 May 1957, 12.

"Committee Findings on McCarthy." *U. S. News and World Report*, 8 Oct 1954, 60-71, 121-38.

Cone, James H. "Black Theology in American Religion." *Journal of the American Academy of Religion*, 1985, 759-765.

_____. "Martin Luther King, Jr., Black Theology-Black Church." *Theology Today*, 1984, 409-20.

_____. *Malcolm and Martin and American: A Dream or a Nightmare?*. Maryknoll, N.Y.: Orbis Books, 1991.

Conti, Joseph G. *Challenging the Civil Rights Establishment: Profiles of a New Black Vanguard*. Westport,: Praeger, 1993.

"Controversial Senators." *Appleton Post-Crescent*, 8 May 1957, 8.

Cosby, John. "About New York: the Metamorphosis of Roy Cohn." *New York Times*, 13 May 1974, 36.

Costello, Gerald. Review of *King: A Critical Biography*, by David L. Lewis. In *America*, 23 May 1970, 567-8.

"Cox Scores Erwin Panel on McCarthy-Like Tactics." *New York Times*, 12 June 1974, 23.

"Critics of U. S. Policy Testify at House Panel." *New York Times*, 20 Feb 1987, B5.

Crosby, Donald F. "The Politics of Religion: American Catholics and the Anti-communist Impulse." In Robert Griffith and Athan Theoharis, eds. *The Specter: Original Essays on the Cold War and the Origins of McCarthyism*. N.Y.: Franklin Watts, Inc., 1974, 20-38.

_____. *God, Church, and Flag: Senator Joseph R. McCarthy and the Catholic Church, 1950-1957*. Chapel Hill: University of North Carolina Press, 1978.

Crowther, Bosley. "Screen: Point of Order, Mr. Chairman." *New York Times*, 15 Jan 1964, 27.

Cuprisin, Tim. "In Defense of Joe McCarthy." *Milwaukee Journal*, 3 May 1987.

Cushman-Wood, Darren. "Martin Luther King, Jr. and Malcolm X: Economic Insights and Influences." *Monthly Review*, May 1993, 21-35.

Davis, John L. "King's Birthday Hailed as Legal Holiday by City and Local Schools." *Atlanta Daily World*, 15 Jan 1971, 1.

Davis, Lenwood G. *I Have a Dream*. Westport: Negro University Press, 1969.

Davis, Peter. "March, Jobs Rally Recall King Dream." *Atlanta Constitution*, 16 Jan 1977, 1, 4.

De Witt, Karen. "Smithsonian Scales Back Exhibit of Plane in Atom Bomb Attack." *New York Times*, 31 Jan 1995, A1.

DeHart, Jane Sherron. "Oral Sources and Contemporary History: Dispelling Old Assumptions." *Journal of American History*, Sept 1993, 582-95.

Delaney, Paul. "Civil Rights Unity Gone in Redirected Movement." *New York Times*, 29 Aug 1973, 1, 16.

DeLeon, Robert. "1,000 Honor King at Church Service." *Atlanta Constitution*, 16 Jan 1970, 1, 20.

"Democrats Fume at McCarthy, But He has Them Terrorized." *Newsweek*, 20 Aug 51, 19.

Dent, Bob. "Reagan Marks King Birthday." *Atlanta Constitution*, 16 Jan 1986, 1.

Department of the Interior, National Parks Service. *General Management Plan, Development Concept Plan, and Environmental Assessment: Martin Luther King, Jr. National Historic Site and Preservation District (May 1985)*. Atlanta, Cultural Resources Planning Division, Southeast Regional Office, 1985.

Department of the Interior, National Parks Service. *Martin Luther King, Jr. National Historic Site: Historic Resource Study (August 1994)*. by Robert W. Blythe, Maureen A. Carroll, and Steven H. Moffson.Atlanta, Cultural Resources Planning Division, Southeast Regional Office, 1994.

Diggins, John Patrick. *Up From Communism*. N.Y.: Harper and Row, 1975.

"Double Crosses . . . Special Privileges . . . Pressure." *U. S. News and World Report*, 21 May 1954, 113-20.

Douglass, Bruce. Review of *King: A Critical Biography*, by David L. Lewis. In *Christian Century*, 15 Apr 1970, 452-3.

"Dr. Irving Peress." *New York Times*, 5 Sep 1976, 29.

"Dr. King Carries Fight to Northern Slums." *Ebony*, Apr 1966, 94-96.

"Dr. King is Honored on 46th Birthday." *New York Times*, 16 Jan 1975, 44.

"Dr. King's Disservice to His Cause." *Life*, 21 Apr 1967, 4.

"Dr. King, Apostle of Nonviolence, Drew World Acclaim." *Washington Post*, 5 Apr 1968, A12.

"Dr. King, Peaceful Disturber." *New York Times*, 18 Jan 1993, A16.

"Dream, Still Unfulfilled." *Newsweek*, 14 Apr 1969, 34-35.

Dudman, Richard. *Men of the Far Right*. N.Y.: Pyramid Books, 1962.

Durcanin, Cynthia. "Freedom Rings Amid War." *Atlanta Constitution*, 22 Jan 1991, C1, 6.

_____. "Freedom Rings Amid War." *Atlanta Constitution*, 22 Jan 1991, C1, 6.

_____. "Jackson Blisters Reagan." *Atlanta Constitution*, 17 Jan 1989, 1, 6.

_____. "King Day Speakers Mark Political Gains Amid Rise in Racism," *Atlanta Constitution*. 16 Jan 1990. 1. 6.

_____. "Missiles Not Part of 'Dream' King's Widow Says." *Atlanta Constitution*, 21 Jan 1991, D1.

_____. "Mrs. King: Spend More on Social Programs." *Atlanta Constitution*, 15 Jan 1990, 1, 6.

Dyson, Michael Eric. "King's Light, Malcolm's Shadow." *New York Times*, 18 Jan 1993, A17.

_____. "Martin and Malcolm." *Transition* 56, 48-59.

"Echoes of the Old, Still Unsettled, McCarthy Battle." *New York Times*, 6 Apr 1979, C22.

"Editorial." *Life*, 12 Apr 1968, 6.

Entman, Robert. *Democracy Without Citizens: Media and the Decay of American Politics*. New York: Oxford University Press, 1989.

Ewald, William Bragg. *Who Killed Joe McCarthy?* N.Y.: Simon and Schuster, 1984.

Fairclough, Adam. *To Redeem the Soul of America,*. Athens, GA.: University of Georgia Press, 1987.

Fabre, Genevieve and Robert O'Meally, eds. *History and Memory in African-American Culture*. N.Y.: Oxford University Press, 1994.

Fentress, James and Chris Wickham. *Social Memory*. Cambridge, Eng.: Blackwell, 1992.

Foner, Eric. *Reconstruction*. N.Y.: Harper and Row, 1988.

_____. Review of *Let the Trumpet Sound*, by Stephen Oates. In *New York Times Book Review*, 12 Sep 1982, 14, 82.

"For Dr. King." *Essence*, Jan 1982, 116.

Fort, Vincent D. "The Atlanta Sit-In Movement, 1960-1961, an Oral Study." in David J. Garrow, ed. *Atlanta, Georgia, 1960-1961: Sit-Ins and Student Activism*. Brooklyn, N.Y., 1989, 113-182.

Fox, Richard Wightman and T. J. Jackson Lears, eds. *The Power of Culture: Critical Essays in American History*. Chicago: University of Chicago Press, 1993.

Francis, Samuel. "The Cult of Dr. King." In Samuel Francis, *Beautiful Losers: Essays on the Failure of American Conservatism*. Columbia, Mo.: University of Missouri Press, 1993, 152-60.

_____. "The Evil that Men Don't Do: Joe McCarthy and the American Right." In Samuel Francis, *Beautiful Losers: Essays on the Failure of American Conservatism*. Columbia: University of Missouri Press, 1993), 139-51.

"Fred Fisher." *New York Times*, 17 Oct 1976, 41.

Frederickson, Paula. "What You See is What You Get: Context and Content in Current Research on the Historical Jesus." *Theology Today*, April 1995, 75-97.

Frial, Frank J. "King and Dream Recalled Across U. S." *New York Times*, 16 Jan 1974, 53.

Fried, Richard. "McCarthyism Without Tears: A Review Essay." *Wisconsin Magazine of History*, Winter 1982-3, 145.

Friendly, Fred. "McCarthyism Revisited." *Washington Post*, 13 Feb 1977, C1, 5.

_____. *Nightmare in Red: The McCarthy Era in Perspective.* N.Y.: Oxford University Press, 1990.

"Friends Observe McCarthy's Death." *Appleton Post-Crescent*, 2 May 1966, B1.

Frisch, Michael. Review of *Mystic Chords of Memory*, by Michael Kammen, and *Remaking America*, by John Bodnar. In *Journal of American History*, Sept 1993, 619-21.

"Gala Festivities to Kick-Off Two-Day Commemoration of King Birthday." *Atlanta Daily World*, 11 Jan 1974, 1.

Galloway, Jim. "Unrest Erodes King Legacy of Nonviolence in Africa." *Atlanta Constitution*, 16 Jan 1987, 1, 12.

Gans, Herbert. *Deciding What's News.* N.Y.: Pantheon, 1979.

Garrow, David J. "King's Plagiarism: Imitation, Insecurity, and Transformation." *Journal of American History*, June 1991, 87-92.

_____. "Martin Luther King, Jr., and the Spirit of Leadership." *Journal of American History*, Sept 1987, 438-447.

_____. *Bearing the Cross: Martin Luther King, Jr., and the SCLC.* N.Y.: William Morrow and Co., 1986.

_____. *Protest at Selma.* New Haven: Yale University Press, 1978.

_____. Review of James Farmer, *Lay Bare the Heart.* In *Nation*, 4 May 1985, 535, 537.

_____. *The FBI and Martin Luther King, Jr.* N.Y.: Norton, 1981.

Garrow, David J., ed. *Atlanta, Georgia, 1960-1961: Sit-Ins and Student Activism.* Brooklyn, N.Y., 1989.

_____. *The Montgomery Bus Boycott and the Women Who Started It: The Memoir of Jo Ann Gibson Robinson.* Knoxville: University of Tennessee Press, 1987.

Gates, Henry Lewis. "Generation X: A Conversation with Spike Lee and Henry Lewis Gates." *Transition* 56: 176-190.

Gaziano, Cecilie. "The Knowledge Gap: An Analytical Review of Effects." *Communications Research*, Oct 1983, 447-86.

Gentry, Jerry. "Celebrating and Exploiting King Day." *Christian Century*, 14 Mar 1990, 268-70.

Gilliard, Deric. "Progress for Blacks Lies in Economic Arena, Says Jackson." *Atlanta Daily World*, 14 Jan 1983, 1.

Glasner, Jack. "Bust of Joe McCarthy Mixture of Age, Youth." *Appleton Post-Crescent*, 2 May 1959, 1.

Godfrey, Vonne. "Just Small Fry Flattened By McCarthyism." *New York Times*, 19 Jan 1980, 33.

Goldberg, Howard. "Poll: Most Say Racial Equality Still a Dream." *Wilmington News Journal*, 27 Aug 1993, A6.

Goldman, P.L. "Dr. King's Last Victory." *Newsweek*, 27 Jan 1986, 16-17.

Goldwater, Barry. "Needed: Conservatives at the Top." *New York Times*, 12 Sep 1973, 47.

Gopnik, Adam. "Read All About It." *New Yorker*, 12 Dec 1994, 84-89.

Gore, Leroy. *Joe Must Go*. N.Y.: Julian Messner, 1954.

Graber, Doris A. *Mass Media and American Politics*. 4th ed., Washington, D.C.: Congressional Quarterly Press, 1993.

Graham, Keith. "Author Examines the Psyche of MLK, Jr.." *Atlanta Constitution*, 15 Jan 1987, B1, 4.

Gramm, Rex. "City Pays Tribute to Dr. King." *Atlanta Constitution*, 15 Jan 1973, 1, 13.

Green, Connie. "Bennett Finds 3rd Graders Did Their Homework." *Atlanta Constitution*, 15 Jan 1986, 7.

_____. "DNR Will Seek Funding to Assist King Center." *Atlanta Constitution*, 8 Jan 1986, 13.

_____. "Two King Aides Visibly Absent from Activities." *Atlanta Constitution*, 18 Jan 1986, 10.

Greenwald, John. "Not Fit for a King." *Time*, 16 Jan 1995, 37.

Griffith, Robert and Athan Theoharis, eds. *The Specter: Original Essays on the Cold War and the Origins of McCarthyism*. N.Y.: Franklin Watts, Inc., 1974.

_____. "American Politics and the Origins of McCarthyism." In Robert Griffith and Athan Theoharis, eds. *The Specter: Original Essays on the Cold War and the Origins of McCarthyism*. N.Y.: Franklin Watts, Inc., 1974, 2-17.

_____. "The General and the Senator: Republican Politics and the 1952 Campaign in Wisconsin." *Wisconsin Magazine of History*, Autumn 1970, 23-29.

_____. "Introduction." In Robert Griffith, *The Politics of Fear*, 1987 Edition. Amherst: University of Massachusetts Press, 1987.

_____. "The Politics of Anti-Communism: A Review Article." *Wisconsin Magazine of History*, Summer 1971, 299-308.

_____. *The Politics of Fear: Joseph R. McCarthy and the Senate*, 2d ed. Amherst, MA.: University of Massachusetts Press, 1987.

Guertzman, Bernard. "John Paton Davies, Jr. is Cleared, Was Ousted in the McCarthy Era." *New York Times*, 15 Jan 1969, 1.

Hamilton, Charles V. Review of *King: A Critical Biography*, by David L. Lewis. In *New York Times Book Review,* 5 Apr 1970, 14,16,18.

Hansen, John O. "Chamber to Help Out With King Holiday." *Atlanta Constitution*, 7 November 1985, 31.

Harding, Vincent. "Beyond Amnesia: Martin Luther King, Jr. and the Future of America." *Journal of American History*, Sept 1987, 468-477.

Harlan, Louis R. Review of *King: A Critical Biography*, by David L. Lewis. *American Historical Review*, Oct 1970, 1797-8.

Harmetz, Aljean. "Films About Blacklist: Hollywood's Bad Old Days." *New York Times*, 20 Oct 1987, C18.

Harris, Karen and Bill Montgomery. "Coca-Cola's Keough Given Top King Award." *Atlanta Constitution*, 19 Jan 1986, D2.

Harris, Kevin. "Commission Gives Pointers on Celebrating King Holiday." *Atlanta Constitution*, 16 December 1985, D1.

Hayden, Dolores. *The Power of Place: Urban Landscape as Public History*. Cambridge, MIT Press, 1995.

"He Had a Dream: Excerpts from *My Life with Martin Luther King, Jr.*" *Life*, 12 Sept 1969.

"He Says He Doesn't Want to be President." *Newsweek*, 7 Dec 1953, 27.

Heilbrun, Carolyn. *Writing a Woman's Life*. N.Y.: Norton, 1988.

Herbers, John. "McCarthy's Poisonous Legacy is Still Felt." *New York Times*, 26 Oct 1975, D2.

Herman, Edward and Noam Chomsky. *Manufacturing Consent*. N.Y.: Pantheon, 1988.

"A Hero to be Remembered." *Ebony*, Apr 1975, 134.

Hinant, Mike. "They Remember Joe 20 Years Later." *Appleton Post-Crescent*, 2 May 1977, B1, 3.

Hiskey, Michelle. "Williams Lashes Out." *Atlanta Constitution*, 16 Jan 1990, D1, 5.

Hixson, William B. *Search for the American Right: An Analysis of the Social Science Record*. Princeton: Princeton University Press, 1992.

Hochschild, Adam. *The Unquiet Ghost: Russians Remember Stalin*. N.Y.: Viking, 1994.

Hofstadter, Richard. "Pseudo-Conservatism Revisited: A Postscript." In Daniel Bell, ed. *The Radical Right: The New American Right, Expanded and Updated*. N.Y.: Doubleday, 1963, 81-6.

_____. *The Age of Reform*. N.Y.: Vintage Books, 1955.

_____. *The Paranoid Style in American Politics*. N.Y., Vintage Books, 1964.

_____. "The Pseudo-Conservative Revolt." In Daniel Bell, ed. *The Radical Right: The New American Right, Expanded and Updated*. N.Y.: Doubleday, 1963, 63-80.

Holmes, David R. *Stalking the Academic Communist: Intellectual Freedom and the Firing of Alex Novikoff*. Hanover, VT.: University Press of New England, 1989.

Holsendolph, Ernest . "63 March in Retrospect: Many Strata of Meaning." *New York Times*, 30 Aug 1973, 35, 54.

Hopkins, Sam. "Call for Holiday Marks King Service." *Atlanta Constitution*, 16 Jan 1982, B1, 3.

Hoskins, Lottie, ed. *"I Have a Dream": The Quotations of Martin Luther King, Jr*. N.Y.: Grosset and Dunlap, 1968.

"Huck Finn's Voice is Heard as Twain Meets Black Youth." *New York Times*, 7 July 1992, A1.

Hughes, Ernest John. "A Curse of Confusion." *Newsweek*, May 1967, 17.

Hunter, James Davison. *Before the Shooting Begins*. N.Y.: Free Press, 1994.

Huskisson, Gregory. "Alternative Group to SCLC Called by Williams Backers." *Atlanta Daily World*, 5 Apr 1979, 7.

Hyatt, Marshall. Review of *Bearing the Cross*, by David J. Garrow. In *The Historian*, Aug 1988, 618.

"I Have a Daydream." *National Review*, 16 Sept 83.

"I Have a Dream." *Atlanta Daily World*, 12 Jan 1984, 6.

"I Like the Word Black." *Newsweek*, 6 May 1963, 27-28.

Ickes, Harold. "A Decoration for McCarthy." *The New Republic*, 10 Apr 1950, 17-8.

_____. "McCarthy Strips Himself." *The New Republic*, 21 Aug 1950, 8.

"Ike vs. McCarthy: Another Round." *U. S. News and World Report*, 12 Mar 1954, 101-104.

"In 800,000 Words of Hearings." *U. S. News and World Report*, 21 May 1954, 48-50.

"In Snow and Icy Winds, a Nation Honors Dr. King." *New York Times*, 16 Jan 1982, 9.

"In Time, More Will Honor King." *Atlanta Constitution*, 3 December 1985, 10.

Jackson, Jesse. "White Religious Leaders and Black Social Justice." *New York Times*, 11 Apr 1973, 46.

Jacoby, Russell. *The Last Intellectuals*. N.Y.: Basic Books, 1987.

"Joe Called 'Fallen Warrior' in Service of His Country." *Appleton Post-Crescent*, 6 May 1957, 1, 10.

Johnston, William. *Celebrations: The Cult of Anniversaries in Europe and the United States Today*. New Brunswick: Transaction Publishers, 1991.

Josephson, Matthew. "The Time of Joe McCarthy." *Nation*, 9 Mar 1974, 312-15.

Joyce, Fay. "Five Thousand March in Demand for Jobs." *Atlanta Constitution*, 16 Jan 1976, 1, 26.

_____. "Passage of Jobs Bill Predicted." *Atlanta Constitution*, 15 Jan 1976, 2.

Kammen, Michael. *Mystic Chords of Memory: The Transformation of Tradition in American Culture*. N.Y.: Knopf, 1991.

Kaplan, Carey and Ellen Cronan Rose. *The Canon and the Common Reader*. Knoxville: University of Tennessee Press, 1988.

Kaplan, Peter W. "Senator McCarthy's Legacy." *Washington Post*, 3 May 1982, C1, 11.

Kaufman, Michael T. "Over 20 Years, the Mood Has Changed Markedly." *New York Times*, 28 Aug 1983, 28.

Kaye, Harvey. Review of *Mystic Chords of Memory*, by Michael Kammen. In *American Quarterly*, June 1994, 251-7.

"Keeper of the Dream." *Newsweek*, 24 Mar 1969, 38.

"Kennedy on McCarthy." *Newsweek*, 6 July 1959, 25-6.

Kenyon, Richard L. "Can You Find Joe McCarthy Around Here?" *Milwaukee Journal Magazine*, 1 Oct 1989.

Kimbrough, Ann Weak. "Businesses Help King Center's Fundraising." *Atlanta Constitution*, 7 Jan 1985, C2.

"King Center is Focus Here." *Atlanta Daily World*, 16 Jan 1972, 1.

"King Holiday Schedule." *Atlanta Daily World*, 14 January 1986, 2.

"King Memorial Today Will Center at Ebenezer. " *Atlanta Constitution*, 15 Jan 1969, 5.

"King Mobilized Forces of Goodwill, Young Argues." *Atlanta Daily World,* 17 Jan 1974, 12.

"King Shrine to Reopen." *New York Times*, 19 Jan 1995, 16.

"King Week Celebration Brings Many to City." *Atlanta Daily World*, 13 Jan 1983, 1, 4.

"King's Targets." *Newsweek*, 22 June 1964, 26.

"King's Dream." *Atlanta Constitution*, 15 Jan 1976, 4.

King, Martin Luther, Jr. "U.S. Plays Roulette with Riots." *Washington Post*, 7 Apr 1968, B1,3.

_____. *Where Do We Go From Here? Chaos or Community*. Boston: Beacon Press, 1968.

Kovel, Joel. *Red Hunting in the Promised Land*. N.Y.: Basic Books, 1994.

Kramer, Hilton. "The Blacklist and the Cold War." *New York Times*, 3 Oct 1976, D1, 16-7.

LaCapra, Dominick. *Representing the Holocaust: History, Theory, Trauma*. Ithaca, Cornell University Press, 1994.

Lacy, Suzanne, ed. *Mapping the Terrain: New Genre Public Art*. Seattle: Bay Press, 1995.

Lamar, Jacob V., Jr. "Honoring Justice's Drum Major." *Time*, 27 Jan 1986, 24-25.

Landis, Mark. *Joe McCarthy: The Politics of Chaos*. Susquehanna, PA.: The Susquehanna University Press, 1987.

Lang, Gladys Engel and Kurt Lang. *Etched in Memory: The Building and Survival of Artistic Reputation*. Chapel Hill: University of North Carolina Press, 1990.

"Last of 2 Million Words." *U. S. News and World Report*, 25 June 1954, 142-51.

Latham, Earl. *The Communist Problem in Washington; from the New Deal to McCarthy*. Cambridge, Harvard University Press, 1966.

Lawrence, David. "Foes May Make Martyr, Hero of McCarthy." *Appleton Post-Crescent*, 23 Mar 1954, 4.

_____. "Forget It's McCarthy—Remember the Constitution!" *U. S. News and World Report*, 8 Oct 1954, 144.

Lentz, Richard. *Symbols, the News Magazines, and Martin Luther King*. Baton Rouge: Louisiana State University Press, 1990.

Levine, Lawrence. *Black Culture and Black Consciousness: Afro-American Folk Thought from Slavery to Freedom*. N.Y.: Oxford University Press, 1977.

Lewis, Angelo. "800 Protesters Demands Jobs Push by President." *Atlanta Constitution*, 15 Jan 1979, 14.

Lewis, David L. "Failing to Know Martin Luther King, Jr." *Journal of American History*, June 1991, 81.

_____. *King: A Critical Biography*. N.Y.: Praeger, 1970.

_____. Review of *Bearing the Cross*, by David Garrow. In J*ournal of American History*, Sept 1987, 482.

_____. Review of *Bearing the Cross*, by David J. Garrow. In *Journal of American History*, Sep 1987, 482-484.

Lewis, Lionel S. *Cold War on Campus: A Study of the Politics of Organizational Control*. New Brunswick, N. J.: Transaction Books, 1988.

Lichter, S. Robert. *The Media Elite*. Bethesda, Md.: Adler and Adler, 1986.

"Lie Detectors, Reds in Defense Plants." *U. S. News and World Report*, 11 June 1954, 142-55.

Linethal, Edward T. "Can Museums Achieve a Balance Between Memory and History?" *Chronicle of Higher Education*, 10 Feb 1995, B1.

Ling, Peter. "More Malcolm's Year than Martin's." *History Today*, Apr 1993, 13-16.

Link, David. "Storyville." *Reason*, Jan 1995, 35-43.

Lipset, Seymour Martin. "The Sources of the 'Radical Right'." In Daniel Bell, ed. *The Radical Right: The New American Right, Expanded and Updated*. N.Y.: Doubleday, 1963, 259-312.

_____. "Three Decades of the Radical Right: Coughlinites, McCarthyites, and Birchers." In Daniel Bell, ed. *The Radical Right: The New American Right, Expanded and Updated*. N.Y.: Doubleday, 1963, 313-377.

Lipsitz, George. *Time Passages: Collective Memory and American Popular Culture*. Minneapolis: University of Minnesota Press, 1990.

Lora, Ronald. "Conservative Intellectuals, the Cold War, and McCarthy." In Robert Griffith and Athan Theoharis, eds. *The Specter: Original Essays on the Cold War and the Origins of McCarthyism*. N.Y.: Franklin Watts, Inc., 1974, 42-70.

"Lord of the Doves." *Newsweek*, 7 Apr 1967, 44.

Lowenthal, David. Letter to the Editor of *Perspectives*, Jan 1994, 17-8.

_____. *The Past is a Foreign Country*. N.Y.: Cambridge University Press, 1985.

"Lowrey Critical of Reagan on King Bill." *Atlanta Daily World*, 12 Jan 1986, 2.

Lyons, Richard D. "Lobbying Goes on to Shift Holidays." *New York Times*, 4 May 1975, 16.

"M.L. King Tribute Slated Here." *Atlanta Daily World*, 14 Jan 1973, 6.

Major Speeches and Debates of Senator Joe McCarthy. Washington, D.C.: Government Printing Office, 1953.

"Man of Conflict Wins Peace Prize." *U.S. News and World Report*, 26 Oct 1964, 24.

"The March Goes On." *Nation*, 1 Feb 1986, 99-100.

"March to Nowhere." *New Republic*, 19-26 Sept 83, 7-10.

"Martin Luther King Medal Sought by Senator." *Atlanta Daily World*, 2 Apr 1970, 8.

"Martin Luther King Will Have His Day." *U.S. News and World Report*, 7 Oct 1983, 16.

Marty, Martin. "MLK: The Preacher as Virtuoso." *Christian Century*, 5 Apr 1989, 348-50.

McAuliffe, Mary S. "The Politics of Civil Liberties: The ACLU During the McCarthy Years." In Robert Griffith and Athan Theoharis, eds. *The Specter: Original Essays on the Cold War and the Origins of McCarthyism*. N.Y.: Franklin Watts, Inc., 1974, 152-170.

McBee, Susanna. "Restrained Militancy Marks Rally Speeches." *Washington Post*, 29 Aug 1963, A14.

"McCarthy at the Barricades." *Time*, 27 Mar 1950, 20-1.

"McCarthy Has His Inning." *U. S. News and World Report*, 30 Apr 1954, 94-9.

"The McCarthy Heritage." *Appleton Post-Crescent*, 6 May 1957, 8.

"The McCarthy Issue: Pro and Con." *U. S. News and World Report*, 7 Sept 51, 24-42.

"McCarthy Name Won't Be on New Justice Center." *Appleton Post-Crescent*, 11 Dec 1991, B-2.

"McCarthy on the Loose." *Atlantic*, May 1950, 4.

"The McCarthy Question." *Commonweal*, 16 Nov 1973, 171-2.

"McCarthy vs. Stevens: Committee's Conclusions." *U. S. News and World Report*, 10 Sep 1954, 76-87.

"McCarthy's Last Stand." *Time*, 17 Jan 1964, 49.

"McCarthyism: Is it a Trend?" *U. S. News and World Report*, 19 Sept 1952, 21-2.

"McCarthyism: The Turning Point." *New York Times,* 1 Apr 1979, F22.

McCormick, Charles H. *This Nest of Vipers: McCarthyism and Higher Education in the Mundel Affair, 1951-52.* Urbana: University of Illinois Press, 1989.

McDonald, Forrest. "Introduction." In Charles Beard, *An Economic Interpretation of the Constitution of the United States*, 1986 Edition. N.Y.: Free Press, 1986, vii-xl.

McIntosh, Sandra. "March is Still on in Forsyth County as Negotiations Fail." *Atlanta Constitution*, 16 Jan 1988, B1, 3.

McKibben, Bill. Review of *Bearing the Cross*, by David J. Garrow. In *New Yorker*, 6 Apr 1887, 102-112.

"The Meaning of the March." *Time*, 6 Sept 1963, 13-15.

Meehan, Thomas. "Woody Allen in a Comedy About Blacklisting? Don't Laugh." *New York Times*, 7 Dec 1975, B1.

Meier, August. "On the Role of Martin Luther King." *New Politics*, Jan 1965, 1-8.

"Memo to MLK." *National Review*, 12 Dec 1967, 1368.

Memorial Services Held in the Senate and the House of Representatives of the United States, Together with Remarks Presented in Eulogy of Joseph Raymond McCarthy, Late a Senator From Wisconsin. Washington, D. C.: Government Printing Office, 1957.

"Memory of Dr. King is Marked in Church Services Around City." *New York Times*, 13 Jan 1975, 32.

"Memphis March Marks Murder of Dr. King." *New York Times*, 5 Apr 1973, 47.

Merriner, Jim and Gregory Jaynes. "Concert Brings King Birth Observance." *Atlanta Constitution*, 15 Jan 1974, 11.

_____. "SCLC Soup Line Opened." *Atlanta Constitution*, 5 Apr 1974, 6.

Meyer, Frank S. "Showdown with Insurrection." *National Review*, 16 Jan 1968, 36.

_____. "The Violence of Nonviolence." *National Review*, 20 Apr 1965, 327.

Meyer, James. "Bust Issue Pits History vs. Infamy." *Appleton Post-Crescent*, 13 Mar 1989, A10.

_____. "Bust Plan Made More Palatable." *Appleton Post-Crescent*, 6 Sept 1991, B-1.

_____. "Downey to Honor McCarthy." *Appleton Post-Crescent*, 12 April 1989, A1.

_____. "Joe's Fans May Get Last Word." *Appleton Post-Crescent*, 21 Aug 1991, A-1.

_____. "McCarthy Bust-Out Push Fails." *Appleton Post-Crescent*, 11 Sept 1991, A-1.

_____. "Taylor Turns Issue of McCarthy Bust Into a Campaign." *Appleton Post-Crescent*, 15 Aug 1991, B-1.

Meyer, Karl. "McCarthyism: Rovere is Too Sanguine." *New Republic*, 15 June 1959, 8-9.

Meyrowitz, Joel. *No Sense of Place*. N.Y.: Oxford University Press, 1985.

Miller, Cliff. "McCarthy's Bust Needn't Just Be a Dust-Catcher." *Appleton Post-Crescent*, 4 October 1989, A-4.

Miller, Keith. "Composing Martin Luther King, Jr." *Publications of the Modern Language Association*, 1990, 70-82.

_____. "Influence of a Liberal Homiletic Tradition on *Strength to Love* by Martin Luther King, Jr." Ph.D. dissertation, Texas Christian University, 1984.

_____. "Martin Luther King, Jr. Borrows a Revolution." *College English*, 1986, 249-265.

_____. "Martin Luther King, Jr., and the Black Folk Pulpit." *Journal of American History*, June 1991, 120-3.

_____. *Voice of Deliverance*. N.Y.: Free Press, 1992.

"MLK Center Gets $500K Pledge." *Atlanta Constitution*, 18 December 1984, C2.

"Monitored Calls—Cruelty—Politics." *U. S. News and World Report*, 18 June 1954, 126-39.

Mooney, Brenda. "Celebration of King Day: Keeping the Dream Alive." *Atlanta Constitution*, 16 Jan 1980, C1, 21.

Moore, Beverly J. "Mrs. King Vows to Carry On Husband's Rights Struggle." *Atlanta Daily World*, 6 Apr 1980, 1, 4.

Morgenstern, Joseph. "See It Now." *Newsweek*, 17 Jan 1972, 83-4.

Morrison, David C. "Airpower *Uber Alles*." *National Journal*, 2 Apr 1994, 805.

"Mrs. King Calls Full Employment 1976 Key Issue." *Atlanta Daily World*, 11 Jan 1976, 2.

"Mrs. King Pleads for All to Fulfill Husband's Dream." *Washington Post*, 7 Apr 1968, A2.

"Murrow vs. McCarthy." CBS, 15 June 1994.

Myrick, Clarissa. "King Followers Told to Retain Leader's Dream." *Atlanta Daily World*, 17 Jan 1975, 1.

"A Myth Exploded." *Time*, 13 Dec 1954, 12-4.

Narvaez, Alfonso A. "Legislature Lacks Power to Summon Special Session." *New York Times*, 5 June 1975, 34.

_____. "Legislature Lacks Power." *New York Times*, 5 June 1975, 34.

"A National Holiday for King." *Time*, 31 Oct 1983, 32.

Nesbit, Robert C. *Wisconsin: A History*. 2d ed., revised and updated by William F. Thompson. Madison: University of Wisconsin Press, 1989.

Neuhaus, Richard John. *America Against Itself*. South Bend: University of Notre Dame Press, 1992.

_____. *The Naked Public Square*. Grand Rapids, MI.: Eerdmans, 1984.

"New Negro Threat: Mass Disobedience." *U.S. News and World Report*, 28 Aug 1967, 10.

Newsome, Lionel and William Golden. "A Stormy Rally in Atlanta." in David J. Garrow, ed. *Atlanta, Georgia, 1960-1961: Sit-Ins and Student Activism*. Brooklyn, N.Y., 1989, 105-112.

Noble, Kenneth T. "Rights Marchers Ask New Coalition for Social Change." *New York Times*, 28 Aug 1983, 1, 30.

Nordheimer, John. "'The Dream' 1973: Blacks Move Painfully Toward Full Equality." *New York Times*, 26 Aug 73 1, 44.

Novick, Peter. *That Noble Dream: The 'Objectivity Question' and the American Historical Profession.* N.Y.: Cambridge University Press, 1988.

"Now, a New Kind of March on Washington." *U.S. News and World Report*, 22 March 1965, 8.

Nuby, C. "He Had a Dream." *Negro History Bulletin*, May 1968, 21.

O'Brien, Michael. "Young Joe McCarthy, 1908-1944." *Wisconsin Magazine of History* , Spring 1980, 179-232.

_____. *McCarthy and McCarthyism in Wisconsin.* Columbia, Mo.: University of Missouri Press, 1980., 121-6.

_____. *McCarthy and McCarthyism in Wisconsin.* Columbia: University of Missouri Press, 1980.

_____. "McCarthy and McCarthyism: The Cedric Parker Case, November 1949." In Robert Griffith and Athan Theoharis, eds. *The Specter: Original Essays on the Cold War and the Origins of McCarthyism.* N.Y.: Franklin Watts, Inc., 1974, 226-238.

_____. "Young Joe McCarthy, 1908-1944." *Wisconsin Magazine of History*, Spring 1980, 179-232.

O'Reilly, Kenneth. *Hoover and the UnAmericans.* Philadelphia: Temple University Press, 1983.

O'Rourke, P.J. *The American Spectator's Enemies List: A Vigilant journalist's Plea for a Renewed Red Scare.* N.Y.: Atlantic Monthly Press, 1996.

_____. "1992 New Enemies List Third Annual Readers' Update." *American Spectator*, Nov 1992, 35-46.

_____. "A Call for a New McCarthyism." *American Spectator*, July 1989, 14-5.

_____. "A New McCarthyism: The List Continues." *American Spectator*, Oct 1989, 14-6.

_____. "Commies—Dead but too Dumb to Lie Down." *American Spectator*, Nov 1991, 12-5.

_____. "Shoot the Wounded." *American Spectator*, Nov 1990, 14-20.

Oates, Stephen. *Let the Trumpet Sound: The Life of Martin Luther King, Jr.* N.Y.: Harper and Row, 1982.

"Official Opening of Martin Luther King Memorial Center." *Atlanta Daily World*, 18 Jan 1970, 10.

Olansky, Marvin N. "Liberal Boosterism and Conservative Distancing: Newspaper Coverage of the Chambers-Hiss Affair, 1948-50." *Continuity*, Fall-Winter 1991, 31-44.

"An Old China Hand Will Explain Why it Just Ain't So." *New York Times*, 12 May 79, 11.

Oshinsky, David. *A Conspiracy So Immense: The World of Joseph McCarthy*. N.Y.: Free Press, 1983.

_____. *Senator Joseph R. McCarthy and the American Labor Movement*. Columbia: University of Missouri Press, 1976.

Pace, Eric. "Honor Comes a Bit Late." *New York Times*, 4 Feb 1973,D5.

Painton, Priscilla. "'Dark Joy' Marks Celebration of King Holiday." *Atlanta Constitution*, 20 Jan 1987, 1, 6.

_____. "After a Sluggish Start, King Holiday is on a Roll." *Atlanta Constitution*, 7 Jan 1986, 1, 8.

_____. "Fly the Flag MLK Day Organizers Urge." *Atlanta Constitution*, 29 October 1985, 17.

_____. "Follow King by Helping Poor, Jesse Jackson Urges Audience." *Atlanta Constitution*, 16 Jan 1986, 7.

_____. "Forsyth Events Sober Celebrants." *Atlanta Constitution*, 18 Jan 1987, 14.

_____. "King Center Struggles to Meet Social Needs, be a Memorial." *Atlanta Constitution*, 17 Jan 1986, 1, 12.

_____. "King Era Would Get Video-Age Touch at Memphis Museum." *Atlanta Constitution*, 15 Jan 1987, 19, 20.

_____. "King Holiday Stirs Thanksgiving at Big Bethel Services." *Atlanta Constitution*, 13 Jan 1986, 1, 4.

_____. "King Parade Planners Run Short on Funds." *Atlanta Constitution*, 4 Jan 1986, 1, 17.

_____. "King's Role in History Revised by Scholars." *Atlanta Constitution*, 18 Jan 1987, 1.

_____. "Setbacks Plague Planners 11 Weeks from King Holiday." *Atlanta Constitution*, 3 November 1985.

Parish, Peter J. *Slavery: History and Historians*. N.Y.: Harper and Row, 1982.

Parsons, Talcott. "Social Strains in America." In Daniel Bell, ed. *The Radical Right: The New American Right, Expanded and Updated*. N.Y.: Doubleday, 1963, 175-192.

"Partisan Clashes in Congress." *New York Times*, 1 June 1984, 20.

"Pastor of St. Mary's Calls for McCarthy's Torch to be Raised." *Appleton Post-Crescent*, 7 May 1957, 17.

Peterson, Merrill. *The Jefferson Image in the American Mind*. N.Y.: Oxford University Press, 1960.

_____. *Lincoln in American Memory*. N.Y.: Oxford University Press, 1994.

"Photograph of Dr. King at the March on Washington." *Ebony*, Jan 1980, 83.

"Photograph of Dr. King at the March on Washington." *Ebony*, Nov 1985,70.

"Photograph of Dr. King at the March on Washington." *Newsweek*, 27 Jan 1986, 17.

"Photograph of Dr. King at the March on Washington." *Newsweek*, 31 Oct 1983, 32.

"Plagiarism and Originality: A Roundtable." *Journal of American History*, June 1991, 11-123.

"Plan for $10 Million King Center Unveiled." *Atlanta Daily World*, 13 Jan 1974, 1.

"Point of Order." *Newsweek*, 8 Nov 1965, 62.

"Poison Claim Refuted." *Appleton Post-Crescent*, 5 May 1969, B1.

Pollack, Roger. "McCarthy Unmasked: How *The Progressive* Helped Ground Tailgunner Joe." *Progressive*, July 1984, 56.

Polsby, Nelson W. "Towards an Explanation of McCarthyism." *Political Studies*, October 1960, 250-71.

Posner, Richard. *Cardozo: A Study in Reputation*. Chicago: University of Chicago Press, 1990.

Potter, Charles. *Days of Shame*. N.Y.: Coward-McCann, 1965.

Powers, Richard Gid. *Not Without Honor: The History of American Anti-Communism*. N.Y.: Free Press, 1995.

"Primaries: Those for Joe Go." *Newsweek*, 27 Sept 54, 28.

"The Prince of Peace is Dead." *Ebony*, May 1968, 172.

Quinn, Kathleen. "Joe McCarthy, Back in Style." *New York Times*, 2 Nov 91, 23.

Raines, Howell and Colleen Teasley. "King Benefit Grosses $75,000." *Atlanta Constitution*, 16 Jan 1973, 1, 15.

_____. "Pressure Rises for Day in Georgia Hailing Dr. King." *New York Times*, 10 Jan 1979, A12.

Rauh, Joseph. "The McCarthy Era is Over." *U. S. News and World Report*, 26 Aug 1955, 68-70.

Ravitch, Diane and Chester E. Finn. *What Do Our 17-Year-Olds Know? A Report on the First National Assessment of History and Literature.* N.Y.: Harper and Row, 1987.

"Reagan and Bush Praise Kings." *Atlanta Daily World*, 18 Jan 1983, 1, 6.

Reagon, Bernice Johnson. "'Nobody Knows the Trouble I See'; or, 'By and By I'm Gonna Lay Down My Heavy Load'." *Journal of American History*, June 1991, 111-119.

Reddick, Lawrence D. *Crusader Without Violence: A Biography of Martin Luther King, Jr.* N.Y.: Harper and Row, 1959.

Redlich, Norman. "McCarthy's Global Hoax." *Nation*, 2 Dec 1978, 593, 610-13.

Reeves, Thomas C. "Tail Gunner Joe: Joseph R. McCarthy and the Marine Corps." *Wisconsin Magazine of History*, Summer 1979, 300-313.

_____. "The Search for Joe McCarthy." *Wisconsin Magazine of History* , Spring 1977, 185-196.

_____. *The Life and Times of Joe McCarthy.* N.Y.: Stein and Day, 1982.

"Reflecting on King's Legacy." *New York Times*, 18 Jan 1993, A16.

Reiner, Duane. "Senate Applauds Tribute to King." *Atlanta Constitution*, 16 Jan 1969, 1, 11.

Reisman, David and Nathan Glazer. "The Intellectuals and the Discontented Classes." In Daniel Bell, ed. *The Radical Right: The New American Right, Expanded and Updated.* N.Y.: Doubleday, 1963, 87-113.

"Remembering the Dream." *Newsweek*, 5 Sept 83, 16-17.

"Render Unto King." *Time*, 25 Mar 1966, 18-19.

Reston, James. "I Have a Dream..." *New York Times*, 29 Aug 1963, 1.

"Returned in Kind." *Time*, 24 July 1950, 16.

"Reunion Recalls Movie on Hispanic Strikes Made a Time of Film Blacklist." *New York Times*, 3 May 1982, A16.

Reynolds, William Bradford. speech given before the Current Domestic Politics Class, University of California, Berkeley, 30 Nov 1983.

Ribuffo, Leo. "Why Is There So Much Conservatism in the United States?" *Journal of American History*, Apr 1994, 441-7.

"Rockefeller Ready to Give Up Stocks." *New York Times*, 17 Dec 1959, 43.

Rodden, John. *The Politics of Literary Reputation.* N.Y.: Oxford University Press, 1989.

Rogin, Michael Paul. *The Intellectuals and McCarthy.* Cambridge: MIT Press, 1967.

Rosteck, Thomas. *See it Now Confronts McCarthyism.* Tuscaloosa: University of Alabama Press, 1994.

Rothman, Stanley, ed. *The Mass Media in Liberal Democratic Societies.* N.Y.: Paragon House, 1991.

Rovere, Richard. "The Last Days of Joe McCarthy." *Esquire,* Oct 1973, 186-91.

_____. *Senator Joe McCarthy.* N.Y.: Harcourt, Brace, and World, 1959.

Rule, Sheila. "On King's Anniversary, Reflections on His Dream." *New York Times,* 15 Jan 1982, B4.

_____. "Youngsters Sing of a Dream on Dr. King's Birthday." *New York Times,* 16 Jan 1980, B1.

Safire, William. "The New McCarthyism." *New York Times,* 9 Jan 1975, 35.

Schrecker, Ellen. *No Ivory Tower: McCarthyism and the Universities.* N.Y.: Oxford University Press, 1986.

_____. *The Age of McCarthyism: A Brief History with Documents.* N.Y.: St. Martin's Press, 1994.

Schudson, Michael. *Watergate and American Memory.* N.Y. : Basic Books, 1992.

Schuman, Murray. "Martin Luther King, Jr.: Leader of Millions in Nonviolent Drive for Racial Justice." *New York Times,* 5 Apr 1968, 25-26.

"SCLC Activities." *Atlanta Daily World,* 1-2 Apr 1993, 5.

"SCLC Plans MLK, Jr. Birthday Fete." *Atlanta Daily World,* 11 Jan 1976, 3.

"SCLC Plans Seminar on April 11." *Atlanta Daily World,* 4 Apr 1974.

Scott-Brookins, Portia. "HUD Secretary Pierce Wins Special King Award." *Atlanta Daily World,* 15 Jan 1984, 1, 7.

"Secret Calls—A Photo Doctored . . . Reprisals?" *U. S. News and World Report,* 7 May 1954, 115-33.

"The Senate Contests." *Newsweek,* 31 Mar 1952, 34.

"Sen. McCarthy's Friends Pay Their Last Respects." *Appleton Post-Crescent,* 8 May 1957, 8.

"Senator McCarthy and the Army Fight it Out." *U. S. News and World Report*, 19 Mar 1954, 74-81.

"Senator McCarthy Gives Views on Investigating Committee Methods." *U. S. News and World Report*, 6 Aug 1954, 64-7.

"Senator McCarthy's Bill of Exceptions." *U. S. News and World Report*, 8 Oct 1954, 142-3.

"Senator McCarthy, Investigations." *U.S. News and World Report*, 2 Jan 1953, 30-3.

Shalhope, Robert . "Republicanism and Early American Historiography." *William and Mary Quarterly*, 1982, 334-356.

Shipp., E. R. "The 'Shameful Era' Begins to End for Professors Dismissed by City U." *New York Times*. 26 Mar 1980, B1.

"Signs of Erosion." *Newsweek*, 10 Apr 1967, 32.

Sitton, Claude. "Wallace Asserts Popular Response Calls for Serious Bid in Wisconsin." *New York Times*, 18 Mar 1964.

"Six Senators Try a 'Censure' Case." *U. S. News and World Report*, 10 Sept 1954, 132-47.

Smith, Kenneth L. and Ira Zepp. *Search for the Beloved Community: The Thinking of Martin Luther King, Jr.* Valley Forge, Pa.: Judson Press, 1974.

Smith-Williams, Charlene P. and Chester Goolrick. "Mrs. King Urges Struggle to Defeat 'Triple Evils'." *Atlanta Constitution*, 13 Jan 1981, C1, 2.

Smith-Williams,Charlene P. "Ivan Allen Receives Peace Prize." *Atlanta Constitution*, 15 Jan 1981, C1, 7.

Smothers, Ronald. "Dr. King and the Movement are Recalled as His 44th Birthday is Observed Here." *New York Times*, 16 Jan 1973, 29.

_____. "Son Envisions a Multimedia Martin Luther King." *New York Times*, 3 Oct 1994, B12.

_____. "Uneven Gains Deepen Pressures on Blacks." *New York Times*, 27 Aug 1973, 1, 22.

"South Carolina March." *New York Times*, 16 Jan 1976, 34.

"The Spook." *The New Republic*, 21 Aug 1971, 6.

St. John, Jeffrey. "The New McCarthyism." *New York Times*, 3 Nov 1975, 35.

"Stage Role Recalls Experience of the McCarthy Era." *New York Times*, 25 Dec 78, 28.

A Stickler for the Law Takes an Unwelcome Job." *U. S. News and World Report*, 20 Aug 1954, 82-5.

Stokes, Thomas. "Solemn Ceremonies, Speeches Highlight King Services Here." *Atlanta Daily World*, 17 Jan 1974, 1, 4.

Straight, Michael. *Trial by Television*. Boston: Beacon Press, 1954.

"Stripped Files...Secret Papers...Mr. X...Threats?" *U. S. News and World Report*, 14 May 1954, 101-14.

Stuckey, Sterling. *Slave Culture: Nationalist Theory and the Foundation of Black America*. N.Y.: Oxford University Press, 1987."

A Sunday for Dr. King." *New York Times*,30 Jan 1981, A36.

"Super Spy Hunt." *The New Republic*, 3 Apr 1950, 14.

Szymanski, Michael. "King Center Donors Honored." *Atlanta Constitution*, 14 Jan 1984, B3.

_____. "King Center Offering Kit for Birthday." *Atlanta Constitution*, 2 Jan 1984, 1, 7.

_____. "King Center Struggles to Stay Afloat Financially." *Atlanta Constitution*, 8 Jan 1984, B2.

_____. "King Week Schedule Expanded." *Atlanta Constitution*, 30 December 1983, 7.

Talbot, Daniel. "On Historic Hearings From TV to the Screen." *New York Times*, 12 Jan 1964, B7.

Taylor, Aaron. "Speakers Pay King Tribute." *Atlanta Constitution*, 5 Apr 1971, 1, 13.

Thelen, David. "Becoming Martin Luther King, Jr.: An Introduction." *Journal of American History*, June 1991, 14.

_____. "Conversation with Cornish Rogers." *Journal of American History*, June 1991, 46.

Theoharis, Athan. *Seeds of Repression: Harry S. Truman and the Origins of McCarthyism*. Chicago: Quadrangle Press, 1971.

_____. "The Politics of Scholarship: Liberals, Anti-Communism, and McCarthyism." In Robert Griffith and Athan Theoharis, eds. *The Specter: Original Essays on the Cold War and the Origins of McCarthyism*. N.Y.: Franklin Watts, Inc., 1974, 264-280.

_____. *The Yalta Myths: An Issue in U. S. Politics*. Columbia: University of Missouri Press, 1970.

Thomas, Lately. *When Even Angels Wept: The Senator Joseph McCarthy Affair—A Story Without a Hero*. N.Y.: Morrow, 1973.

Thornton, J. Mills, III. Review of *Let the Trumpet Sound*, by Stephen Oates. In *Journal of Southern History*, Nov 1983, 640-1.

Thurston, Scott and Ron Taylor. "A Mood of Protest Accompanies Floats, Bands at Holiday Parade." *Atlanta Constitution*, 20 Jan 1987, D1.

_____. "King Center Nearer its Goal of Establishing True Identity." *Atlanta Constitution*, 9 Jan 1983, 1, 14.

_____. "MLK, Sr., 'Gandhi' Director Get Prizes." *Atlanta Constitution*, 16 Jan 1983, 1, 11.

_____. "Packed Ebenezer Service Launches King Week '83." *Atlanta Constitution*, 10 Jan 1983, 8.

Tolchin, Martin. "House Sets Back a Plan to Make Dr. King's Birthday a U. S. Holiday. " *New York Times*, 6 Dec 1979, A1.

_____. "House Sets Back a Plan." *New York Times*, 6 Dec 1979, A1.

Trillin, Calvin. "State Secrets." *New Yorker*, 29 May 1995, 54-64.

"An Unfulfilled Dream." *U.S. News and World Report*, 21 Jan 1991, 8.

"Union Honors Dr. King by Declaring a Holiday. " *New York Times*, 12 Jan 1980, A25.

"Vice-President Among Leaders Paying Tribute." *Atlanta Daily World*, 23 Jan 1986, 1.

Viereck, Peter. "The Revolt Against the Elite." In Daniel Bell. ed. *The Radical Right: The New American Right, Expanded and Updated*. N.Y.: Doubleday, 1963, 135-154.

"Vindication on China." *New York Times*, 4 Feb 1973, D14.

Waldron, Martin . "James Earl Ray to Move to U. S. Prison." *New York Times*, 28 Dec 1973, 26.

_____. "Trenton Topics." *New York Times*, 3 Feb 1977, 71.

Ward, John William. *Andrew Jackson: Symbol for an Age*. N.Y.: Oxford University Press, 1953.

"Was Huck Finn Black?" *Time*, 20 July 1992, 18.

Watkins, Arthur. *Enough Rope*. N.Y.: Bobbs-Merrill, 1969.

Watson, Denton L. "Did King Scholars Skew Our Understanding of Civil Rights?" *Education Digest*,Sept 1991, 56-8.

Weaver, Paul H. "The Intellectual Debate." In David Boaz, ed., *Assessing the Reagan Years*. Washington, D.C.: The Cato Institute, 1988, 413-422.

Wehrwein, Austin C. "A Wisconsin Race By Wallace Seen." *New York Times*, 12 July 1964, 59.

Weintraub, Bernard. "Reagan Opens Observances Leading to Dr. King's Birthday." *New York Times*, 14 Jan 1986, A16.

Weiss, Carol H. and Eleanor Singer. *Reporting of Social Science in the National Media*. N.Y.: Russell Sage Foundation, 1988.

Wershba, Joseph. "Murrow vs. McCarthy: See it Now." *New York Times*, 6 Mar 1979, D31, 38.

Westin, Alan F. "The John Birch Society," In Daniel Bell, ed. *The Radical Right: The New American Right, Expanded and Updated*. N.Y.: Doubleday, 1963, 201-226.

"What Did We Lose?" *Life*, Apr 1993, 56-67.

"What Martin Luther King Means to Me." *Ebony*, 3 Jan 1992, 74-80.

"What Martin Luther King, Jr. Means to Me." *Ebony*, 3 Jan 1992, 76-80.

"What Martin Luther King, Jr. Means to Me: Ten Prominent Americans Reflect." *Ebony*, 31 Jan 1986, 74-78.

"What McCarthy Told Watkins Committee." *U. S. News and World Report*, 17 Sep 1954, 130-43.

"Which Way for the Negro?" *Newsweek*, 15 May 1967, 27-28, 30, 33-34.

White, Hayden. *Metahistory: The Historical Imagination in Nineteenth Century Europe*. Baltimore, Johns Hopkins University Press, 1973.

_____. *The Content of the Form: Narrative Discourse and Historical Representation*. Baltimore: Johns Hopkins University Press, 1987.

"Whitewash . . . Hostage . . . Phony Charts . . . Treason." *U. S. News and World Report*, 4 June 1954, 89-94.

Whitfield, Ellen. "New Civil Rights Chapter Opens on the Subtleties of the 90s." *Atlanta Constitution*, 10 Jan 1993, 1, 6.

"Who Will Stand Up Against McCarthy." *The New Republic*, 12 Jan 1953, 5.

"Why They Riot." *National Review*, 9 Mar 65, 178-80.

Wicker, Tom. "Lessons of Lattimore." *New York Times*, 9 June 1989, 31.

_____. "Smearing the Dead." *New York Times*, 11 July 1989, 19.

Wilkins, Roger. "The Innocence of August 1963." *Washington Post*, 28 Aug 1973, A20.

Will, George F. "Joe McCarthy as Seen Some 30 Years Later." *Appleton Post-Crescent*, 14 June 1984, A1.

_____. "The Fall of Joe McCarthy." *Washington Post*, 14 June 1984, A23.

Williams, Preston N. "Remembering King through His Ideals." *Christian Century*, 19 Feb 1986, 175-77.

Williams-Lewis, Donna. "SCLC Officials are Banned From Governor's Office." *Atlanta Constitution*, 16 Jan 1987, 15.

Winter, Don and Richard B. Matthews. "City Striker Shot in Fight." *Atlanta Constitution*, 5 Apr 1970, 1, 4.

"With But One Voice." *Nation*, 24 Apr 1967, 515-516.

Wrong, Dennis. "Theories of McCarthyism—A Survey." *Dissent*, Autumn 1954, 385-392.

"A Year of Homage to Martin Luther King." *Ebony*, Apr 1969, 31-42.

Yerxa, Fendall W. "Humphrey Sees a Rise in Strife if Goldwater Policies Prevail." *New York Times*, 27 Oct 1964, 21.

Zaferos, William. "'Joe Was Right,'" *Appleton Post-Crescent*, 5 May 1987, A1, 12.

_____. "Could a McCarthy Happen Again?" *Appleton Post-Crescent*, 6 May 1987, A1, 5.

_____. "Larger Than Life, Even in Death." *Appleton Post-Crescent*, 3 May 1987, A1.

_____. "McCarthy Bust to Stay Put for Now." *Appleton Post-Crescent*, 11 July 1986, A1, 3.

_____. "McCarthy Statue Inappropriate?" *Appleton Post-Crescent*, 9 July 1986, A1, 5.

_____. "McCarthy Statue Inappropriate?" *Appleton Post-Crescent*, 9 July 1986, A1.

_____. "The Legacy," *Appleton Post-Crescent*. 4 May 1987. A1, 2.

_____. "Urban and Joe: Pals Through it All." *Appleton Post-Crescent*, 3 May 1987, A1.

Zelinsky, Wilbur. *American Nationalism*. Chapel Hill, University of North Carolina Press, 1988.

Zelizer, Barbie. *Covering the Body*. Chicago: University of Chicago Press, 1992.

Zepp, Ira. "The Intellectual Sources of the Ethical Thought of Martin Luther King, Jr., As Traced in His Writings with Special Reference to the Beloved Community." Ph.D. dissertation, St. Mary's Seminary and University, 1971.

Index